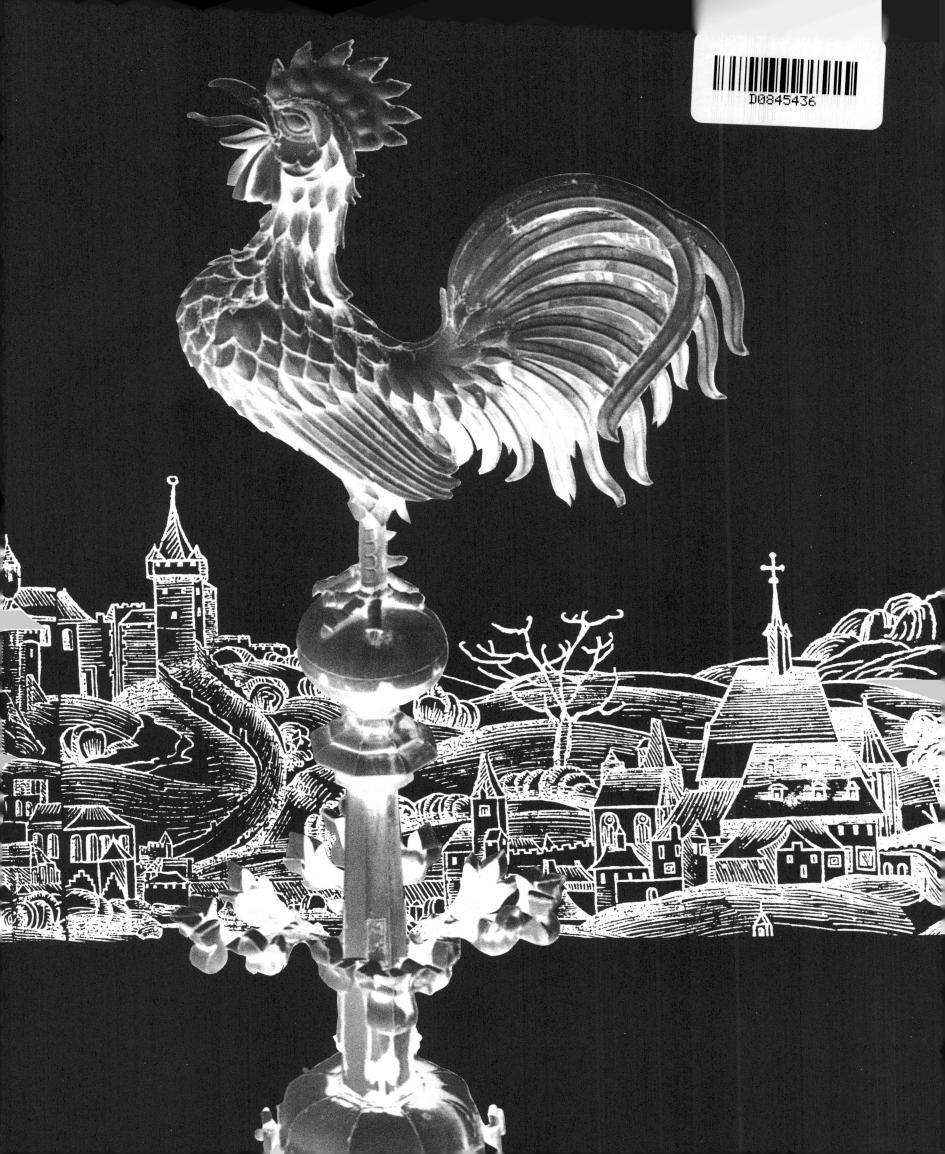

D0845436

THE CASTLE
OF
PRAGUE
AND ITS TREASURES

FLINT RIVER

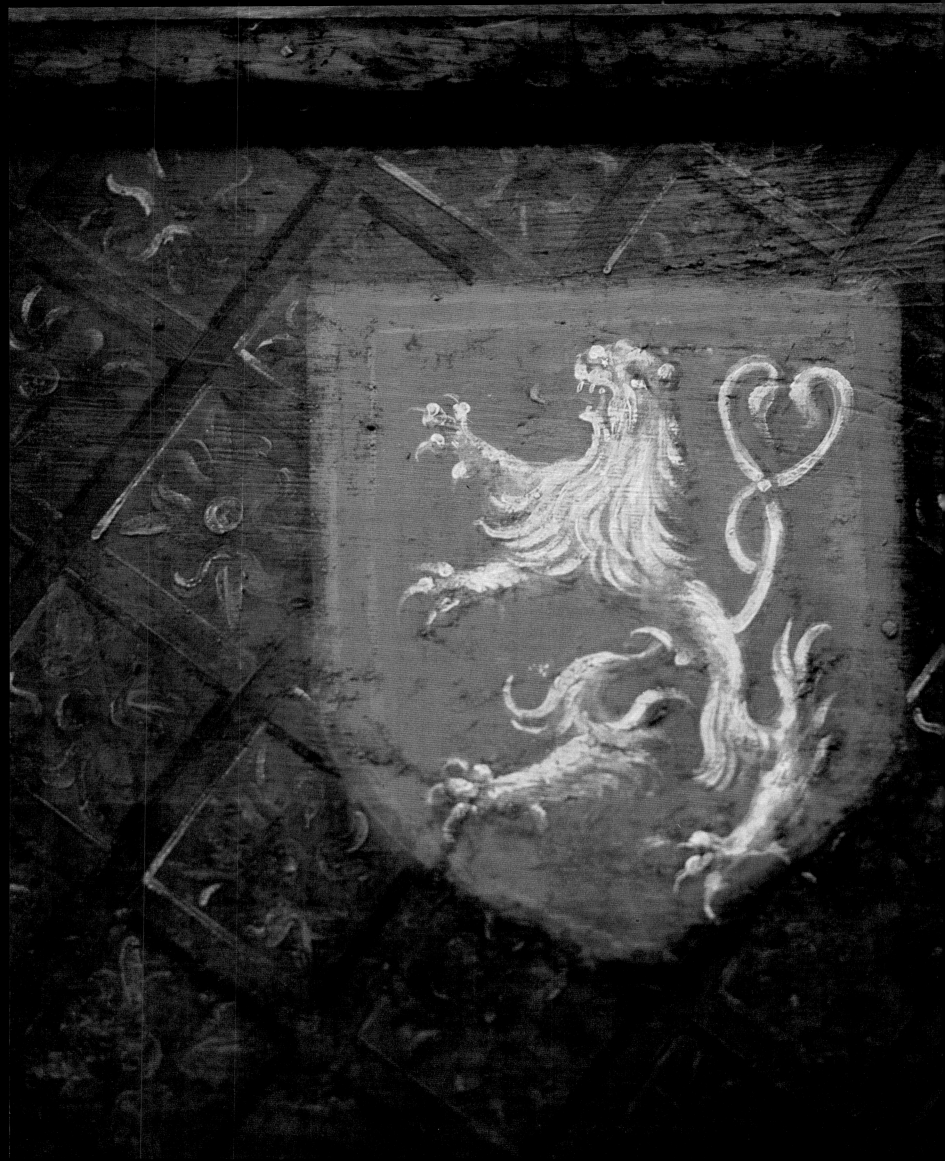

THE CASTLE
OF
PRAGUE
AND ITS TREASURES

Texts
Charles, Prince of Schwarzenberg
Ivo Hlobil, Ladislav Kesner, Ivan Muchka, Tomáš Vlček

Photography
Miroslav Hucek and Barbara Hucková

Design
Emil M. Bührer

English translation
John Gilbert

A Motovun Group Book

First published in the United Kingdom
by Flint River Press
28, Denmark Street
London WC2H 8NJ

© 1992 Motovun (Switzerland) Co-Publishing
Company Ltd., Lucerne;
Barbara and Miroslav Hucek, Prague
(photographs)

© 1994 Flint River Press
for the English edition excluding North America

All rights reserved

ISBN 1-8714-89-5-6

Coordinating Editor
Irina Mirabaud, Lucerne

English Edition Editor
Madge Phillips

Editorial Assistant
Sarah Bland

Colour separation by
Lanarepo, Lana

Typesetting and layout by
Avalon

Printed and bound in Italy by
Grafiche Lema,
Maniago PN

Pages 2-3: *blazon with the Czech lion.*
Sculpted on the sarcophagus of Prince
Vratislav in St George's Basilica of the
convent of the Benedictines, this is one of
the wooden coats-of-arms on the tomb of
the church's founder. It is an important
monument of the Přemyslid and
Luxembourg eras of Prague Castle.

Jan Žižka, military leader of the Hussites,
with his army. Jena Codex, before 1500.

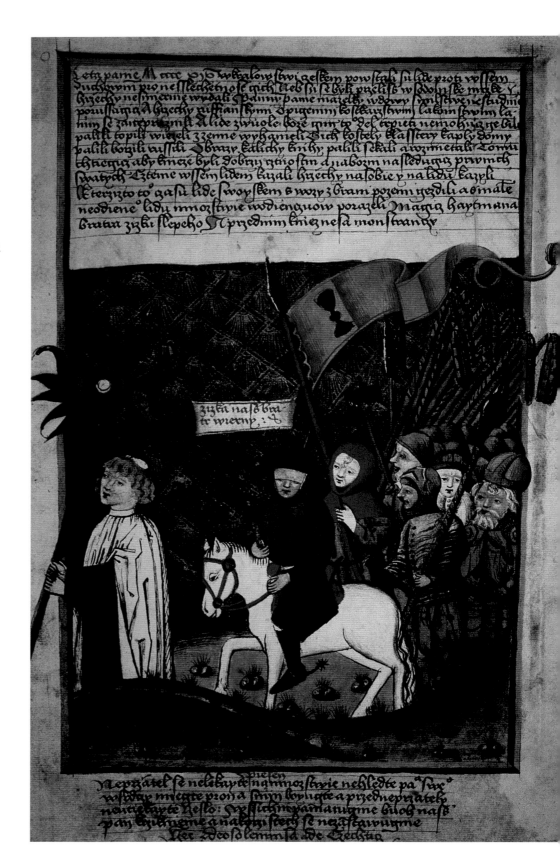

'Ancient, sublime, shrouded in mystery,
like a precious jewel borne by a pauper woman,
unalterably beautiful beneath her wrinkles:
such is Prague in the hands of Bohemia'.

Pavel Kohout

Prague
stands at the crossroads of history,
where past and present converge,
as on a measureless stage that has seen
mighty political encounters and manoeuvres.
Here, the representatives of religious and worldly powers
have clashed with one another in argument and battle.
Here, on the stage of European diplomacy,
threads of intrigue have been woven,
stratagems have been laid,
and the drama of revolution has been enacted.
For in Prague,
history has seldom paraded as light-hearted entertainment,
burlesque or empty comedy.
Its constantly repeated themes are far more serious:
they have to do with the nation's very existence,
its striving for statehood and its claim to
its rightful place in Europe.

Václav Havel

Václav Havel

Bust of Charles IV by Peter Parler, placed in the triforium of St Vitus's Cathedral, a realistic representation of the emperor in old age. Of all monarchs, Charles IV was undoubtedly the best equipped to build the residence of the Czech and Germanic kings and emperors, and it was not by chance that the Czech people expressed their admiration for him by dubbing him "father of the country".

Pages 8-9: *view of Prague from the Strahov Gardens.* This view from the east shows the picturesque site of the town in the Vltava basin, dominated by the powerful towers of Prague Castle. On the right is the crest of Petřín Hill.

Below: *the Charles Bridge,* built in 1357, by order of Charles IV, on the site of the Romanesque Judith Bridge, destroyed by flooding. Resting on sixteen arches, the bridge is 520 m (1700 ft) long and 10 m (33 ft) wide. Between 1683 and 1714, it was decorated with 30 statues of saints.

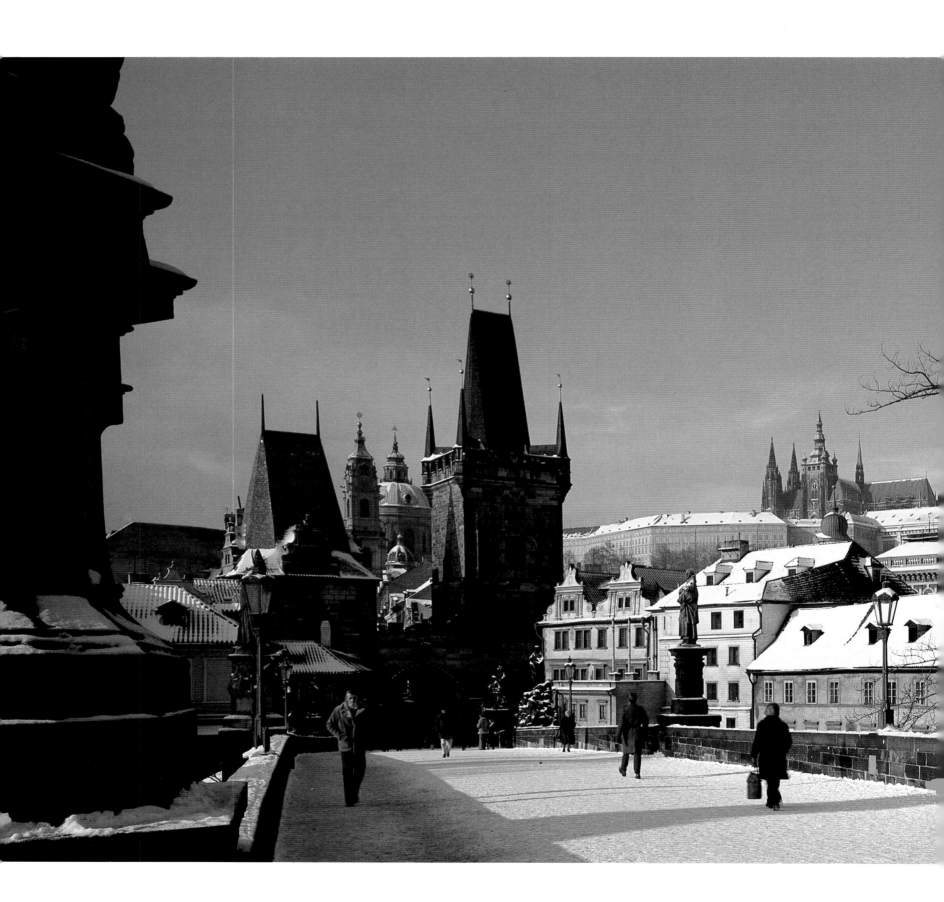

Pages 12-13: *classic panorama of Prague Castle* reflected in the waters of the Vltava with, in the foreground, the Gothic bridge and its statues, and the Malá Strana quarter dominated by the Baroque St Nicholas's Church; behind are the harmonious façades of the castle buildings, above which are outlined the towers of St George's Basilica and St Vitus's Cathedral.

Pages 14-15: *general view of Prague Castle from the Malá Strana tower of the Charles Bridge*, with St Nicholas's and St Thomas's churches. It also shows an important historical monument, the Bishop's Court, originally the residence of the bishops of Prague, of which only one polygonal tower (lower right) survives.

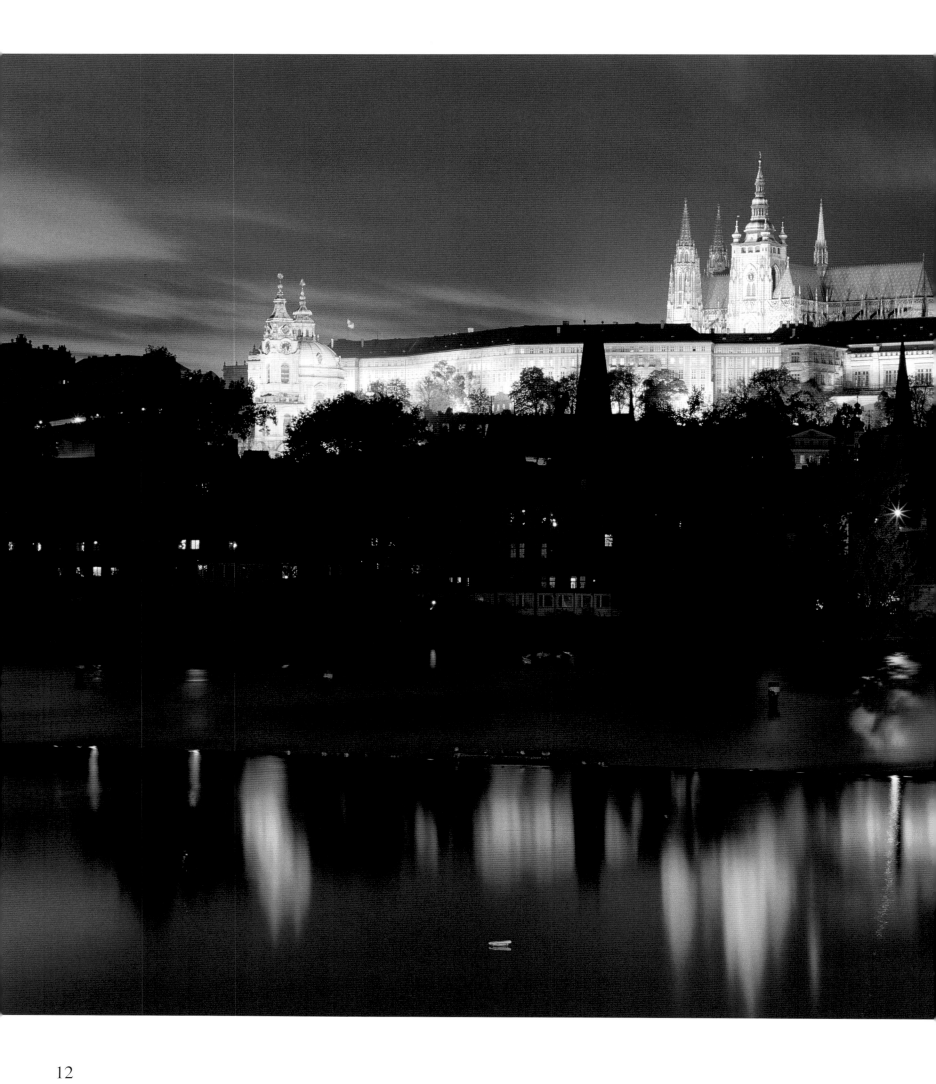

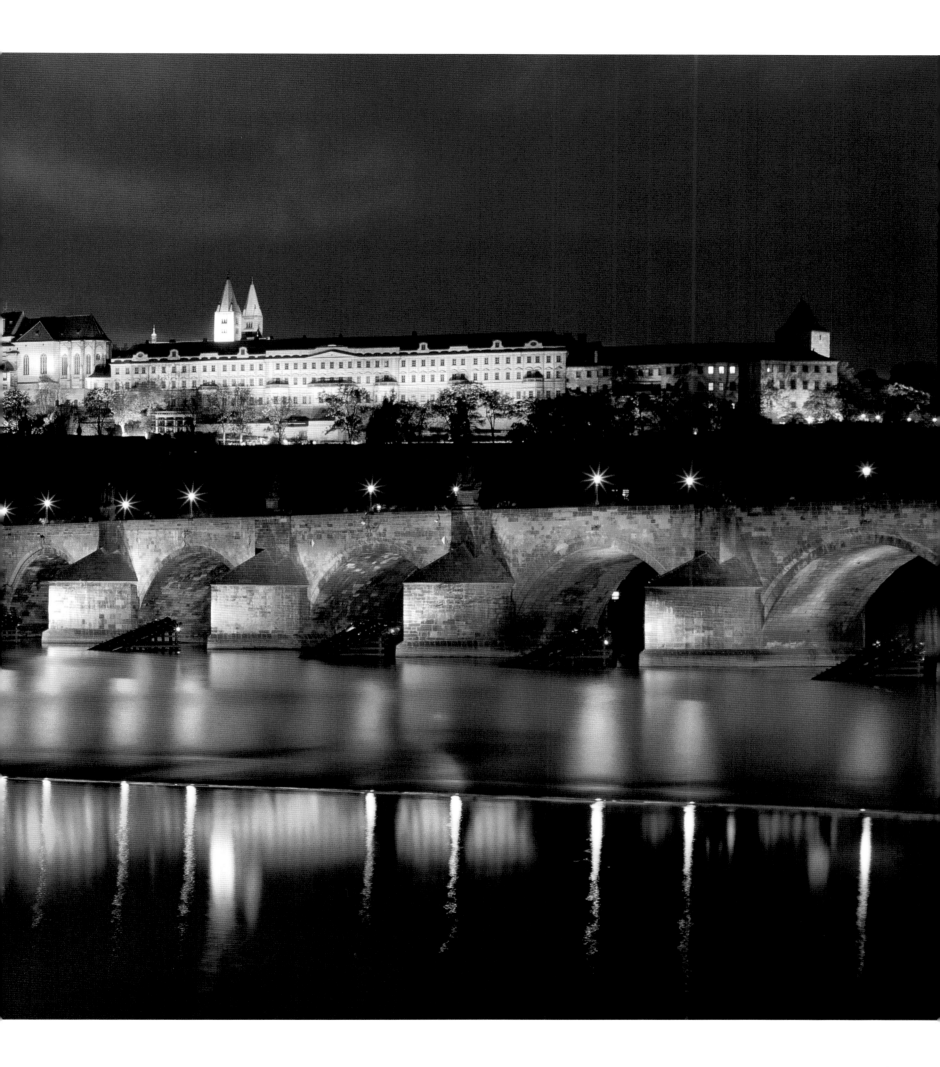

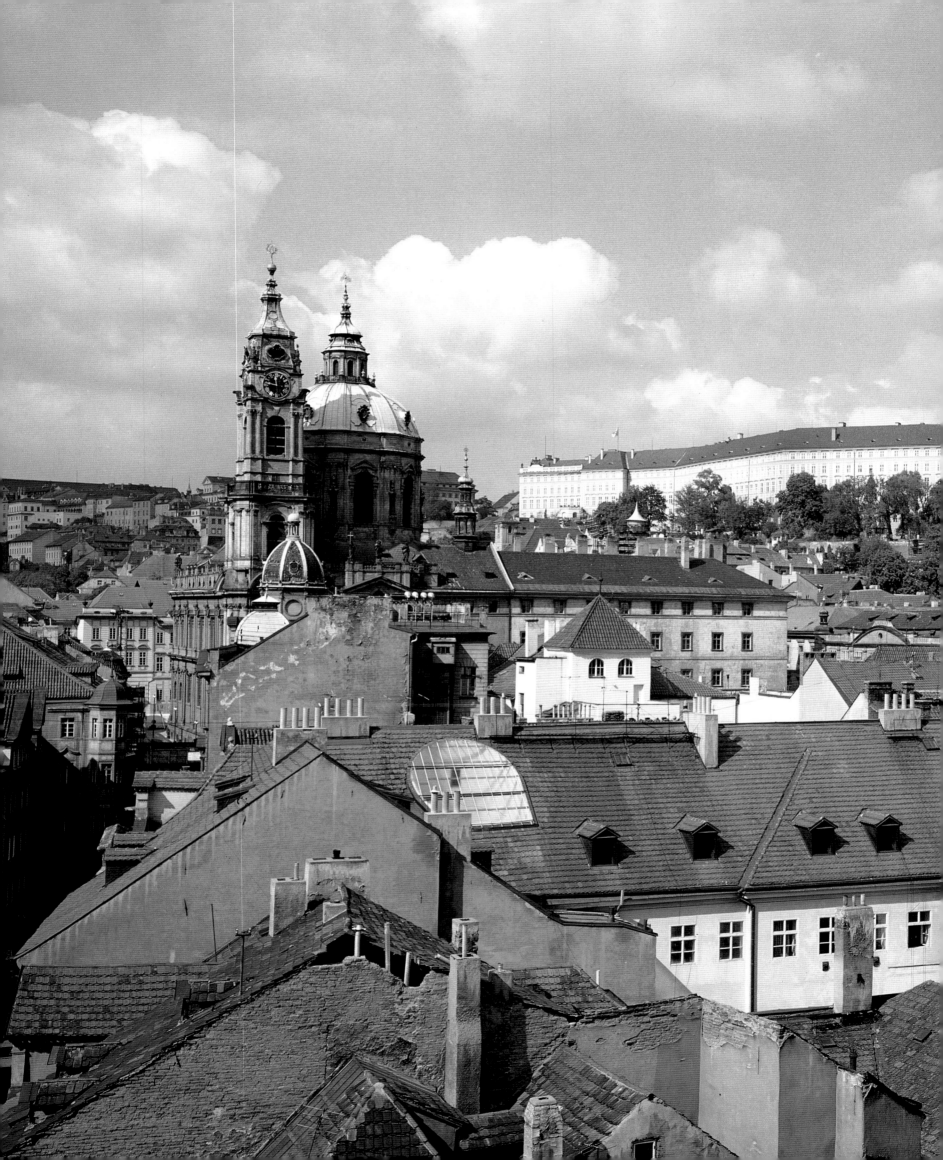

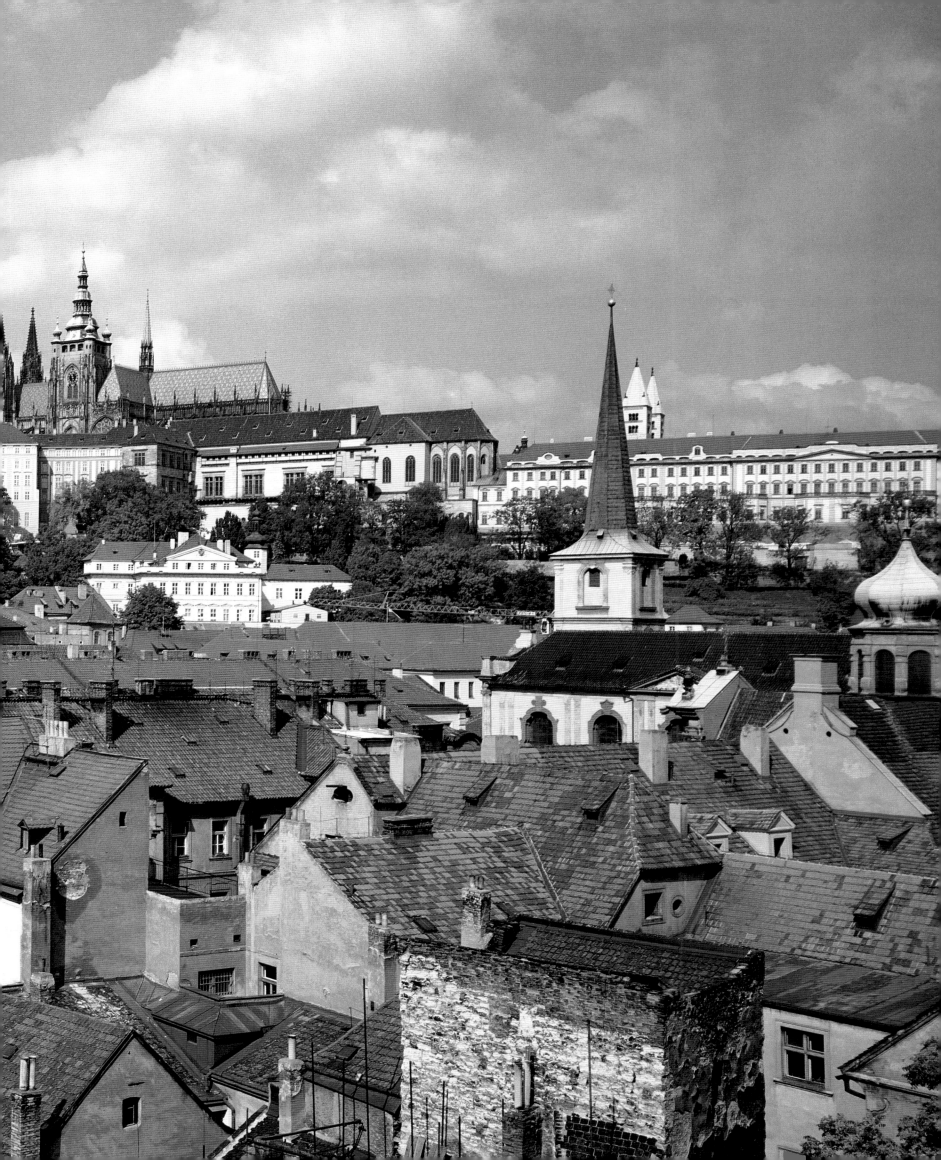

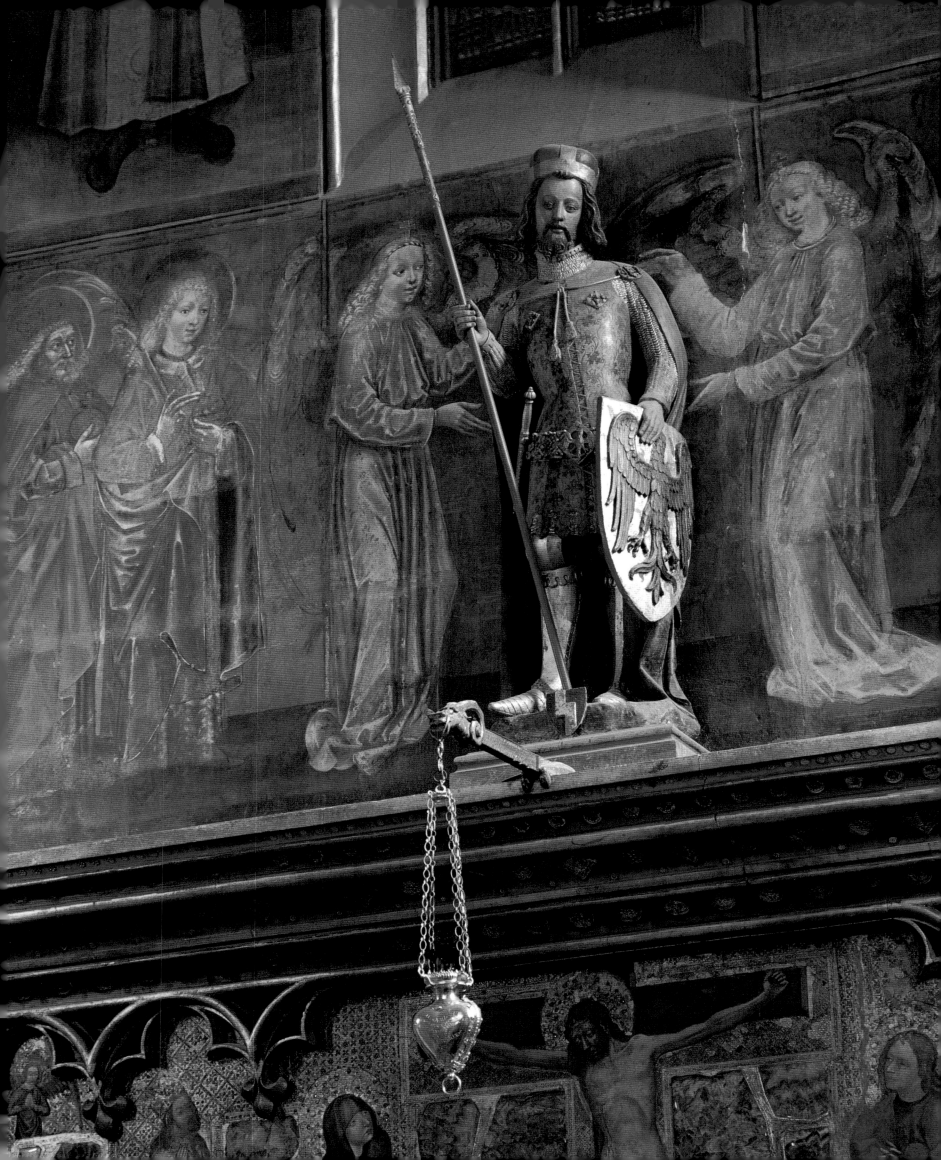

ORIGINS AND HISTORY OF PRAGUE CASTLE

There is an engraving, dating back to the Baroque era, of Bohemia, shown as a rose with one hundred petals, at the heart of which is Prague. But the true heart of Bohemia always was, and still remains, Prague Castle. Its origins are veiled in mystery. At the end of the 11th century, Kosmas, the first Czech chronicler, resorted to legend: the daughter of the mythical king Krok, the aristocratic, gracious and chaste Princess Libuše, endowed with the gift of prophecy, had predicted the future to the elders of the nation in these terms:

'I see a great castle whose glory will reach to Heaven; it is located in a deep forest, bounded by the waves of the Vltava. There, a large rocky mountain called Petřín heaves like the back of a porpoise, the seahog, and winds towards the river. You will find there a man who is digging out a threshold. And because even the great noblemen must bow low before a threshold, you shall give the name Prague (*Praha*) to the castle that you shall found there. This castle shall then give birth to two golden olives whose tips shall reach the seventh heaven; and miracles and wonders shall light up the world. All those generations living in the Czech lands, and other peoples too, shall pay honour to them with gifts and sacrifices. The first olive shall be called *Více slávy* (*Svatý Václav*) ['Greater glory', St Wenceslas]; the second *Voje utěcha* (*Svatý Vojtěch*) ['Consolation of Voj', St Vojtěch = Adalbert].

Such was the prophecy of Libuše, whose marriage to the 'ploughman' Přemysl gave rise to the line of the Přemyslids which gradually came to dominate the whole of Bohemia.

What was the true origin of Prague Castle? Apparently, after its arrival in the country, the Slav tribe of the Czechs moved north towards the Elbe. Subsequently it set up one of its earliest fortresses, named Levý Hradec (now situated some 10 kilometres north of Prague), on a rocky promontory facing the Vltava. It was here, too, according to legend, that the first Christian church in Bohemia was built.

The tribe chose its headquarters in a place where the Vltava, until then hemmed in by steep hills, forms a meander, with a flat catchment basin that had been inhabited for centuries. There, almost in the very centre of the country, protected on all sides by mountain barriers, at the most convenient spot for fording the river, stood a crossroads of ancient trade routes which ran northward from the south and the west until they reached the sea, thence proceeding onward to the Near and Far East. To the north, the basin was defended by a string of prehistoric strongholds, the names of which are lost. To the south, on the river's left bank, stood the powerful castle of Děvín. On the opposite bank, a little higher up, the castle of Vyšehrad, regarded in Czech royal legend as the most ancient of princely seats, perched on a rock, surrounded by the Vltava and the Botič. Certainly, around the middle of the 12th century, the castle often served as the residence of Czech monarchs (who kept there the bast slippers worn by the first prince, Přemysl, to recall his peasant origins); and until the Hussite Wars, Vyšehrad, at various times, contained more shrines than Prague Castle itself.

In the middle of this protected basin, the mountain of Petřín (which must originally have been fortified as well) narrowed to form the legendary 'porpoise's back', shielded to the south by a sheer drop down to the river, and to the north by the steep valley of the Brusnice stream. So all that was needed for defence was a deep trench dug across the col formed by the mountain backbone (i.e. between the present Archbishop's Palace and the First Courtyard of the castle). The oldest stronghold was protected by ramparts with palisades and gates facing west, south and east; inside was the prince's residence and a raised area called Žiži, doubtless a tomb (apparently situated between the eastern end of the modern cathedral and St George's Basilica), which may have been used in a fire cult and, at the same time, as the stone base of the prince's throne.

Opposite page: *statue of St Wenceslas* on the cornice of the façade wall of the chapel dedicated to him in St Vitus's Cathedral. The principal patron saint of Bohemia is represented in a typical guise of the Middle Ages, as a knight, his shield emblazoned with a spread eagle. The statue, in marl, with precious traces of medieval polychromy, is by Peter Parler and Heinrich of Gmünd (1373).

The Czechs immediately adopted the Christian faith that had arrived from the West: in the year 845 fourteen Czech princes went to be baptised at Ratisbon (Regensburg). The second wave of Christianity, certainly much stronger, was of Eastern origin: in 863 Cyril and Methodius were sent as missionaries from Constantinople to Moravia, carrying relics of St Clement (Kliment). It was to this saint that the first churches of Levý Hradec, Vyšehrad and Stará Boleslav — but not Prague Castle — were dedicated. The earliest Christian church in Prague was built, in the late 9th century, in honour of the Virgin Mary.

During the first third of the 10th century, Prague Castle was the scene of a dramatic confrontation between the forces of paganism and the new faith. Before 921, Prince Vratislav had built St George's Basilica: the story of the saint's fight against the dragon was surely understood as being symbolic (the rotunda of Mount Říp is dedicated to the same saint and it was said that a dragon lived in the castle of Wawel at Cracow). According to Czech legends, the drama reached its culmination after the death of Prince Vratislav in 921, while his son Wenceslav (Václav) was still a minor. Vratislav's widow, Drahomíra, who must have been a staunch pagan, forced the Princess Ludmila (whom legends say was the grandmother of St Wenceslas) to flee to Tetín Castle, on the Berounka, and then sent assassins who strangled her. Later, Prince Wenceslas brought the body of Ludmila to St George's Basilica at Prague Castle. But because of the spring that gushed from the ground, the body could not be buried there, and it was only when the basilica was consecrated by the bishop of Ratisbon that it was permitted to lie in peace.

During the reign of Prince Wenceslas, when the Church of Cyril and Methodius was destroyed by the Hungarian invasion, Bohemia turned its spiritual gaze to the West. This is proved by contacts that already existed with the bishop of Ratisbon and, moreover, by the fact that the new church which Prince Wenceslas now built in Prague Castle was dedicated to St Vitus (Vít). He was a saint virtually unknown at home but venerated in Saxony (only a few historians have sought to associate this saint's name with the cult of Svantovít which flourished among the Slavs on the shores of the Baltic). Prince Wenceslas had obtained the shoulder of the saint from Emperor Henry I of Saxony and the rotunda of St Vitus subsequently became the foundation of the cathedral. The flames that appear on the eagle of St Wenceslas are said to refer to the importance of the saint and to the legend of his martyrdom.

In fact, the death of Wenceslas was the occasion for the third confrontation between the pagan and Christian faiths, from both west and east. In either 929 or 935 Wenceslas was invited by his brother Boleslav to the castle of Stará Boleslav for the festivities of St Comus (Kosma) and St Damian (Damián) on 27 September. These, together with the feast of St Michael (Michal) on 29 September, were the Christian replacements of the older pagan harvest and vintage festivals. Comus and Damian, two physicians from the east, already had their church at Stará Boleslav (the crypt had always been dedicated to them) and it was there that Wenceslas proposed a chivalric toast to St George. The next morning he was murdered by his brother near the door of the cathedral and Boleslav assumed power in Prague. The miracles that occurred at the tomb of Wenceslas caused his body to be transported, three years later, to Prague and buried in St George's Rotunda. The first golden olive of Libuše's legend had flourished and had been destroyed.

The second olive found its embodiment in the person of Bishop Vojtěch (Adalbert) of Prague. Prince Boleslav I the Cruel (d. 967) did his utmost to have a diocese created at Prague Castle and sent his daughter Mlada to Rome to conduct negotiations. In Rome Mlada learned of the existence of the Benedictine order; the pope consecrated her as abbess and she returned to Prague with a papal bull to found there, beside St George's Basilica, a convent of Latin liturgy 'not conforming to the rites of the Russian or Bulgar peoples or to the Slav language'. She died as mother superior of the convent, and of saintly reputation, in 994. The diocese had by then been established, in 973, during the reign of Boleslav II the Pious, and it owed obedience to the archbishop of Mayence. The Saxon

Coins: Bořivoj II, *c*. 1100, with a rider.
Vladislav I, *c*. 1109, with a warrior.

monk Dětmar (who knew the Slav tongue) became its first bishop: he had been enthroned in 975 in St Vitus's Cathedral while choristers sang the German canticle *Kriste Ginado*, to which the congregation gave the response of *Kyrie Eleison*, in the Czech phonetic form of *Krlèche*.

On the death of Dětmar, St Adalbert was proclaimed bishop by the great assembly of nobles and common folk held at Levý Hradec in 982. He was a member of the Slavník family which held sway over the whole of eastern Bohemia, and the hope was that his election as bishop would enable the Přemyslids to re-establish good relations with the rival dynasty. In fact, Adalbert became embroiled in incessant quarrels with the leading families of Prague and was compelled to return to Rome. During his second stay in Italy, in 995, on the anniversary of the death of St Wenceslas, his entire family was massacred at Liblice Castle. The bloodthirsty climax to the power struggle, imposing unification by force, terminated Adalbert's episcopal functions. He set off for the north as a missionary to the heathen Prussians and died there, a martyr, in 997. His body was brought to the Polish town of Gniezno which, as a consequence of this translation, became the metropolitan archdiocese of Poland.

This period, too, saw a radical change in the relations between Poland and Bohemia. Until then the Czechs had held Cracow, but in the year 1000 the Polish king, Boleslaw the Brave, not only captured the town but also proceeded soon afterwards to take Prague. Fighting continued, with various changes of fortune, until 1039, when Prince Bretislav I conquered Gniezno and preached a sermon to the rival factions, at the tomb of St Adalbert, enjoining them to observe the Christian faith, particularly in respect of marriages and burials and in the consecration of Sunday to God. He returned to Prague with the body of the saint and with

vast quantities of stolen treasures, burying the remains of St Adalbert in a chapel beside the entrance to St Vitus's Rotunda.

From 1050 Prague Castle was gradually and steadily transformed into a typical feudal stronghold. Stone fortifications were constructed and, next to St Vitus's Rotunda a great basilica with a three-aisled nave was built and placed under the patronage of St Vitus, St Wenceslas and St Adalbert; only the crypt retained its original consecration to St Comus and St Damian. The bishop was given his own residence and St George's Basilica was refitted. In 1198, the Czech princes obtained the hereditary title of king of Bohemia, reconstructed their palace, dug additional moats on the west side, raised towers over the gates and built All Saints Chapel.

The golden age of the castle began with the reign of Charles IV. After his return from France, in 1333, he decided to build a new palace and to strengthen the fortifications; and in 1342 he created a chapter at All Saints Chapel. In 1344 he succeeded in raising the diocese of Prague to the status of archdiocese and, soon afterwards, laid the foundation stone of the new St Vitus's Cathedral. Moreover, the establishment of a university at Prague and the enlargement of the town (by creating an extensive new quarter, Nové Město, the New Town) bear testimony to the fact that Charles IV was methodically rebuilding Prague with a view to its becoming the new capital of the Holy Roman Empire. He collected valuable saintly relics from all over Europe, embellishing them with gold, silver and precious stones, displaying most of them in the cathedral (where they still represent the most beautiful part of its treasure), and assigning the remainder to the castle of Karlštejn, then in course of construction.

Přemyslid through his mother, Luxembourg through his father, Charles IV adhered to the traditions of both dynasties. He had tombs carved in the cathedral for his Czech ancestors, adorned the sarcophagus of St Wenceslas with gold, and covered the walls of his chapel with semi-precious stones. He recalled his father's traditions by commissioning, for the palace, portraits of the emperors who had preceded him and

transporting the remains of St Sigismund into the cathedral, where he built a chapel for them, facing that of St Wenceslas. He officially declared six national protectors: St Vitus, patron saint of the cathedral; Wenceslas the Přemyslid; Bishop Vojtěch (Adalbert); Ludmila the Přemyslid (whose carved tomb, in the new chapel of St George, he embellished); St Procopius, founder in the mid-11th century of a Slav convent in the Sázava region; and, finally, St Sigismund. All these saints are depicted on the mosaic of the cathedral's Golden Gate (south entrance), in the sculptures of the upper level of the triforium, and on the ex-voto of Archbishop Jan Očko of Vlašim. Adding a final and wholly modern touch, Charles IV immortalised his entire family, the archbishops, bishops and even the architects of the cathedral with marvellously realistic busts situated on the lower level of the cathedral's triforium.

There were various interrelated influences behind Charles IV's plan to build his new European capital. The impact of ancient Rome and papal Rome was evident in the portraits of the emperors, in the transfer of copies of the Virgin from the basilica of Sta Maria d'Aracoeli and of the Veraïkon of Christ; France and the age of chivalry were recalled in the construction of All Saints Chapel, a beautiful imitation of the Sainte-Chapelle in Paris; and the walls of St Vitus's Cathedral and of Karlštejn Castle, encrusted with semi-precious stones, harked back to wealthy Byzantium. Yet, although his work in Prague marks a peak of Gothic culture, his dream of making Prague the centre of the empire did not survive the emperor himself, who died in 1378. His son, Wenceslas IV, did not dare even to lay claim to the imperial crown, and embarked on a quarrel with Archbishop Jan of Jenštejn that reached its climax when he had the archbishop's vicar-general, John of Nepomuk, later to become the saint of Czech Baroque, tortured and drowned. He did not even manage to complete the cathedral, of which only the monumental torso of the choir and the powerful South Tower remain.

The national and social rivalries of the age soon plunged the country into the Hussite religious revolu-

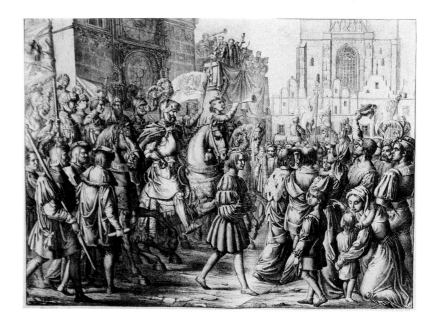

tion. The fact that the newly elected (in 1458) Czech king, George of Poděbrady, did not take up residence at the castle, but in the so-called Royal Court in the Old Town (Staré Město) quarter, near the Powder Tower, demonstrates the rising power of the Hussites. It was not until 1485 that King Vladislav II, of the Polish Jagiello dynasty, restored the castle to its former glory. Above the palace of Charles IV he built the gigantic Vladislav Hall (from which the President today sets out for his election), as well as the Riders' Staircase leading to it. In the cathedral the foundations were laid of the North Tower and the Royal Oratory was incorporated. Finally, Vladislav built the fortification towers. Thus, as the Gothic age gave way to the Renaissance, the heroic era of Prague Castle came to an end.

The breakthrough of the Renaissance in Bohemia was linked with the accession of the Hapsburgs in 1526. In the castle it is represented by the charming summer pavilion known as the Belvedere, one of the purest Italian Renaissance-style buildings to appear north of the Alps. But before it was completed, in 1541 a terrible fire broke out in the castle: it destroyed a number of buildings (including Charles IV's All Saints Chapel), the new fittings in the cathedral and the Crown Jewels, as well as the property registers where for centuries the tenants of the lands belonging to the

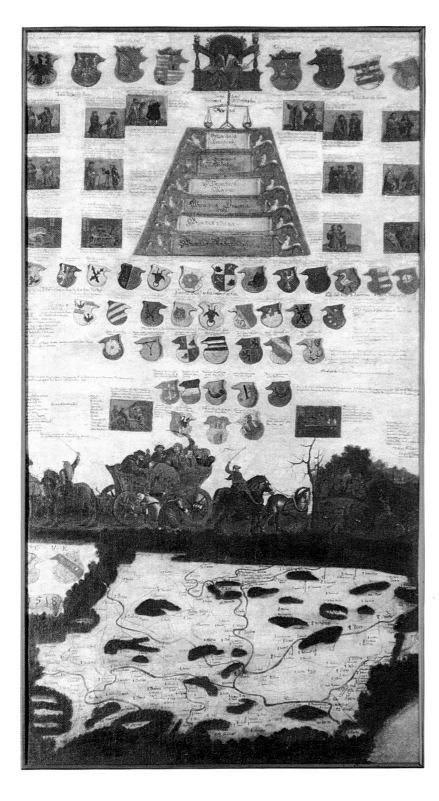

Map: first map of Bohemia with Czech place names, drawn by Mikuláš Klaudián and dated 1518.

Trent (1545-63). The Catholic nobility, although few in number and in a minority, were nevertheless rich and influential: the immense Rožmberk (Rosenberg) Palace, which then occupied the entire eastern part of the castle's south front, bore witness to the power of the Catholic aristocracy. The papal nuncio and Spanish ambassador, along with the highest functionaries and their Spanish wives (whom they had met during their missions to Spain) formed a 'Spanish faction' which had a strong influence on policy. One of their actions was to arrange for the translation of the remains of St Procopius to All Saints Chapel (from the convent of the Sázava region which had been suppressed).

The emperor himself showed signs of ruling under constraint and coercion. He was mainly interested in his collections of paintings, statues, precious stones and curiosities of nature for which he built the magnificent Spanish Room. He invited to court the painters Giuseppe Arcimbolo, Hans von Aachen and Bartholomeus Spranger; the sculptors Hans Mont and Adriaen de Vries; the medallist Abondio and dozens of others. His lively interest in all the sciences kept him in touch with research throughout Europe. The scholar John Dee came from England to see him, together with the spiritualist Edward Kelley; the astronomer Tycho Brahe arrived from Denmark and Johannes Kepler soon joined him; and in the course of a journey across Europe, Giordano Bruno also passed through Prague. The famous Prague rabbi, Yehuda Löw ben Bezaliel, apparently gave the emperor a demonstration of the secrets of the camera obscura. All these astronomers, astrologers, mineralogists, botanists, mathematicians, geometricians, specialists in exact sciences and charlatans received a warm welcome at Rudolf's court.

The castle set a rare example of refined culture and artistic endeavour. Indeed, it became virtually the most influential centre of Mannerism north of the Alps. Of this richness little remains: the Royal Ball Court, the white marble mausoleum of the Czech kings, several tombs in the cathedral and a few paintings and statues. Meanwhile, the popular new radical trend persuaded the emperor to publish, in 1609, imperial letters that

nobility had been listed.

It was at this time, too, that the country rapidly veered towards Lutheranism under the influence of neighbouring Saxony; and there was even an attempt, in 1547, to defy the Catholic king. A religious compromise of a conciliatory nature was effected under Maximilian II (emperor from 1564 to 1576). But the accession of Rudolf II, his successor to the Czech throne in 1576, was already marked by a militant Catholicism reflecting the spirit of the Council of

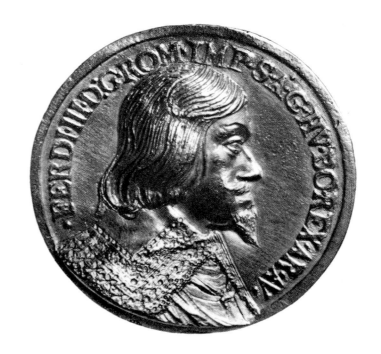

granted freedom of conscience. But shortly afterwards, in 1611, the Czech Estates placed Matthias, brother of Rudolf II, on the royal throne of Bohemia, and the emperor, stripped of almost all his powers, died in the following year, isolated amid his precious collections. Events were soon to explode, irreversibly, into crisis.

The Catholic and Protestant nations of a divided Europe prepared for a struggle that actually began at Prague Castle, in 1618, when the Catholic lieutenant-governors were hurled out of the windows of their offices at court. The rebellious estates now chose Frederick, the elector Palatine, as their new Czech king; he displayed his Calvinist leanings shortly before Christmas 1619 when he 'cleansed' the cathedral of its altars, statues and 'idolatrous' paintings. It was a very ill-advised action in a country proud of its past. Thus, for the Catholics, the defeat of King Frederick at the battle of the White Mountain, in 1620, and his flight from Prague constituted a well-deserved punishment. Ferdinand II, the victorious emperor, now subjected the country to extremely harsh measures: the abolition of many social and economic rights, the outlawing of non-Catholic religions (which led to a massive exodus of the nobility, the middle classes and intellectuals), and the suppression of the Czech language. The Thirty Years' War, which broke out at Prague Castle, also ended there in 1648 when the city was captured by the Swedes. They made off with the magnificent collections of Rudolf II, some of them going back to Sweden, some being dispersed all over Europe and the rest being offered by Queen Christina, a Catholic convert, to the pope.

The organic life of the castle also came to an end with the Peace of Westphalia, in 1648. Only on exceptional occasions, and increasingly rarely, did the castle now receive imperial guests from Vienna. Apart from Joseph I, Joseph II and Franz Joseph I, monarchs continued to be crowned at Prague Castle, but they gradually lost interest in it as an imperial residence. The cathedral alone remained a living force, a proud symbol of the nation's faith and conscience. Matouš Ferdinand Sobek of Bílenberk, archbishop from 1668 to 1675, dreamed of endowing the country with a new

Slav saint. He made a bid to canonise St Ivan, a legendary hermit who had formerly lived not far from Ludmila's Tetín, but the attempt failed. He then resorted to a prophecy which predicted that whoever finished the building of the cathedral would go on to conquer the Turks. In 1673 massive columns were stacked in the cathedral's building yard, but war soon ended the work.

A close colleague of Archbishop Sobek was his vice-general, Tomáš Pešina of Čechorod, an ardent patriot who wrote histories of the land and of the cathedral. In 1673, in a work entitled *Phosphorus septicornis*, he drew up a thorough inventory of the cathedral's collection of jewels and relics, which he himself had meticulously arranged. Another patriotic friend of Pešina was Bohuslav Balbín, a fervent Jesuit, who besought the Virgin Mary to protect 'an already declining nation' and, in a desperate attempt to discover a saint who would restore past glory to the humiliated Czechs, wrote the legendary biography of the medieval doctor of canon law, John of Nepomuk.

In the ensuing decades there were repeated attempts to bring about John's canonisation. A commission, made up of professors of medicine from Prague University, examined his tomb in Prague Cathedral and found his tongue intact (recent inspection of the saint's remains, carried out in the 1980s, led to the astonishing discovery that some brain tissue had been preserved, testifying to the conscientious work of the 17th-century professors). Many miracles were witnessed at the site of the tomb. In 1721 John of Nepomuk was beatified, and finally, in 1729, canonised. The city of Prague had not known such festivities since the days of Charles IV.

Medal: representation of Emperor
Ferdinand II of Habsburg (1608-57), a
work by Alessandro Abondio.

The canonisation was celebrated with triumphal arches and illuminations, sermons and prayers, songs, music, theatrical performances and long processions converging on the saint's tomb. The cathedral now enjoyed a new lease of life as the glory of the saint was shared in neighbouring parts of Europe. In 1733 the tomb was enriched with an enormous silver mausoleum, paid for by the donations of grateful citizens. The canonisation of St John of Nepomuk coincided with the summit of the Baroque era in the cathedral. It also signalled a turning point in the country's life and fortunes. From then on, spurred by the continuing resistance of its heretics and the patient work of historians and philologists, the concept of liberation took root and prospered.

The accession to the throne of the Empress Maria Theresa, in 1740, coincided with the outbreak of the War of the Austrian Succession. The king of Prussia, Frederick the Great, besieged Prague and, with unnecessary brutality, deliberately pointed his cannons at the city's most important monuments. He bombarded the castle and, above all, the cathedral. The damage caused by the war eventually encouraged the empress to undertake a vast reconstruction of the castle. She refurbished the Rožmberk Palace and set up an institute for the daughters of the nobility. Then, in 1755, she commissioned the architect Niccolo Pacassi to unify the entire west part of the castle in a single block which, though monotonous in appearance, created a suitably monumental effect.

After 1780, the reign of her son Joseph II ushered in a series of radical reforms which granted social freedoms and liberty of conscience. But this had a negative impact on the castle, with the closure of churches, chapels and St George's Convent. Indeed, the emperor even envisaged turning the whole castle into a barracks. The tragic fate of the castle collections, sold by auction in 1782, was thus typical of the age. Even Přemysl's bast slippers were sold and the fate of the ancient Trojan torso (which had originally graced the gallery of Rudolf II) epitomises the manner and spirit in which these sales were handled. This 'marble cornerstone' failed to find a buyer but was eventually sold, as a last resort, in 1814, to the king of Bavaria for the ludicrous sum of 6,000 ducats.

At the beginning of the 19th century, Prague Castle was dead in every sense. 'Never before,' recalled one contemporary witness, 'had so many ghosts been about in Prague.' The castle survived as a cluttered lumber room for a succession of monarchs: l'Aiglon, the unhappy son of Napoleon and titular king of Rome, stayed there; Charles X, the destitute king of France, lived there; and, from 1845 to 1875, the emperor of Austria, Ferdinand I, ended his days there after his abdication. The changes that were made to the castle reflected the taste of the age: the rebuilding of All Saints Chapel in the Second Courtyard, around 1852-6, and the pseudo-Baroque renovation of the Spanish Room.

The completion of the cathedral, from 1843, posed a number of problems. In a spirit of strict historicism, the Baroque installations had been partially dispersed or destroyed, and not even the Gothic remains had been spared, subsequently proving difficult to rediscover in private collections or abroad. The existing part of the building, with its single high tower, and the Cyclops-like appearance of the transept with its enormous empty dome, still without windows, seemed to be an invitation to complete the cathedral in a spirit and style consonant with the nation's historic evolution. In 1859, a Union for the Completion of St Vitus's Cathedral was set up. Work commenced in 1873 and the building of the three-aisled nave and the west façade with its two towers was finished in 1929, in time to celebrate the millennium of the martyrdom of St Wenceslas. The amount of money collected for carrying out this work testifies to the nation's attachment to this monument and its proud place in popular tradition. The Union continued to exist even after the work's completion and was dissolved only by the Communists in 1954. Among modern developments, the stained glass windows, based on the designs of eminent Czech artists, once more flood the cathedral triumphantly with sunlight.

In Bohemia, the prophecy of Libuše was never commemorated more fervently than in 1848, which promised to be a year of rebirth and new hope for

many nations. The symbol of the castle, with its dim outlines of saints and Czech monarchs, was reflected once more in painting and sculpture. Josef Václav Myslbek carved a statue of Libuše, face turned towards the castle, for a new bridge in Prague; it was also his idea to build a monument of St Wenceslas for the busiest thoroughfare in the modern capital, Wenceslas Square (Václavské náměsti). The same symbolic fervour pervaded poetry and music: Smetana's opera *Libuše* celebrated the nation's resurrection; its blazing fanfares still sound today to announce the arrival of the Republic's president.

Yet for all the enthusiasm generated by the nation's 'awakeners', there was a reverse side to the coin. Certain politicians at the beginning of the present century criticised the castle as representing, above all, a monument to Austrian imperialism and the vanished power of the Church. One should not therefore be surprised at the embarrassment shown by the founder of the new Czechoslovakian state, Tomáš Garrigue Masaryk, when, after his election as president of the Republic, he was assigned the old imperial apartments as his residence. However, as a dedicated democrat, he managed to resolve the dilemma with his customary common sense. His plan was to make the castle more accessible to everyone, without in any way damaging its monuments. He entrusted the work in 1920 to the Slovenian architect Josip Plečnik, who was unburdened with the weight of history and local tradition. The granite monolith which he put up in the Third Courtyard for the tenth anniversary of the Revolution was, for Masaryk, the symbol of the castle's response to the new age.

The first Republic lasted no more than twenty years. On 15 March 1939, the German army entered Prague and, from a window in the castle, Adolf Hitler looked down on a subservient city. Despite that, in the hearts of the nation, Hradčany Castle remained throughout the war the emblem of hope and independence. It is hard to describe the three intoxicating years of freedom that followed 1945 when the second president of the Republic, Edvard Beneš, returned to take up residence in the castle, which took on a distinctly civic air and

promised to flourish anew. It was not to be. Significantly, after the Communist *coup d'état* of February 1948, President Beneš pointedly left the castle to take refuge in his summer residence. He resigned in the summer of the same year and died soon afterwards, in September.

The first so-called 'workers' president', Klement Gottwald, saw his entry into the castle as the symbolic victory for the 'working class' over the 'bourgeois democrats' and the feudal lords of yesteryear. It would nevertheless be unjust to underestimate the changes made to the castle during the forty years of Communist rule. Whereas, in the country at large, monuments deteriorated and disappeared, Prague Castle represented a cultural challenge for its new masters. Thanks to the work of the best architects of the time (Pavel Janák, who had already worked there before the war, Jaroslav Fragner, Josef Gočár and others), restoration was carried out on the Royal Ball Court and the Riding School; the burgrave's residence was converted into a children's home, and the castle's Art Gallery was installed in the old stables; St George's Convent was refurbished to accommodate the collection of ancient art from the National Gallery and, finally, an exhibition of the National Museum was opened in the Lobkowicz (Lobkovic) Palace. Major exhibitions were also held in the Vladislav Hall. Altogether the restorations were carried out with great sensitivity. But the general attitude of the regime was also evident in these new areas: the absence of organic links between the great art of the past and the *nouveau riche* aspect of contemporary utilitarian works of art could only arouse ridicule. At last, in November 1989, came the 'velvet revolution', opening new horizons for the nation and bringing liberation to the castle.

Prague Castle has stood as the centre of the tribe, of a nation, of the Holy Roman Empire; it has served as a residence for saints and iconoclasts; it has been the symbol of oppression and of intoxicating freedom. It has been transformed over the centuries and will continue to be so; change is inherent in its life, just as life among the people associated with the castle is also subject to endless change.

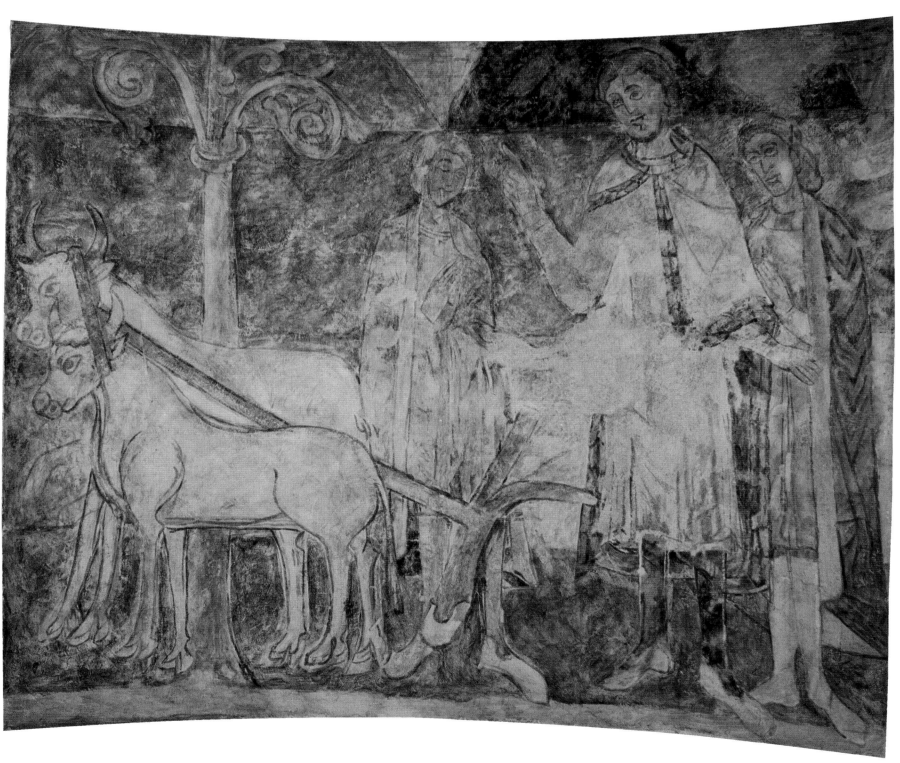

*According to legend, the founder of the Czech dynasty of the Přemyslids, the ploughman Přemysl, was summoned by Princess Libuše to share her power: The princess's envoys had found him ploughing a field. This scene is one of the **wall paintings** of St Catherine's Rotunda at Znojmo, which date from 1134.*

LANDMARKS IN TIME

An overview of 1200 years of the history of Bohemia, of the city of Prague and its castle, as reflected in important local events and lives. The parallel selective list of dates sets these in the broader context of European and world history.

Opposite page, above: **973** *The diocese of Prague was created at the Romanesque St Vitus's Rotunda. The present Gothic cathedral of the archbishops of Prague has remained under the same patronage.* **Silver bust of St Vitus**, *dating from 1699, made after a model by František Preiss, in the Vlašim Chapel of St Vitus's Cathedral. The busts of the Czech patron saints are placed on an altar.*

First-century nasal helmet, known as the helm of St Wenceslas, *the most important archaeological discovery associated with the beginnings of history in Czech lands.*

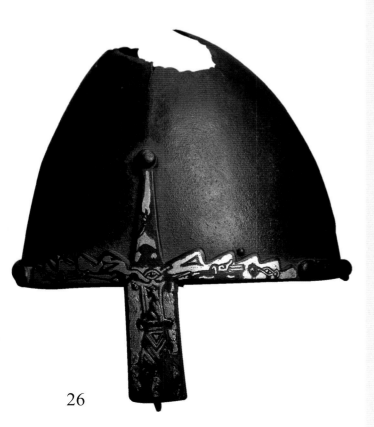

PRAGUE & BOHEMIA

7th century: A Frankish merchant, Samo, reigns for some thirty years over a union of Slav tribes dedicated to fighting the Avars.

723: Legendary date of the foundation of Prague.

From 830 to 908: Foundation of the kingdom of Greater Moravia which, at its peak, comprises not only present-day Moravia but also Bohemia, Slovakia and Pannonia (part of modern Hungary and Austria). In 895 the Czech tribes scattered through Bohemia throw off the Moravian yoke and seek protection from the Frankish king. Greater Moravia is broken up in 908 by Hungarian raids.

845: Baptism of fourteen Czech princes at Ratisbon.

863: Constantinople sends two missionaries to Moravia, Constantine (better known by the name of Cyril, which he later assumed in Rome) and Methodius (who becomes the first bishop of Moravia in 869). The pope authorises the Slav liturgy, which he replaces with the Latin liturgy in 885.

870-874: The Moravian sovereign Svatopluk breaks with Byzantium and extends his possessions northward to Cracow.

874: Baptism of the Czech prince, Bořivoj I (-894), in Moravia. He builds the first Christian church in Bohemia at Levý Hradec and the first church of Prague Castle, dedicated to the Virgin Mary. According to the chronicle of Kosmas, the reigning Princess Libuše, daughter of the mythical King Krok, had married a simple labourer named Přemysl, thus founding the Přemyslid dynasty, of which Bořivoj is the first identifiable descendant.

894-921: Spytihněv I and Vratislav I (*c.* 888-921), the sons of Bořivoj, try to reconquer the Moravian territories, but these do not return to the Czech crown until the 11th century.

920: Vratislav builds St George's Basilica at Prague Castle.

EUROPE & THE WORLD

c.500: Salic Law of Succession. The oldest version of this law goes back to the time of Clovis (465-511). It is known mainly for a clause that excluded women from succeeding to the throne.

527: Justinian I (d. 565), codifier and legislator, becomes Byzantine emperor.

563: St Columba, missionary and abbot, founds a monastery on the Northumbrian island of Iona.

622: On 16 July, Mahomet flees from Mecca to Medina: this departure is the Hegira (the beginning of the Islamic calendar).

672-735: Venerable Bede, monk and theologian, author of the *Ecclesiastical History of the English Nation*.

696: Foundation of the state of the doges in Venice.

711: Beginning of the conquest of the Iberian peninsula by the Arabs who capture the Visigoth state. In 712 the Arabs occupy Samarkand.

732: Charles Martel (*c.* 688-741) checks the invasion of the Arabs, led by Abdal-Rahman, at Poitiers.

760: *Book of Kells*, Latin gospels, written in Ireland.

793: An attack on the English monastery of Lindisfarne marks the beginning of the age of the Vikings.

800: Charlemagne (742-814), king of the Franks since 768 and king of the Lombards, is consecrated as Western emperor in Rome. Emergence of the Carolingian Renaissance.

843: Treaty of Verdun, dividing the Carolingian empire into France, Germany and Italy with Lotharingia (Lorraine).

Early 10th century:
- Birth of Romanesque art.
- The caliphate of Cordova attracts scholars from the Islamic world.
- Beginning of Christian reconquest of Spain under Alfonso III of Castile.
- England is divided into shires, with county courts to protect civil rights.

PRAGUE & BOHEMIA

921: Princess Ludmila, widow of Bořivoj I, murdered on the orders of her daughter-in-law, Drahomira, opposed to Christianity. She later becomes the first Czech saint.

924: The remains of Ludmila transferred to St George's Basilica by her grandson Wenceslas (Václav) when he comes to power.

After 926: Wenceslas builds a rotunda with four horseshoe-shaped apses on the site of the castle, which he dedicates to St Vitus. Some historians believe his choice of this saint to have been a politically astute move: the Czech name (Vit) is similar, phonetically, to that of a pagan idol, Svantovit.

EUROPE & THE WORLD

910: Foundation of the Benedictine abbey of Cluny by William the Pious, duke of Aquitaine. Thanks to its exemption privileges, the abbey was never controlled by a bishop or a feudal lord but was responsible directly to the papacy. The golden age of the Cluniacs came in the early 12th century.

925: Henry I the Fowler, king of Germany from 919 to 936, founds the first Saxon dynasty and joins Lorraine to Germany. The Přemyslids recognise his sovereignty in 929.

937: The English king, Athelstan, defeats the Danes and the Scots at Brunanburh.

Right: **929** or **935** *According to legend, Prince Wenceslas was assassinated by his elder brother in front of the closed doors of the St Comus and St Damian Church at Stará Boleslav.* **Painting by Master IW** *on this subject, dating from 1543, in St Wenceslas's Chapel of St Vitus's Cathedral.*

Below: **1032 Old Slavic text of one of the Glagolitic fragments of Prague,** *written in Glagolitic characters (writing used in the kingdom of Greater Moravia) before the first half of the 11th century. A treasured relic of national and Slav culture, it was made for the convent of the Sázava region, where the mass was said in Slavic.*

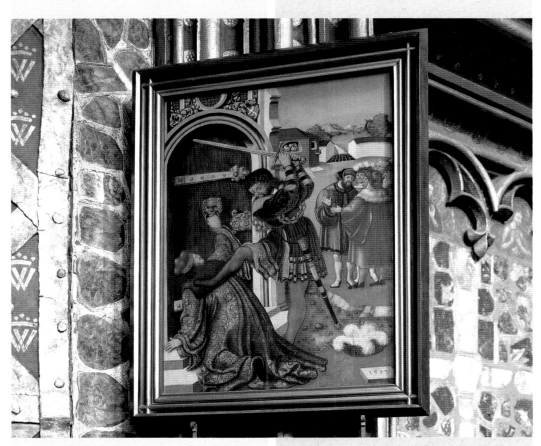

929 or 935: Prince Wenceslas, the first Czech martyr and saint, murdered on the orders of his brother, who reigns until 967 as Boleslav I the Cruel. His successors are Boleslav II the Pious (967-9) and Boleslav II the Red (999-1003).

962: Otto I the Great, son of Henry the Fowler and king of Germany from 939 to 973, founds the Holy Roman Empire.

966: St Oswald founds Worcester Cathedral.

976: Building of St Mark's, Venice, begins.

1125 Floor tile with the bust of the emperor Nero. *Part of the collections of the National Museum to be found in the historical exhibition at the Lobkowicz Palace, it comes from St Vavřinec's Basilica at Vyšehrad and dates from 1129 or 1130.*

1142 Romanesque bas-relief representing St Paul: *fragment of a sandstone tympanum from the middle of the 12th century, which came originally from the commune of Předhradí, near the ancient town of Poděbrady.*

PRAGUE & BOHEMIA

973: Creation of a bishopric at St Vitus's Rotunda (first bishop, Dětmar). Foundation of a Benedictine convent, the first in Bohemia, beside St George's Basilica.

993: Foundation of a Benedictine monastery, the first in Bohemia, at Břevnov.

995: Boleslav II the Pious consolidates the power of the Přemyslids in Bohemia by having the rival Slavnik family assassinated.

997: Adalbert (Vojtěch), second bishop of Prague from 983 to 995, is murdered during a journey as missionary to the pagans of Prussia. He later becomes one of the Czech patron saints.

1003: Boleslaw II the Brave of Poland captures Prague Castle and reigns for two years over a Polish-Czech kingdom.

1032: St Procopius (Prokop) establishes the mother house of Benedictine Slav-liturgy monasteries in the Sázava region. The monks are expelled in 1055 and settle in Hungary. The abbot's body is subsequently transferred to Prague Castle. In 1097 the monastery is taken over again by Latin-liturgy Benedictines.

1060: Prince Spytihněv II (1031-61), who succeeds his father Břetislav I in 1055, founds the basilica dedicated to St Vitus, St Wenceslas and St Adalbert at Prague Castle. It is consecrated in 1096.

1085: Prince Vratislav II concedes the non-hereditary title of king of Bohemia to the German emperor Henry IV.

1125: Death of the first known Czech chronicler, Kosmas (born *c.* 1045).

1135: Prince Soběslav II (died 1140) begins the Romanesque rebuilding of the castle and St George's Basilica. After a terrible fire ravages the castle in 1142, the rebuilding work continues until 1182.

1158: Frederick Barbarossa confers the hereditary title of king of Bohemia on Vladislav II, but refuses, in 1173, to recognise his son Bedřich.

EUROPE & THE WORLD

987: Hugh Capet, king of France, founds the Capetian line.

1000: Christianity reaches Iceland and Greenland.

1054: Schism within the Church. The Eastern (Orthodox) Church separates from the Western (Catholic) Church.

1066: Duke William of Normandy defeats the English king, Harold II, at Hastings and is crowned William I of England.

1096-1099: First Crusade, led by feudal princes of France and Italy.

1122: Concordat of Worms between Pope Calixtus and Emperor Henry V ends the investiture controversy by distinguishing temporal jurisdiction from the spiritual jurisdiction of the clergy.

c.1130: Birth of Gothic art. In France, the new Gothic style appears in the architectural renovation of St-Denis where, for the first time, ogives and ribbed vaults combine as supports.

1163-1182: Building work begins on Notre-Dame de Paris: the bulk of this is completed by 1245 but work continues until 1345; restoration by Viollet-le-Duc from 1845 to 1864.

1167: Foundation of Oxford University. The earliest colleges date from the mid-13th century.

1171: Saladin the Turk founds the Ayyubid dynasty in Egypt and captures Jerusalem in 1187.

1189: Third Crusade, led by Richard I of England, Philip II Augustus of France and the Holy Roman Emperor Frederick Barbarossa (drowned en route). Acre is captured in 1191.

1199: Introduction of inquisitorial procedure by Pope Innocent III: in his bull, *Vergentis in senium*, he equates heresy with the crime of treason.

1204: Armies of the Fourth Crusade capture and sack Constantinople and subsequently establish the Latin Empire.

1212 *Under the terms of the* **Sicilian Golden Bull**, *the king of Sicily and the Germanic emperor Frederick II established the rights of the Czech state in relation to the Holy Roman Empire, confirming, among other things, the hereditary title of king of Bohemia on Přemysl Otakar I.*

Right: **1197-1230** *Charles IV commissioned sumptuous sarcophagi, similar to this* **tomb of Přemysl Otakar I** *in the Chapel of the Holy Sepulchre, a work by Peter Parler from 1376.*

Above: **1278-1305** *The opening of the Kutná Hora silver mines enabled coins to be struck, known from around 1300 as* **Prague grosche** *(3.86 g of silver).*

PRAGUE & BOHEMIA

1198: Emperor Frederick II of Sicily confers the hereditary title of king of Bohemia on Přemysl Otakar I (king from 1197 to 1230). In 1212 he confirms, by the Sicilian Golden Bull, this hereditary title and lists the rights and privileges attaching to it (the king of Bohemia, most importantly, becomes an elector of the Holy Roman Empire and, consequently, eligible as emperor).

1230-1253: Reign of King Wenceslas I (born 1206) who profits from the principle of primogeniture adopted in 1216.

1253-1278: Reign of Přemysl Otakar II, king of Bohemia, duke of Austria and elector of the Holy Roman Empire, killed at the battle of Moravské Pole (Marsfeld) fighting the Habsburg

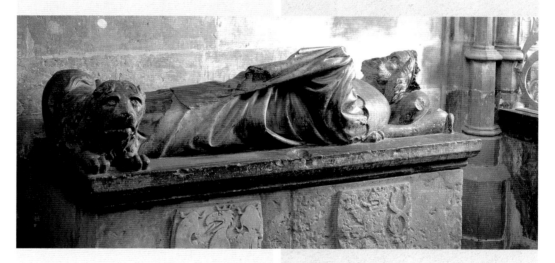

Rudolf I, German emperor since 1273. Their differences mark the beginning of a power struggle that pits, with varying fortunes, the Přemyslids against the Habsburgs.

1278-1305: Reign of Wenceslas II (1271-1305), son of Přemysl Otakar II, who advantageously re-establishes the Polish Kingship and obtains the crown of Hungary for his son, the future King Wenceslas III.

1306: Assassination, at Olomouc, of Wenceslas III, last of the Přemyslids, who, after renouncing the Hungarian crown, lays claim to the crown of Poland but reigns for only one year.

1310: John of Luxembourg marries Elisabeth (Eliška), the last Přemyslid, and becomes king of Bohemia.

EUROPE & THE WORLD

1215: King John of England signs the Magna Carta at Runnymede. Definitively reissued by Henry III in 1225, this was the great charter of English civil liberties.

c.1220-c.1292: Roger Bacon, English philosopher, scientist and educational reformer, author of treatises on the sciences.

1228: Emperor Frederick II leads the Sixth Crusade and recovers Jerusalem.

1251-1259: Peak of Mongol power which, under the leadership of Mangu, conquers China.

1257: Foundation of the Sorbonne by Pierre de Sorbon. The University of Paris becomes the intellectual centre of continental Europe, rivalled by Oxford and Cambridge Universities in England.

1265-1321: Dante Alighieri: *The Divine Comedy*, 1307.

1271: Marco Polo (d.1324) sets out from Venice on his travels to the East. He reaches China and the palace of Kublai Khan in 1275, remaining there for seventeen years, returning to Venice in 1299 to dictate his adventures.

1304-1374: Francesco Petrarca (Petrarch), Italian humanist and lyric poet.

PRAGUE & BOHEMIA

1316: Birth of their eldest son, baptised Wenceslas (Václav), but who takes the name Charles (Karel) in Paris where he is brought up during adolescence at the royal court of his cousin, Charles V. His tutor is Pierre Roger de Beaufort, the future Pope Clement VI from 1342 to 1352. His father entrusts him to manage the affairs of the Czech kingdom in 1341 and he reigns as Charles IV from 1346 to 1378.

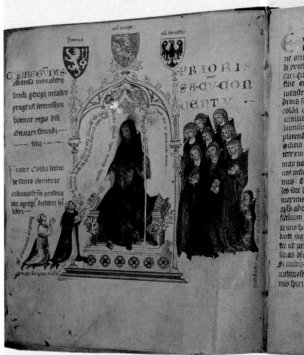

1321: Death of Cunegonde (Kunhuta), abbess of St George's Convent, daughter of Přemysl Otakar II and author of a *Passional*.

1344: Foundation of the archbishopric of Prague, the first incumbent of which (until 1364) is Arnošt (Ernest) of Pardubice, a friend and counsellor of Charles IV. The foundation stone is laid of St Vitus's Cathedral at Prague Castle: the building commission is given to a French architect, Matthew of Arras.

1346: John of Luxembourg is killed at the battle of Crécy. Charles IV becomes the German king at Aix-la-Chapelle (Aachen) in 1349, then Holy Roman Emperor at Rome in 1355.

EUROPE & THE WORLD

1309: The French-born Pope Clement V settles in Avignon. Rome does not again become a papal seat until 1367.

1310-1375: Giovanni Boccaccio, Florentine novelist: *Decameron* 1349-51.

1314: Battle of Bannockburn, in which the Scots led by Robert Bruce rout the English under Edward II.

1315: Battle of Morgarten: in defeating the Austrians, the Swiss of the Three Cantons (Uri, Schwyz and Unterwalden) obtain their independence and renew their 'perpetual pact' of 1291.

1327: The Aztecs of Mexico reach the site of their capital Tenochtitlán.

c. 1320-1384: John Wycliffe, English religious reformer and inspirer of Jan Hus. He opposes the papacy, attacks some of the central doctrines of the Church and makes an English translation of the Bible.

1333 or 1337-after 1400: Jean Froissart writes his *Chronicles* in French; they cover the period 1325 to 1400.

Right: **1321** *Cunegonde (Kunhuta), daughter of Přemysl Otakar II, died in 1321 after having been head of the Benedictine convent near St George's Basilica. The Passional of the abbess Cunegonde, dated between 1313 and 1321, is in the National Library of Prague. In the* **illumination,** *kneeling before the abbess, is the author of the text, the Dominican Kolda of Koldice, and the scribe and illuminator of the manuscript, Beneš, canon of St George's Basilica.*

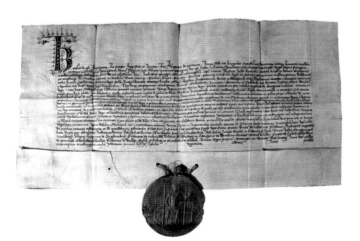

1348 Letter patent of Charles IV, *confirming all the privileges previously accorded to the kings of Bohemia by the kings and emperors of the Holy Roman Empire.*

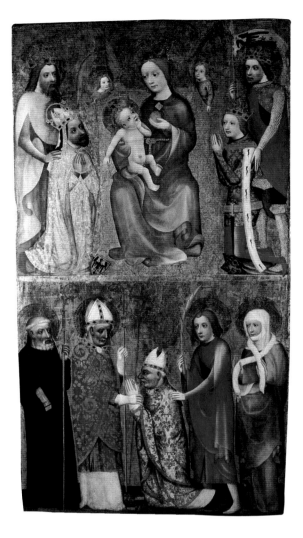

After 1370 Ex-voto of the archbishop of Prague, *Jan Očko of Vlašim, destined for the chapel consecrated in 1371 of the castle of Roudnice on the Elbe, the archdiocesan residence. On the upper, "celestial" part, to the right of the Virgin Mary, is Charles IV, kneeling in prayer and, to her left, his son, the future Wenceslas IV. Behind Charles IV is his patron, St Sigismund, and behind the crown prince, St Wenceslas. In the lower "terrestrial" lower part, the donor kneels among the country's patron saints (from left to right, St Procopius, St Adalbert, St Vitus and St Ludmila). The painting is today kept in the gallery of St George's Convent.*

PRAGUE & BOHEMIA

1348: Charles IV founds at the Prague Carolinum a university that still bears his name. He builds Karlštejn Castle to accommodate the Crown Jewels. Prague becomes the third most important city of Europe, after Rome and Constantinople.

1356: Peter Parler is summoned to Prague to continue the construction of St Vitus's Cathedral, following the death of Matthew of Arras in 1353.

1364-1378: Jan Očko of Vlašim is the second archbishop of Prague.

1375: Death of Beneš Krabice of Weitmile, chronicler of the court of Charles IV.

1379-1396: Jan of Jenštejn is the third archbishop of Prague. He leaves for Rome (where he dies in 1400) following quarrels with Wenceslas IV which are resolved by the murder of John of Nepomuk, the future Czech saint of the Baroque era.

1382: King Wenceslas IV leaves Prague Castle to live at the royal court (Králův dvůr) in Prague's Old Town.

1385: The vault of the choir of St Vitus's Cathedral is set in place.

1399: Death of Peter Parler. His sons Václav and Jan continue his work in the cathedral.

Left: **1385** *Indications as to the foundation and progress of building work on the Gothic St Vitus's Cathedral are given on a* **commemorative plaque,** *dating from 1396, placed on the west pillar of the south door (the Golden Gate). Its author was apparently Václav of Radeč, the fifth works director. The vault of the choir was only built after its consecration "in honore beate Marie et Sancti Viti" ("in honour of the Blessed Virgin and St Vitus") by the archbishop of Prague, Jan of Jenštejn, on 1 October 1385.*

EUROPE & THE WORLD

1337-1453: The Hundred Years' War begins with the confiscation of Guienne by Philip VI and ends with the reconquest of Bordeaux by Charles VII. The English fleet defeats the French at the battle of Sluis in 1340; the English infantry and artillery crush the French at Crécy in 1346. The English take Calais in 1347 and hold it for two centuries. In 1415, the English beat the French at Agincourt. Then the tide turns in the French favour, with the period of Joan of Arc, followed by the recapture of Paris in 1436 and of Guienne from 1450 to 1453. But the Hundred Years' War only really ends with the Treaty of Picquigny, signed in 1475.

c. 1340-1400: Geoffrey Chaucer, English poet: *Troilus and Criseyde*, *Canterbury Tales*, etc.

1346-1349: The Black Death ravages Europe. A third of the population of England is killed.

1350: The English parliament divides into two chambers, the House of Commons and the House of Lords.

1361: The Danes capture the Hanseatic town of Visby.

1363: The building of the Kremlin is ordered by the grand duke, Dimitri Ivanovich Donskoi.

1378-1417: Great Schism in the Roman Catholic Church: there is one pope in Rome and another in Avignon; then, in 1409, there is a third in Pisa. Not until the Council of Constance (1415-18) is a single pope elected in 1417.

1390: Byzantines lose remaining possessions in Asia Minor to Turks.

1400:
- Beginning of the ascendancy of the Medicis in Florence.
- The Justinian Code finds increasing application throughout the Holy Roman Empire.
- Prosperity of craft corporations.
- Polychrome porcelain manufacture is initiated in China, near Nanking.

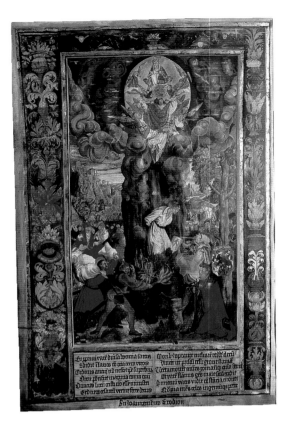

1415 *Jan Hus was burned alive as a heretic on 6 July 1415, at Constance — a tragic event in medieval Czech history. Later he was venerated as a saint by the Calixtins (Utraquists). The* **Gradual of Litoměřice,** *done prior to 1517, depicts the death and apotheosis of Jan Hus (donated by Wenceslas of Řepinice, burgomaster of Litoměřice).*

Below: **1424** *Jan Žižka of Trocnov, the one-eyed general of the radical Hussites, died on 11 October 1424, during a military campaign. This* **sculpted head,** *dating from 1516 and originally in the town hall of Tábor, is the oldest representation of Jan Žižka, although not necessarily an authentic portrait.*

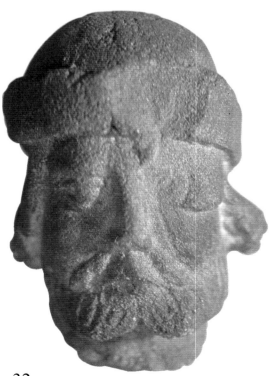

PRAGUE & BOHEMIA

1415: On 6 July, Jan Hus is burned as a heretic at Constance. A supporter of the Reformation, Hus had committed the crime of preaching against the abuses of the Catholic Church and had demanded that the University accord the Czech language the same status as German, Latin and Serbo-Croat.

1419: The victims of the first defenestration in Prague, on 30 July, are the municipal counsellors of Nové Město (the New Town quarter of Prague), chosen from the anti-Hussite faction by Wenceslas IV. It sparks off the ensuing riots and violence. The king dies on 16 August at Kunratice. The work on the cathedral is interrupted.

1420: Sigismund, king of Bohemia, steals precious gold and silver artefacts from St Vitus's Cathedral.

1421: Hussite iconoclasts destroy paintings and statues in St Vitus's Cathedral. Konrád of Vechta, the seventh archbishop of Prague, accepts the demands of the Hussites and is excommunicated. The Prague archbishopric remains vacant for 140 years.

1424: Jan Žižka of Trocnov, military head of the Hussite faction of intransigents, dies of the plague.

1434: The battle of Lipány seals the victory of the Catholics over the radical Hussite wing. The conflict does not really end until 1436 after several pockets of resistance have been wiped out.

1437: Death of Sigismund, last king of Bohemia of the Luxembourg family.

1438-1439: Reign of Albert II of Habsburg as German emperor. Having married Sigismund's daughter, he is also king of Bohemia and Hungary (1437). His reign is marked by a diminution of royal powers.

1458-1471: Reign of George (Jiří) of Poděbrady who has run the country since 1448. He restores the state's economic and cultural power. He proposes the first plan for the unification of Europe, a union of Christian monarchs designed to restrict interference by the papacy in political affairs, to repel the Turkish threat and to bring peace to Europe. This plan falls through.

EUROPE & THE WORLD

c. 1422-1491: William Caxton, translator and first English printer, notably of French and English works, including Chaucer's *Canterbury Tales* and Sir Thomas Malory's *Morte d'Arthur*.

1431: Joan of Arc is burned at Rouen after a trial for heresy.

1434-1455: J. Gutenberg invents the printing press in 1434 and, in 1441, the ink that allows printing on both sides of the paper; in 1455 he prints the first Bible with metal characters.

1450:
- Florence, under the Medicis, is the hub of Renaissance culture and humanist thought.
- In the Near East and Europe, delicate, blue-decorated Chinese porcelain influences Islamic and European art (e.g. Delft pottery).

1453: The Turks take Constantinople: Greek scholars flee to Italy and help to initiate humanism. End of the Eastern empire.

1455-1487: The Wars of the Roses, fought between the armies of the houses of York and Lancaster and their allies for the English throne. The civil war ends at Bosworth Field (1485) in the defeat of the Yorkist Richard III by Henry Tudor, who as Henry VII establishes the Tudor dynasty.

c.1466-1536: Erasmus, Christian humanist and key figure of the northern Renaissance.

1469: Ferdinand of Aragon marries Isabella of Castile.

1472: Tsar Ivan III marries Sophia Paleologus. Russia is unified and looks westward to Europe.

1476: The Swiss Confederation, allied to Louis XI, defeats Charles the Bold at the battle of Morat.

1481: Ferdinand V of Spain ends the period of religious tolerance and sets up the Inquisition. The emigration of persecuted Moors and Jews ruins the country's industries.

1482-1499: Leonardo da Vinci (1452-1519) in Milan, where his masterpieces include the *Virgin of the Rocks*, the *Sforza Monument* and *The Last Supper*.

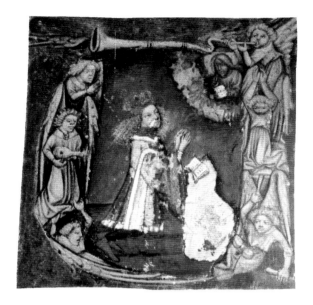

PRAGUE & BOHEMIA

1468: First book printed in the Czech language, *The Chronicle of Troy (Trojánská Kronika)*, followed twenty years later by the first Czech Bible, edited by Jan Pytlík.

1471-1516: Vladislav II (Vladislas), king of Poland and Hungary, is the first Czech king of the Jagiello dynasty. His reign ushers in a period of humanism and a blossoming of arts and culture.

EUROPE & THE WORLD

1492: Spanish conquer Moorish kingdom of Granada. Christopher Columbus discovers America.

1494: Treaty of Tordesillas signed, dividing the possessions of the New World between Spain and Portugal according to a longitudinal demarcation line 100 leagues west of the Cape Verde Islands.

Above: **1453-7** *Ladislav Posthumus, son of the Czech king and emperor Albert II of Habsburg, died suddenly at the age of eighteen. George of Poděbrady was suspected of having ordered his murder. On this* **page of**

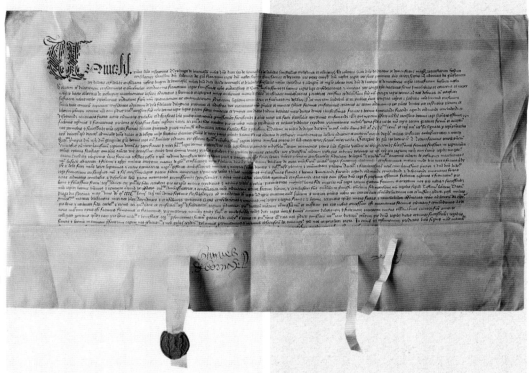

the missal of Ladislav Posthumus, *dating from after 1453, is a decorated initial with the young king kneeling.*

Above: **1468** *The oldest Czech incunabulum is the* **Chronicle of Troy,** *published at Plzeň (Pilsen) around 1468 by an unknown printer. It contains the translation in Czech of the Latin narrative of this classical subject by Guido della Collona.*

Above, right: **1458-71** *At the end of the Middle Ages, George of Poděbrady tried to form an alliance with other Christian kings — a sort of security system for Europe. This is a* **treaty signed with King Louis XI of France** *at Dieppe on 18 July 1464.*

Right: **1458-71** *Reign of George of Poděbrady: descended from the Czech branch of the lords of Kunštat, he was the only Czech king elected by the Czech nobility from its own ranks. This* **portrait,** *done later, is in the Chronicle of the Foundation of the Czech Nation by Martin Kuthen, 1539.*

1483: Following troubles in the city, Vladislav II re-establishes Prague Castle as a royal residence.

1486: Work begins on rebuilding Prague Castle in Late Gothic style. From 1490 it is apparently directed by Benedikt Ried (*c.* 1454-1534).

1493: The oldest 'view' of Prague is printed in *Liber Chronicarum (Book of Chronicles)* by Hartman Schedel. It is the work of the German engravers Michael Wolgemut and Wilhelm Pleydenwurff.

1502: Completion of the Vladislav Room and the Riders' Staircase at Prague Castle.

1506: Completion of the Louis (Ludvík) Wing.

1500-1506: Leonardo da Vinci paints the *Mona Lisa* and *Battle of Anghiari* in Florence.

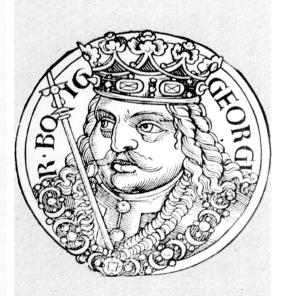

1471-1516 *The Czech king Vladislav II Jagiello, son of the Polish king Kazimierz IV, embarked on a large-scale restoration of the royal castle as soon as he arrived in Prague.* His **monogram and blazon with the Czech lion** *were modelled, soon after 1490, by Hans Spiess, on the ceiling of the Vladislav Hall.*

Opposite page, above: **1559-63 Volumes from the Land Rolls.** *The Land Rolls, where changes in ownership of the lands of the Czech kingdom were registered, constitute an irreplaceable body of juridical documentation.*

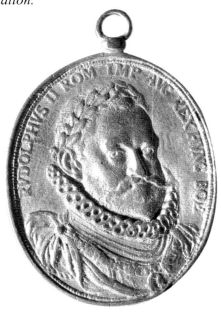

Above: **1576 Medal of Rudolf II.** *Various artists and craftsmen played an important role at the court of Rudolf II. Medallists were represented mainly by Antonio Abondio and his son Alessandro, who made this medal around 1608.*

PRAGUE & BOHEMIA

1515: At the Congress of Vienna, the Jagiellos and the Habsburgs settle their disputes by the marriages of the grandchildren of Maximilian I of Habsburg to the successors of Vladislav II Jagiello. Bohemia and Hungary now come under Austrian domination.

1516-1526: Reign of Louis II, last of the Jagiellos on the Bohemian throne. Married to Mary of Habsburg (daughter of Charles V), he is killed at the battle of Mohács at the age of twenty, without issue. The Jagiellos hand over to the Habsburgs.

1518: Map of the kingdom of Bohemia made by Nicolas Claudián (Mikuláš Klaudián).

1526-1564: Ferdinand I, king of Bohemia and Hungary (1526), becomes king of the Romans in 1531 and Holy Roman Emperor in 1558. In 1521 Ferdinand marries Anna Jagiello, and his eldest brother, Charles V, recognises his right, in that same year, to the five Habsburg States (Edict of Worms), appointing him, in 1522, governor of southern Germany, Tyrol and Upper Alsace.

1538: Building work begins (for Queen Anna) on the pleasure pavilion known as the Royal Belvedere, an architectural jewel of the Renaissance.

1541: A catastrophic fire in Malá Strana spreads to the castle and the Hradčany quarter.

1545-1560: Construction of Pernštejn Palace.

1556-1597: Arrival in Prague of the Order of Jesuits which, in addition to the Clementium, create colleges at Olomouc, Brno, Český Krumlov, Chomutov, Jindřichův Hradec and Klodzko to resist the Reformation.

1559-1563: Reconstruction of the Diet Room.

1561: The archbishopric of Prague again has an incumbent: Antonín Brus of Mohelnice.

1563: Jan Kozel and Michal Peterle: first colour engraving of Prague.

EUROPE & THE WORLD

1509: Beginning of traffic in black slaves from Africa to America.

1513: Machiavelli (1469-1527) writes *The Prince* (not published until 1532).

1517: The Reformation begins in Germany as Martin Luther (1483-1546) posts his famous 95 theses on the door of Wittenberg Church: salvation by faith alone.

1519: Ulrich Zwingli (1484-1531), key figure of the Swiss Reformation, preaches at the Grossmünster in Zurich. His doctrine differs in some respects (e.g. on communion) from that of Martin Luther.
- Ferdinand Magellan sails on 20 September on his voyage to circumnavigate the world. He is killed on 27 August 1521.

1520-1566: Ottoman power in Europe reaches its peak under Suleiman the Magnificent.

1521: The Spanish conquistadors under Hernán Cortés sack Tenochtitlán and destroy the Aztec empire.

1525: Revolt of German peasants, led by Thomas Münzer, is suppressed.

c. 1525: Paracelsus (1493-1541) inspires developments in medicine and chemistry.

After 1530-40: Italian artists, on the invitation of Francis I, arrive in France and help transform French medieval castles from military strongholds into palaces (e.g. Amboise, Chambord, etc.).

1531: Henry VIII is recognised as Supreme Head of the Church in England. After divorcing Catherine of Aragon and marrying Anne Boleyn, he is excommunicated by the pope in 1533.

1533: John Calvin (1509-64) supports the Reformation. He publishes, in 1536, his *Institution de la religion chrétienne*, a summary of the most important principles of the reformed faith. In 1541 he settles in Geneva, where he imposes his scheme of reform ('Ecclesiastical Ordinances'). Calvinism spreads in France (the Huguenots), the Netherlands, England and Scotland.

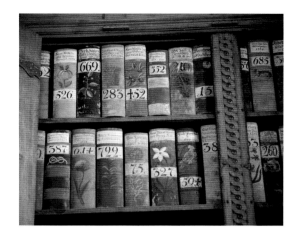

Below: **1516-26** *Louis II Jagiello (1506-26) was killed while fleeing from a defeat by the Turkish armies of Suleiman the Magnificent. His death signalled the end of the Jagiello era on the Czech throne. The young king is depicted in this* **illumination in The Compilation of the Laws of the Town of Znojmo** *by the scribe Štěpán Vyškov, printed in 1523 by Wolfgang Frölich.*

PRAGUE & BOHEMIA

1564: Maximilian II (1527-76) succeeds Ferdinand I and becomes Holy Roman Emperor after being elected king of the Romans (1562), of Bohemia (1562) and of Hungary (1563). His reign is marked by fighting against the Turks and by a measure of religious toleration.

1569-1571: The larger Royal Ball Court is built.

1576: Rudolf II succeeds Maximilian II. In 1584, he decides to live permanently in Prague and transforms the city into a centre of arts and sciences. He provides the castle with a room for art treasures, a gallery for paintings and a room for sculptures (the future Spanish Room).

EUROPE & THE WORLD

1535: Sir Thomas More (b. 1478), English politician and humanist, author of *Utopia*, is executed during the unrest following Henry VIII's break with the Church of Rome.

1541: Michelangelo (1475-1564) completes his fresco of the *Last Judgement* (begun in 1536) in the Vatican's Sistine Chapel.

1543: A few days before his death, Copernicus (b. 1473) publishes the work containing his theory of the dual movements of the planets, turning on themselves and around the sun. This hypothesis is later proved by Johannes Kepler and Galileo Galilei.

1558: Accession of Queen Elizabeth to the English throne.

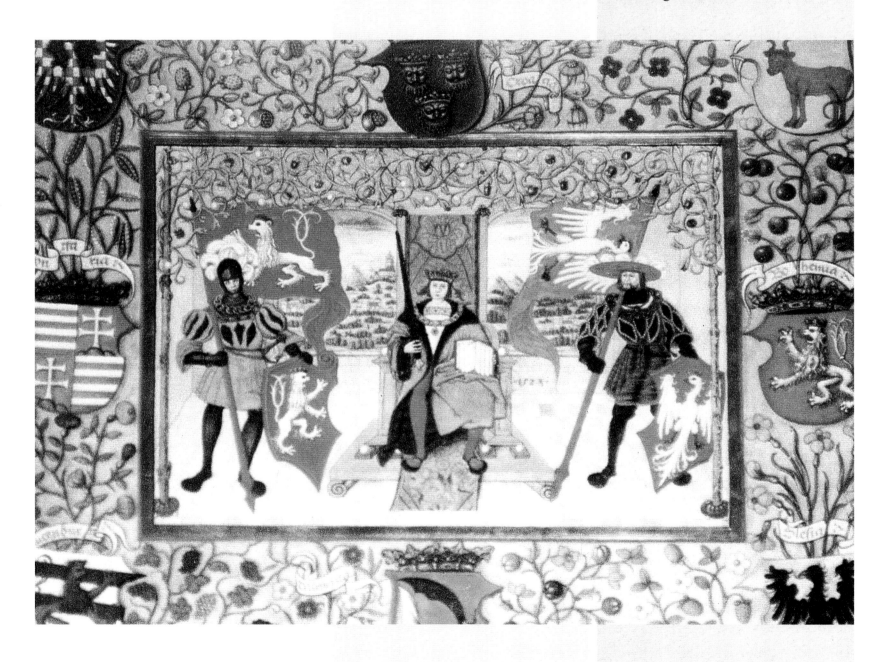

Below, right: **1593 Painting of a session of the Enlarged Supreme Court of Bohemia.** *Although the composition of the court is purely hypothetical, the picture does allude to a particular session, summoned to deliver judgement on Ladislav Lobkowicz and Sebastián Vřesovec, who had organised the Estates in opposition to Rudolf II in 1593. At the feet of the emperor sits the grand burgrave of Prague, Adam of Hradec. On the emperor's right are Jiří of Lobkowicz, grand steward of the Court, and Joachim of Kolovrat, burgrave of Karlštejn. To the left of the emperor sit Jan of Wallenstein (Valdštejn), grand chamberlain of the Court; Jiří Bořita of Martinic, the supreme judge; the grand chancellor and the president of the Aulic Council. (Until the 13th century, this*

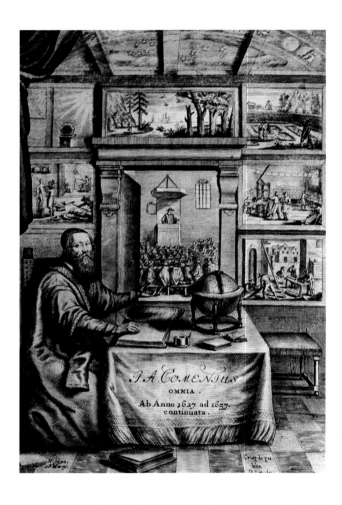

council was the country's supreme tribunal, but at the end of the 16th century it was no more than a tribunal of arbitration between the king and the nobility, mainly in matters relating to mortmain property.)

Above: **1592 Title page of the complete works of Comenius (Jan Amos Komenský).** *In this engraving by David Loggan, dated after 1657, and based on a portrait by Crispin de Passe, Comenius is seated at his table; behind him are the different spheres of human activity, such as he described in his "Orbis pictus".*

PRAGUE & BOHEMIA

1592: Birth of Comenius (Jan Amos Komenský) in Moravia. Last bishop of the Bohemian Brothers (Hussites), this humanist thinker and teacher dies an exile in Amsterdam, in 1670.

c.1600: Creation of the Crown Jewels (sceptre and orb).

1601: Death of the astronomer Tycho Brahe, protégé of Rudolf II following his disgrace in Denmark.

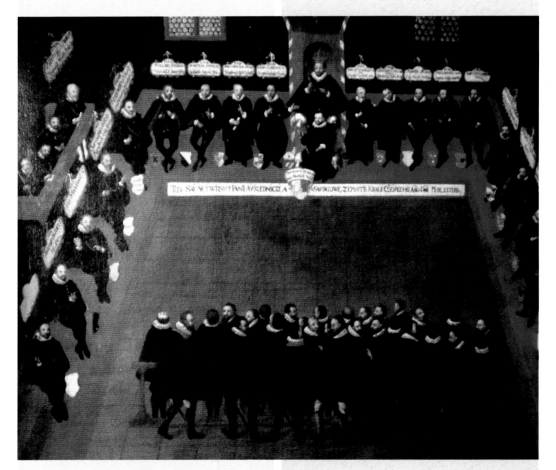

1608: Rudolf II grants his brother Matthias the crown of Hungary, Moravia and Austria.

1609: Rudolf II publishes a royal decree guaranteeing freedom of conscience and worship to the Protestants and the Czech Brothers.

1611: Rudolf II abdicates the throne of Bohemia in favour of his brother who becomes Holy Roman Emperor in 1612 as Matthias II on the death of his elder brother.

EUROPE & THE WORLD

1572: Massacre of St Bartholomew's Day, in which more than two thousand French Protestants are murdered, including their leader, Admiral de Coligny.

1576-1596: Tycho Brahe, Danish astronomer, having discovered a 'new star' in Cassiopeia in 1572, works on the island of Hven, near Copenhagen, and founds an observatory there.

1577-1580: Francis Drake circumnavigates the world in the *Golden Hind*.

1588: The 'invincible' Spanish Armada, despatched by Philip II to conquer England, is defeated and scattered by the English fleet commanded by Lord Howard of Effingham.

1596-1650: René Descartes, French philosopher and mathematician, who reduces knowledge to the principle of *'Cogito ergo sum'* ('I think, therefore I am'). Pointing the way to 17th- and 18th-century rationalism, his principal works are the *Discours de la Méthode* and the *Méditations Philosophiques*.

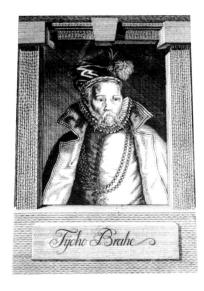

Tycho Brahe

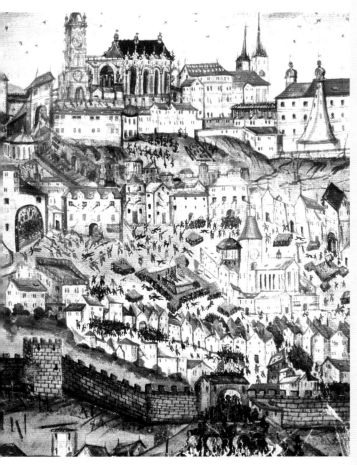

1611 The army of Passau entering Prague. *Illustration from the Memoirs of Jindřich Hýrzl of Chody, officer of the imperial army. The army of the emperor's cousin, Archduke Leopold, bishop of Passau (Bavaria), coming to Rudolf II's rescue, entered Malá Strana by the Újezd Gate.*

PRAGUE & BOHEMIA

1601 Portrait of the Danish astronomer Tycho Brahe *by A. Niederhofer. Under Rudolf II, Prague became a centre of scientific research. Brahe lodged close to the castle, at Pohořelec, and carried out his astronomical observations from Queen Anna's Summer Pavilion.*

1614: This date, on the Matthias Gate, marks the end of the work, during Rudolf's reign, on Prague Castle.

1618: Second defenestration of Prague: Czech Protestants throw two royal stewards, Martinic and Slavata, out of the castle windows, an act that is instrumental in sparking off the Thirty Years' War.

1619: The Protestant Elector Palatine Frederick becomes king of Bohemia when Ferdinand II, successor to Matthias II, is removed by the Czech Estates.

1620: The Czech Estates are defeated at the battle of the White Mountain. Frederick V, the elector palatine, 'king for a winter', is forced to flee, and Ferdinand II then regains his throne (Habsburg rule in Bohemia is to last until 1918). This defeat marks the beginning of enforced Catholicism in the land and the suppression of the Czech language.

1621: Execution, in the square of the Old Town, of twenty-seven Czech aristocrats, heads of the mutiny by the Czech Estates. Non-Catholics are mercilessly persecuted, their properties and wealth are confiscated and redistributed among the Austrian, German, French and Spanish nobility allied to Ferdinand II. Hundreds of thousands of Protestants are forced to escape abroad.

1627: Succession of the Habsburgs to the Bohemian throne becomes hereditary. Catholicism is proclaimed the official state religion. German becomes the country's administrative language, along with Czech.

1631: Prague and its castle are temporarily occupied by the Saxon army in the course of the power struggle between the Habsburgs and the other electoral princes.

EUROPE & THE WORLD

1601-1612: William Shakespeare (1564-1616) follows his comedies and historical plays with his great tragedies and last plays, notably *Hamlet, Othello, King Lear, Macbeth, Antony and Cleopatra, The Winter's Tale* and *The Tempest.*

1603: James VI of Scotland crowned James I of Great Britain and Ireland.

1607: The first English colony is established in Virginia. In 1620 102 emigrants, including 41 Puritan 'pilgrims', land from the *Mayflower* near Cape Cod and create the colony of New England.

1634: Cardinal Richelieu, minister to Louis XIII, founds the Académie Française.

1642-1649: English Civil War between Cavalier supporters of King Charles I and the Roundheads (Parliamentarians) commanded by Oliver Cromwell. Charles is executed on 30 January 1649 and England declared a Commonwealth.

1648: The Peace of Westphalia brings the Thirty Years' War to an end. Germany emerges politically and economically weakened.

1660: English monarchy restored under Charles II.

1661: Louis XIV (1643-1715) reigns as absolute monarch in France.

1665: Great Plague of London rages for four months.

1666: Great Fire of London (2-9 February).

1667: *Paradise Lost* by John Milton (1608-74).

1675: Foundation of the Greenwich Observatory.

1688: James II is forced to flee and William of Orange is invited to England (the 'Glorious Revolution'). In 1689 he is crowned William III and reigns jointly with his wife Mary.

1687: Publication of *Philosophiae Naturalis Principia Mathematica* by Sir Isaac Newton (1642-1727), English physical scientist and mathematician.

1634 **Engraved portrait of Albrecht of Wallenstein, duke of Friedland,** *whose life inspired Schiller's dramatic trilogy* Wallenstein (*1798-9*). *In this engraving by Peter of Iode, dating from the second half of the 17th century, it is noted that it was based on a portrait by Antony van Dyck, which has not survived.*

Right: **1648 Engraving of the siege of Prague by the Swedes** *during the Thirty Years' War. The town is seen from the east, with the Hradčany quarter and Petřin in the background.*

Below: **1729** *John of Nepomuk was priest of the St Havel Church in the Old Town and chancellor of the archbishop of Prague, Jan of Jenštejn. He paid dearly for his dissent against Wenceslas IV and the archbishop: on the orders of the king, he was arrested, tortured and finally thrown from a bridge into the Vltava. Well before his canonisation, a statue of* **John of Nepomuk** *was erected on the Charles Bridge, with bas-reliefs showing various episodes from his life, a work by Matthias Rauchmiller.*

PRAGUE & BOHEMIA

1634: Albrecht of Wallenstein, Ferdinand II's military chief, is assassinated at Cheb on suspicion of having made contact with the Protestants.

1637: Emperor Ferdinand III (1608-57) succeeds his father, Ferdinand II.

1638-1642: The architect Giuseppe Matei draws up plans for the 'empress's wing' and the 'ladies' wing'. These plans include the building of the castle's Third Courtyard.

1648: General Königsmark and the Swedish army occupy part of Prague, notably Malá Strana and the castle. They make off with Rudolf II's art collections.

1657: Leopold I (1640-1705) succeeds his father, Ferdinand III.

EUROPE & THE WORLD

1701: The elector of Brandenburg becomes king of Prussia as Frederick I.

1701-1713: The War of Spanish Succession to determine dynastic claims to the Spanish throne by Bourbons and Habsburgs. Maritime Powers, under the Duke of Marlborough and Prince Eugene of Savoy, defeat the French and Bavarians at Blenheim (1704), followed by further victories at Ramillies (1706), Oudenaarde (1708) and Malplaquet (1709). Spain cedes Gibraltar to England under the Treaty of Utrecht (1713).

1715-1774: Age of Enlightenment in France. Regency (1715-23), then the reign of Louis XV (1723-74).

1721: Peter I (the Great) proclaimed Emperor of Russia.

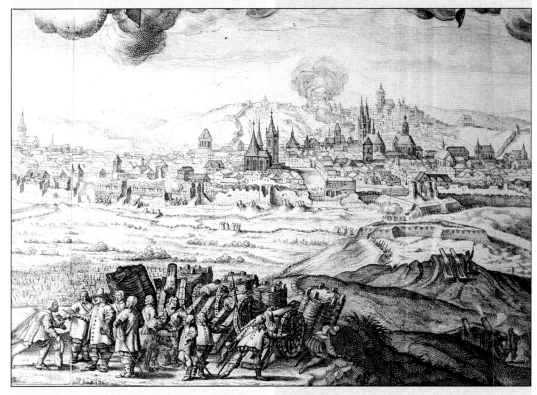

1673: Fruitless attempt to complete the building of St Vitus's Cathedral.

1694: The Winter Riding School, designed by Jean-Baptiste Mathey, is built.

1705: Emperor Joseph I (1678-1711) succeeds his father, Leopold I.

1755: Foundation of the first Russian university in Moscow thanks to the patronage of the Empress Elisabeth.
- Samuel Johnson (1709-84) completes the *Dictionary of the English Language*, begun in 1747.

1756-1791: Wolfgang Amadeus Mozart, Austrian composer.

1740 Empress Maria Theresa with her family. *This painting, from the studio of Martin van Meytens, was probably done before the death (in 1765) of Francis of Lorraine, husband of the empress. It shows the four sons and seven daughters of Maria Theresa; missing from the group are Charles Joseph (d. 1761) and John Gabriel (d. 1762).*

1743 Coronation of Empress Maria Theresa *as queen of Bohemia in St Vitus's Cathedral in 1743. Maria Theresa's coronation in Prague inspired many contemporary writers and artists. Johann Joseph Dietzler and the engraver M. Tyroff recorded all the stages of the procession, which left from the Nová Město quarter and crossed Prague by the "Royal Way" to reach the cathedral.*

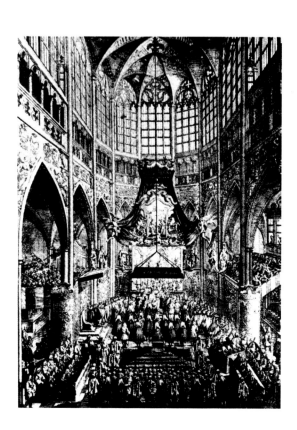

PRAGUE & BOHEMIA

1711: On the death of Joseph I, his brother, Charles VI (1685-1740) becomes emperor of Germany and king of Bohemia and Hungary. In 1713, he issues the 'pragmatic sanction', assuring the succession of the Habsburgs through the female line.

1729: Canonisation of John of Nepomuk who, according to legend, was drowned in 1393 for having refused to divulge the secret of the queen's confession for the benefit of King Wenceslas IV.

1730: Kilián Ignác Dientzenhofer is named court architect.

1733-1736: A funerary monument to John of Nepomuk is built in St Vitus's Cathedral, on the plans of Johann Emmanuel Fischer von Erlach.

1740: Charles VI dies without a male descendant. First and only beneficiary of the 'pragmatic sanction' (1713), his daughter, Maria Theresa (1717-80), becomes empress of Austria and queen of Bohemia and Hungary.

1741-1743: In pursuit of the Prussian army of Frederick II the Great, a Franco-Bavarian army occupies Bohemia and Prague, and the electoral prince, Charles Albert, becomes king of Bohemia as Charles VII.

1743: Maria Theresa ejects this Franco-Bavarian army and has herself crowned queen of Bohemia.

1753-1755: General rebuilding of Prague Castle according to the plans of Niccolo Pacassi.

1756-1763: Seven Years' War between Austria and Prussia, which sees many changing alliances.

1757: Battle of Kolín on the Elbe; Prussian bombardments ravage the Royal Garden of Prague Castle.

1780: Accession of Joseph II (1741-90), son of Maria Theresa.

1781: Joseph II proclaims an edict of tolerance and abolishes slavery and forced labour. Later he institutes civil marriage, organises the secular clergy and carries out a series of other reforms.

EUROPE & THE WORLD

1756-1763: The Seven Years' War ends with British expansion of empire in Canada and India.

1759: *Candide*, by François-Marie Arouet Voltaire (1694-1778), French writer and philosopher.
- British Museum opened at Montagu House, London.

1762: *Du contrat social* by Jean Jacques Rousseau (1712-78), French-Swiss moralist.

1770-1827: Ludwig van Beethoven, German composer.

1770-1831: Friedrich Hegel, German philosopher, founder of dialectics.

1772: Captain James Cook (1728-79), English navigator and explorer, sails on second of his three great voyages of discovery in the southern hemisphere.

1776-1781: American Declaration of Independence is followed by American Revolution, culminating in British surrender at Yorktown.

1782: James Watt (1736-1819), Scottish engineer, invents the double-action steam engine.

1789: French Revolution, storming of the Bastille, *Declaration of the Rights of Man and the Citizen*.

1793: Execution of Louis XVI and Marie Antoinette.

1796: Napoleon Bonaparte (1769-1821) launches his campaign in Italy, followed by the invasion of Egypt in 1798.

1798: William Wordsworth (1770-1821) and Samuel Taylor Coleridge (1772-1834) publish *Lyrical Ballads*, one of the starting points of the Romantic movement in English poetry, as exemplified by Lord Byron (1788-1824), Percy Bysshe Shelley (1792-1822) and John Keats (1795-1821).

1755-75 Entrance gate of the Court of Honour. *The monograms of Maria Theresa and her son Joseph II are interlaced above the entrance gate to the Court of Honour, as a symbolic expression of the fact that during the reign of the empress the castle took on its definitive appearance, in both architectural and artistic terms.*

PRAGUE & BOHEMIA

1790: Leopold II (1747-1792) succeeds his brother. Alarmed by the repercussions of the French Revolution, he retracts some of Joseph II's reforms.

1792: Francis II succeeds his father, Leopold II. He is the last Holy Roman Emperor (1792-1806) and the first hereditary emperor of Austria (1804-35) under the name of Francis I. In 1815, he becomes president of the German Federation and adheres to the Holy Alliance.

1805: Victory of Napoleon I at Austerlitz (Slavkov): it forces Francis II to abdicate, on 6 August 1806, his title of German emperor.

1814-1815: Congress of Vienna. The members of the Holy Alliance, victors over Napoleon, proceed to reorganise Europe.

1826-1834: The lithographer Antonín Langwell makes a scale model of Prague: it is displayed today in the National Museum (at the top of Wenceslas Square).

1835: Accession of Ferdinand I of Austria (1793-1875), emperor of Austria, king of Hungary and Bohemia (under the name of Ferdinand V the Debonair).

1841-1845: Arrangement of Queen Anna's pleasure pavilion, designed by the architect Bernard Grueber, for the use of the Society of the Patriotic Friends of the Arts.

1848: At the end of this year of revolution in Europe, Emperor Ferdinand I (King Ferdinand V of Bohemia) abdicates in favour of his nephew, Franz-Joseph I (1830-1916). Ferdinand dies in Prague in 1875. The new Austrian emperor reigns over Bohemia.

1852: Alexander Bach, advocate of absolutist centralisation, becomes state chancellor to Franz-Joseph I. He is dismissed in 1860 and, in that same year, the emperor promulgates the October Charter, whereby he renounces absolutism and recognises the historic rights of Bohemia. One year later, the Czech candidates win the Prague municipal elections against the Germans and take control of the city.

EUROPE & THE WORLD

1804-1815: Napoleon Bonaparte, initially first consul (1799-1804) is emperor. French land victories at Austerlitz (1805) and Jena (1806). French invasion of Russia (1812) ends in retreat and rout. Following his abdication and banishment to Elba, Napoleon is defeated by Wellington and Blucher at Waterloo, 18 June 1815.

1808: Part I of *Faust* by Johann Wolfgang von Goethe (1749-1832), who together with Friedrich Schiller (1759-1805) inaugurates the *Sturm und Drang* ('Storm and Stress') movement in reaction against rationalism and classicism.

1824: National Gallery of London founded.

1825: Opening, on 27 September, of Stockton-Darlington railway, the first passenger train, drawn by a locomotive built by George Stephenson (1781-1848), English inventor and founder of railways.

1831: Discovery of electromagnetic induction by Michael Faraday (1796-1867), English physicist and chemist.
- Cholera pandemic from India spreads through Central Europe.

1834: Invention of the 'analytical engine' (forerunner of the modern computer) by English mathematician Charles Babbage (1792-1871).

1837: Samuel Morse (1791-1872), American artist and inventor, exhibits his electric telegraph in New York.

1848: Karl Marx (1818-83) and Friedrich Engels (1820-95) jointly publish *The Communist Manifesto* and *Das Kapital* (first volume 1867, Marx; second and third volumes, 1885 and 1894, Engels).

1854-1856: Crimean War, in which Russia is defeated by the combined forces of Great Britain, France and Turkey.

1859: Publication of *On the Origin of Species by Means of Natural Selection* by English naturalist Charles Darwin (1809-82).

1836 The Coronation of Ferdinand V, *painting by Leopold Bucher. This scene of the crowning of Ferdinand V the Debonair as king of Bohemia in St Vitus's Cathedral is signed "Leopold Bucher pinx. 1847". Ferdinand V (emperor of Austria under the name of Ferdinand I) kneels before the high altar, then surmounted by the painting by Jan Gossaert, known as Mabuse, of St Luke Painting the Holy Virgin. Dozens of political personalities of the time are faithfully portrayed in this coronation scene, albeit in miniature.*

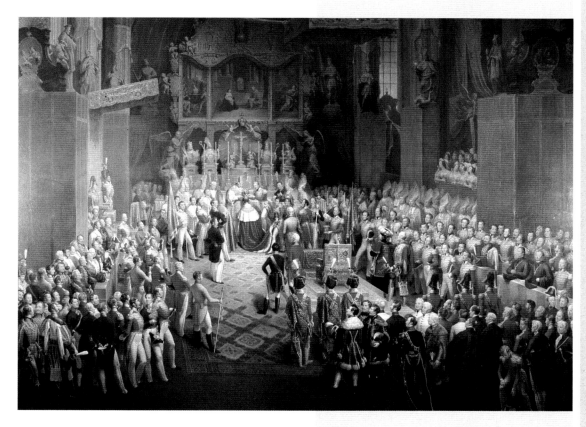

1867 Renaissance coats-of-arms of the lands of the Holy Roman Empire *in the choir of St Vitus's Cathedral. Included are the blazons of most central and European countries, whose destinies, as in the case of Hungary, were inextricably linked.*

PRAGUE & BOHEMIA

1859: Creation of the Union for the completion of St Vitus's Cathedral.

1866-1868: Rebuilding of the Spanish Room and the gallery of Rudolf II in neo-Renaissance style, designed by Ferdinand Kirschner and Heinrich von Ferstel.

1867: The Austro-Hungarian compromise, signed in February, brings the Austrian empire to an end and creates the Austro-Hungarian 'dual monarchy'. Bohemia is disappointed not to have been included in the compromise.

1916: Death of Franz-Joseph I. His grandnephew Charles I (1887-1922) succeeds him for two years as emperor of Austria and king of Hungary.

1918: Creation of a Czech Republic which includes Bohemia, Moravia, Slovakia and sub-Carpathian Russia. Its founding father, Tomáš Garrigue Masaryk, is its first president. Prague Castle is the presidential residence.

1920: New building work begins on Prague Castle, directed by the Slovenian architect Josip Plečnik.

EUROPE & THE WORLD

1861-1865: American Civil War. Defeat of seceding Confederacy by Union forces of the North paves way for abolition of slavery in South.

1870: French Impressionist school of painting, so named from Monet's *Impression, soleil levant* (1864).

1876: Alexander Graham Bell, American physicist, invents the telephone.

1888: Suez Canal internationalised (Constantinople Convention).

1889: Universal Exhibition in Paris, for which Gustaf Eiffel builds his famous tower in the Champ de Mars.

1895: First public film show in Paris by Lumière brothers, inventors of cinematography. Eight years later, they invent the polychrome plate, the first commercial process of colour photography.
- Invention of X-rays by Wilhelm Conrad Röntgen (1845-1923) who wins the Nobel Prize for physics in 1901.

1900: *The Interpretation of Dreams* by Sigmund Freud (1856-1939), founder of psychoanalysis.

1901: Gugliemo Marconi (1874-1937), Italian physicist, transmits first telegraphic radio messages from Cornwall to Newfoundland.

1903: On 17 December Orville and Wilbur Wright make the world's first successful sustained flight in a powered airplane near Kitty Hawk, North Carolina.

1905: Albert Einstein (1879-1955) publishes his *Theory of Relativity*.

1914-1918: First World War, following the assassination in Sarajevo of the Archduke Ferdinand of Austria.

1917: October Revolution in Russia. Lenin, Trotsky and Zinoviev create Soviet Russia, which becomes the USSR (Union of Soviet Socialist Republics) in 1922.

1919: Prohibition in the USA: it is not lifted until 1933.

Above: **1918 The standard of the president of the Republic***: in the centre of this large blazon are the coats-of-arms of all the territories formerly belonging to the Czech crown. The device "Pravda vitězí" means "truth conquers" (although in times of difficulty, to keep hopes high, people always said: "Pravda zvitězí", "truth will conquer".)*

PRAGUE & BOHEMIA

1935: Death of President Masaryk, aged eighty-five. Edouard Beneš (1884-1948) becomes the second president of the Republic.

1938: The Munich Agreement, signed by Germany, Italy, France and Great Britain, forces Czechoslovakia to cede the Sudeten frontier region to Germany.

President Beneš leaves for England and sets up, in 1941, a Czechoslovak government in exile. Judge Emil Hácha assumes presidency of the Republic.

1939: On 15 March, Hitler enters Prague. The Wehrmacht occupies Bohemia and Moravia, which become German protectorates. Slovakia becomes an independent state governed by Jozef Tiso, who places it under German protection.

1944: Slovak nationalist uprising put down in October by the Germans.

1945: Uprising in Prague, 5 May: the Soviet army reaches the capital on 9 May, and the American army halts at Plzeň, near the country's western border.

Czechoslovakia is reconstituted, with the exception of sub-Carpathian Russia, annexed by the USSR. Edouard Beneš is once more president.

1948: The February coup enables the Communists to grab power. The president of the Communist party, Klement Gottwald, replaces Edouard Beneš.

1951: The architect Otto Rothmayer, who continues Plečnik's work at Prague Castle, rebuilds the 'angled corridor' in front of the Spanish Room.

1952-1955: Restoration of the Royal Belvedere and reconstruction of the parterre in front of the building.

1953: Death, on 15 March, of Klement Gottwald, after catching a chill at Stalin's funeral. He is replaced as president of the Republic by Antonín Zapotocký, a politician with a trade union background. Antonín Novotný becomes leader of the Czechoslovak Communist Party.

1957: Antonín Novotný replaces Zapotocký as president of the Republic and carries out his duties under the direction of the Communist Party.

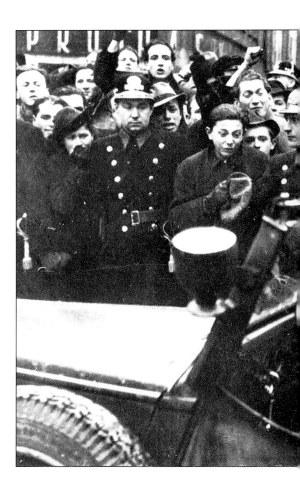

Left: **1918** *The university professor* **Tomáš Masaryk** *became first president of the free state because of his important contribution towards the ideal of independence. This statue is by Jan Štursa, a leading sculptor of the first half of the present century.*

Above: **1939 Entry of the German army into Prague, 15 March 1939.** *This photo-*

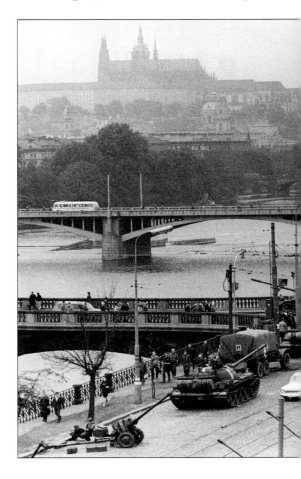

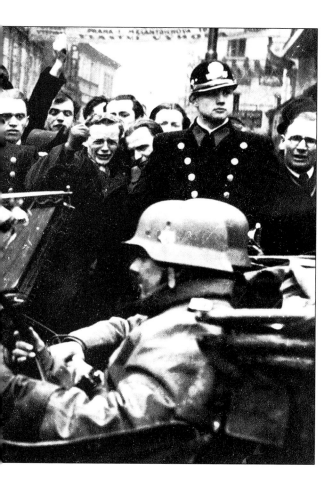

graph by Karel Novák sums up the despair, the grief and the bitterness felt by the Czech people in the face of enemy occupation.

Below: **1968** On the night of 20 August, troops of the Warsaw Pact invaded Czechoslovakia. **Soviet tanks** line the quays of the Vltava.

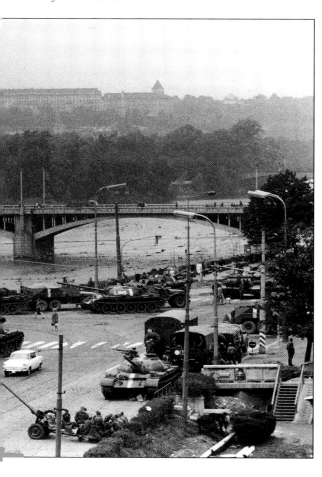

PRAGUE & BOHEMIA

1960: Czechoslovakia becomes a 'socialist' republic, the intials ČSR being changed to ČSSR.

1965: Opening of the gallery of painting at Prague Castle.

1968: The 'Prague Spring', as reforming Communists try to liberalise the regime. On 5 January, Novotný is replaced as head of the Communist Party by Alexander Dubček who, in April, hands over the presidency of the Republic to General Ludvík Svoboda. On 21 August Czechoslovakia is invaded by five member-nations of the Warsaw Pact, which brings to an end this attempt at 'socialism with a human face'. The 'temporary' occupation by Soviet troops is to last until June 1991.

16 January 1969: On 16 January the student Jan Palach burns himself to death at the foot of the St Wenceslas statue in protest against Soviet intervention and occupation.

1969: Czechoslovakia becomes a federal state comprising Bohemia-Moravia on the one part, and Slovakia on the other. In April, Gustav Husák replaces Alexander Dubček as head of the party; after several months of 'stabilisation' he proceeds to 'normalisation'.

1969-1975: Renovation of St George's Convent to accommodate the permanent exhibition of the paintings and sculptures from the National Gallery's department of ancient Czech art.

1971: End of the restoration of the Royal Ball Court (the work began after World War Two and continued intermittently).

1975: President Svoboda, aged eighty, is replaced by the head of the Communist party, Gustav Husák, who combines the two functions.

1977: Birth of the 'civic initiative' known as Charter 77, bringing together citizens of various shades of opinion: opposition to the regime thus comes out into the open, specifically denouncing the excesses of 'normalisation' and proposing democratic reforms. The persecution that ensues leads to the formation of the VONS (Committee for the Defence of Persons Unjustly Harassed) which publicly condemns the government policy. Among the founders is dramatist Václav Havel.

EUROPE & THE WORLD

1920: Creation of the League of Nations in Geneva and of the Nansen passport for displaced persons.

1929: Stock market crash precipitates the collapse of the American economy.

1936-1939: Spanish Civil War. Supported by Hitler and Mussolini, the nationalist insurgents, led by General Franco, are victorious.

1939-1945: Second World War. Nazi Germany surrenders on 9 May 1945 and the atomic bombs dropped on Hiroshima and Nagasaki lead to the surrender of Japan on 14 August.

1945: The conference between Churchill, Roosevelt and Stalin at Yalta agrees on occupation zones in Germany.

1946-1954: War in Indochina. France withdraws after the Geneva agreements.

1947: The Marshall Plan brings American economic aid to Europe. Adoption of the universal declaration of human rights by the United Nations (UNO): abstention by the USSR and the five people's democracies. UNO partitions Palestine into a Jewish and an Arab state, the prelude to Israeli-Arab conflicts.

1948: Assassination of Mahatma Ghandi.

1949: On 1 September Mao Tse-Tung proclaims the People's Republic of China in Peking, recently captured by the Communists.

1952: The USSR and the Eastern Communist regimes create their military organisation by signing the Warsaw Pact.

1956: Polish and Hungarian uprisings are crushed by the invasion of Hungary by Soviet troops.

1959: Fidel Castro overthrows the Batista regime in Cuba.
- The Dalai Lama flees to India.

1960: John Fitzgerald Kennedy president of the United States. He is assassinated in 1963.

1961: Building of the Berlin Wall.
- First man in space: the Soviet cosmonaut Yuri Gagarin.

1989 *On 29 December 1989* **Václav Havel** *was solemnly elected president of the Republic by deputies of the two houses of the Federal Parliament, sitting in the Vladislav Hall of Prague Castle. It was in this historic room, with its hallowed connotations for the Czech people, that he took the oath. Behind him, on the left, Alexander Dubček, elected president of the Federal Parliament in December 1989, proclaims Havel's election.*

PRAGUE & BOHEMIA

Late 1988-1989: Large-scale Catholic demonstrations against state control of the Church, the commemoration, on 16 January, of the suicide of the student Jan Palach in 1969, and a series of civil initiatives that include a petition for democratic reforms (supported by many intellectuals and artists who, until then, have not sided openly with the opposition) culminate in the silent demonstration on 17 November 1989 in Prague (harshly suppressed) and to other mass demonstrations that come to constitute the 'velvet revolution'. On 19 November, the opposition regroups as the Civic Forum (Občanské forum).
On 24 November, the leadership of the Communist Party resigns en bloc. On 28 December, Alexander Dubček is elected president of the Federal Parliament which next day elects Václav Havel head of state.

1990: The country is renamed the Czech and Slovak Federal Republic, and the initials ČSSR are replaced by ČSFR.

On 8 June the first free legislative elections since the end of World War Two are held, with the Civic Forum emerging victors. The new parliament re-elects Václav Havel as president of the Republic for two years, the time needed to re-establish normal, pluralist politics prior to organising new and genuinely democratic elections.

1991: On 21 February, Czechoslovakia becomes the twenty-fifth member of the Council of Europe. A multitude of political parties and lesser groups see the light. In Slovakia, independent voices are heard. In Bohemia, there is a clear rejection of left-wing views.

1992: The major victors of the June elections embark on a process of partitioning Czechoslovakia. They are Ladislav Klaus (Democratic Civic Party, ODS), ex-minister of finance and new head of the Czech government, and his Slovak counterpart, Vladimír Mečiár (Movement for a Democratic Slovakia). On 3 July, the nationalist Slovak deputies, backed by the Communists and extreme right-wing Czechs, prevent the re-election of Václav Havel, who resigns on 20 July.

1993: The Czech parliament re-elects Václav Havel as president.

EUROPE & THE WORLD

1965-1973: War in Vietnam, with heavy commitment of US armed forces. The occupation of Saigon by North Vietnamese troops in April 1975 ends almost thirty years of civil warfare.

1968: Assassination of Martin Luther King and Robert Kennedy.

1969: American astronaut Neil Armstrong is the first man to walk on the Moon.

1973: Watergate scandal: American President Richard Nixon is forced to resign the following year.

1980: The first free trade union in an eastern-block country, 'Solidarity', led by Lech Walesa, is established in Poland.

1981: The Shah of Iran is overthrown. An Islamic republic is set up under the Ayatollah Khomeini.

1984: Assassination of Indian Prime Minister Indira Ghandi. Her son Rajiv later suffers the same fate.

1985: Mikhail Gorbachev comes to power in the USSR. He tries to lead the country towards democracy (*perestroika* and *glasnost*).

1989: Destruction of the Berlin Wall. End of the Cold War between West and East.
- In China, demonstrations by students in favour of democracy are ruthlessly suppressed.

1990: Reunification of Germany.
- Occupation of Kuwait by Iraq in August leads to the Gulf War, which lasts until February 1991.

1991-1992: Collapse of the USSR. Gorbachev resigns. Boris Yeltsin takes over power. Break-up of the former Soviet Union awakens nationalism.
- Disintegration of Yugoslavia as civil war erupts.

1992: Maastricht Treaty as a step towards European union. Conference of the Earth at Rio.

THE CASTLE

THE CASTLE SITE: ITS PLACE IN THE CITY'S LIFE AND LANDSCAPE

Prague is indisputably one of the most spectacular cities of Europe. Not only is it embellished by its remarkable, centuries-old architecture, but it enjoys a privileged position in an extraordinary landscape. The city is situated in a broad basin formed by a bend of the Vltava and fringed by gently sloping hills. The highest of these hills is on the left bank of the Vltava, its spurlike summit dominating the river valley; on the other side, the hill is blocked by the gorge of the Brusnice stream. Over the centuries, the summit of the hill has been the principal scene of building activity and the focal point of political influence. It was here, in the Middle Ages, on the foundations of a Slavic stronghold, that a castle was built. This castle was destined to become the heart of the kingdom and later of the Holy Roman Empire. And at intervals, as rebuilding and renovation altered its appearance, it was the centre of political power, of science and of art, its cultural activity always indissolubly linked with the life of the city below.

Although, in the course of its growth over more than a thousand years, Prague Castle was never isolated, either culturally or politically, from the rest of the city, it nevertheless retained its special and individual identity. At all times, however, the bond between the castle and the city has remained indissoluble.

Today the castle gives the overall impression of having been built on an island. The terrain is actually a narrow spur, which the first chronicler, Kosmas, at the very end of the 11th century, compared to the back of a porpoise. Over the centuries new buildings were erected, the fortifications were strengthened and the various palaces were linked by courtyards and passages to form a coherent whole. The castle owed very much of its importance and charm to the unique character of its site, which made it a favourite subject of paintings and engravings from the 15th to the 18th century.

During the 19th and 20th centuries, Prague Castle attracted many writers and artists, not only Czechs but also Germans, who were inspired by it as a magical place still haunted by its dramatic past, but one that nurtured untold possibilities and as yet unrealised hopes for the future.

The cathedral towering over the ramparts gives the castle an unworldly appearance which, at the dawn of the modern age, corresponded precisely to the romantic concept of an idealised spot graced by nature itself — often represented in art by an island or a mountain — and doubly blessed by its sacred architecture. Writers of the 19th and early 20th century glimpsed, in the themes associated with Prague Castle, a reflection of the human mystery and the modern world: this is exemplified in the works of Jan Neruda, Julius Zeyer, Gustav Meyrink, Max Brod and Franz Kafka.

In the verses of Apollinaire's poem *Zone*, dating from the early 1910s, the influence of Prague Castle on the poet is evident: this pioneer of European avant-garde literature and art saw in the hallowed stones of St Wenceslas's Chapel in St Vitus's Cathedral the portents of his own destiny. The theme of Prague Castle recurs in many other avant-garde works, for example, the verses of Vítěslav Nezval and Jaroslav Seifert or the paintings of Antonín Slavíček and Oskar Kokoschka, and continues to spur the imagination of writers and artists to this day. The geographical location of the castle, its architectural diversity, its eventful history — spanning catastrophe and triumph, despair and faith — combine to give Prague Castle the semblance of a microcosm of human destiny.

The imposing silhouette of the castle is an ever-present symbol to the people of Prague and remains an unforgettable memory for visitors. In fair and foul weather, it floats majestically against the skyline, most spectacularly at sunset. And this powerful visual impression is reinforced by the interior of the castle, with its multiplicity of styles in the

course of over a thousand years of continuing historical development.

THE ROYAL PALACE AND THE MEDIEVAL BUILDINGS OF PRAGUE CASTLE

Archaeological research, carried on for more than a century, has shown that the first building of Prague Castle dates back to the second half of the 9th century. This was the stronghold of Prince Bořivoj, comprising a mound of earth that served as a rampart and wooden constructions inside enclosing walls. This stronghold stood on the top of the spur, in the area between the wing that nowadays separates the Second and Third Courtyards and the eastern end of St George's Convent. To the west and east, a ditch completed the fortifications, marking out on the periphery of the narrow spur the line of the foundations of the future castle.

Whereas the architectural plan of the castle had been determined, for several centuries, by considerations of defence, its later development was notable for the construction of sacred buildings, in advance of their time and important for the entire region. They were among the first buildings in local masonry. The oldest was the Church of the Virgin Mary, situated in the western bailey of the stronghold. Here were found tombs identified as those of Prince Spytihněv I, who died in 915, and his wife.

The other sacred buildings from the beginning of the 10th century are St George's Basilica and St Vitus's Rotunda. As for the original appearance of the prince's palace, we know only that it stood in the centre of the future princely and royal palaces, near the south wall, almost in the middle of the fortress and perhaps opposite the episcopal palace. The bishopric had been created in 973 and the episcopal palace was built soon after the year 1000. This was the dramatic period when the Czech state was founded, on the basis of Christian ideals, in the

course of wars and invasions involving the mightiest rulers and dynasties of Central Europe.

In 1003 Prague Castle was captured by King Boleslaw the Brave of Poland and later, in 1041 by Emperor Henry III. Nevertheless, the Přemyslid princes who reigned at Prague Castle were never completely vanquished and continually rebuilt the castle as their centre of power. In the 11th century they began to improve the defences. After 1041 Prince Břetislav proceeded to reinforce the earth ramparts with an enclosing wall of stone. His successor, Spytihněv II, then began to rebuild St Vitus's Rotunda in order to make it a basilica. In the reign of Vratislav II, Spytihněv's successor, the question of the primacy of the Church exacerbated the differences between the ruler and Bishop Jaromir, forcing Vratislav to move to another castle stronghold in Prague, Vyšehrad, where the Czech princes resided until 1135. Later, Vratislav's successor, Soběslav I, returned to live at Prague Castle and embarked on a large-scale programme of reconstruction, replacing the earth ramparts with a marl-brick wall. This powerful surrounding wall reached a height of 14 metres (45 ft) in certain places, as can be seen from the remains of the south ramparts which served as the basis of the later transformations of the Royal Palace.

The fortification works of Soběslav also included the erection of three gate towers giving access to the castle. In the south-west section of the wall he built the White Tower, today part of the wing situated between the Second and Third Courtyards. In front of the princely palace he built the South Tower and at the eastern end the Black Tower, which still stands today. A gateway in the west wall of the fortifications completed these three gate towers.

Work on rebuilding the Royal Palace was begun in 1253, the year that saw the death of Wenceslas I and the accession of Otakar II. A new wing was raised at right angles to the main building. New vistas opened up during the reign of Přemysl Otakar II, whose political influence was such as to make him the strongest contender for the crown of the Holy

Roman Empire. The fortifications were further strengthened and were extended on the south side of the castle with the ramparts of Malá Strana.[1] Přemysl's other projects never saw the light of day because of his tragic death on 26 August 1278 in the battle of Moravské Pole against Rudolf of Habsburg.

Wenceslas II, still a minor when he succeeded and under threat during the regency, re-established political power and even extended it for a brief time to include the crown territories of Poland and Hungary, but he did not make any notable contribution to the building of Prague Castle. It was only under the Luxembourg dynasty, following the accession of John of Luxembourg to the Czech throne in 1310, that fresh work began.

Even in John's reign such work was limited in scope, but under his son, later Charles IV, whom he had summoned to Bohemia in 1333, the entire castle site hummed with renewed activity. In his autobiography, *Vita Caroli*, Charles IV described the state of the castle, as he found it on his arrival: 'Prague Castle had been so devastated, demolished and dilapidated that, since the reign of King Otakar, it had been wholly destroyed down to the ground level.' Charles, who represented his father at the castle, had embarked on its restoration by rebuilding the Royal Palace. On the north side, he enlarged its Romanesque foundations with arcades to support the apartments and ceremonial rooms of his new palace. To the west he extended the palace so as to include the Romanesque tower of the south gate. The heart of the palace was a reception hall which stood on the site of the present Vladislav Hall. But Charles IV's work on the castle was likewise concentrated essentially on its sacred buildings: St Vitus's Cathedral and St George's Basilica, and plans for the reconstruction, on the model of Sainte-Chapelle, of All Saints Chapel adjoining the Royal Palace. Charles's dream was to rebuild the

1. Quarter of Prague, situated on the left bank, which begins at the Charles Bridge and climbs the hillside to the Hradčany quarter and Prague Castle.

entire castle. He broadened the fortifications and built forward enclosing walls in front of the existing Romanesque ramparts. He also restored the gates of the entrance towers which had recently been crowned by roofing in gilded lead, as testimony to the importance that he attached to Prague and its castle as the symbolic heart of his imperial power.

Yet the ambitious work on which he embarked was still incomplete at his death, in 1378, and remained so during the reign of his successor, Wenceslas IV. The latter also wished to decorate the Royal Palace and the castle in the prevailing artistic style. He modified Charles IV's work by replacing the beamed ceilings with rib vaulting.

A legacy of the building activity of Wenceslas IV is the Hall of Columns, situated in the western part of the palace, a work in the Flamboyant Gothic style, which in Bohemia and Moravia attained its pinnacle in various artistic fields. After the work initiated by Wenceslas, all building activity at Prague Castle was interrupted for a considerable time. With the death of the king and the onset of the Hussite Wars, royal power, as symbolised by his actual presence in the castle, began to disintegrate, since Wenceslas's brother Sigismund, Holy Roman Emperor and king of Hungary, was only represented there by a military garrison.

THE CHANGES TO PRAGUE CASTLE FROM THE LATE GOTHIC TO THE BAROQUE

After Wenceslas IV, the castle remained abandoned for more than sixty years. It only recovered its traditional importance, in a new guise, during the period of transition in Europe from medieval to modern times: between the last flickerings of Late Gothic and the heyday of the Renaissance. This was a time when inherited patterns of temporal power came under challenge from innumerable individual,

Copper engraving: Vladislav Hall by Egidius Sadeler, dating from 1607. This engraving is not only a remarkable work of art but also an interesting historical document; it shows shelves installed along the entire length of the hall containing drawings, books, arms, pewter objects...

economic, political and cultural initiatives, coinciding with the spiritual clash between the supporters of the Reformation and the adherents of the established faith. It was this interaction of old and new that inspired the next sequence of developments at Prague Castle, around 1500, inaugurating one of the most significant achievements in contemporary European architecture.

This occurred during the reign of Vladislav II Jagiello, elected king of Bohemia on 27 May 1471 at Kutna Hora. Very shortly after he was crowned, to strengthen his political position Vladislav chose Prague Castle as the central symbol of his power. Apparently inspired by the example of the rebuilt castle of the dukes of Saxony at Meissen (where a historic landmark had been renovated in order to epitomise the economic prosperity of the new Saxe-Wittenburg territories), the Bohemian king entrusted the reconstruction of Prague Castle to the master craftsman Benedikt Ried of Piesting[2]. In all probability, Ried was in contact with the office in charge of the rebuilding work from 1484, and within the next few years gradually came to play a leading role in the vast reconstruction project for the Royal Palace and the modernisation of the castle fortifications. Ried concentrated his principal activity on the building of the hall designed for coronations and ceremonies, and the area adjoining it, given over both to official royal functions and to the monarch's private life.

The changes that Ried brought to the castle were wholly individual, based on architectonic principles that were astonishingly audacious for their time. Rebuilding work had already begun before he was called in: a corridor already linked the palace to the oratory in the south part of the cathedral close by. Evidently this oratory was also the work of another architect, as was the 'green room', adjacent to the corridor, which has retained its characteristic Late Gothic stellar vault: according to most recent studies, this was the work of Hans Spiess of Frankfurt.

2. Known also in Bohemia under the name of Rejt.

Fortunately, Benedikt Ried's grandiose plan for the castle was not interrupted by the accession of King Vladislav II Jagiello to the throne of Hungary in June 1490. Ried's work includes, above all, the Vladislav Hall, the Riders' Staircase, the old Diet Hall and the beginning of the perpendicular Gothic south wing, known as the Louis Wing.

The Vladislav Hall was built on the foundations of the Romanesque palace and the Gothic palace of Charles IV, the two floors of which form its base. Ried unified the area and did away with parts of the old palace, including the chapel, to make a large hall 16 metres (52 ft) wide, 62 metres (203 ft) long, 13 metres (43 ft) high. Its dimensions were appropriate to the changes that had come about in the life of the castle, and it met with the enthusiastic approval of Prague's nobility. The large size and majestic appearance of the Vladislav Hall made it eminently suitable, in due course, for important ceremonial occasions, including coronations, tournaments, receptions and even as a marketplace for exclusive merchandise, as during the first industrial exhibition in Bohemia. It is used, too, for the election of the Republic's president. Here, in the Vladislav Hall, Václav Havel was elected president and made his address to the nation and Parliament.

In many ways, Ried's design of the Vladislav Hall harmonised with the rest of the castle. He also developed a number of structural and functional elements of Charles IV's architecture, giving them a new appearance and dimension. His work was thus a synthesis of Late Gothic motifs, principally derived from Danubian architecture, but he attained a level of expressiveness quite beyond the existing range of local architects, schools and workshops. For Ried, the most important element of such a building was the vault; and he embellished it with the most picturesque features of Late Gothic to create a wholly original design in which his personal vision blended with an impersonal rhythm that unified an area divided into five bays of vaulting. The historian of Czech art, Václav Mencl, has described Ried's work as follows: 'The surface of the vault,

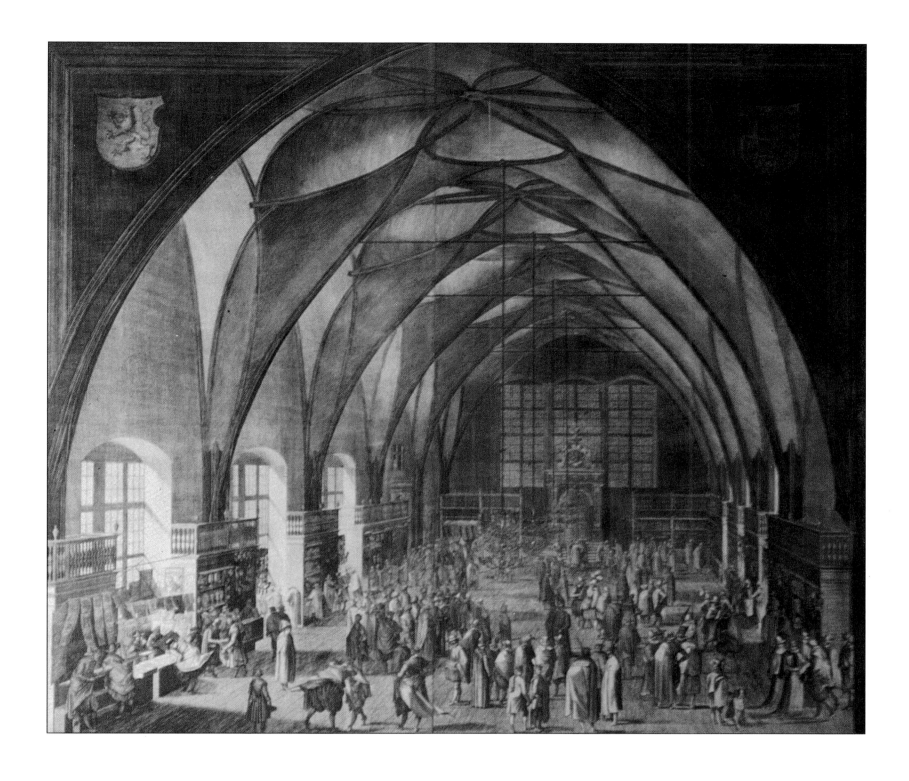

perfectly balanced, seems to ripple with the softest
movement, summit and base merging in a long,
vibrant, luminous surface, virtually imperceptible to
reason and imprecise in form, yet full of melody
and music, where the supple forms of the space are
imparted to the material of the vault and where the
rigid structural frontier between matter and space is
completely obliterated.'

By applying the discoveries of Late Gothic to a
vast area and by exhibiting them in the context of
continuously changing surfaces, Ried modelled

himself on Peter Parler, elaborating the theme of
transformation and continuity of the surface in
space, with results that were further developed,
locally, only in the work of that genius of Baroque,
Santini Aichel. The hall built by Ried is justly
regarded as one of the architectural masterpieces of
Central Europe around the year 1500 and was
already recognised as such in his time. Václav
Hájek, the 16th-century Czech chronicler, wrote of
it: 'There was not, in the whole of Europe, a similar
construction, unsupported by pillars, of such width,

length and height.' Hájek went on to describe the Vladislav Hall as the 'jewel of the Czech kingdom'.

In many respects, Ried's work is testimony to his remarkable insight into the traditions of Czech architecture, the characteristic features of which he was able to apply in a new manner. One is struck not only by the continuity of the interior space but also by the dramatic contrast between this interior and the façade of the building. This façade has the attributes of Italian Renaissance at its finest, as exemplified in its harmonious proportions, its restrained appearance and the sumptuous character of the different elements of the building, such as the windows and the main doorway. The combination of Late Gothic and Renaissance elements achieves a degree of syncretism that is typical not only of Central European art, but more specifically of the castle architecture as a whole, in which so many different styles are astonishingly reconciled and crystallised.

The interlinking of Late Gothic and Renaissance is equally characteristic of Ried's later work at Prague Castle, notably on the apartments in the Louis Wing, named after the son of Vladislav II Jagiello, who succeeded him in 1516 and in whose reign the wing was completed. This extraordinary synthesis of styles is evident, however, in all the architectural work on the castle. The architect experimented boldly and was able to manipulate conventional styles as if they were elements of a language that in combination could be used to create new expressions and patterns. This was the case, for example, in the composition of the door to the Riders' Staircase, where the Late Gothic saddleback motif of the architrave would be unthinkable in Renaissance architecture; or of the doorway leading from the Vladislav Hall to the Diet, where the Renaissance fluted pilasters are deliberately coiled in the form of a screw, while the overall plan of the doorway pays tribute to the purity and simplicity of the Renaissance style.

The new Renaissance motifs used by Ried for the windows and doorways of the palace found no other application in the construction and decoration work at Prague Castle. After the death of Louis II Jagiello, following his defeat by the Turks at the battle of Mohács (1526), there was a further interruption in work at the castle. In 1526 the Czech Estates elected Ferdinand of Habsburg king of Bohemia, he having promised them to live in Prague. During his reign, without touching the heart of the castle, all building work was concentrated on the northern buttresses, situated behind the Stag Moat. To gain access to this area and to reach its buildings, a new bridge had to be constructed in the northern wall. In this way the castle was opened out towards its gardens, creating a new horizontal focal point, undreamt of by those responsible for its medieval layout.

In 1541 a fire in a house in Malá Strana spread to Prague Castle and the entire Hradčany quarter, even affecting the buildings behind the Stag Moat. This event delayed all new building activity for more than ten years. The work was not resumed until the time of Ferdinand of Tyrol who, after the death of Queen Anna, represented the government of Ferdinand I of Habsburg in Bohemia (1547-63). Thanks to him, reconstruction of the castle continued and the Royal Garden was completed. To do this, Ferdinand of Tyrol created a Court Building Office, which at first was run by Paolo della Stella, then by Hans Tirol and, from 1556, by Boniface Wohlmut. The last-named completed the castle repairs, showing both good taste and an eye for beauty: he respected the work of his predecessors and carried out restorations in their spirit. Thus he built the vault of the Diet, leading to the Vladislav Hall, in Late Gothic style, modelling himself on Ried. He proved himself a champion of Palladianism in building the tribune of the chief clerk of the Land Rolls, which had been lodged at the Diet in 1564. After the fire which destroyed a whole series of buildings at Prague Castle, new opportunites presented themselves; and it was builders employed by the nobility — the Rožmberks and the Pernštejns — who were given

Wood engravings: Two views of the town and castle of Prague by Joris Hoefnagel, court painter to Rudolf III, in *Civitates Orbis terrarum*, a work in several volumes by Georg Braun, dating from 1595.

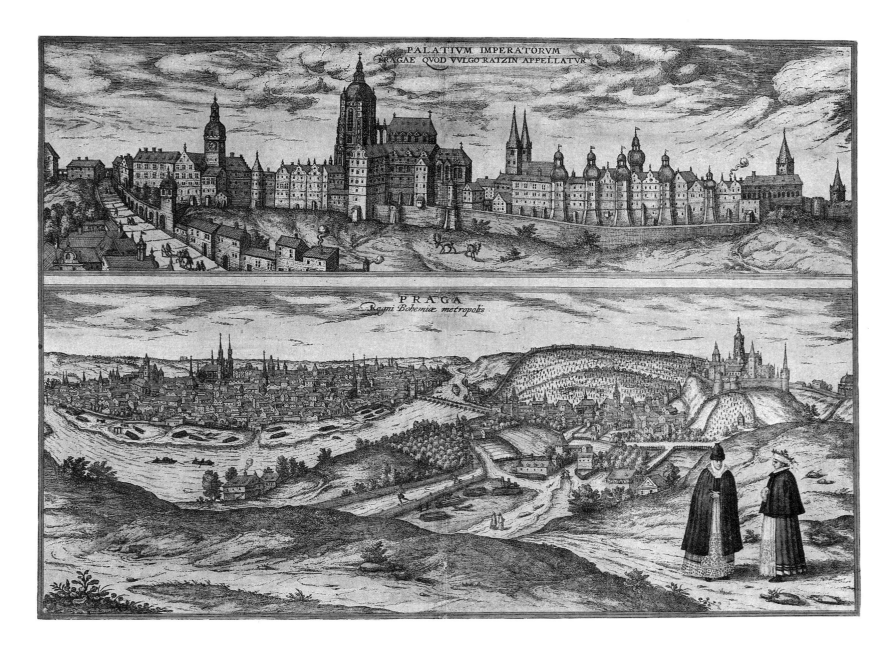

Wood engravings: Two views of the town and castle of Prague by Joris Hoefnagel, court painter to Rudolf III, in *Civitates Orbis terrarum*, a work in several volumes by Georg Braun, dating from 1595.

the responsibility. But in the palace itself, only the royal apartments adjoining the White Tower were rebuilt in the reign of Maximilian II, who had succeeded Ferdinand I in 1564.

Emperor Rudolf II, Maximilian's successor, settled permanently in Prague after his accession to the throne in 1576. He launched major building operations, decisive for the future of Prague Castle.

(Continued on page 81)

THE SITE
OF THE CASTLE

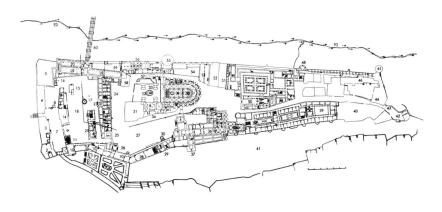

Copy of the plan of Prague Castle before its reconstruction during the reign of Maria Theresa of Austria (before 1755).

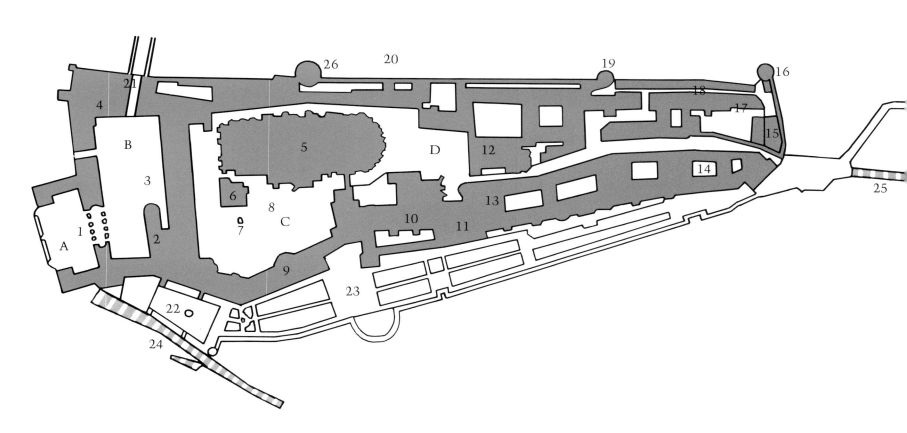

A First Courtyard
B Second Courtyard
C Third Courtyard
D George Square (Jiřské náměsti); also commonly known as St George's Square (Náměsti u svatého Jiří)
1 Matthias Gate
2 Holy Cross Chapel
3 Kohl Fountain
4 North wing of the castle, with the Spanish Room and Rudolf Gallery
5 St Vitus's Cathedral
6 Old Provost's Lodging
7 Monolith
8 St George's Fountain
9 South wing of the castle: offices of the president of the Republic and his chancellery
10 Louis Wing and Vladislav Hall
11 All Saints Chapel
12 St George's Basilica and Convent
13 Former Former Rožmberk Palace, later the Institute for Noblewomen
14 Pernštejn Palace, later Lobkowicz Palace
15 Black Tower
16 Daliborka Tower
17 Burgrave's House
18 Golden Lane
19 White Tower
20 Stag Moat
21 Powder Bridge
22 Paradise Garden
23 Ramparts Garden
24 New Castle Steps
25 Old Castle Steps
26 Mihulka (Powder) Tower

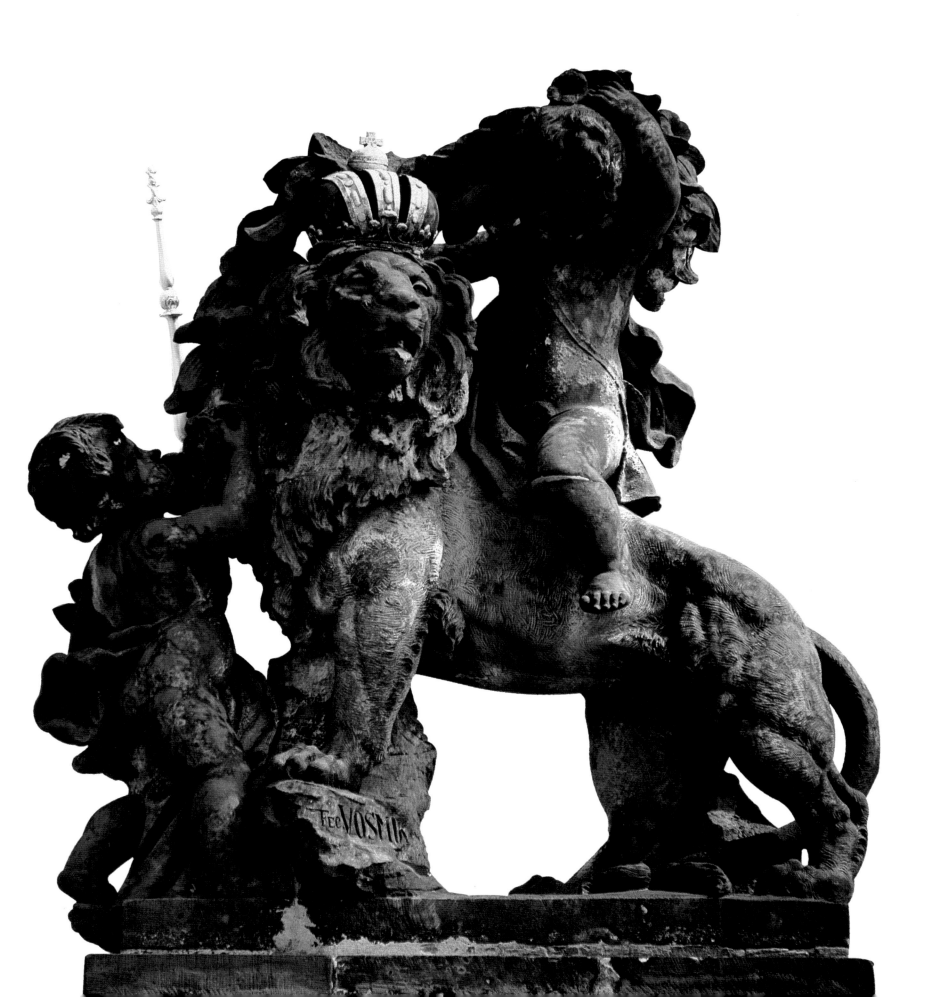

Putti playing with a lion: fragment of a
sculpture by Ignác Platzer, dated 1770-1,
part of the decorative railing separating the
Court of Honour from Hradčany Square.

Below and right, p. 55: *The Fighting Giants*: sculptures by Ignác Platzer, dating from 1770-1, on the pillars of the entry gate to the Court of Honour.

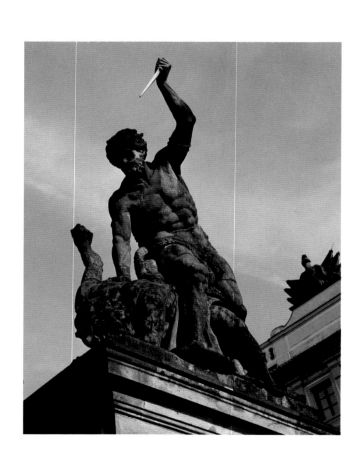

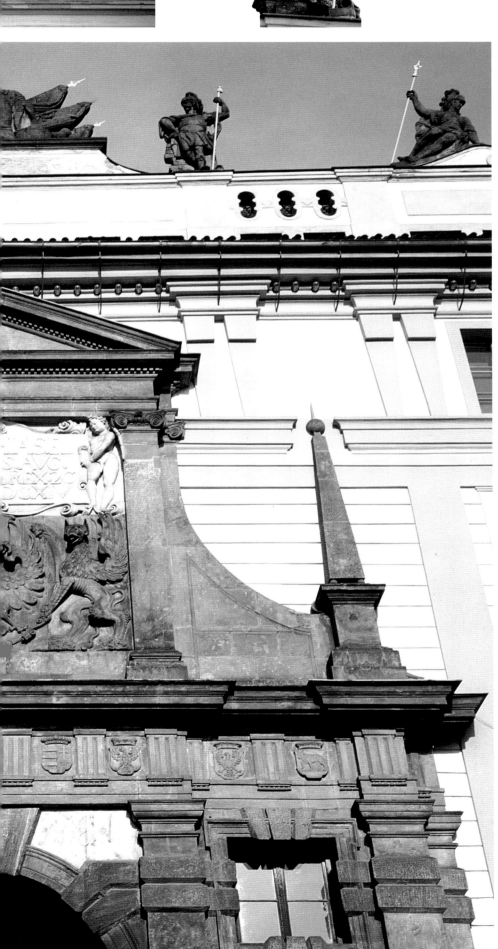

Centre: *the Matthias Gate*: designed near the end of the reign of Rudolf II by Giovanni Mario Filippini and built in 1614 under Matthias II. Originally isolated, in the course of the reconstruction carried out by Niccolo Pacassi it was linked to the castle by the perpendicular wing, thus becoming the centrepiece of the Court of Honour and the main entrance gate to the castle. On the attic storey is an allegory of War and Peace, as well as war trophies (a work by the Platzer workshop).

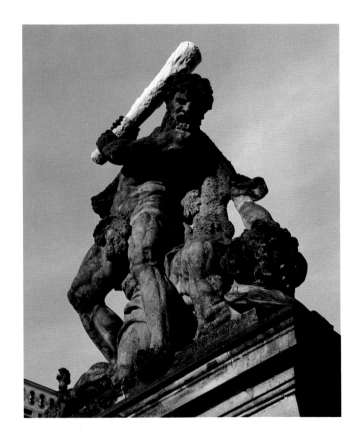

55

HRADČANY SQUARE

View from the third floor of the west wing of the castle, with the gate and railings of the Court of Honour in the foreground:

On the left, in the foreground, is the *Salm Palace*, formed of three wings, with a courtyard opening onto the square. The palace was built from 1800 to 1810, on classical lines, by the architect František Pavíček for Prince Vilém Florentin Salm-Salm, archbishop of Prague from 1793 to 1810.

Behind it stands the *Schwarzenberg-Lobkowicz Palace*, one of the most impressive examples of the Renaissance style, built from 1545 to 1567 by the Italian architect Agostino Galli. The walls are decorated with diamond-point bossage and the façades surmounted by stepped gables and lunette cornices.

The *Thun-Hohenstein Palace* or Tuscan Palace, in the centre, was built in the Baroque style between 1689 and 1691 for Count Michal Oswald Thun. Its construction is attributed to the Burgundian architect Jean-Baptiste Mathey who, with Francesco Caratti, introduced the monumental Baroque style into Bohemia.

The *Archbishop's Palace*, on the right, has undergone several transformations. The ancient Gryspek Palace, dating from before 1538, was rebuilt from 1562 to 1564 by Ulrico Aostalli, to the designs of Boniface Wohlmut, for Archbishop Antonín Brus of Mohelnice who, from 1561, was the first incumbent of Prague's

archbishopric after the Hussite Wars. Jean-Baptiste Mathey renovated the palace in Baroque style from 1675 to 1694, slightly altering its structure, and Jan Josef Wirch adorned it with an elegant Rococo façade between 1763 and 1765.

THE CASTLE COURTYARDS

Second courtyard of the castle, north-east side. On the right is the northern end of the Holy Cross Chapel. The wing of the castle with the façade visible here was built by the architect Antonín Haffenecker from 1772 to 1775 in the context of the general reconstruction of the castle by Niccolo Pacassi for Empress Maria Theresa, his objective being to give uniformity to the whole site.

Centre: *view of the Third Courtyard,* from the south tower of St Vitus's Cathedral; the paving and the additions of the fountain and the monolith were the work of Josip Plečnik.

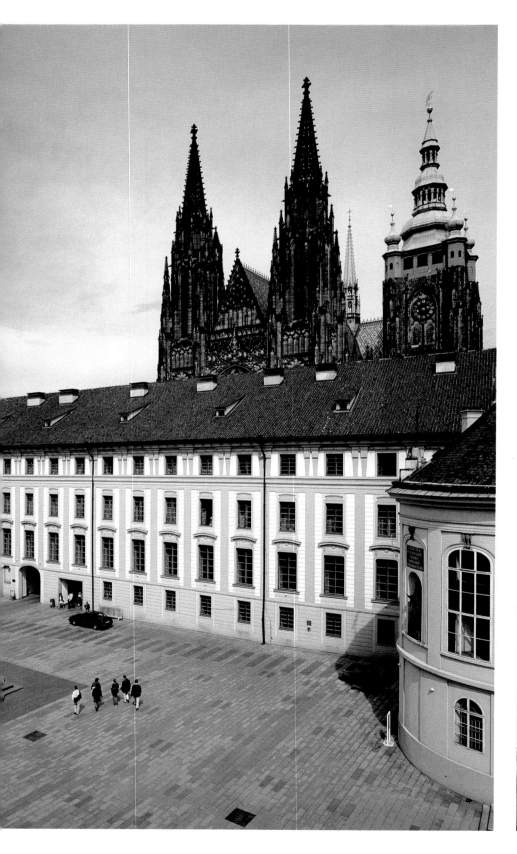

Right: *view of George Square (Jiřské náměsti)*, also known as St George's Square (Náměsti u svatého Jiří). This little square is dominated by the west front and towers of St George's Basilica. Behind is the Vltava, crossed by two bridges. The nearer is the Svatopluk Čech Bridge, built from 1906 to 1908 by Jiří Soukop and Jan Koula in the Secession style; it is an iron structure with transverse arches, adorned with elegant lampposts and flanked, at either end, by four marble columns topped by winged statues. In the distance is the Josef Hlávka Bridge, in reinforced concrete, built by Pavel Janák (1909-12), giving access to Štvanice Island, used since the 1980s exclusively for tennis.

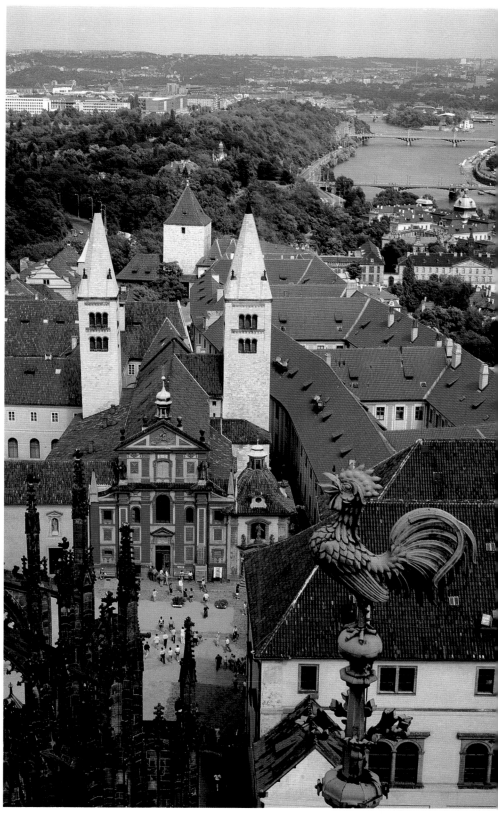

59

THE CASTLE'S ROMANESQUE BUILDINGS

Right: lower floor of the Romanesque palace.

Opposite page: Romanesque barrel *vault* from the mid-12th century.

Below: *model* of the castle site seen from the west, around 1250, with the two towers of St Vitus's Romanesque basilica in the foreground, and the basilica of St George's Convent in the background.

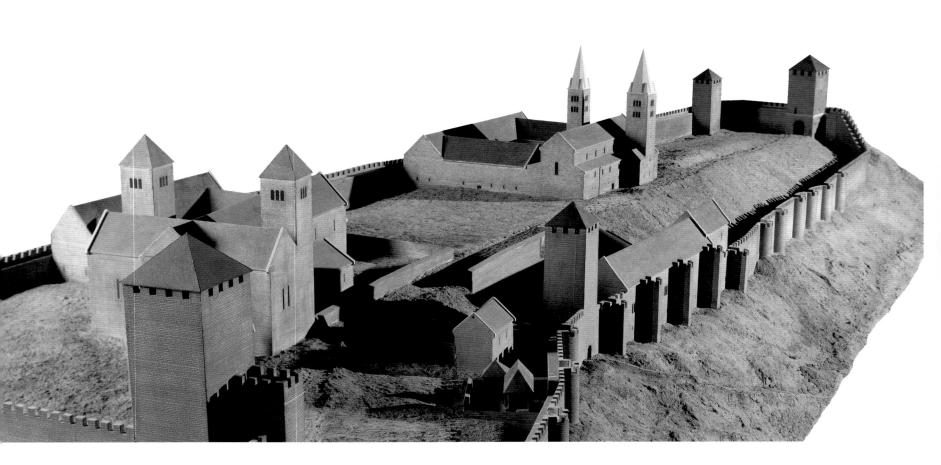

THE GOTHIC PALACE

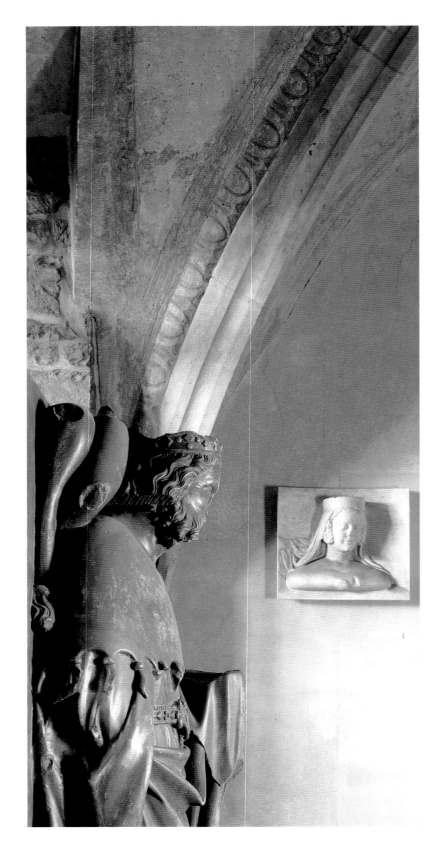

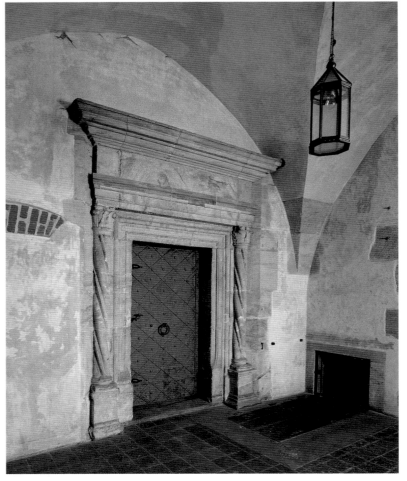

Together with the cathedral, *the Charles Room of the Royal Palace* is the most important architectural achievement of the reign of Charles IV.

Left: corner of the vaulting; on the walls are mouldings of Gothic statues from St Vitus's Cathedral.

Above: first Renaissance doorway leading to the Gothic part.

Opposite page: view of the Charles Room.

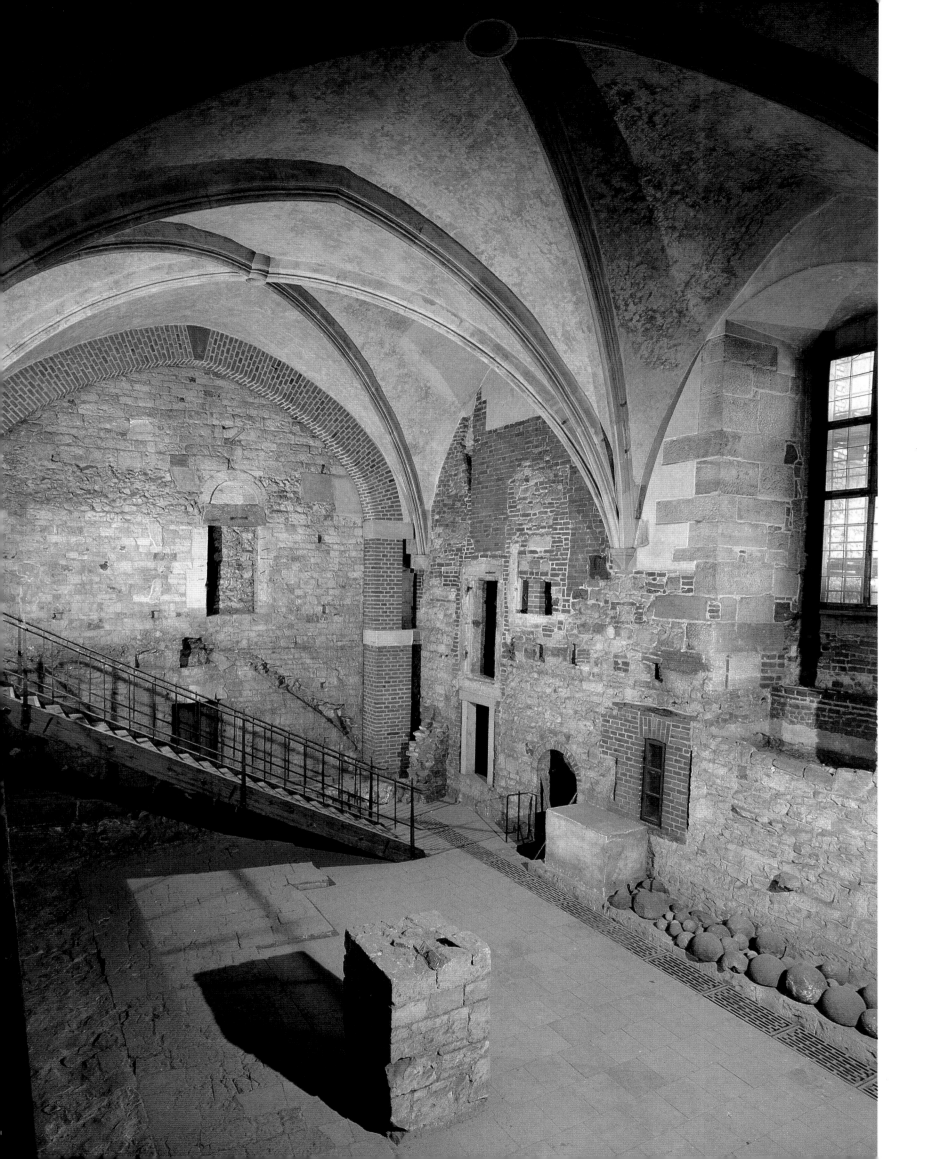

South front of the Louis Wing, with Renaissance windows designed by Benedikt Ried between 1502 and 1509. The obelisk with a cross, in Early Baroque style, was placed in the gardens laid out by Josip Plečnik as a monument commemorating the defenestration of the two pro-Catholic royal officials, Jaroslav Bořita of Martinic and Vilém Slavata of Chlum, on 23 May 1618.

Opposite page: *Renaissance doorway* in the Louis Wing, with a view of the Bohemian Chancellery, built to the plans of Benedikt Ried between 1502 and 1509.

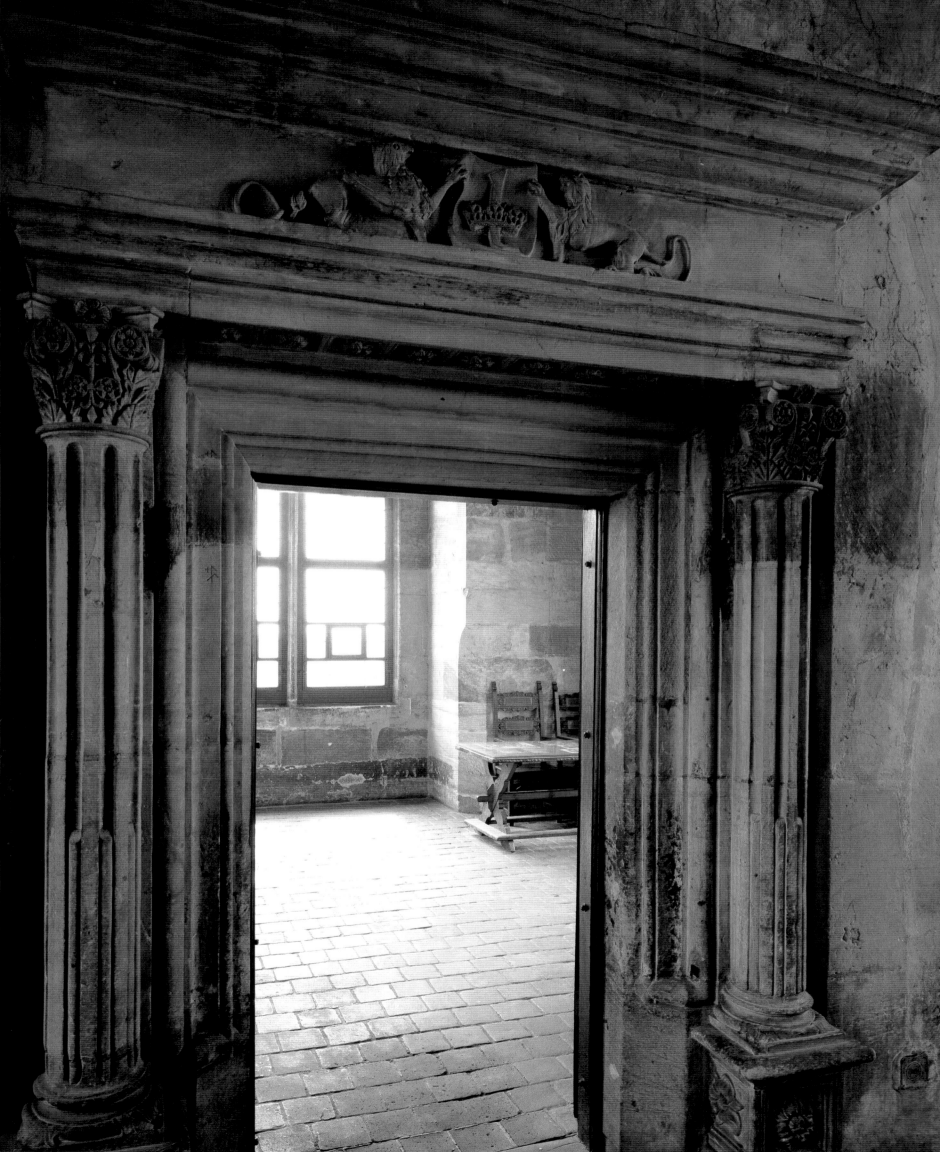

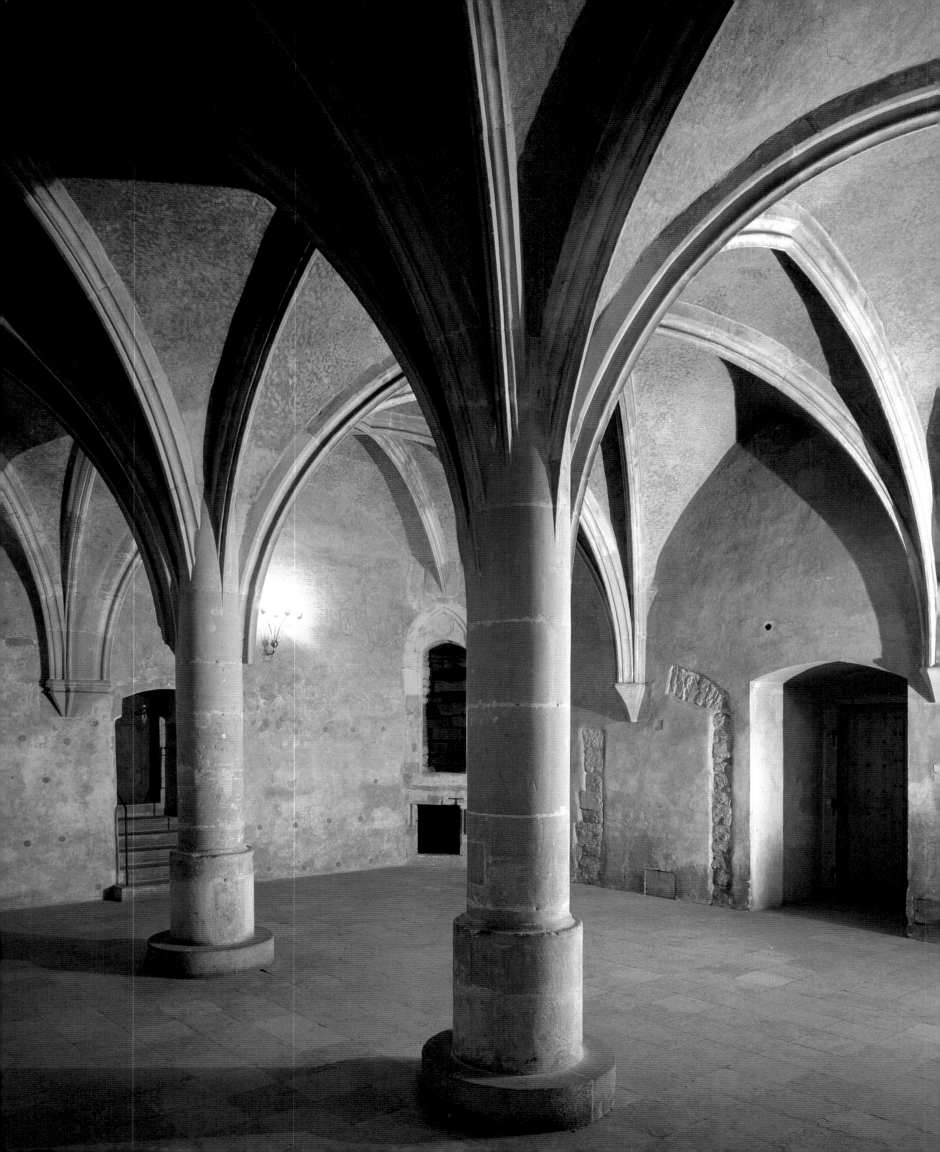

Opposite page: *Wenceslas IV's Hall of Columns*, built around 1400 by the royal building workshop of Točník Castle. The hall is one of the most striking examples of Gothic architecture of the Luxembourg era, known as Flamboyant Gothic. An atmosphere of elegance and purity is conveyed by the use of space and the various structural elements , notably the optical contraction of the ribs of the vault, which spring directly from the smooth, rounded columns or from the walls.

Right and below: *the Diet Hall on the first floor of the Louis Wing*. The doors are decorated with marquetry; on the walls are portraits of the Habsburgs; on the left, a portrait of Philip V of Spain (copy of a Velasquez); in the centre, a painting by Ignác Raab, the *Siege of Prague by the Prussian Army*; and, in a corner of the hall, a 17th-century faïence stove. From the Middle Ages this was the room where negotiations were held between the king and his nobles, and it was, above all, the seat of the Aulic Council of the Czech kingdom, whose deliberations were entered in the Land Rolls registers.

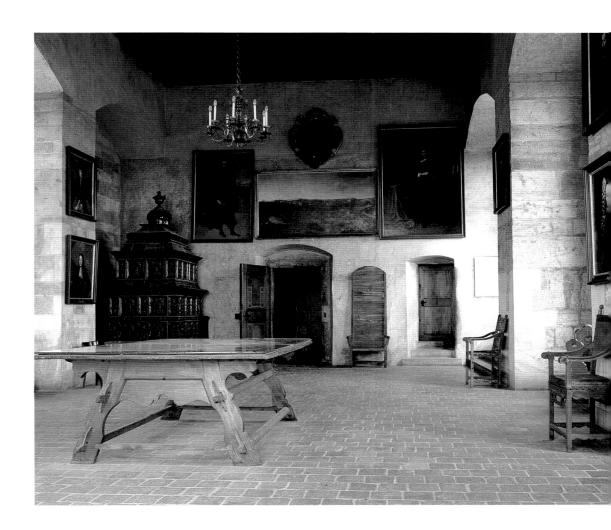

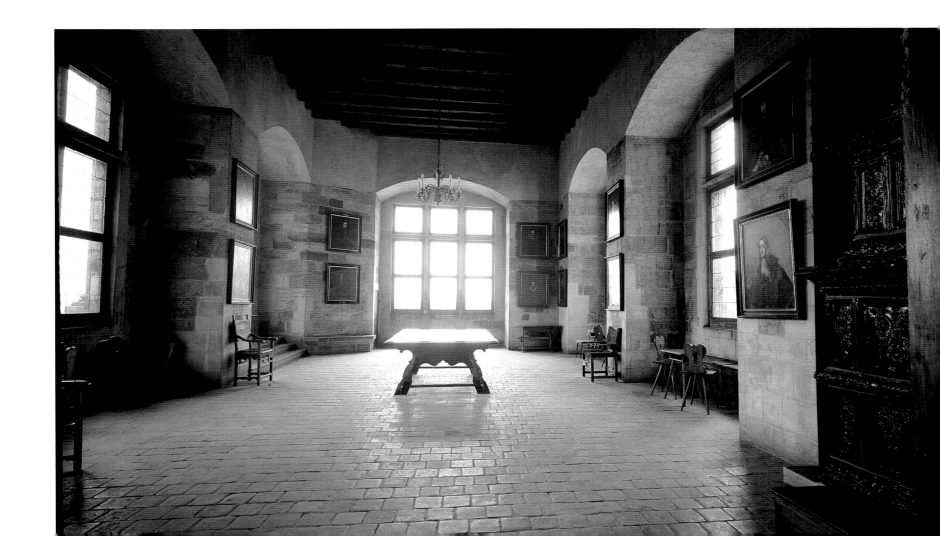

THE OLD DIET HALL

Old Diet Hall: winged head and dragon in a springing of the vault, above the clerk's tribune.

Opposite page: during the reign of Ferdinand I, Boniface Wohlmut built, in a corner of the Diet Hall *a tribune* for the chief clerk of the kingdom, which was linked to the room where the new Land Rolls registers were kept. A throne dating from the 19th century placed in the Diet reflected the wish of Czech society to see the rights and institutions of the kingdom re-established.

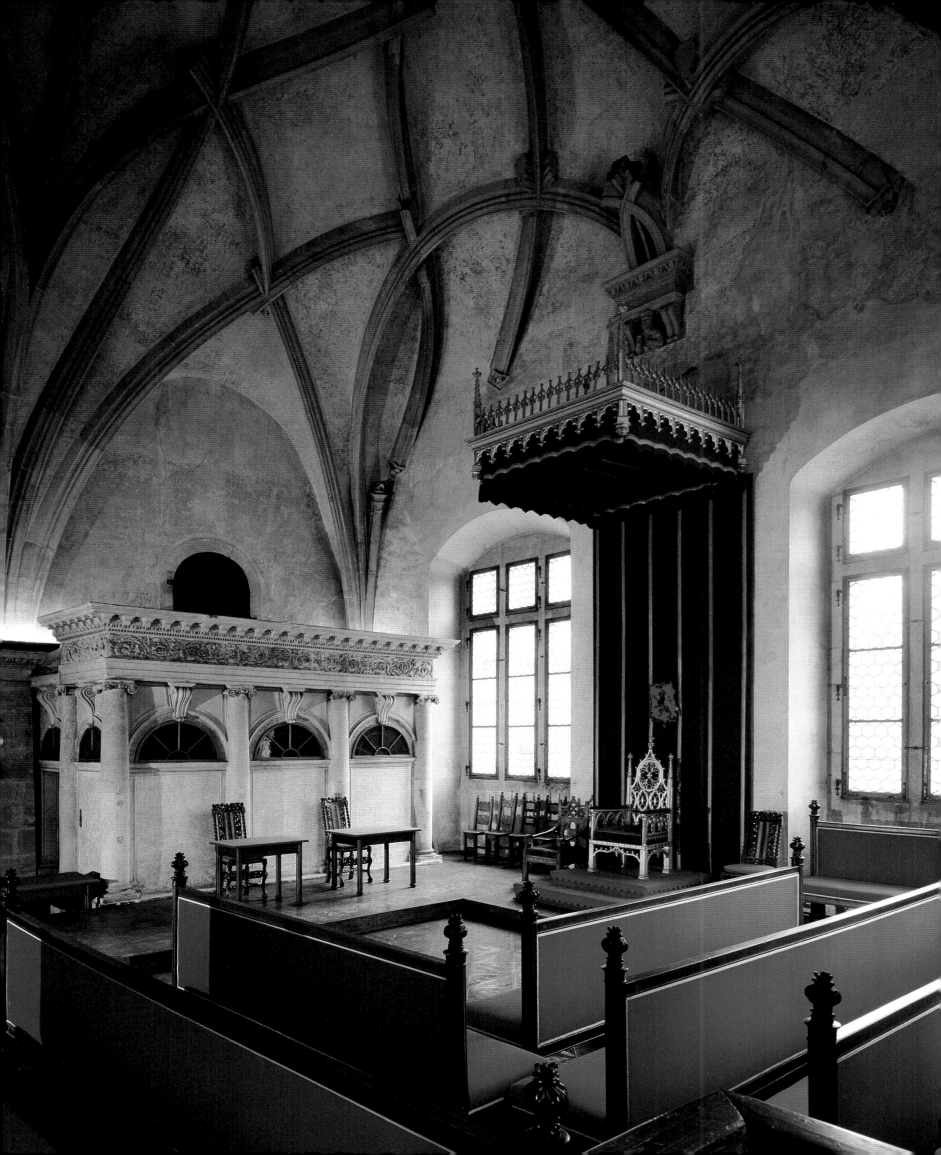

Vault of the Diet, constructed in 1559-63 by Boniface Wohlmut after the vault built by Benedikt Ried around 1500 had been destroyed by a fire in 1541.

Wohlmut built a vault in which the semicircular arches were buttressed by a network of ribs, the flowing lines of which combine to create the overall impression of much greater size.

Detail: according to legend, Boniface Wohlmut intended to add his own bust opposite that of Ferdinand I, placed on a bracket above the throne.

71

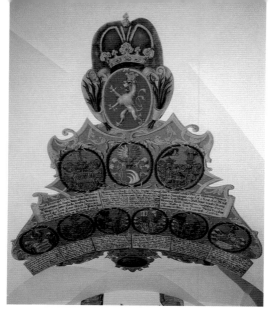

Room of the new Land Rolls, decorated with the coats-of-arms of the officials in charge of them from 1561 to 1774. In the rooms adjoining the Vladislav Hall, where the Land Rolls were kept, the ornamentation was in strict order of precedence. Thus, beneath the Czech lion from right to left, were the blazons of the royal steward, the supreme judge and the chief clerk: on the lower row were those of the steward of the kingdom, the deputy supreme judge, the royal clerk, the agent of the Land Rolls, the deputy chamberlain and the clerk of the minor Land Rolls.

Opposite page: in 1737, the wing containing the rooms that housed the Land Rolls was extended to include another room for the safekeeping of the archives concerning the St Wenceslas Crown and, subsequently, the Crown Jewels.

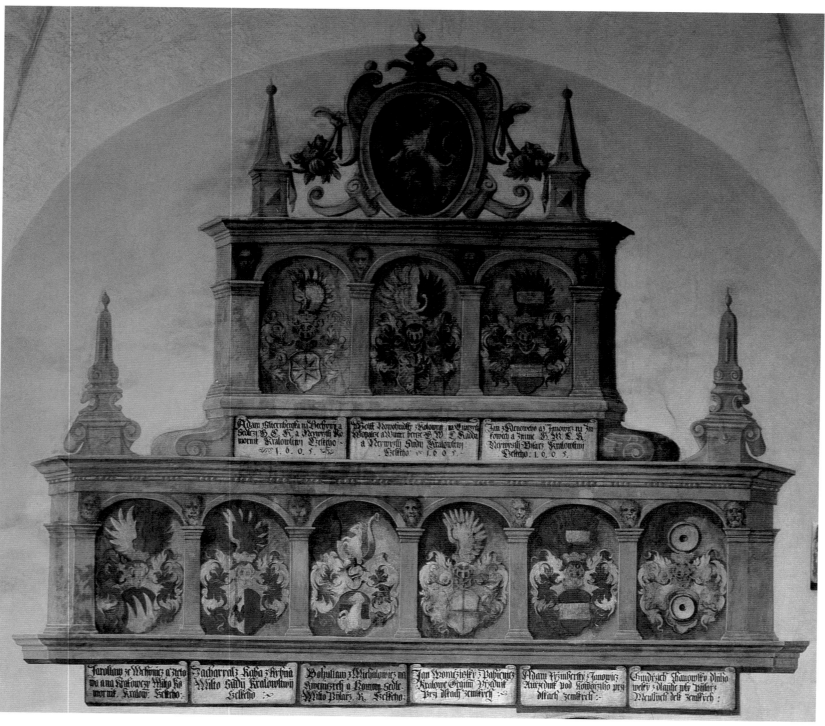

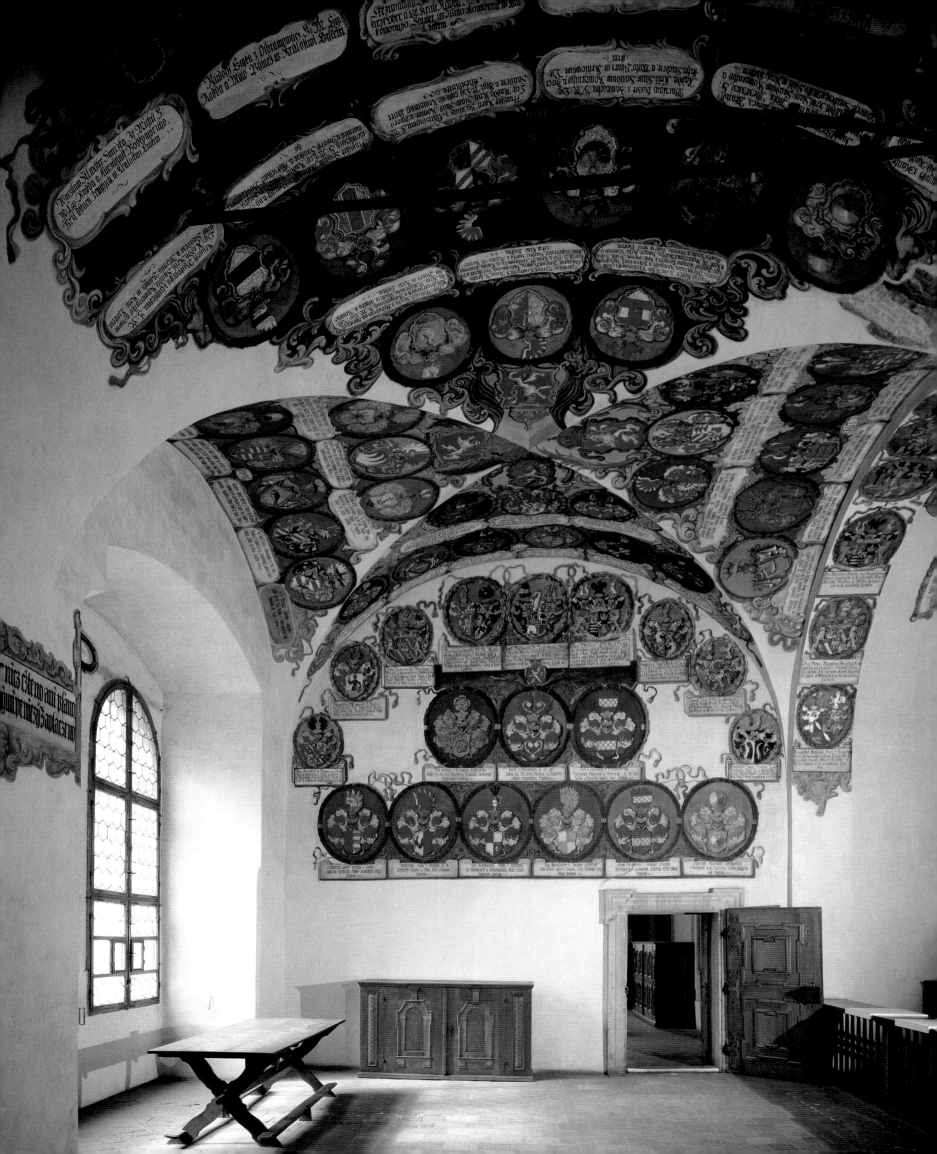

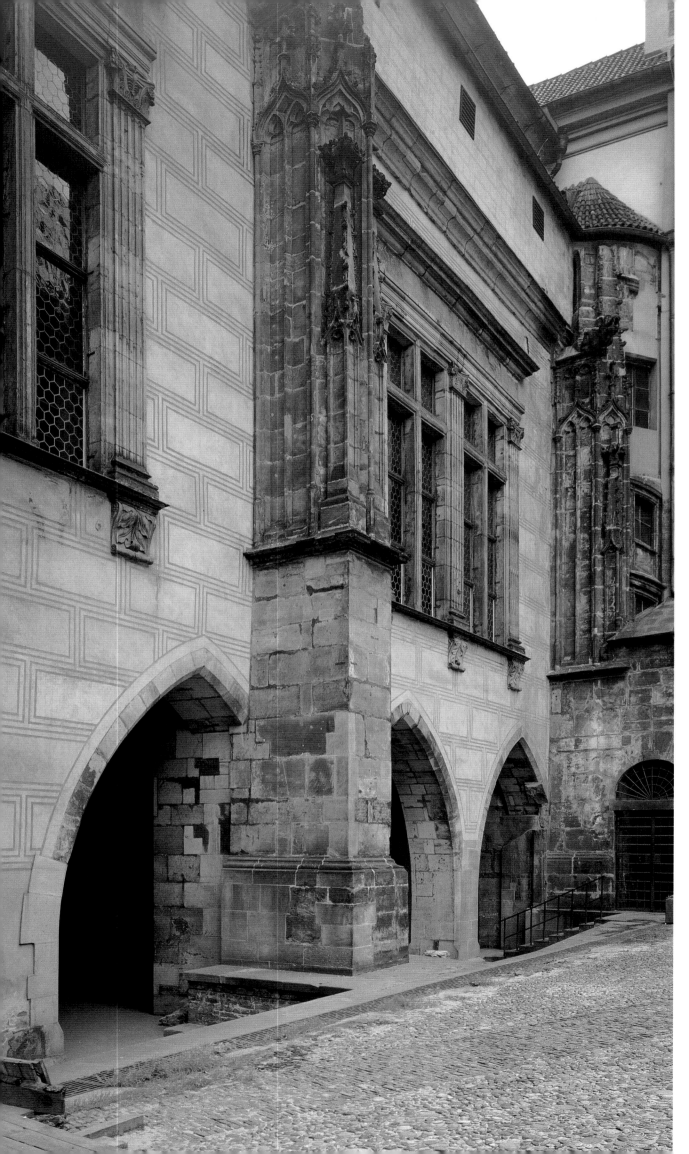

THE VLADISLAV ROOM AND HALL

North wall of the Vladislav Hall: the upper part of the façade, built between 1490 and 1502 by Benedikt Ried, rests on the foundations of the Gothic palace of Charles IV.

Opposite page: with its Late Gothic stellar vault, the so-called *Vladislav Room* was one of the first to be built in the course of the castle reconstruction that commenced in 1486, during the reign of Vladislav II Jagiello. The architect of the vault is thought to have been Hans Spiess of Frankfurt.

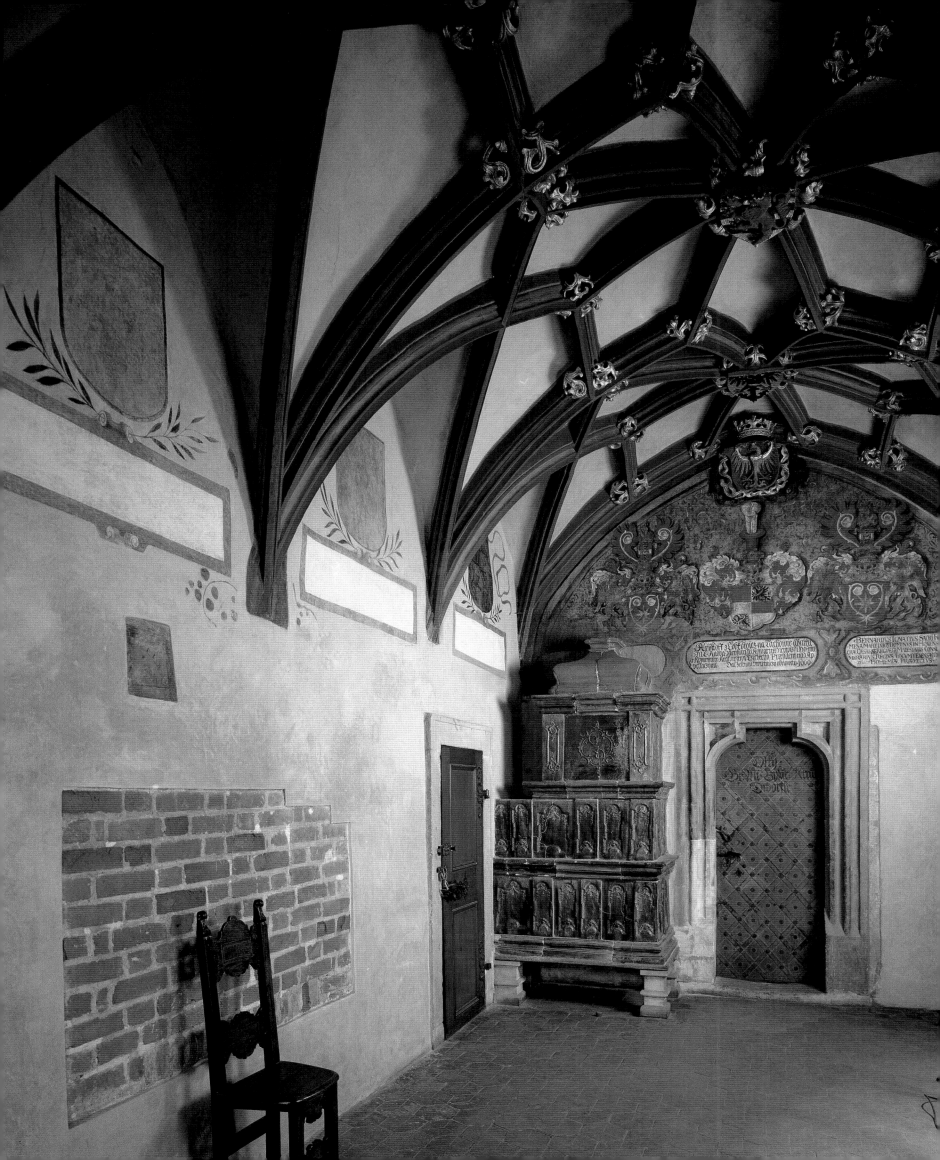

The areas adjacent to the Vladislav Hall allowed Benedikt Ried to apply his creative talents and imagination and to convey a sense of movement to the stone vaulting, its spanning ribs and the bay of the vault surrounded by columns and walls.

Below: the stairs leading to the south-west corner of the Vladislav Hall.

Opposite page: *the Riders' Staircase*, giving competitors on horseback access to the tournaments held in the Vladislav Hall.

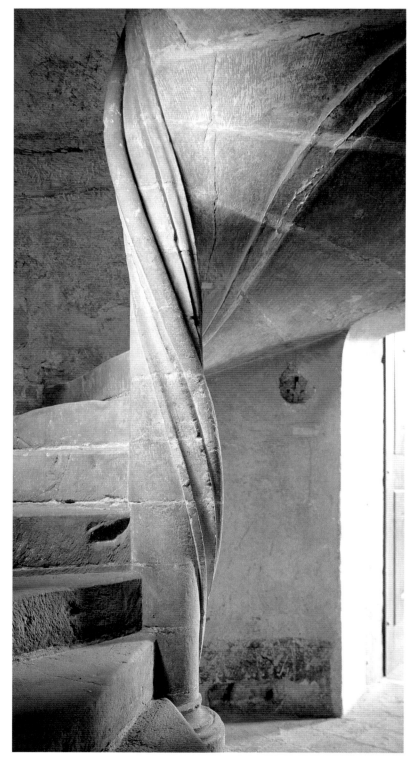

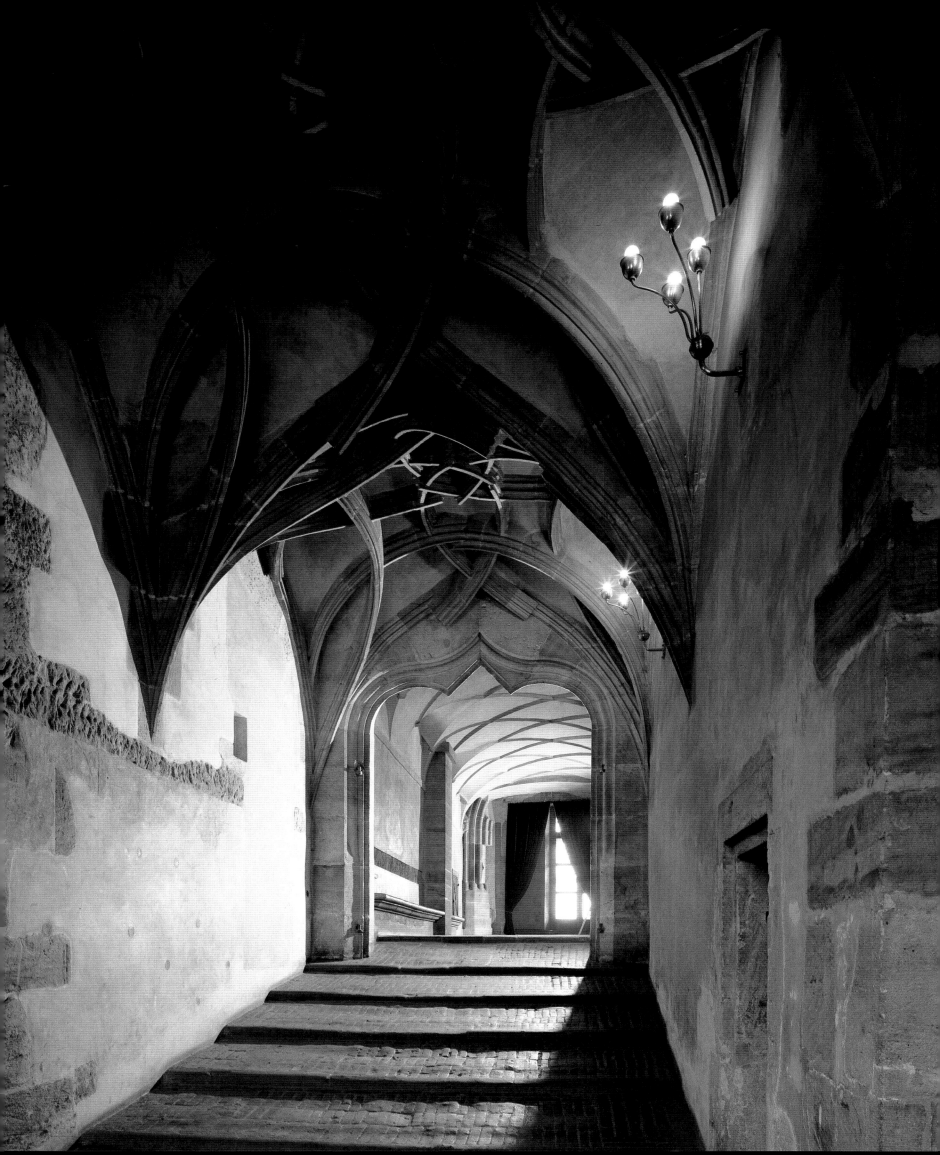

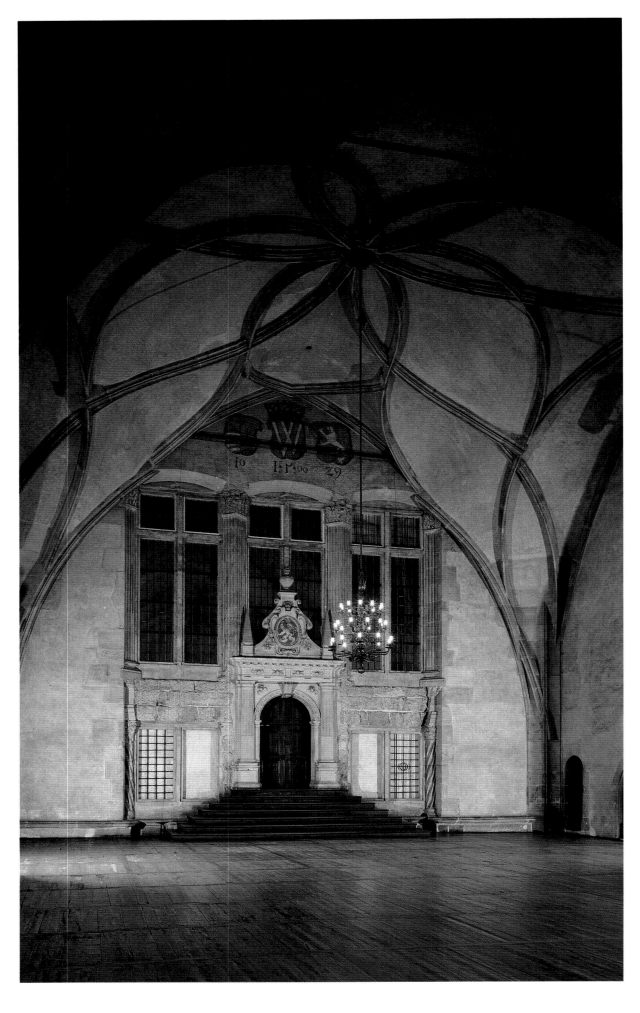

The Vladislav Hall: the most extensive enclosed space of the Royal Palace of Prague Castle represents one of the peaks of Late Gothic architecture. The hall was built above the Romanesque and Gothic storey. Benedikt Ried boldly joined together several rooms of Charles IV's old palace to create an area of impressive dimensions and harmonious proportions based on the juxtaposition of contradictory features of Gothic and Renaissance styles.

Over the centuries this hall has been used for the most important events in the political and social life of the Czech kingdom and of the Czechoslovak state, such as coronation banquets and gatherings of the Estates General. This is where constitutions were adopted and where, from 1918, the elections of the president of the Republic have been held. During the time of Rudolf II, the hall was also the setting for knightly tournaments and for sales of valuable works of art and expensive merchandise.

Left: the east wall of the Vladislav Hall, with the Mannerist doorway of Giovanni Gargioli, who linked the hall to All Saints Chapel: it was used by the highest functionaries of the realm and by witnesses to the swearing of oaths in the chapel.

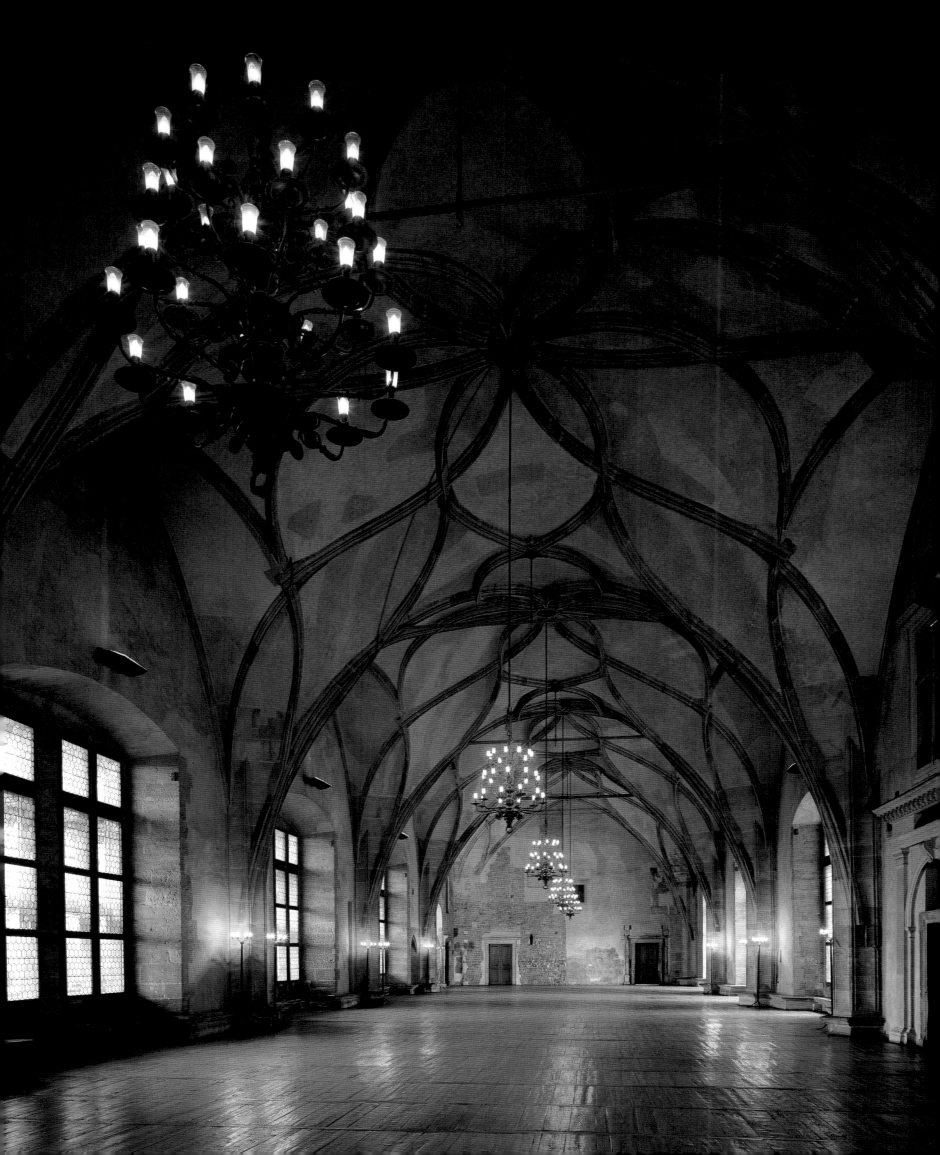

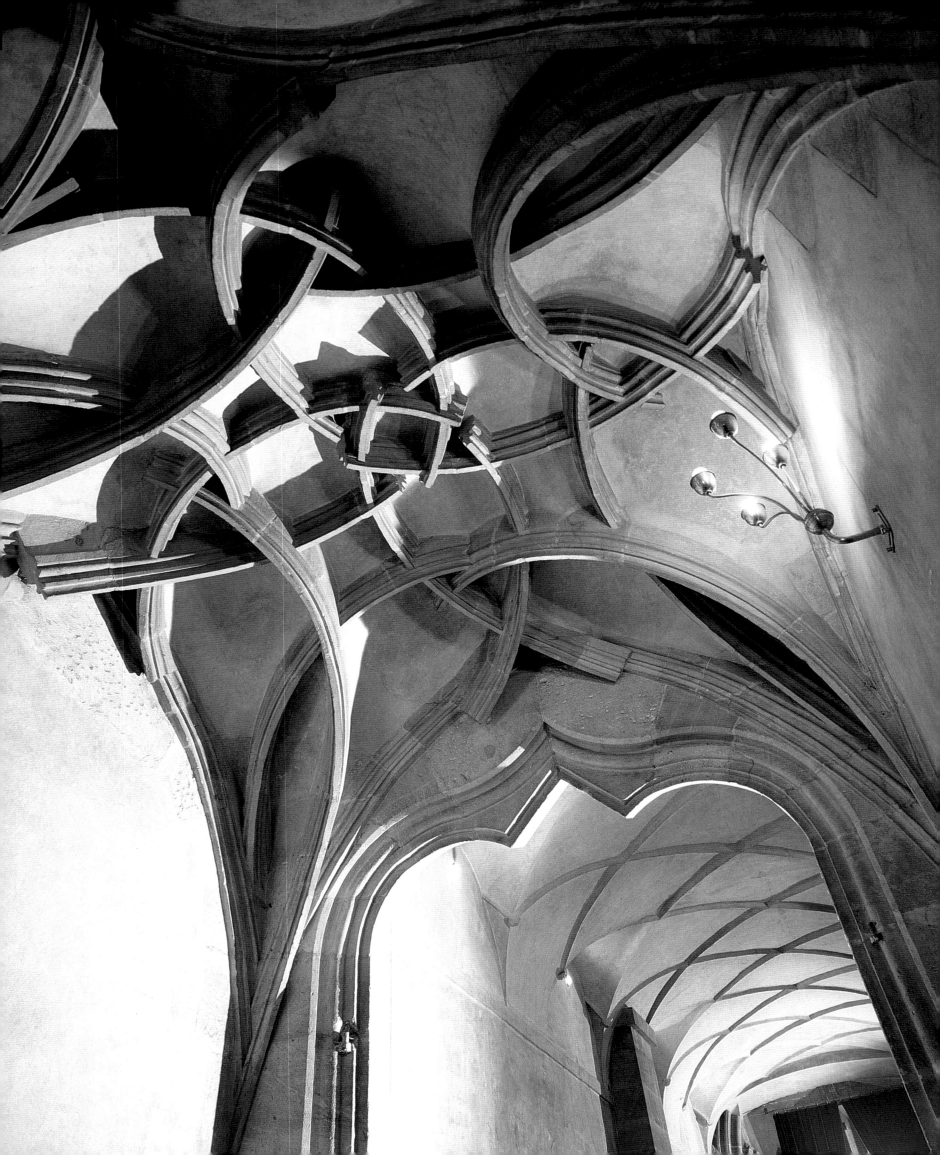

Fresco: on the second storey of the
White Tower, where Rudolf II had his
armoury, Bartholomeus Spranger painted
a fresco reflecting the function of the
place, namely the armed Minerva with
Mercury.

During his reign Prague and its castle not only became the heart of the Holy Roman Empire but also a cultural centre of exceptional importance. Karel van Mander, painter and theorist, and one of the guests of the social and cultural court entourage, wrote in 1604: 'Whoever aspires today to do anything great need only come (if he can) to Prague, to the greatest patron of the contemporary world, the emperor Rudolf II; he will see there, in the imperial residence, as in the collections of other great art lovers, an extraordinary number of excellent and precious things, special, unusual and beyond price.'

Rudolf initiated the new architectural activity in 1576 by commissioning the Royal Steward's House, next to the White Tower. During the 1580s he gradually developed his idea of transforming Prague Castle into a royal residence comparable to the Spanish Escorial, but his grandiose scheme was only partly realised. A new and very spacious wing of the palace was started in 1589 on the north side of the castle and was not completed until the early 1610s. It is not known who was the principal designer. Apparently a succession of Italian artists and craftsmen in the emperor's service played a part in it: they included the Florentine architect Giovanni Gargioli (d. 1585), the stonemason Giovanni Antonio Broca and the architects Giovanni Maria Philippi, Martin Gamborina and Antonio Valladra de Codero. The ground floor of the new wing served as stables for the Spanish stud horses; above were large rooms, one of which was named the Spanish Room, while another became the Rudolf Gallery, designed to house the royal art collection. Even though Rudolf was unable to carry through his plan to build a monumental edifice comparable to the Escorial, the new wing was nevertheless one of the most sumptuous buildings of its kind in Central Europe, thanks largely to its interior decorations by the eminent court sculptors and painters, Adriaen de Vries, and Hans and Paul Vredeman de Vries. Unhappily, in the 18th and 19th centuries this wing was refurbished in such a

manner that, apart from the entrance door and some of the engravings, nothing remains of its original décor.

The uncertainty as to which architects and craftsmen were responsible for the royal building activities during the reign of Rudolf II is in some measure due to the very fact that so many were employed on the castle, then enjoying such extraordinary pre-eminence as a centre of learning and culture. One new and unusual feature was the so-called 'mathematical' tower, which was fashioned from the old episcopal tower and provided with an interior spiral staircase, a project inspired by the theory and example of Andrea Palladio and Vincenzo Scamozzi. This tower was subsequently demolished in the course of the reconstruction of the central part of the castle under Empress Maria Theresa in the 1770s.

After the reign of Rudolf II, Prague Castle no

longer enjoyed the pride of place and favour accorded it by an emperor renowned for his interest in the arts and sciences. Although the new emperor, Matthias II, who succeeded his brother in 1611, continued the building work initiated by Rudolf, using architects who had already seen service at the castle or who had been drawn to Prague by the reputation of the court, the years of glory had departed. Among the visitors who now came to Prague was the remarkable Venetian architect Vincenzo Scamozzi, to whom the new building work in the west wing was originally, though incorrectly, attributed. Matthias planned this wing as a link, on the south side of the castle, between the royal apartments and the Spanish Room. Another of his initiatives was the gate on the western side of the castle, which effectively ended Rudolf's dream of a palace with a frontage extending almost to Hradčany Square. Dynamically heightened to accommodate the carriageway, and featuring a dramatic series of architectonic elements, this gate is the first example of Bohemian Early Baroque. Indeed, the local saying that Baroque in Bohemia entered by way of the Matthias Gate seems fully justified.

During the first decades of the 17th century, which saw the onset of profound cultural and political changes in Europe, Prague Castle was notable as one of the earliest sites to be affected by the Baroque style. More dramatically, it was the place where a political and religious crisis flared up, with the defenestration of the Catholic nobles Martinic and Slavata on 23 May 1618. As a result of ensuing political developments, with Catholicism sweeping the country, Prague Castle lost its capital position in European politics and art. As the crisis of the Thirty Years' War erupted, construction work on the castle came to a virtual halt, and the important collections that had made the castle one of the most remarkable places of the age were dispersed.

PRAGUE CASTLE, POLITICAL AND ADMINISTRATIVE CENTRE OF COUNTRY AND STATE: FROM REFORMED MONARCHY TO DEMOCRATIC REPUBLIC

It was not until the middle of the 18th century that Prague Castle once again came to play a key role in the plans of imperial Vienna and emerged as one of the political centres of the Habsburg monarchy. In 1755, Empress Maria Theresa sent a communication to the council of the Czech governor, issuing the order 'to transform, reconstruct and furnish our royal residential castle, so that it can be comfortably inhabited, in our Czech city of Prague'. Once the decision had been taken to make more frequent use of the castle, the services to be provided clearly had to be in keeping with the living standards and administrative needs of the imperial court.

Ceiling: in certain parts of the central wing, beamed ceilings have been preserved. They date from 1640, as is testified by the monogram of Ferdinand III on some of the beams. At the time this part of the castle was called "the wing of the Ladies' Bedchambers".

These were the considerations that now determined the nature and style of the rebuilding programme

Under the direction of Niccolo Pacassi, the architect of the Viennese imperial court, the work began in 1755 with the construction of the south wing which led from the old Royal Palace to the Hradčany quarter. In 1759 the western part was tackled, linking the new south wing to the north wing built under Rudolf. The work terminated with the construction of the wing connecting the northern and southern parts of the palace — the heart of the building that effectively divided the central courtyard into two sections. In extending the south and north wings towards the Hradčany quarter, Pacassi also created an additional courtyard eminently suitable for court ceremonial. The First Courtyard is still used today for special occasions. Visually and spatially, it was a small but welcome apendage to the overall structure of Prague Castle as devised by Paccasi, for the architect's plans completely sacrificed the picturesque variety of the castle buildings. Pacassi modernised the castle from top to bottom, applying a uniform pattern to the façades. The scheme he adopted was strictly horizontal, with deliberate repetition of window and mullion elements, a far cry from the verticality and diversity of the former buildings, many of which dated from the Middle Ages or rested on medieval foundations.

It was Anselmo Lurago who carried out Pacassi's plans, aided by Anton Kunz, who had come from Vienna. In 1766, on Lurago's death, Kunz assumed control of the work and, on his own death in 1769, its direction was entrusted to Antonín Haffenecker, who completed the project in 1755. A number of Prague artists and craftsmen were involved: stucco workers, cabinet-makers, carpenters, painters and sculptors. The sculptor Ignác F. Platzer made an important contribution: he created the statues of the *Fighting Giants* flanking the piers of the entry gate of the First Courtyard, facing Hradčany Square. Pacassi's achievement was to have transformed Prague Castle into a centre responding perfectly to the requirements of the country's new administration. The castle was now an ideal place from which to exercise tutorial and, in due course, state policy.

Pacassi's uniform style introduced a new dimension to the architecture of Prague Castle, to which all earlier architectonic schemes on the site had to accommodate. The subsequent 19th-century alterations and additions were centred principally on the sacred buildings and, with the exception of the Chapel of the Holy Cross, the castle site itself remained untouched. Czech society was meanwhile undergoing radical change, influenced by the interconnected concepts of rationalism and national renewal, but even more by the country's economic development. Expansion of the capital brought hundreds of thousands of new inhabitants to Prague, and the many buildings needed to accommodate them completely transformed the face of the city. Yet Prague Castle, with its Baroque outlines, still looked down, unaltered, from its hill, ever the symbol of administrative centralism.

With the birth of the Czechoslovak state in the 20th century, it was felt that the fortunes of Prague Castle needed to be integrated with the life of the Republic. This was immediately recognised by the first president of the Czechoslovak Republic, Tomáš G. Masaryk, elected on 14 November 1918. In his philosophical and sociological works Masaryk had roundly criticised the alienated culture of modern times, justly condemning this tendency as represented by many features of Pacassi's architecture. With a view to giving democratic life and meaning to Prague Castle, Masaryk envisaged certain essential developments. In the course of his search for someone to undertake the task, Václav V. Štech, professor of art history, and Jan Kotěra, professor of architecture, introduced him to the Slovenian architect Josip Plečnik.

Plečnik, without doubt the most gifted student of Otto Wagner's school in Vienna, was already familiar with Prague, where he had successfully directed, since 1910, the architectural studio of the School of Decorative Arts. Masaryk recognised in him a man

whose conception of art was extraordinarily akin to his own: both of them saw art as an essential component of life and longed to restore to it the status it had enjoyed during the period when the humanist tendency of European culture found expression in Greek classicism. Just as, for Masaryk, the work of the ancient Greek philosophers and, above all, of Plato was the source of his philosophical thinking, centred as it was upon the constituents of modern alienated culture, so, too, the classic elements of Greek and Mediterranean architecture had become the fundamental motifs of the work of Plečnik who, rejecting contemporary conventions, resorted to earlier styles as the inspiration, well in advance of his time, of his 20th-century architecture.

In 1920 Masaryk appointed Plečnik architect of Prague Castle and charged him with the replanning of the courtyards and surroundings. The president's spiritual legacy was to be formulated in the clearest terms in a testament of 1925, in which he recapitulated the key elements of his thinking, explained his choice of Plečnik and the directives he gave the latter for his work at the castle: 'I wish Professor Plečnik to be the builder of the castle and to take decisions on all the necessary repairs and alterations... the layout of the gardens and also the new buildings there... I wish the work done at the castle to be an example for the nation, both in its careful preparation and its reasoned approach, and in its choice of good materials and the excellence of its accomplishment. The overall programme should be carried out with due consideration and in stages... The reason for establishing these criteria is to make the castle the residence of a democratic president; all the appointments of the castle, both inside and outside, should convey a sense of simple, yet artistic nobility, symbolising the ideas of independence of the state and of democracy... The people look on the castle as a national concern and for that reason not only presidents, but also governments, should be interested in seeing the transformation of a castle that was planned and built from a monarch's standpoint into a castle that is truly democratic.'

Masaryk discussed his ideas about the castle both directly with the architect and through the intermediary of his daughter Alice. Once these ideas were jointly agreed, Plečnik proceeded to express them in the clearest and most cultivated architectural terms. His plans related both to the inside and outside of the castle.

Shortly before his official appointment as castle architect, Plečnik had made a study of the Paradise Garden, adjacent to the south front of the building, and it was here that he began his work. He suggested altering the lie of the land, without affecting the building that overlooked the garden. The changes he introduced to this corner of the castle, previously hemmed in and of comparatively little interest, converted it into an area of striking originality, one of the first to be encountered by visitors approaching the castle from Malá Strana. Plečnik boldly opened up the garden, setting a gate in the old surrounding brick wall and exposing the slope of the terrain; to give access he provided the monumental staircase that was to become its most remarkable feature. He planned to connect the garden with what remained of an abandoned landscaped park, with its shrubs and trees, by setting up various symbolic objects, notably an obelisk near the steps and an enormous granite vase in the lower part of the garden. Even though the obelisk idea never came to fruition, the staircase was to constitute the garden's key architectonic element, affording splendid views of the castle, the lawns and the city. The garden was completed in 1924, at the same time as a neighbouring garden, located a little to the east, known as the Ramparts Garden. If the Paradise Garden, with its simple yet masterfully realised forms, conveyed an impression of space, with the panorama of town and castle symbolically framed by huge vases, the Ramparts Garden incorporated various architectonic themes characteristic of the city, accentuating the links between town and castle.

The Ramparts Garden begins with a small parterre in the middle of which Plečnik placed a Baroque fountain taken from the Paradise Garden.

The garden extends eastward by way of a level path, encompassing a narrow, geometrically divided area with a long view from the Baroque fountain to the eastern ramparts. The lengthwise section described by paths running from east to west is intersected at right angles by other paths leading to pavilions and terraces that offer interesting viewpoints of Prague. To emphasise the interrelationship of town and castle, Plečnik lowered the level of the surrounding wall to reveal the gardens lying below the ramparts. It was from this point of the ancient bastions that he provided spectacular views of the dominant buildings and landmarks of Prague, exploiting the natural beauty of the city as an inherent feature of the garden itself. Thus, for example, the semicircular terrace in the centre of the garden affords a commanding view of St Nicholas's Church in Malá Strana. The church can also been seen along the axis of the staircase which leads from the Third Court into the garden through a boldly columned doorway — yet another feature underlining the historic links between the castle interior, the garden area and the town. This semicircular terrace is an eye-catching feature, both horizontally and vertically, of the garden plan, its position highlighted by the adjoining obelisk.

The singular arrangement of the individual constructions in the Ramparts Garden transforms its geometrical structure into a living and evocative architectonic ensemble. In addition to panoramic pavilions, balustrades, colonnades and pergolas, Plečnik gave pride of place to various symbolic objects, such as the columns, obelisk and pyramid, intended to reinforce the spiritual significance of the castle and its place in history. One monument, for example, recalls the site of the historic defenestration of Martinic and Slavata in 1618. And among the exceptional buildings of the garden are the Bellevue colonnade, the panoramic summer house and the Moravian bastion. Each is unique, not only because of its positioning, but also for the original conception of its elements, the happy choice of its constituent materials and its ideological integration

into the overall scheme. Classic architectonic motives are here transformed and integrated with exquisite aesthetic sensibility.

The Paradise Garden and the Ramparts Garden linked the south face of the castle and the city in a novel manner. The doors of this sealed monolith of a building were literally flung open, thanks to the new access to the gardens, and the gardens themselves now formed a panoramic link with the historic city monuments in the immediate vicinity of the castle. For the rest, Plečnik's primary aim was to do away with the barracks-like uniformity which characterised the castle courtyards and interiors.

In 1921 he was offered and accepted the chair of architectonic composition at Ljubljana University. From then on he planned all his work during alternate stays in Prague and Ljubljana and through an exchange of correspondence with the president, his daughter Alice and his friends, including Jan Kotěra. The associations of Plečnik with Ljubljana seem to have reinforced the Mediterranean character of his work, as well as his expressive originality and individuality. He was conspicuously successful in applying the tasteful, cultivated southern European tradition to the space at his disposal. In his subsequent changes to the castle interior, Plečnik never lost sight of the surrounding areas, aiming at an interpenetration, at once spatial and ideological, of the enclosed block of buildings, the courtyards and the gardens.

Plečnik's reconstruction of the First Courtyard consisted essentially in repaving it and adding two flagpoles, 25 metres (82 ft) high, placed in front of the Matthias Gate. The alterations to the Bastion Garden, carried out from 1927 to 1930, were of greater significance. Plečnik built a new passage from the Second Courtyard into this garden, and enclosed it with a wall intended to effect a transition between the Late Baroque style of the Archbishop's Palace and the modern atmosphere he had created in the garden. This time, showing considerable inventiveness, he designed two semicircular flights of steps, one convex, the other concave, linking the

two garden levels. At the front of the garden, facing Hradčany Square, he contrasted the stylised greenery of the existing conifers with the natural informality of the Stag Moat: the garden was joined to the moat by arcades, above which a railed path led over sloping ground to the Masaryk panorama, itself a new garden feature.

The refurbishing of the castle's three courtyards was a particularly challenging task. Plečnik gave a feeling of unity to all three by applying a geometrical structure to the pavements, and by using fairly large granite flagstones, the identical dimensions of which helped to create an overall impression of spaciousness and deliberate significance. For the flags, he utilised materials from different parts of the country, avoiding monotony thanks to the subtle colour nuances of the stone which enliven the whole composition and suggest yet another symbolic link between the castle and the various regions of the Republic.

The work carried out in the Third Courtyard of the castle (situated between the south wing of the Royal Palace, the perpendicular main building and the cathedral) was particularly arduous. There, too, Plečnik provided a link with the garden via a staircase, in the form of a closed pergola, emerging at the east corner of the courtyard. In the foreground, he introduced two objects of particular interest: at the corner of the Old Provost's Lodging he set up a granite monolith, 16 metres (52 ft) high, in memory of the Czechoslovak Legions and in honour of the democratic republic, and to the east of this monolith he set up a fountain, in the form of a Gothic equestrian statue of St George and the dragon. The fountain, on a massive block of granite, stands off-centre to the rectangular water basin beneath; and this, in turn, is placed off-centre to the circular railing that surrounds it. The monument testifies to Plečnik's masterly skill in combining selected materials (bronze, stone and water) to create a composition which observes the principles of asymmetry and harmony, which achieves a balanced horizontal and vertical division of space, and which constitutes, in every detail, a pure work that in its materials and motifs is unashamedly respectful of historical tradition.

Inside the castle Plečnik embarked on a major project which was continued by his talented pupil Otto Rothmayer and by Pavel Janák, the immediate successor to Plečnik as architect of Prague Castle.

In some places, Plečnik did away with the separate levels which, in Pacassi's alterations, implied a distinction between the life of the imperial court and the administration. His most radical achievement was the building of the Hall of Columns in the west wing of the palace, facing the passage situated behind the Matthias Gate. It was here that Plečnik gave clearest expression both to the democratic idealism of the new state and to his own temperament and personal credo. He unified the verticality of the room with three superimposed horizontal rows of columns, set inside the enclosing wall of the palace. This balanced and dignified composition, so characteristic of southern classical architecture, was very rare in a Czech environment loyal to its Baroque tradition. The harmony of the colonnades was enhanced by the innovative use of a classical motif on the front wall, in the form of columns, an arch and a round window directly above.

Plečnik's plans, approved by Masaryk, for the private apartments and the library of the president were likewise attuned to the needs and tastes of a head of state who was imbued with the ideals of democracy and freedom.

In the block of buildings situated in the south wing of the castle, Plečnik found further opportunity to make a link between the presidential apartments, the courtyard and the garden. His solutions for the inside passages of communication and, in particular, the access corridor to the staircase and the lift were particularly ingenious. The lift and the spiral staircase surrounding the lift-shaft were likewise exceptional achievements. Plečnik placed the steps inside a barrel vault, the structure of which, like that of the walls, was thrown into relief by white pointing. It was a remarkably inventive example of a

geometrically structured curved surface in space, demonstrating, as in all his work, a thorough appreciation of the emerging principles underpinning an apparently simple construction.

Plečnik paid just as much attention to the reception rooms of the presidential apartment, particularly to the inner vestibule, situated beneath a light well deriving from an ancient skylight at the point where the wings of the historic palace intersected. He made no attempt to conceal the original purpose of this area: on the contrary, he emphasised it by making it the focal point of his new scheme. He covered the skylight of the vault with glass tiles, complementing the curvature with arches dividing the hall into sections, and placing directly below the well, in the centre of the room, a table with a vase full of water, its surface artificially lit. Thus the presidential apartment was furnished with a traditional motif of a Roman house — an atrium complete with impluvium — harmonising perfectly with its modern setting. And in his work on other parts of the private apartments and offices at Prague Castle, Plečnik displayed a similar insight into the values of past and present, with equally happy results.

Plečnik remained at Prague Castle only a little longer than the Republic's first president. In 1935 T.G. Masaryk resigned the presidency and in 1936 a new architect for Prague Castle was appointed, namely Pavel Janák, who had succeeded Plečnik to the chair of architecture at the School of Decorative Arts. In his study on Plečnik, Janák expressed respect for the extraordinary work of his predecessor and appreciation of the values that his inventiveness had brought to 20th-century architecture: '... [Plečnik] does not subscribe to the customary definitions and conventions of space or form; but impelled by deep inner feeling, he arranges his columns, his pillars and his materials, which are at once simple and innovative, in a manner that is strikingly original, yet wholly authoritative. He is in no sense a romantic classicist, but a complete man of his time, who has to justify everything to himself, to create everything.'

The true successor of Plečnik at Prague Castle, however, was not Janák, but Plečnik's pupil and colleague Otto Rothmayer. Having collaborated with Plečnik, Rothmayer was sufficiently in tune with his teacher's ideas and objectives to pursue the work in the same spirit, notably by reinforcing the bonds between the castle, the gardens and the city. Thus he built a graceful spiral staircase to link the Ramparts Garden with the Vladislav Hall. The staircase was placed against the wall of the south rampart, on a projection contiguous to the Vladimir Hall. Between 1947 and 1950, again using Plečnik as his model, Rothmayer designed and built a large hall in the west wing and a corridor joining this room to the historic areas of the castle's south wing. At the point where the corridor crossed the room, he set up two Ionic columns, clearly based on Plečnik's use of classic elements in a modern architectural context. Yet Plečnik's concept of architecture, as reflected in all his work, was unshackled by modern conventions. The judgement of the Czech architect Otakar Novotný puts it succinctly: 'In fact, Plečnik was opposed to all modern architecture. He was one of Wagner's best pupils, but it was in himself that he found true mastery, in his deep religious conviction, in his inflexible sense of truth and beauty...'

At Prague Castle, Rothmayer provided Plečnik's work with an epilogue worthy of his genius, fulfilling his teacher's ambition to revalue a thousand years of architectural tradition. Paradoxically, his work coincided with a period, from 1948 and for some forty years, when the ideals of democracy were silenced throughout the country, and all attempts to find meaning and inspiration in the new architectural heritage of Prague Castle were repressed. Today, once more, the castle is the object of appreciation, assessment and study. Its historic and recent achievements, particularly the work of Plečnik, are a challenge to the architecture, the art and the culture of the 20th century.

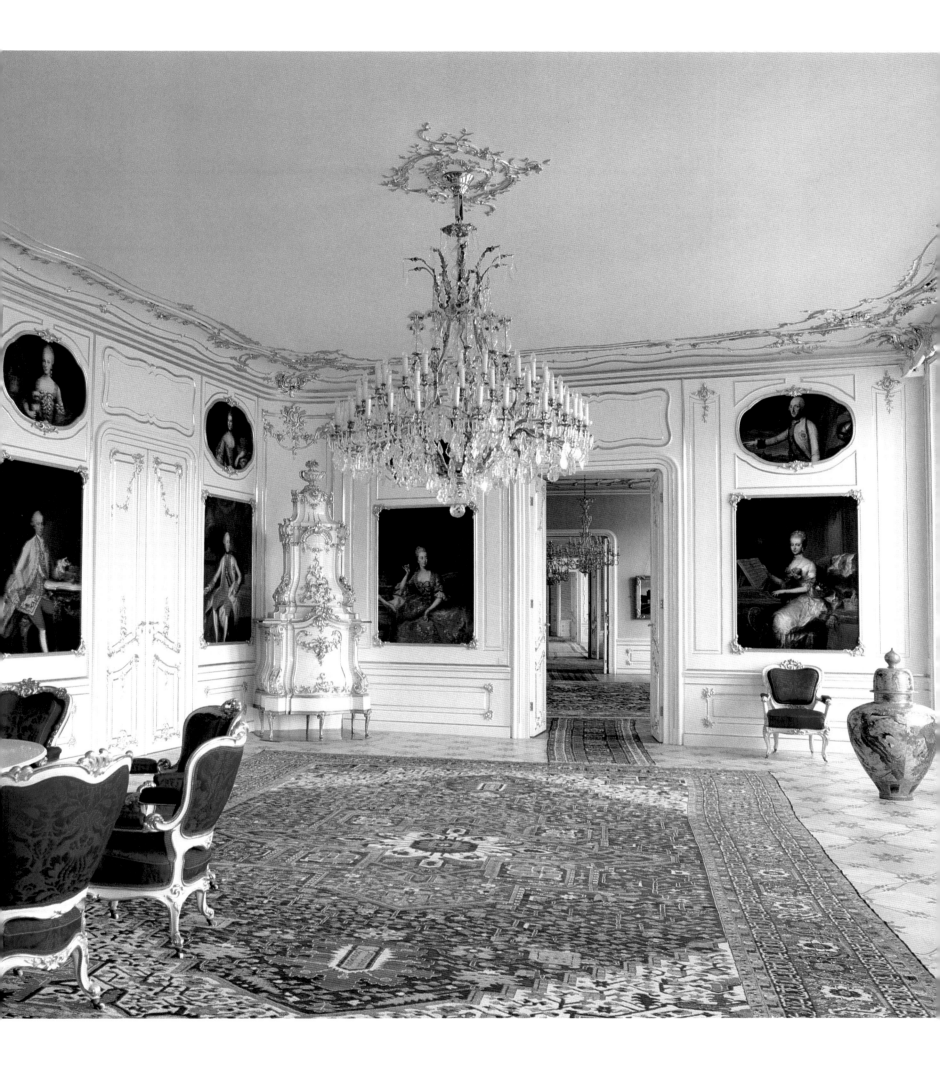

THE HABSBURG ROOM

Preceding and opposite pages: in all the royal residences or nobles' castles, one room was always devoted to ancestors. In Prague Castle, on the first floor of the south wing, there is a gallery of this nature, relatively restrained for its period, comprising twenty-two portraits of the family of Empress Maria Theresa, whose own portrait was given place of honour in the centre of the main wall. On her right is her husband, Francis of Lorraine, and on her left, her son Emperor Joseph II. The other large paintings (which from their style may be attributed to the court portraitists Martin van Meytens and Johann Karl Auerbach) are of the sons and daughters of the empress, each surmounted by a smaller portrait of their spouse. There are

also portraits of Maria Theresa's brother and sisters, hung between the windows, and two of children, one (above) of her grandson (1768-1835), who was to become emperor in 1792 under the name of Francis II (last ruler of the Holy Roman Empire). In order to enliven this series of portraits, some people are shown with the instruments of their hobby: Marie Caroline, future queen of Naples, holds painting implements, the Archduchess Marie Elisabeth sits at a spinet, etc. These portraits also constitute valuable historical and cultural documents inasmuch as they reproduce royal crowns, insignia of orders and various kinds of costume ornamentation.

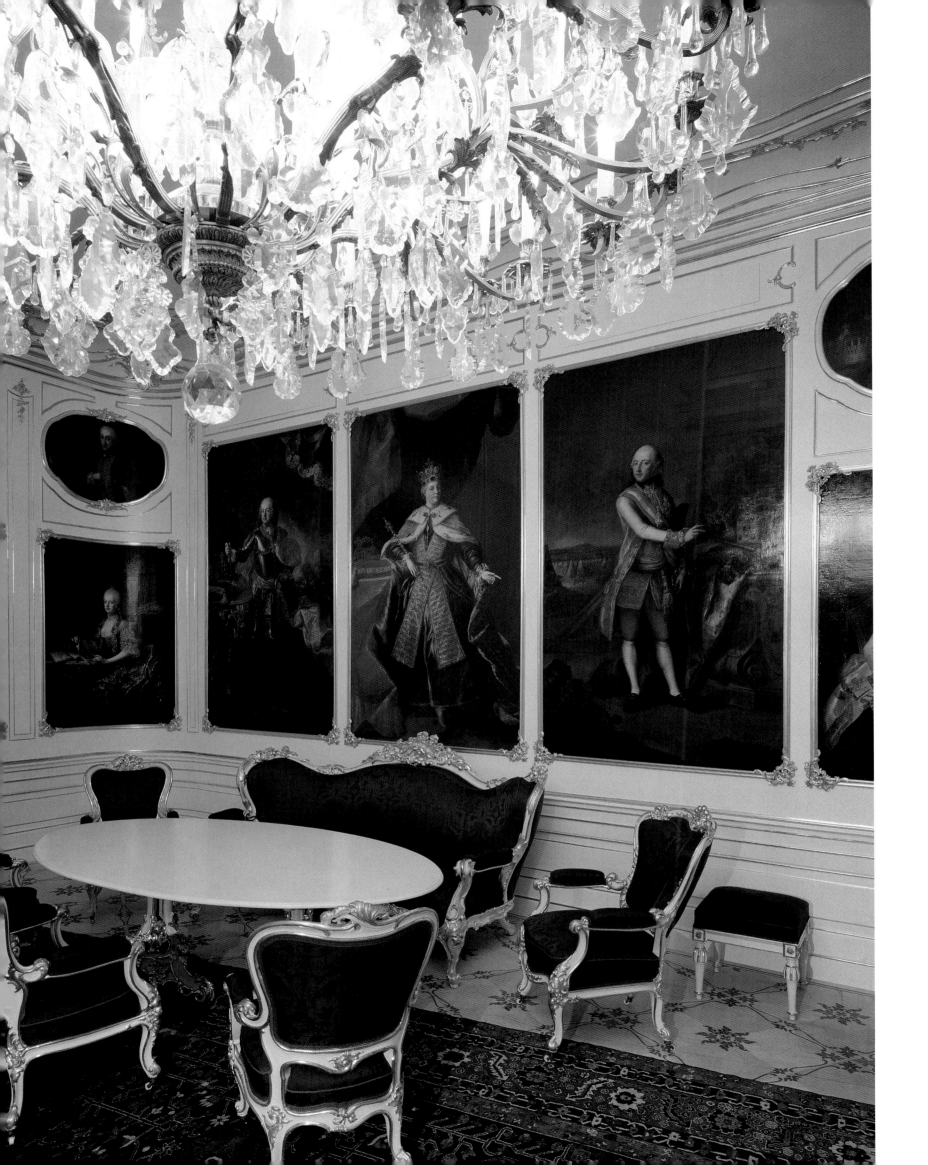

THE BROŽIK ROOM

In the many reception rooms on the first floor of the castle's south wing (reached by a staircase situated the Matthias Gate) two principal features are found: firstly, stucco decorations on the walls and ceilings (some

from the time of Empress Maria Theresa and others completed in the 19th century) as well as furniture, all modelled on the interiors of the Schönbrunn Palace, which combine to give an impression of stylistic unity; secondly, certain objects of an individual nature which serve to differentiate the various rooms. Thus, the main drawing room is distinctive for an immense painting by Václav Brožík, done in Paris in 1878, with a historical subject: the mission of the Czech king, Ladislav Posthumus, to the court of the French king, Charles VII. This picture, originally in the imperial gallery in Berlin, was bought for Prague Castle in 1922 and has been hanging in its present position since 1938.

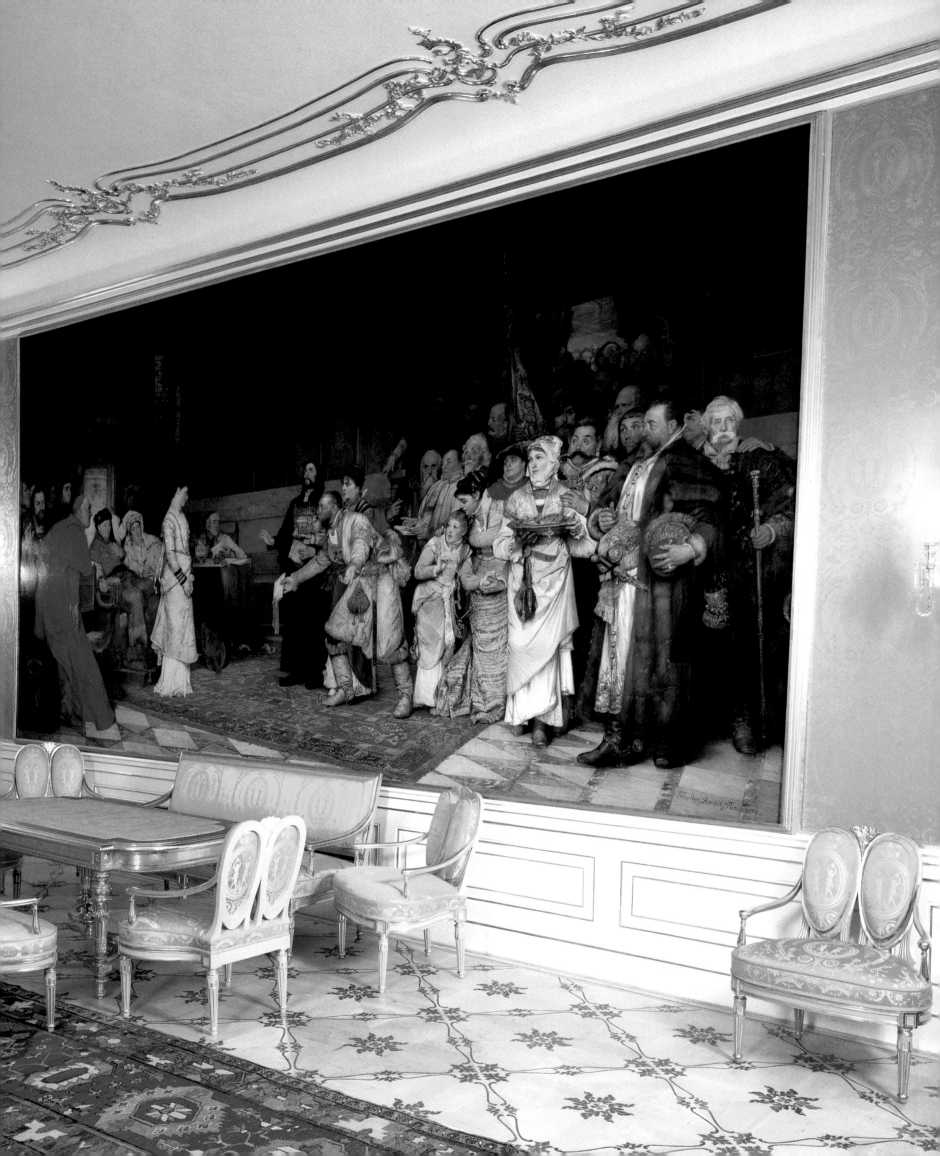

The music room, its contours following those of the building, is one of the reception rooms designed by the court architect, Niccolo Pacassi, for the south wing of Prague Castle. In a niche is a copy of Matyaš Bernard Braun's sculpture, *Night*. The Rococo faïence stove is part of the original furniture.

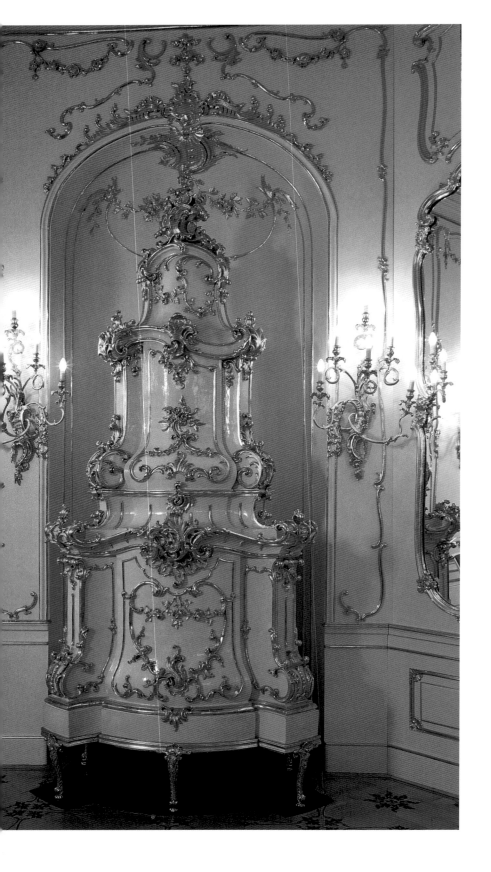

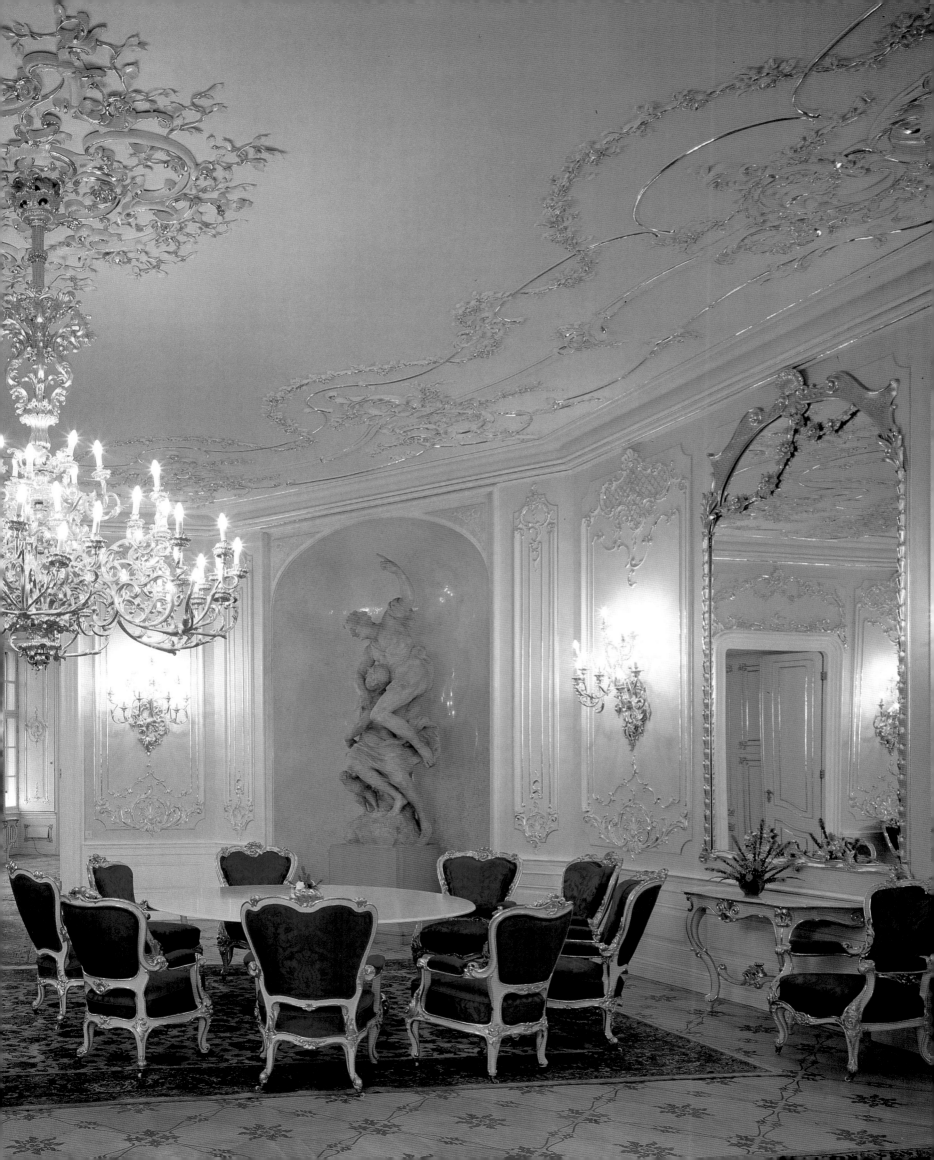

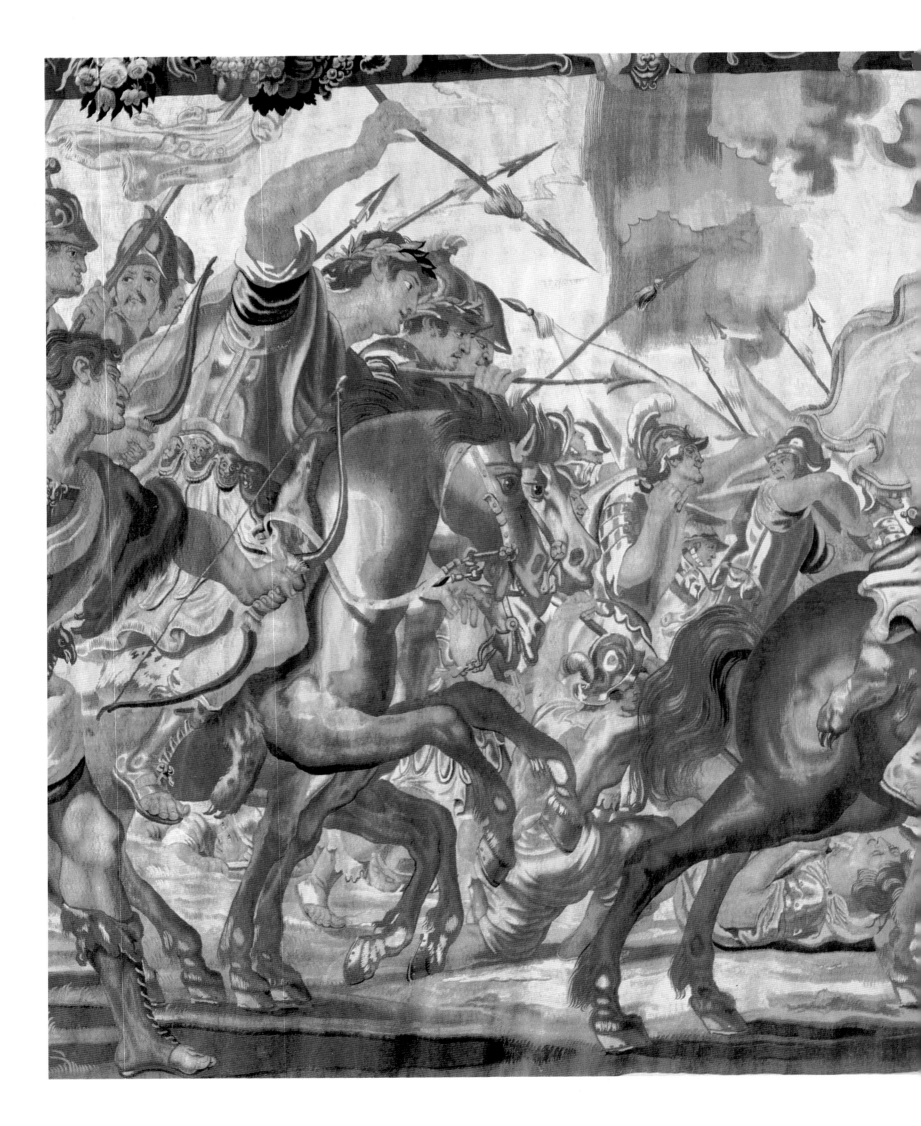

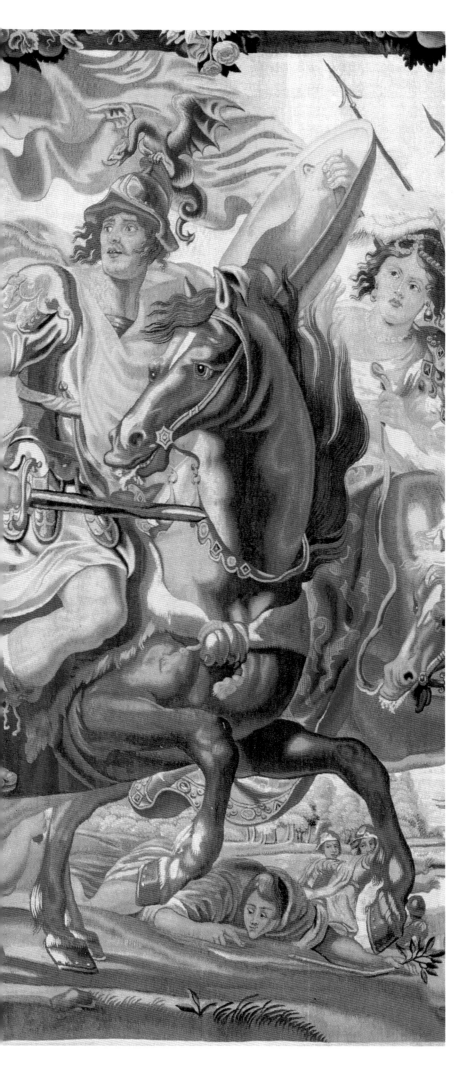

Space on the first storey of the central building: this is one of the few areas of the old Renaissance palace that has been preserved, or rather reconstructed. It served as a passage between the king's private apartments, which extended from the south wing of the castle overlooking the town to the central or perpendicular wing containing the arts room and the corridors transformed into a painting gallery. The various bays of the vault are accentuated by the unobtrusive but artistically effective ornamentation of astragals.

Left: *tapestry of the Antony and Cleopatra cycle.* Certain series of tapestries from the Early Baroque period — notably those originating in the Brussels factories of celebrated tapestry makers like Geraert Peemans, Jan van Leefdael and others, devoted to subjects popular at the time, such as the different parts of the world, the months of the year, etc. — give some idea of the extraordinary quality of the original castle tapestries. They were subsequently dispersed, either because of the fortunes of war or because they were transferred to the imperial court in Vienna. The series of seven tapestries in the Antony and Cleopatra cycle, made around the middle of the 17th century by Jan van Leefdael and Geraert van der Strecken, includes this *Battle Under the Ramparts of Alexandria*.

97

THE GALLERY OF RUDOLF II AND THE SPANISH ROOM

Concealed behind the monotonously uniform façades of the castle's Second Courtyard are interiors quite different in character: the southern part was reserved for the private apartments of the king (and also for President Masaryk), while the north wing was used for exhibiting collections and, after these were dispersed, for official celebrations. This is more obvious on the north side of the castle, where the large windows of Rudolf II's Gallery open in a semicircle overlooking the Stag Moat. The emperor had this room built in 1597-8 as a picture gallery, but the present neo-Renaissance restoration, to the designs of Heinrich von Ferstel, dates only from 1866-8.

Pages 99-101: In the time of Rudolf II, the largest chamber, the Spanish Room, was devoted to the exhibition of sculpture. The statues were placed not only in the room itself, then divided by columns, but also in the niches, now hidden by large mirrors, in the south wall. From this period all that remains is the stucco decoration to be seen in the spandrels above the niches and windows and on the frieze that surrounds the room. As in Rudolf II's Gallery, most of the refurbishing was done in 1866-8, based on the designs of Ferdinand Kirschner, assisted by the court sculptor, Auguste le Vigne. Today this room has two functions: it is used by the president of the Republic for occasions of protocol (for example, the signing of a treaty with Germany in 1992), and it is thrown open to the public for concerts, conferences and social gatherings.

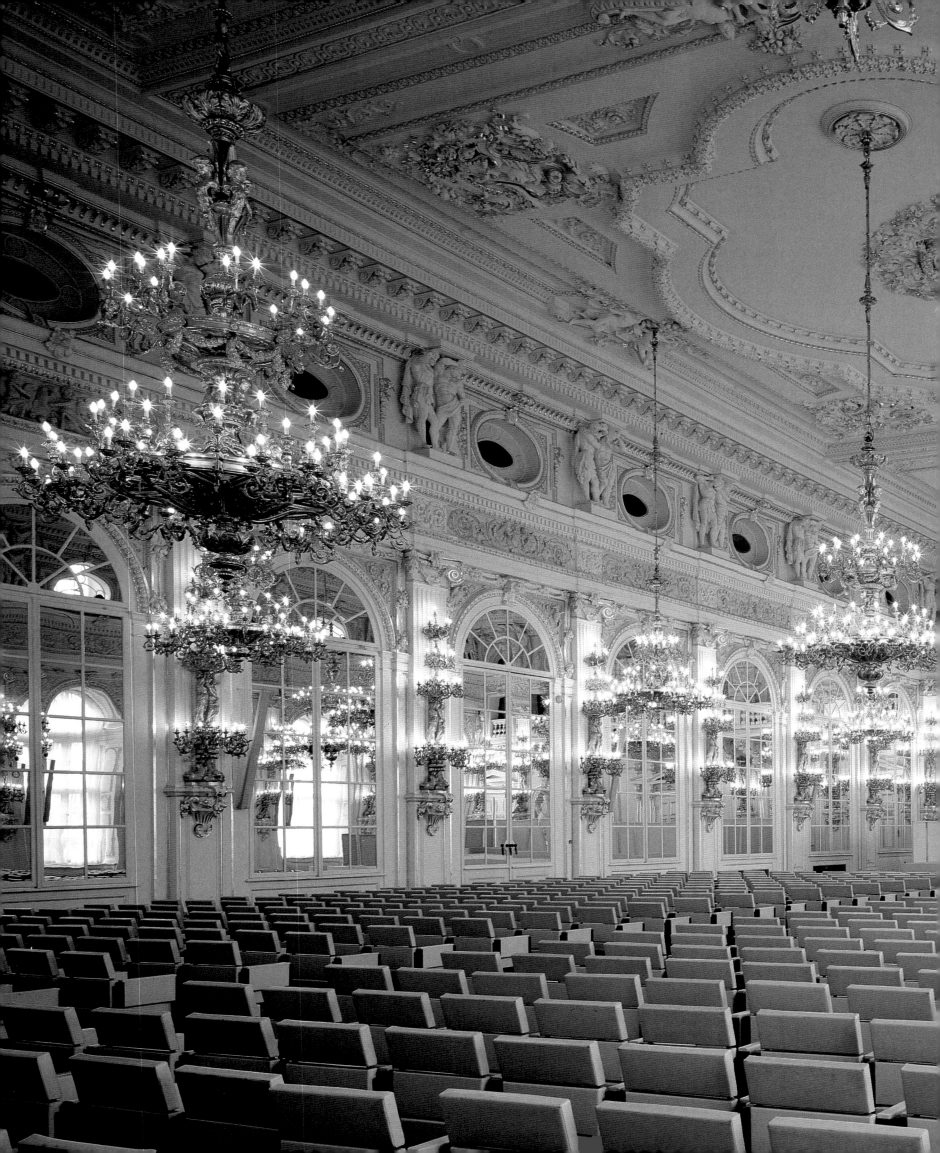

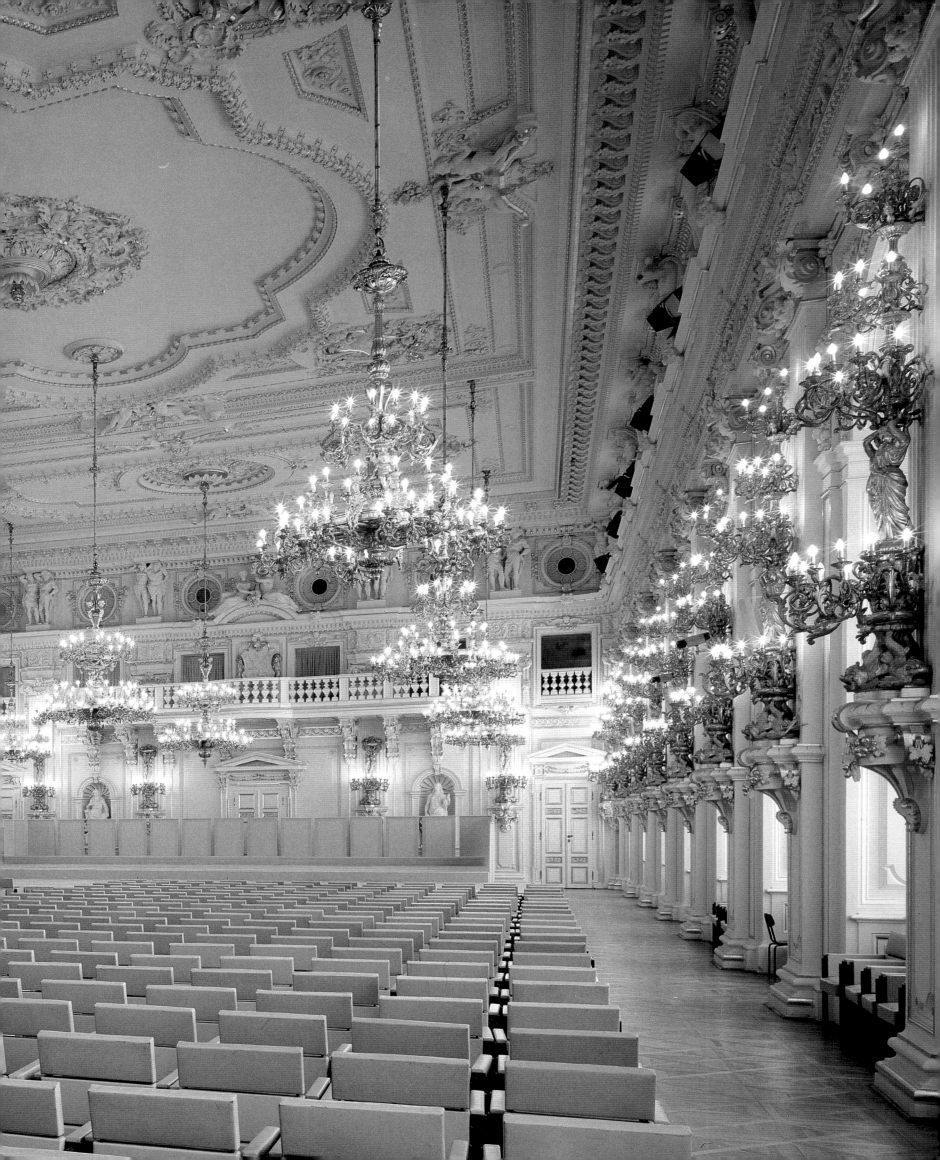

PLEČNIK'S HALL OF COLUMNS

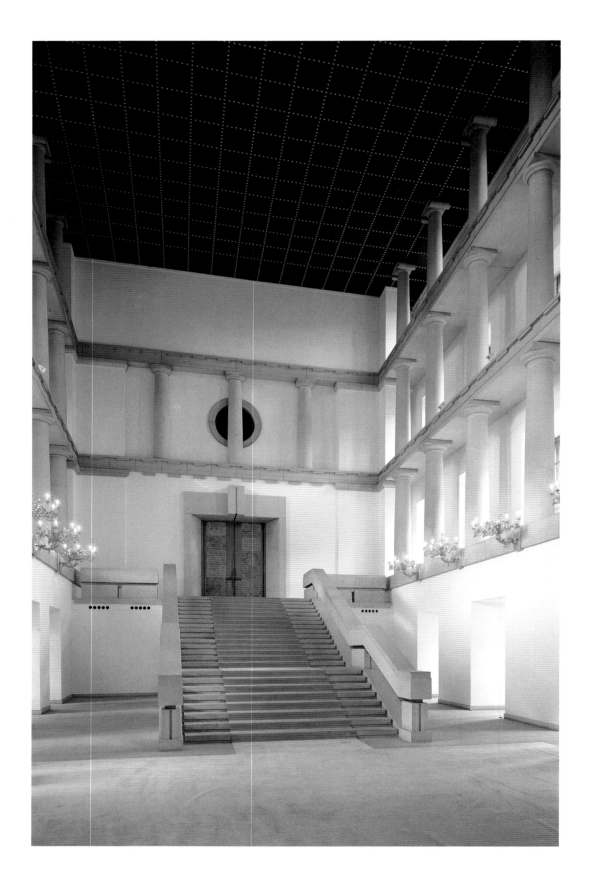

This room was created in the perpendicular wing between the First and Second Courtyards and linked by a passage to the Matthias Gate. Plečnik removed Pacassi's interior floors to make an immense hall which would constitute an official entrance to the castle and stand as a symbol of the new democracy. By using three superimposed rows of columns with Ionic capitals, Plečnik divided the height and created a harmonious combination of vertical and horizontal lines, directing the eye upward. The architecture expressed Masaryk's endeavours to achieve a creative linkage between the modern Republic and its classical cultural heritage. The monumental columns, placed at the point where the hall (which extends to the wing situated behind it) intersects with the corridor, form, as it were, an epilogue to the ancient dream that is linked, here in the castle, with the names of Tomáš Masaryk and Josip Plečnik. The columns were designed by the architect Otto Rothmayer, who succeeded Plečnik at the castle and, ironically, completed the work in the 1950s, at the very moment when the democratic ideals of the First Republic were smothered by the totalitarian Communist regime.

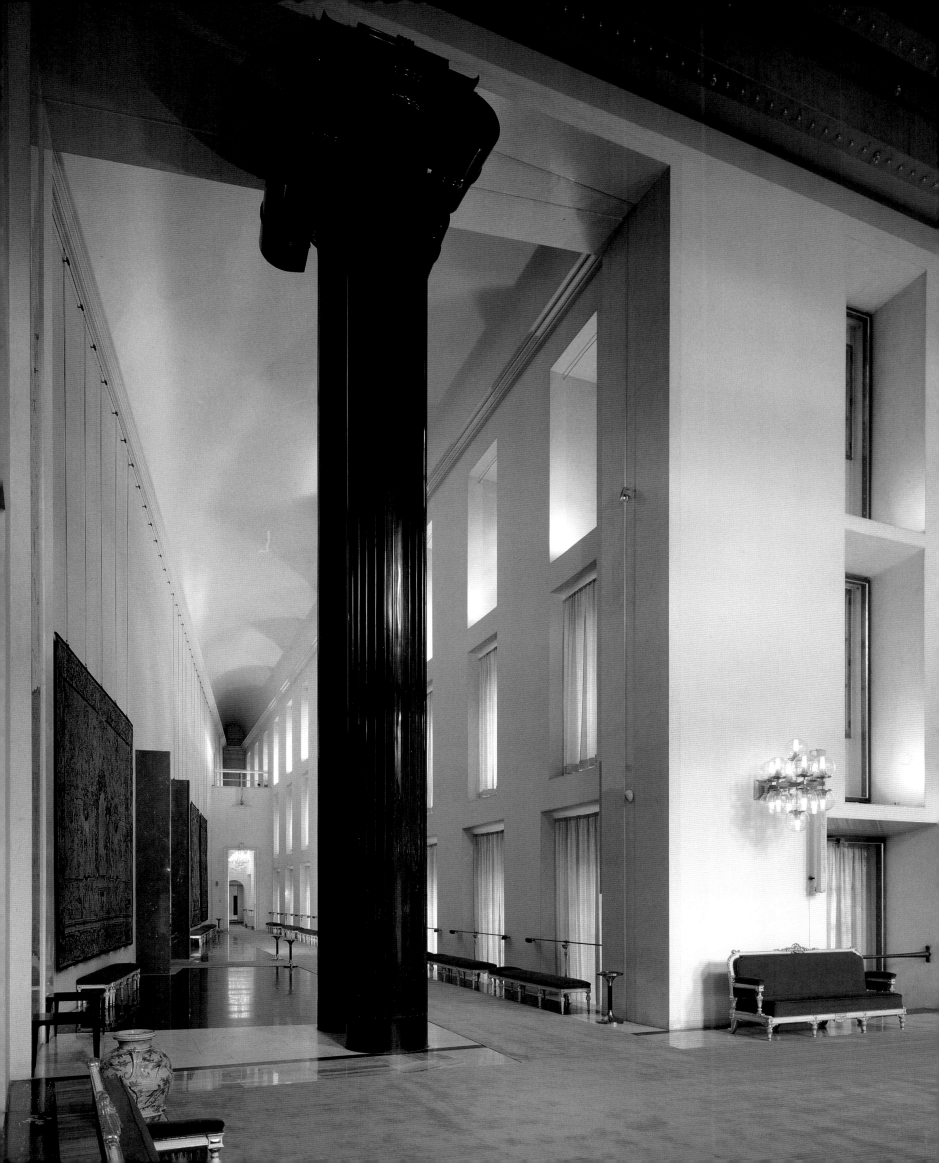

THE CASTLE RESIDENCE OF THE PRESIDENT OF THE REPUBLIC

At the point where the south wing of the castle crosses the perpendicular wing (between the First and Second Courtyards) Josip Plečnik found the necessary space to build, in the 1920s, the private apartments and reception rooms of the residence of President Tomáš Masaryk.

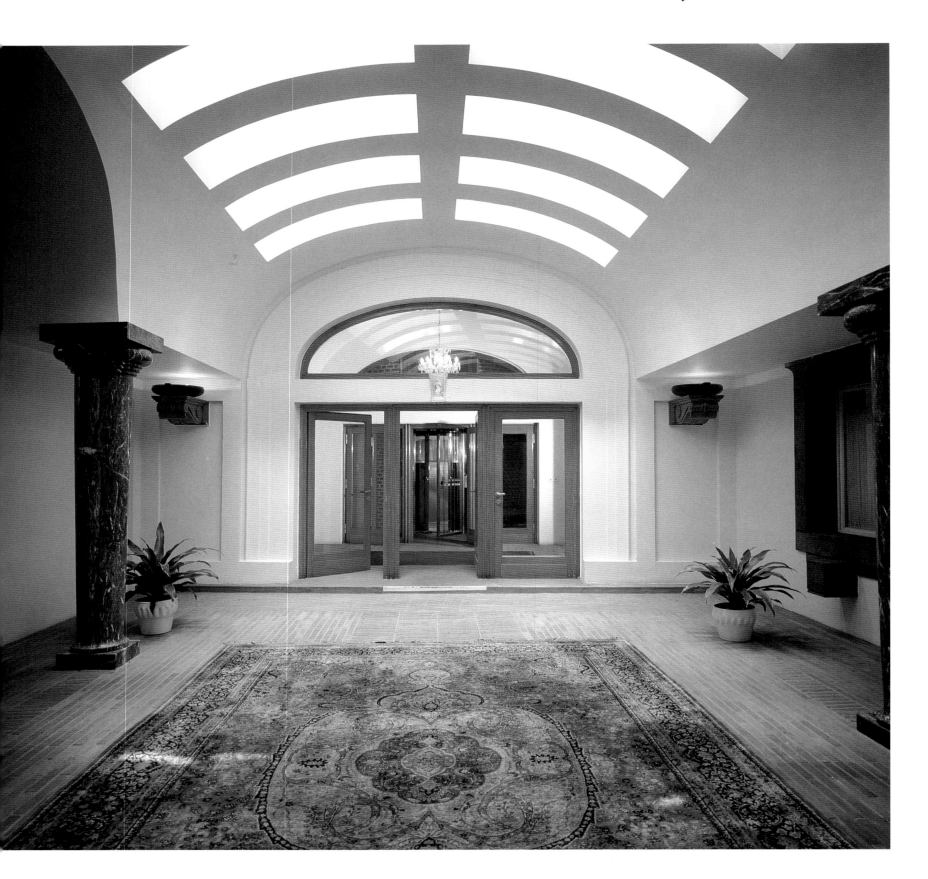

Opposite page: *entrance hall*, created by covering a small inner court in the centre of the southern part of the castle.

Impluvium: Plečnik made the best possible use of this area below a skylight to express the spiritual values that President Masaryk considered to be the most important aspects of human life and society. Plečnik bounded the impluvium with pillars supporting the semicircles of the walls, and completed it with vases, creating a harmonious whole which, through the significance of forms and materials, conveyed a mystical impression.

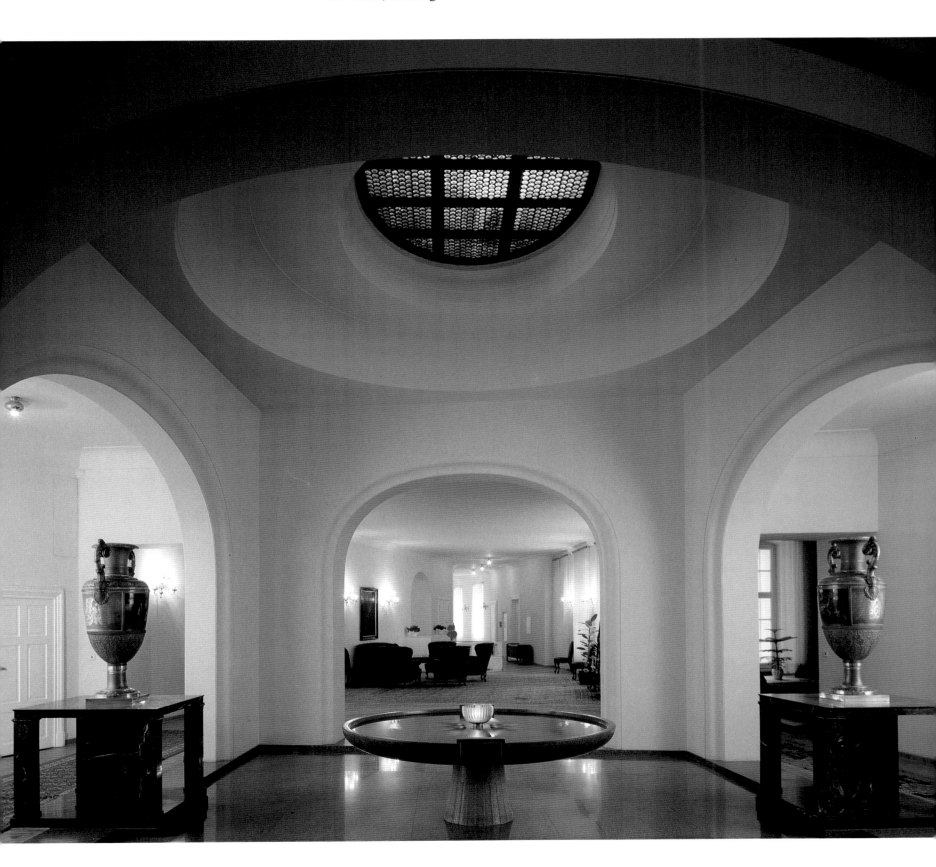

The Golden Room or *Harp Room* was part of the residence of President Masaryk in the south wing of the castle. It was conceived by Josip Plečnik in the traditional spirit of the most important interiors of the Czech kingdom, notably St Wenceslas's Chapel in the cathedral and the Holy Cross Chapel of Karlštejn Castle. The fact that the walls and ceilings were decorated in gold is an allusion to these chapels. The Yugoslav sculptor Damian Pešan assisted with the ornamentation, and was responsible for the sculpture above of the door (*detail above*).

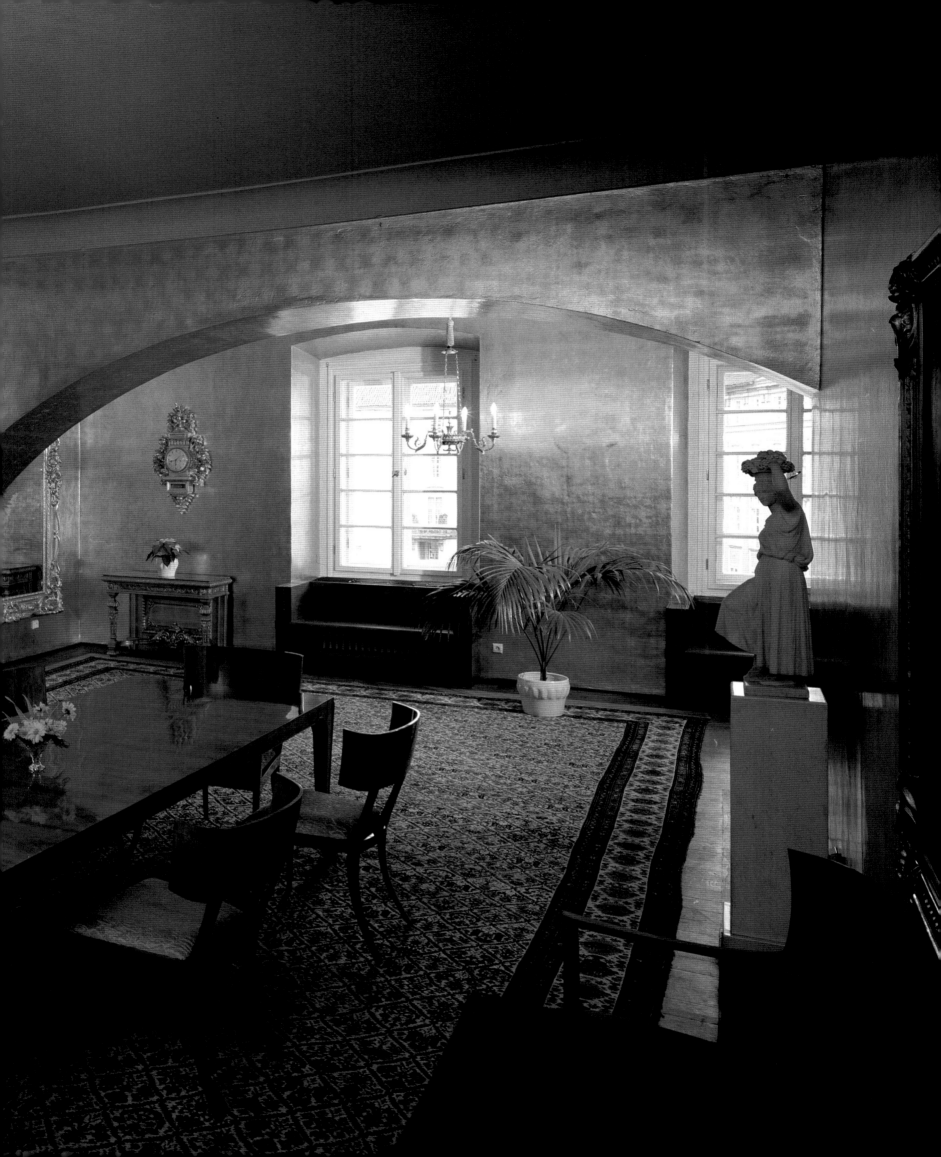

THE OFFICES OF THE PRESIDENCY

The mural painting and the entrance door are the work of the contemporary Czech painter Aleš Lamr. These rooms were arranged after the election of Václav Havel as president of the Republic in 1989. The large office is decorated with contemporary and older works of art. Plečnik was responsible for the spiral staircase, with panelling and a marble ramp, which links the private apartments of the president (situated on the ground floor) to the reception rooms on the first floor of the residence.

THE OFFICE OF PRESIDENT VÁCLAV HAVEL

Below: Secession-style objects on the president's desk.

The president's library.

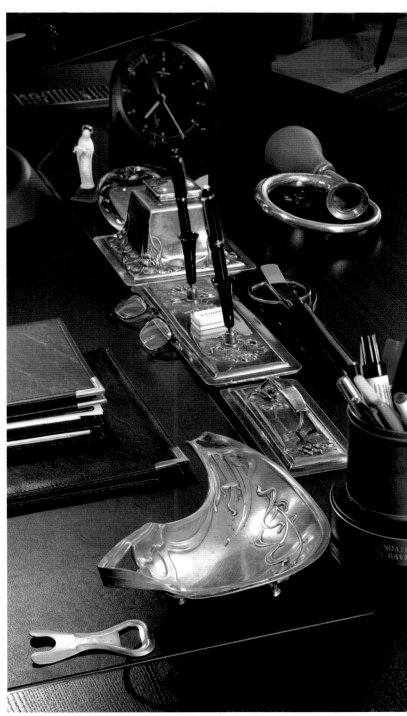

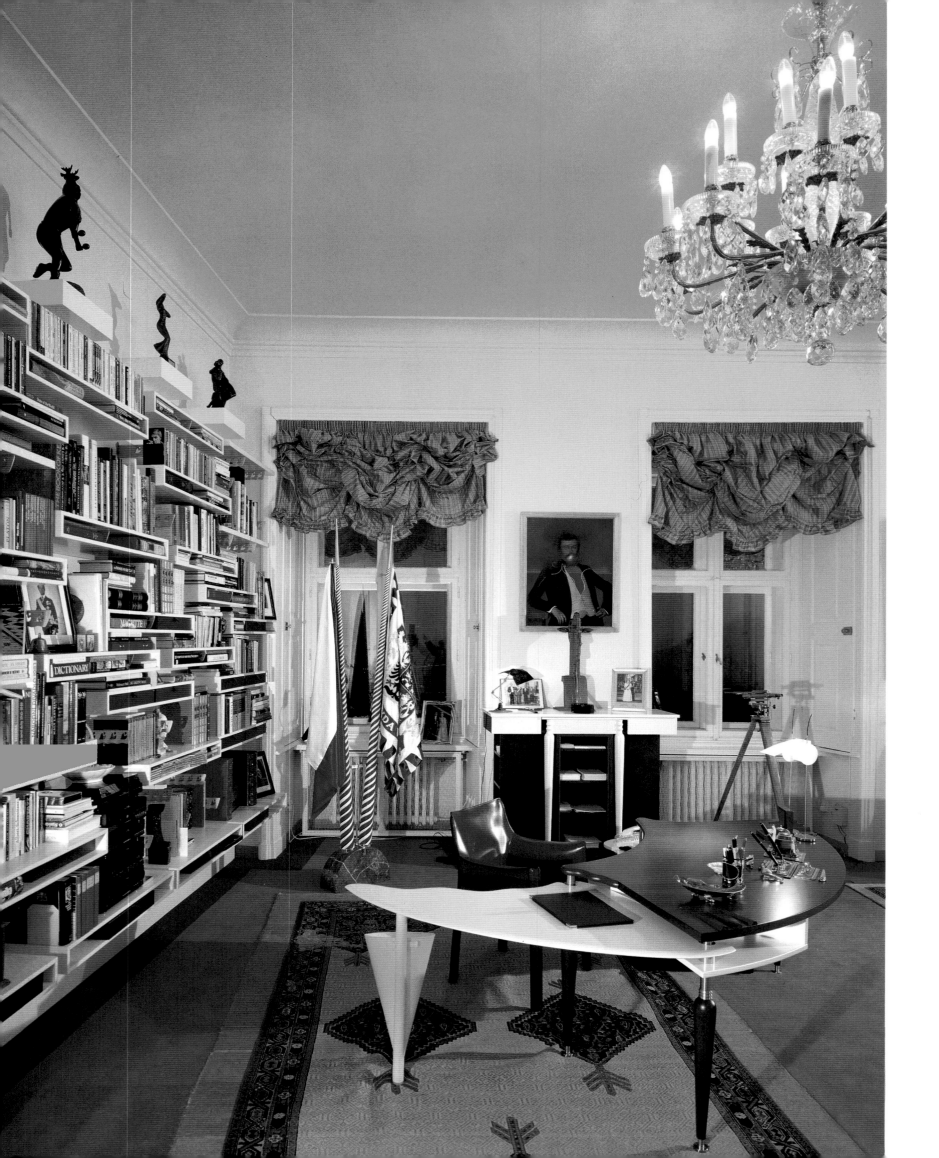

Opposite page: The new office of President Václav Havel designed by Bořek Šípek, a Czech living in the Netherlands: between the windows, a painting by Josef Vyletal; behind the desk, Plečnik's two flagpoles intended for the presidential banner and the flag of the Republic. The bookcase has many photographs of head of states.

Below: View from the desk onto the room. The map attributed to Johann Müller is of Bohemia in the 18th century without Moravia and Silesia. The statue is by the Czech sculptor Olbram Zoubek.

Page 112: *winding staircase* built by Josip Plečnik around the lift shaft, in the presidential palace.

ST VITUS'S CATHEDRAL

Prague Castle, overlooked by St Vitus's Cathedral, is the dominating feature of the city landscape. Viewed from the river, Hradčany is one of the most sensational sights of Europe. Inseparable from the secular and religious life of Prague, the thousand-year-old castle is a potent symbol of the Czech nation and its history. St Vitus's Cathedral, the metropolitan church of the Czech lands, is, from the viewpoint both of art history and conservation, the most important of the state's sacred buildings.

The cathedral's origins date back to the reign of the three Luxembourg kings on the Bohemian throne. John of Luxembourg (reigned 1310-46), known as the Blind, began the actual construction, but it was Charles IV (reigned 1346-78) who determined its appearance, and Wenceslas IV (reigned 1378-1419) who completed the medieval part of the cathedral. Under the Luxembourgs the Czech lands acquired great political importance and a cultural reputation in marked contrast to the chaos that had followed the murder of Wenceslas III, last male heir of the Přemyslids — the original Czech dynasty — in 1306, at Olomouc.

Charles IV, historically the most influential of the three Luxembourg monarchs, came to the throne of Bohemia on the death of his father, John, killed at the battle of Crécy where, despite his blindness, he fought with the French against Edward III of England. Charles, whose mother was a Přemyslid, had been baptised Wenceslas, but had been raised in the French court, where he had acquired a rich cultural background. He returned to Prague in 1333, at the age of seventeen. During his reign, Prague became the capital of the Holy Roman Empire. Elected Roman king on 11 July 1346, Charles IV was crowned at Bonn the same year, then ceremonially enthroned at Aachen (Aix-la-Chapelle) in 1349. He was consecrated by the pope as Holy Roman Emperor, in Rome, in 1355. Nowadays Charles is remembered principally for having founded Prague University (1348), the oldest in central Europe, as well as the city quarter of

Nové Město in the same year. This New Town covered almost 360 hectares (900 acres), a huge area for that time. He was also responsible for building a stone bridge over the Vltava and the celebrated Karlštejn Castle, where the imperial Crown Jewels were to be safely housed.

Charles takes credit, too, for establishing the archdiocese of Prague and for building the city's cathedral. Enea Silvio de Piccolomini (1405-64), who became Pope Pius II in 1458, said that Charles IV 'would certainly have been a truly illustrious monarch if only he had not been more preoccupied with the Czech kingdom than with the Holy Roman Empire', and others were to echo this opinion. However, this view was emphatically rejected by the Czechs, who have always looked on Charles as the father of the country. The only native challenge to this assessment was to come from the rebellious Hussites. Both extremes of belief have to be taken into account, because Czech history from the Middle Ages to modern times has been moulded equally by the cultural and social advances that were initiated in Europe during Charles's time and by the Hussite resistance, based on the moral precepts of the Bible, to papal supremacy.

The present St Vitus's Cathedral was, in fact, the third church of the Prague diocese, which had been established in 975-6 at the site of the first ancient rotunda. Later, St Vitus's Rotunda was replaced by the Ottonian basilica of Prince Spytihněv II (reigned 1055-6). Completed by his successor, Vratislav II, it had been solemnly consecrated in 1096 by Kosmas, head of the chapter and the most important chronicler of the early Přemyslid state. The building of the new cathedral stemmed directly from the wish of the Czech kings to raise the diocese of Prague to the status of archdiocese. On 30 April 1334, this ambition was achieved when Pope Clement VI (Charles IV's former tutor from his Paris years) despatched a bull creating the archdiocese of Prague. The first archbishop was the king's counsellor and friend, Arnošt of Pardubice (1297-1364).

The foundation stone of the cathedral was ceremonially laid on 21 November 1344, after the archbishop's public enthronement. Beneš Krabice of Weitmile, chronicler of Charles's court, noted that 'the new archbishop of Prague, the king of Bohemia, his two sons John and Charles, and a large number of churchmen and nobles came out of the church and made their way to the place that had been dug and prepared to receive the new foundations. The archbishop, the king and his two sons descended to the site... and laid, with all due respect and piety, the first building stone of the new church... while the choir joyfully sang the *Te Deum Laudamus*.' At the same time, the king of Bohemia, together with his sons, made a donation towards the building of the church 'for eternity, of one-tenth of the royal revenues from taxes levied on the Kutná Hora silver mines'. Under an act dated 13 October 1341, kept in the archives of St Vitus's chapter, John of Luxembourg had already donated one-tenth of royal revenues of all the Bohemian silver mines, at that time highly profitable, for the building of the new cathedral.

John of Luxembourg had expressed the wish that the available finances should be used primarily to embellish the tombs of St Wenceslas and St Adalbert (Vojtěch), buried in St Vitus's Cathedral '*primo pro decore et exaltatione seu structura sepulchrorum beatorum Wenzeslai et Adalberti... cum argenteis tabulis et imaginibus deauratis cum gemmes et lapidibus pretiosis*'. This was undoubtedly to make good the wrong he had done in 1336 when he had removed from St Wenceslas's tomb the silver statues of the twelve apostles — statues that Charles had commissioned three years previously on his return to Bohemia. According to contemporary legend, this act could well have brought on the blindness that later afflicted King John.

In due course Charles IV enriched the treasure of St Vitus's Cathedral with an astonishing quantity of precious relics and reliquaries. The first and most important of these treasures was the huge gold St Wenceslas Crown, made for his coronation as king of Bohemia on 1-2 September 1347, and thenceforth kept in the cathedral. After being altered in 1354 and 1378, the crown weighed almost 2.5 kilos (5 lbs). It was studded with ninety-one precious stones (sapphires, spinels, emeralds and rubies) and twenty pearls. The crown itself was surmounted by a reliquary in the form of a cross, with a cameo containing one of the thorns of Christ's crown. Charles had dedicated his crown to St Wenceslas and since 1358 it had rested on the head of the saint's gold-encased bust. In response to Charles's request, a papal bull from Clement VI, dated 6 May 1346, was received, guaranteeing the St Wenceslas Crown special protection: the bull stipulated that the crown should not be removed from the saint's head except for coronations and, exceptionally, for 'ceremonies entailing the use of the royal crown, but only in Prague or its suburbs'. Anyone attempting to steal, sell or pawn the crown would be punished, among other ways, by excommunication. 'Whoever dares to do it or attempt it will incur the wrath of all-powerful God and of the saintly apostles Peter and Paul,' proclaimed a letter patent which was certainly intended to strike fear into the hearts of Charles's successors to the Czech throne. (Events during the following centuries showed that this protection was effective. Even today, the crown of the ancient Czech kings is displayed only on commemorative or special state occasions, and has never been exhibited in a museum.)

Among the most valuable gold objects in the cathedral treasure dating from the early part of Charles's reign, two deserve special mention. These are an onyx cup with an inscription that identifies it as a gift from Charles IV, dating from 1351, and a no less astonishing receptacle, 87 cm (34 in) high, containing many relics and Roman and Byzantine cameos. Made in 1354, it was originally destined for Karlštejn Castle. During his travels of 1354-5 to mark his coronation as Holy Roman Emperor, Charles acquired a large number of relics. At Pavia he obtained the head and body of St Vitus, patron saint of Prague's cathedral; at Einsiedeln he was

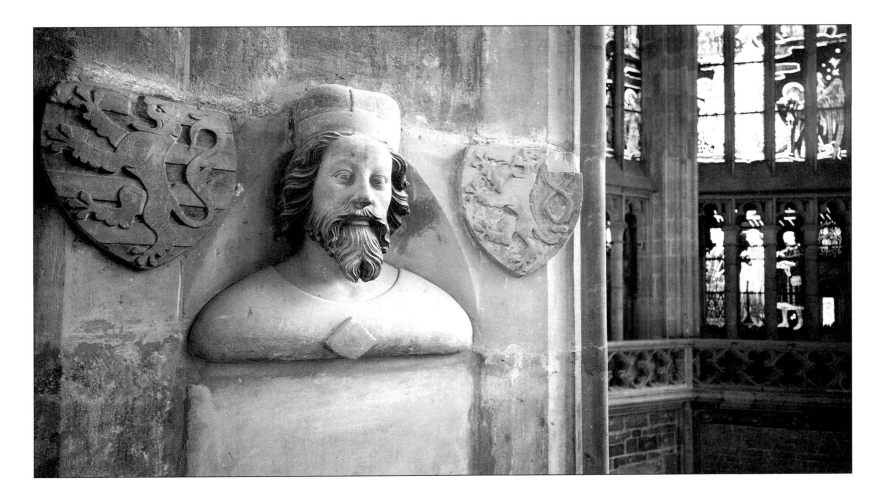

given a large piece of the skull of St Sigismund, king of Burgundy in the 6th century, which Charles, himself crowned king of Burgundy, kept in order to propagate the cult. Then, in 1365, at St-Maurice d'Augane (diocese of Sitten in Switzerland) Charles was donated the body of St Sigismund, which he placed in a special chapel in the new cathedral. One year later, by a decision of the synod of Prague, St Sigismund became the national patron saint. Unfortunately, golden statues of the two saints on their columns subsequently disappeared.

One object in particular testifies to the quality of the goldsmiths' work commissioned by Charles IV during those years. It is a reliquary bust of Charlemagne in silver-gilt, surmounted by the crown of the Roman king, dating from 1349, cleverly made in Prague and now part of the treasure of

Aachen Cathedral. E. Poche has advanced the theory that the bust itself was originally kept in Prague, associating it with the sculpture of Peter Parler's early period. From 1350, during the Easter festivities, the most important relics and reliquaries given to the cathedral by Charles IV were exhibited to the crowds of pilgrims (up to 100,000 people) who gathered in the cattle market (now Charles Square) in Prague's Nové Město quarter. The vast majority of pilgrims were sure to visit the cathedral and expected to contribute towards the building of a new choir. Once the necessary money was found, work could proceed with the construction of the cathedral during the seventy-five years that followed the laying of the foundation stone.

Matthew of Arras (*primus magister fabrice*) was summoned from Avignon, in 1344 at the latest, to

direct the building of the new cathedral. Certainly, the choice of a French builder was not due entirely to the links that existed between the Luxembourgs and Pope Clement VI: it was mainly as a result of Charles's declared intention to transform Prague into a town modelled on those of the West, furnished with a cathedral in the prevalent French Late Gothic style. (After Prague, the only cathedral of the French type to be built abroad was in Milan, in 1387.)

In Prague, Matthew of Arras envisaged a complete cathedral plan: a raised choir, a hexagonal ambulatory surrounded by closed radiating chapels, a separate transept and a three-aisled basilica with a west front topped by twin towers. In 1352, on the death of Matthew, it became clear that such a project could never be realised. The parts that had been finished included the columns of the polygon and the ambulatory around the choir and its constituent chapels, up to the level of the triforium; in the northern section, the east wall of the sacristy was up, and in the southern section, Matthew had completed the first three side chapels, although the third, the Holy Cross Chapel (originally the St Simon and St Jude Chapel) is only partially attributable to him, by reason of an altered plan.

The creative art of Matthew of Arras is associated with the development of French architecture at the end of the 13th and beginning of the 14th centuries. The most characteristic feature of his architecture is the balanced, rhythmic effect of space, based on the repetition and breaking up of horizontal planes. A carefully devised system involving the use and juxtaposition of different architectonic elements gives a lively and dynamic overall effect to a style of architecture that does not abound in figurative or individual ornamental detail.

After the death of Matthias of Arras, the activities of the building workshop were directed for three or four seasons by one of his assistants, a foreman (*parlerius, parlier*) whose identity is unknown. The team now began to build (*construiere*) the first new altars, the scarce remains of which testify to the sculptural talents of the workshop's stonecarvers: examples include the stone antependium in the Chapel of the Holy Relics (originally the St Adalbert and St Dorothea Chapel), made for Rudolf, duke of Saxony (d. 1356), and the antependium in St Wenceslas's Chapel (transferred from St Anne's Chapel), which was commissioned by Purchard, burgrave of Magdeburg (before 1358). Nevertheless, however important these works may be from the historical and iconographical viewpoint, their artistic worth is negligible in comparison with the remarkable quality of the later sculpture of St Vitus's Cathedral.

In 1356 Charles IV found a solution to this period of transition by calling upon a new German architect and sculptor from Schwäbisch Gmünd (*secundus magister fabrice, magister operis*). He was Peter Parler (son of Heinrich Parler of Cologne) who was then only twenty-three. Peter Parler took charge of the cathedral construction from 1356 until the end

Bust of Peter Parler.

(when ordinary labourers often earned no more than one grosch weekly). The building workshop of the cathedral which he set up employed highly qualified stonemasons from many different German-speaking lands and towns: among them were several of his relatives and, later, his own sons Wenzel and Johann. Charles could not have wished for a more brilliant architect and sculptor than Peter Parler to carry through his visionary schemes. Inventive in conception and pleasing in execution, Parler's works paved the way for the final period of European Late Gothic throughout the Czech and German territories and far beyond.

Several precise dates indicate the systematic manner in which work on the new choir of St Vitus's Cathedral progressed under Parler's supervision. In 1362 the north side of the sacristy was completed with two bays of stellar vaults and pendentives, the first of their kind in Bohemia. In the same year Archbishop Jan Očko of Vlašim consecrated the high altars of St Vitus and of the Virgin Mary. In 1373 Peter Parler built the triumphal arch (*arcus magnus*). In 1385 a great net vault, again the first of its kind in Europe, was constructed in the choir. In 1392 the foundation stone was laid of the three-aisled basilica, dedicated to the Visitation of the Blessed Virgin, to St Wenceslas and to the other patron saints of Bohemia. Subsequently, in 1396, Archbishop Olbram of Škvorec had the relics of St Adalbert and the Five Brother Saints (martyrs of the missionary journey of St Adalbert to Poland and Prussia),which had been brought from Gniezno to Prague in 1039, transferred from the old church to the eastern part of the new central nave, then under construction. Most of these donations, as well as others, are inscribed on the plaque, dated 1396, on the west pier of the cathedral's south doorway, the text of which is probably by Wenceslas of Radeč, who was then head of the workshop.

The architectural conception of Peter Parler, as seen in the cathedral choir, differs considerably from that of Matthew of Arras and his colleagues. Parler retained only fragments of the parts previ-

of the century. Moreover, at the emperor's behest or with his express agreement, he created a number of other remarkable works in the Luxembourg Gothic style: the stone bridge over the Vltava; the choir of St Bartholomew's Church at Kolin, on the Elbe; All Saints Chapel in Prague Castle; and perhaps, in part, St Barbara's Church at Kutná Hora. Before coming to Prague, in addition to his apprenticeship in his father's workshop at Schwäbisch Gmünd while the Holy Cross Church was under construction, Peter Parler had already worked in Augsburg (on the east choir of the Cathedral of the Virgin Mary), at Nuremburg (in the Frauenkirche), and perhaps also in Cologne, the native town of his future wife, Gertrude.

Peter Parler was completely at home in Prague. From 1359 he was the owner of a house in the Hradčany quarter and he often sat on the municipal council. His salary as director of works at the cathedral was 56 Bohemian grosche per week

ously completed, and continued the work in his own fashion. Obviously in accord with the wishes of Charles IV and possibly also with those of the archbishops of Prague and the chapter (and thus in keeping with the direction of contemporary architecture, already far removed from the universality of Late Gothic cathedral building), Peter Parler abandoned the homogeneous conception of the choir for an indiviual conception of an entity of separate parts, each related to the other, yet each with its own significance and function. The carefully ordered geometrical plan of the basilica within the context of the ideal cathedral, as envisaged by Matthew, was no longer considered obligatory, any more than the latter's conception of the walls and the handling of space. Everywhere, new creative approaches were used to attain an original expressive effect. The striking changes affecting the volume and variety of architectonic elements hark back, in a sense, to the traditional forms of the 13th century. The details deriving from Romanesque art (such as the semicircular arches) juxtaposed, at the other extreme, with modern elements reminiscent of similar tendencies in mainland Europe and England (the airy interplay of vaults and the flamboyant motifs of rose windows) are altogether remarkable. Equally notable is the effect produced by the contrast between the lower level of the choir, relatively dark, given the nature of the material composing its walls, and its bright upper part, with the large windows of the triforium letting in plenty of natural light.

All the parts of the cathedral built by Peter Parler were planned independently of one another. This was particularly true of St Wenceslas's Chapel, especially revered as a place of worship and spiritual inspiration, being the chapel of the oldest Czech saint, that duke of Bohemia who was a distant Přemyslid ancestor of Charles IV himself. The key importance of this chapel arose from the fact that the original site of Wenceslas's tomb had been venerated since the translation of his remains, in 938, from Stará Boleslav, on the orders of his brother, Boleslav I, who had murdered him in either 928 or 935. Charles IV adhered to this tradition and did not place the remains of Wenceslas near the high altar, in 1358, which would have entailed changing the identity of the cathedral's original patron. However, as noted by Beneš Krabice of Weitmile, he commissioned for the saint a new 'funerary monument in pure gold, and had it adorned with the costliest of jewels and choice semi-precious stones, and embellished it in such a manner that its like could be found nowhere else in the world' (it vanished, after the brutal intervention of Emperor Sigismund at the beginning of the Hussite Wars). The veneration Charles IV showed to St Wenceslas is attested by his inscription on the monument: *Hystoria nova de sancto Wenceslao martyre, duce Bohemorum, per dominum Karolum, imperatorem Romanorum, regem Bohemie compilata.*

Constructed on an extensive square plan, St Wenceslas's Chapel extends into the south arm of the transept, in line with the chapels on the south side of the choir. Flanked by massive walls and lit only by small windows, this chapel was doubtless regarded originally, because of its valuable contents, as a treasure chamber. Nevertheless, its overall visual and emblematic effect was designed to convey a sense of other-worldly beauty, probably with the intention of representing, symbolically, celestial Jerusalem. The complexity of the stellar vaulting, supported on huge triangular-based pedestals, suggests a protective baldaquin spread high above the sacred tomb. In 1372 Peter Parler's stonemasons lined the chapel walls, under the projecting cornice of the surrounding vault, with flat semi-precious stones which, with their gilded stucco work, provide a rich frame for the eleven mural paintings of Christ's Passion, by the imperial painter Oswald. Above the altar is a Crucifixion, showing Charles IV kneeling with his third wife, Elizabeth of Pomerania. Unfortunately, Late Gothic repainting has altered the appearance of these works.

Other paintings by Oswald, which evidently played an important part in decorating the cathedral, are preserved in the Vlašim Chapel, originally dedi-

cated to St Erhard and St Odile, and today to St Adalbert. On the east wall is the *Baptism of St Odile*, with the donor, Bishop Jan Očko of Vlašim (after 1370); and on the west wall is Jan Očko of Vlašim as cardinal (he had been consecrated on 27 September 1378), kneeling before Christ and the saints. Oswald's work is directly descended from that of Master Theodoric, who did the panel paintings in the Holy Cross Chapel at the imperial castle of Karlštejn. Belonging to a school allied to that of Oswald, Theodoric executed the mural painting representing the Adoration of the Magi in the St Adalbert and St Dorothea Chapel, the so-called Saxony Chapel, which also contained the ancient reredos of St Adalbert. He was also responsible for the painting of the Madonna and St Mary Magdalen in the chapel to this saint, also known as the Wallenstein (Valdštejn) Chapel.

From the original St Wenceslas's Chapel there still remains a large iron reliquary, in the shape of a tower, for which the master smith Wenceslas was paid 1200 Bohemian grosche. The small gilded doors of the wall custodial behind the altar is also a delicate piece of ironwork and locksmith's work, apparently from the same period. A Romanesque bronze door-knocker, in the form of a lion's head, emphasises the Romanesque character of the north door. According to legend, St Wenceslas clung to this door-knocker as he died a martyr's death in front of the church of Stará Boleslav.

Charles IV certainly regarded St Wenceslas's Chapel as a place of great religious and ideological importance. Peter Parler reiterated this belief by placing a stone statue of St Wenceslas outside the chapel in the wide space demarcated by the supporting pier above the chapel. The statue is two metres (just over six feet) high and bears on the pedestal Parler's personal inscription (since the end of the 19th century this has been a copy). Made in 1373 with the assistance of his nephew, Heinrich of Gmünd, it is one of Parler's masterpieces. To the left of the chapel, an open, two-newel winding staircase climbs towards the roof of the great transept vault:

dating from 1372, it is unique of its kind and among Parler's most remarkable achievements.

On the outside, the individual contribution of Peter Parler to the construction of the cathedral is shown in his emphatic treatment of the south front, flanked, on the transept side, by St Wenceslas's Chapel to the east and by a tall tower to the west. The importance given to the south façade was a consequence of its position, opposite the Royal Palace. The area between these two main buildings, symbolising temporal and spiritual authority and power, was sufficiently spacious to accommodate splendid assemblies and processions in keeping with the ostentation of the Luxembourgs. That was the reason why the doorway, known as the Golden Gate, leading to the south arm of the transept of the emergent cathedral was chosen to be the principal entrance to the new church, duly emphasised by its three-part portico. In 1367 Beneš Krabice of Weitmile noted *à propos* this subject: 'A fine work has just been completed and perfected: a great doorway and portico for St Wenceslas's Chapel, in the cathedral of Prague, a very sumptuous work of sculpture.' The statues that stood on the central and engaged piers have not survived. Judging by the number of empty plinths, they must have been of Christ and the twelve apostles, worshipped on either side by Charles IV and Empress Elizabeth of Pomerania, accompanied by pages, or possibly by Charles IV and Wenceslas IV with their wives.

From the start, St Vitus's Cathedral was intended to be used for coronations. At the request of John of Luxembourg, on 5 May 1344, Pope Clement VI granted the archbishops of Prague the right to crown the kings of Bohemia. On the eve of his own coronation on 1 September 1347, Charles IV drew up the *Ordo ad coronandum regem Boemorum*, a new set of regulations concerning the coronation of the Czech monarchs, established on the lines of the old, 10th-century Germanic ceremonial and completed by certain liturgical texts deriving from the French ceremonial of 1328. He took into consideration, too, ancient Přemyslid traditions. The cathedral also

served as the royal burial place. Both coronation and funeral processions entered the cathedral by the Golden Gate, on which, in 1370-1, the symbol of heavenly protection was set, with a mosaic of the Last Judgement made by Venetians invited to Prague. Behind the wall with the mosaic was the original sacristy of St Wenceslas's Chapel, where the chapel's precious relics were kept, as well as the St Wenceslas Crown, at times when these were not on display. According to V. Kotrba, the terraced platform overlooking St Wenceslas's Chapel and the Golden Gate was intended for displaying relics and church treasures, but was not used for this purpose because of the death of the emperor in 1378 and the years of unrest that followed. Even the High Tower remained unfinished. Designed in Charles's time, but begun only later, it was to have accentuated even further the importance of the south front. The symbolic purpose of this tall landmark was to direct the cathedral, the castle, the city of Prague and the Czech kingdom towards heaven.

Peter Parler used his great talent and feeling for sculpture to enrich St Vitus's Cathedral with a large number of monumental works, created on a progressive iconographical pattern worked out by Charles IV himself. Many other figurative details, large and small, were added by the stonecutters of Parler's workshop, working under his orders. Parler's own importance as a creative sculptor derives from the sense of realism he brought to the Late Gothic style and, even more, from the new conception of form that he bequeathed to the ensuing period, the Flamboyant Gothic of the late 14th century. Mention has already been made of the vanished stone statues of the south portal, and the huge statue of St Wenceslas, considered to be one of the supreme original examples of this new style. The figurative brackets of the chapel's north portal are also of extraordinary quality. The left-hand one represents St Peter denying Christ, the right-hand one, occupying more space, the devil tearing out the tongue of Judas. The oldest funerary monument by Peter Parler in the cathedral is the sarcophagus of Archbishop Jan Očko of Vlašim (1364-78) in St Adalbert's Chapel. In the parish of Klodsko he had already made the marl sarcophagus of Arnošt of Pardubice (d. 1364), Jan Očko's predecessor as bishop of Prague; and then, in Wroclaw Cathedral, he fashioned the tomb of Bishop Przeclaw of Pogorzel (d. 1376).

In December 1373, Emperor Charles IV gave orders for the translation 'of the bodies of the ancient Czech princes and kings who were buried in the new choir of the church of Prague' (Beneš Krabice of Weitmile). For six of them, stone sarcophagi had been built in three of the radiating chapels that surrounded the ambulatory. Placed face to face and in chronological order, the recumbent figures represented the Přemyslid monarchs with their emblems and armour: the princes Břetislav I (d. 1055), who had transferred the body of St Adalbert from Gniezno to Prague; Spytihněv II (d. 1061), founder of the episcopal basilica of St Vitus, St Wenceslas and St Adalbert; Břetislav II (d. 1100) and Bořivoj II (d. 1124); and the two Czech kings, Přemysl Otakar I (d. 1230) and Přemysl Otakar II, who died in 1278 at the battle of Moravské Pole (not far from the village of Dürnkrut in Lower Austria) fighting Rudolf of Habsburg. On 30 August 1377, on the emperor's orders, Peter Parler was paid the relatively large sum of 900 Bohemian grosche. The magnificent statue of Přemysl Otakar I is impressive for its sheer bulk and power. The king's face, evidently a very good likeness, expresses deep melancholy brought on by the burdens of life. The recumbent figure of Přemysl Otakar II is also certainly Peter Parler's work, whereas the statue of Spytihněv II is attributed to Heinrich Parler (of Gmünd). The other sarcophagi are the work of various stonecutters and sculptors from the workshop responsible for the construction of the cathedral.

The gallery of twenty-one busts in the cathedral triforium, above the nave arcades, is unrivalled. The busts, set in the wall, are in sandstone, originally polychrome, and almost life-size. They were not all done at the same time. The oldest of them, placed

Tomb: Among the many tombs of monarchs placed in the radiating chapels of the ambulatory, there is also the sarcophagus of a dignitary of the church, Jan Očko of Vlašim, archbishop of Prague.

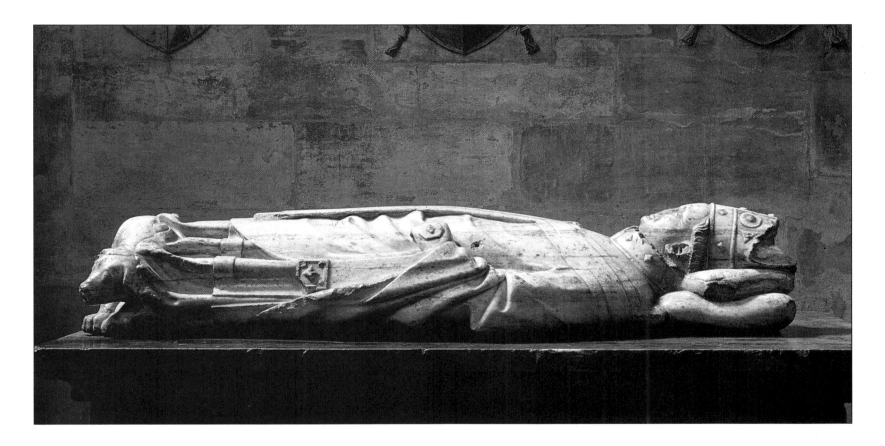

on the pillars at the end of the polygon, represent Charles IV and the closest members of his family. On his left are his four wives: Elizabeth of Pomerania-Stolp (d.1393), Anne of Silesia-Schweidnitz (d. 1362), Anne of Bavaria (d. 1353) and Blanche de Valois (d. 1348). To the north of these are the busts of Charles's two brothers: John Henry, margrave of Moravia (d. 1375) and Wenceslas, duke of Luxembourg and Brabant (d. 1383), courtly poet and protector of Jean Froissart, the greatest French chronicler of the Middle Ages. On the south side, to the right of Charles IV, are the busts of his parents, John of Luxembourg and Elizabeth, last of the Přemyslids (d. 1330), of his eldest son, Wenceslas IV, king of Bohemia (d. 1419), and of Wenceslas's first wife, Joanna of Bavaria (d. 1386). The busts on the sides of the triforium date from the years 1379-80. These represent the first three archbishops of Prague and four work-masters (*directores fabrice*) of the cathedral;

the bust of the fifth, Wenceslas of Radeč, was added later.

To this gallery of the highest temporal and spiritual dignitaries of the kingdom of Bohemia, were added the busts of the two architects, Matthew of Arras and Peter Parler, each bearing on his chest a plaque with an identifying inscription. Their inclusion is most surprising for their time, but was undoubtedly intended as a mark of recognition of exceptional merits. Not all the triforium busts are by the same hand; they were done by several stonemasons from the workshop (which normally turned out little sculpture), under the direction of Peter Parler. Several are attributed to the architect, among them the one of Parler himself which, according to J. Homolka, is the 'first monumental self-portrait in Late Gothic sculpture'.

Some time ago, K.M. Svoboda deciphered the symbolic meaning of the arrangement, on three levels, of the monumental sculptures by Peter Parler

and his workshop in St Vitus's Cathedral: the sequence expresses the continuity of the divinely protected Czech dynasty, from its ancient Přemyslid past (the sarcophagi of the dark lower floor) to the contemporary Luxembourg line (the busts in the well-lit triforium). Another series of busts, placed on the entablatures of the surrounding pillars, on the upper level of the triforium symbolises heavenly protection. They represent Christ, the Virgin Mary, foreign saints much venerated in the country: Vitus, Sigismund, Cyril, and Methodius; and the local saints: Wenceslas, Ludmila, Adalbert and Procopius. According to extant invoices dating from 1375, these ten busts were the work of the stonemason Hermann, the best-known sculptor of the period from the St Vitus's Cathedral workshop. They would have been executed, of course, under the direction and with the participation of Peter Parler and perhaps of his nephew and colleague, Heinrich of Gmünd. Hermann's art, probably French in tendency, brought a measure of naturalism to portraiture. He is likely to have influenced the artistic expression of Wenceslas and Johann, Peter Parler's sons, who subsequently made some of the busts, doubtless with other sculptors, on the sides of the lower triforium.

According to the inscription, dated 1386, on his own bust in the triforium, Peter Parler worked on the construction of the choir stalls, which had been covered and consecrated shortly before (the stalls were burned in 1541). The only surviving testimony to the high quality of sculpture in Peter Parler's workshop, and its tendency towards the Flamboyant Gothic style, is the aforementioned bust of Wenceslas of Radeč and the astonishing figurative brackets of the baldaquins on the central piers at the polygonal end of the choir, notably that of the south pier representing Adam and Eve before the Tree of Knowledge. The statues of the Virgin Mary and Christ the Saviour, which were positioned over the baldaquins, have long since been destroyed. It is thought that the panel painting of the St Vitus's Madonna in the Prague National Gallery is a surviving part of the original cathedral decorations: it may have been commissioned at the same time as its frame in relief by Archbishop Jan of Jenštejn to commemorate the laying of the cathedral's foundation stone in 1392.

Peter Parler supervised the building of the cathedral until his death. This occurred on 13 July 1399 according to the inscription on his funerary slab, discovered in 1928, at the same time as the epitaph of Matthew of Arras, near the north sacristy (the two slabs were placed in the St Mary Magdalen or Wallenstein Chapel). In 1397 Wenceslas, elder son of Peter Parler, succeeded his father for a short while; his younger son Johann then took charge from 1398 to 1406, followed by a certain Petr, known as Petrlík, whose family name is not known. The latter continued construction work on the cathedral until the start of the Hussite disturbances in 1419. It included the erection of the high South Tower and a connecting railing above the window arch of the south arm of the transept. The wealth of decorative motifs indicates that the stonecutters of the cathedral workshop had lost none of their creative flair. Even after Peter Parler's death, the high level of accomplishment of the figurative works of sculpture apparently did not decline. The mastery of overall composition, as well as the intricacy of detail, can be seen from the reliefs of the corner brackets above the gallery of the façade, on the first floor of the high South Tower. One has the fantastic appearance of a bat, another of a dragon. Albert Kutal, the eminent historian of Czech art, investigated the evidence that enables us to identify the three last 'workmasters' of St Vitus's Cathedral during the Luxembourg era as being landed proprietors of Prague, which continued to turn out painters, builders and stonemasons renowned throughout Europe until the end of the Middle Ages.

Even after the death of Charles IV (1378) additions were made to the already considerable cathedral treasure, of which detailed inventories were prepared in 1387, 1396 and 1413. This treasure also included the furnishings of the sixty-four altars of

the pre-Hussite church, apparently stored in the two sacristies. Above the main sacristy, situated on the north side of the choir and comprising an altar dedicated to St Michael, there was a special room that served as a treasure chamber. It opened onto the nave by an entrance with a semicircular vault leading to 'a small balcony... where sacred objects were sometimes displayed' (Václav Hájek of Libočany). Among the reliquaries that survive, two dating from the last years of Charles IV deserve special mention: the so-called Pope Urban V reliquary, containing a fragment of the Holy Shroud, fashioned in gold in the shape of a cross and decorated with enamel and precious stones (height: 31.3 cm/13 in); and a beautifully-made reliquary in silver-gilt, struck with the mark of Peter Parler, probably donated to the cathedral by a member of the Parler family. The archives and precious books of the St Vitus chapter were apparently kept in the chamber above the chapter room, near the west wall of the South Tower. This vast collection of archives today constitutes the essential source of all documented study of St Vitus's Cathedral and Prague Castle: they are now kept, together with the rich chapter library, in the new palace situated in the Third Courtyard.

The Hussite uprisings that began on 30 June 1419 were in great part a reaction against the preceding era of profligacy, which had long been criticised by the reform movement. On 16 August of the same year, Wenceslas IV died and the insurrectionist Estates prevented his burial in St Vitus's Cathedral (it was not until 1424 that his remains could be transferred to the royal crypt). Historical events had tragic consequences for the cathedral itself. During his coronation as king of Bohemia performed on 28 and 29 July 1420, Sigismund of Luxembourg 'took possession, in the church of Prague and St George's Convent, of the heads, hands, monstrances and other gold and silver treasures, giving orders for them to be smashed, using them to pay the salaries of his army...' The following year, the people of Prague occupied the castle and, on 10 June 1421, at

the instigation of the radical Hussite priest Jan Želivský, 'blasphemously burned the very beautiful pictures and precious triptychs of the altar... And had not a number of lords and other brave men intervened to prevent them, this bunch of good-for-nothings would have destroyed the castle, with the church of our patron saints,' noted Vavřinec of Březová, the most important historian of the Hussite period. And he asked this question: 'Who committed the gravest sin? Those who destroyed the paintings on wood or those who destroyed the silver effigies?'

But even before these tragic events, the building of the cathedral had been interrupted again and was not to be resumed for many years. The choir dating from the Luxembourg period (enclosed and separated from the triple nave, then under construction, by a temporary wall) and the shell of the uncompleted tower represent fragments of the cathedral as conceived by Matthew of Arras and Peter Parler. The generations to come inherited the challenge to complete the unfinished work.

(continued on page 141)

ST VITUS'S CATHEDRAL

Metropolitan church of Bohemia and Moravia, coronation and burial place of Czech kings, the cathedral is the dominant feature of Prague Castle. Founded in 1344 by John of Luxembourg and the Margrave Charles, the future Emperor Charles IV, it was erected on the site of the 10th-century rotunda dedicated to the same saint. The construction of the eastern medieval part of the cathedral (including the high South Tower) lasted until 1419. The three-aisled nave and the west front with its two towers were only completed between 1859 and 1929. The objects, furnishings and ornaments are from different periods, from 1350 to the 20th century.

1. Golden Gate
2. St Wenceslas's Chapel
3. Royal Oratory
4. Chapel of St John of Nepomuk and St Adalbert
5. Tomb of St John of Nepomuk
6. Chapel of Holy Relics (Saxon Chapel)
7. Ancient Sacristy
8. St Sigismund's Chapel
9. Royal Mausoleum
10. Staircase leading to the Treasure Chamber
11. Schwarzenberg Chapel
12. Bartoň of Dobenín's Chapel
13. St Ludmila's Chapel
14. Holy Sepulchre Chapel
15. Thun Chapel

Period of building under the direction of Matthew of Arras, 1344-52

Period of building under the direction of Peter Parler, 1356-99

Period of building under the direction of Josef Mocker and Kamil Hilbert 1873-1933

Opposite page: *the neo-Gothic west front* (1873-1929) with the great rose window. In 1928 Jan Jareš made the stained-glass windows representing the creation of the world, based on the designs of František Kysela.

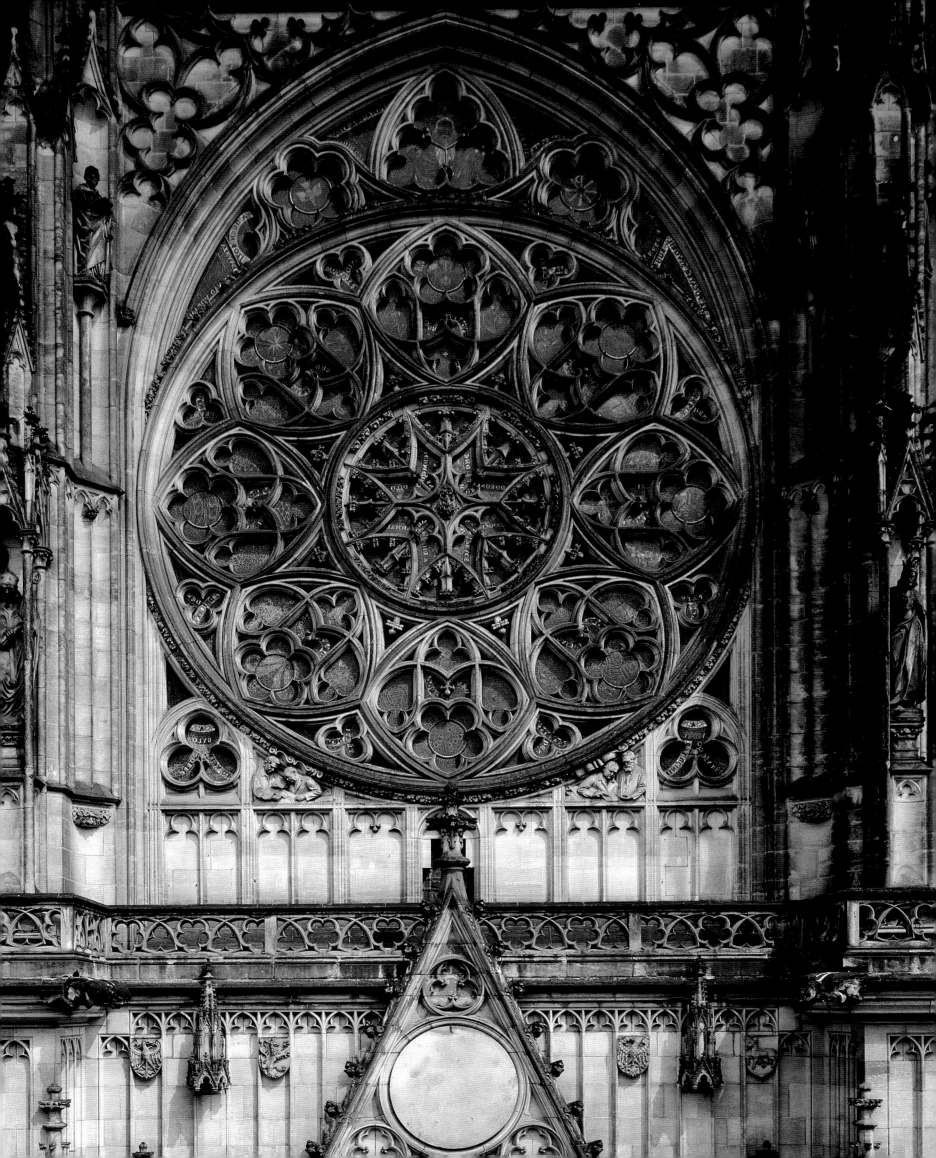

The tympanum of the central doorway of the west front: the Crucifixion and other scenes of the Passion by Ladislav Pícha, based on the models of Karel Dvořak (1893-1950).

Opposite page: the *South Tower*. Begun in 1396 by Peter Parler, its construction continued under other cathedral work-masters from 1398 to 1419. The architecture is of the Flamboyant Gothic late style of Peter Parler's workshop. It was completed by a Renaissance gallery and an onion-shaped dome, designed by Boniface Wohlmut (d. 1579) and renovated in 1770 by Niccolo Pacassi. Thanks to Kamil Hilbert, the cathedral was spared the attentions of neo-Gothic purists wishing to impose stylistic uniformity.

Pages 128-129: south view of *St Vitus's Cathedral* from the Third Courtyard of the castle. This shows the medieval façade of the church dating from the reign of Charles IV (d. 1378), with the Golden Gate leading to the south arm of the transept, the neo-Gothic lower storey of the tower and a part of the Gothic triple nave.

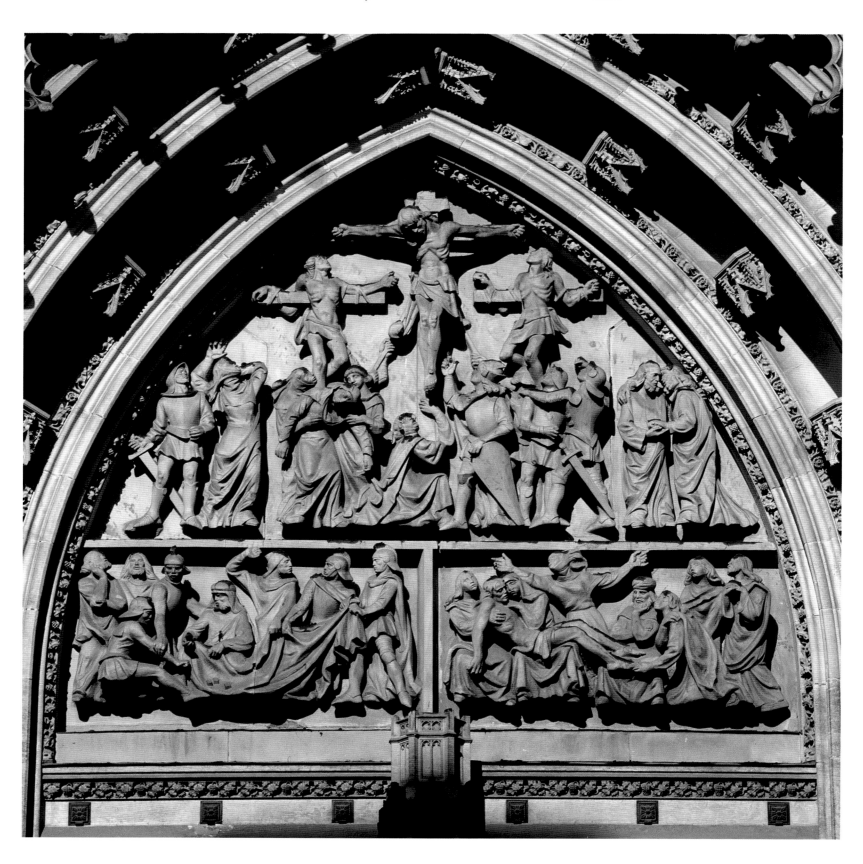

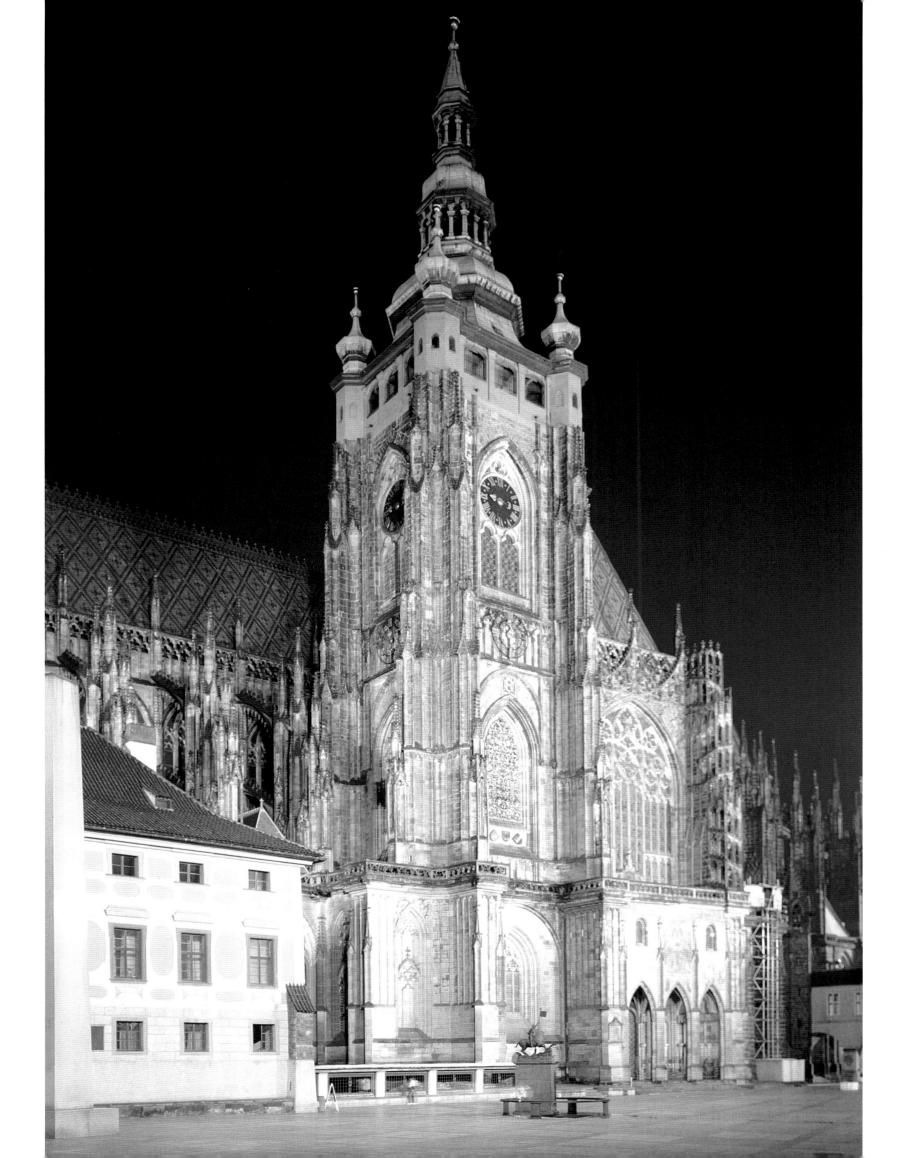

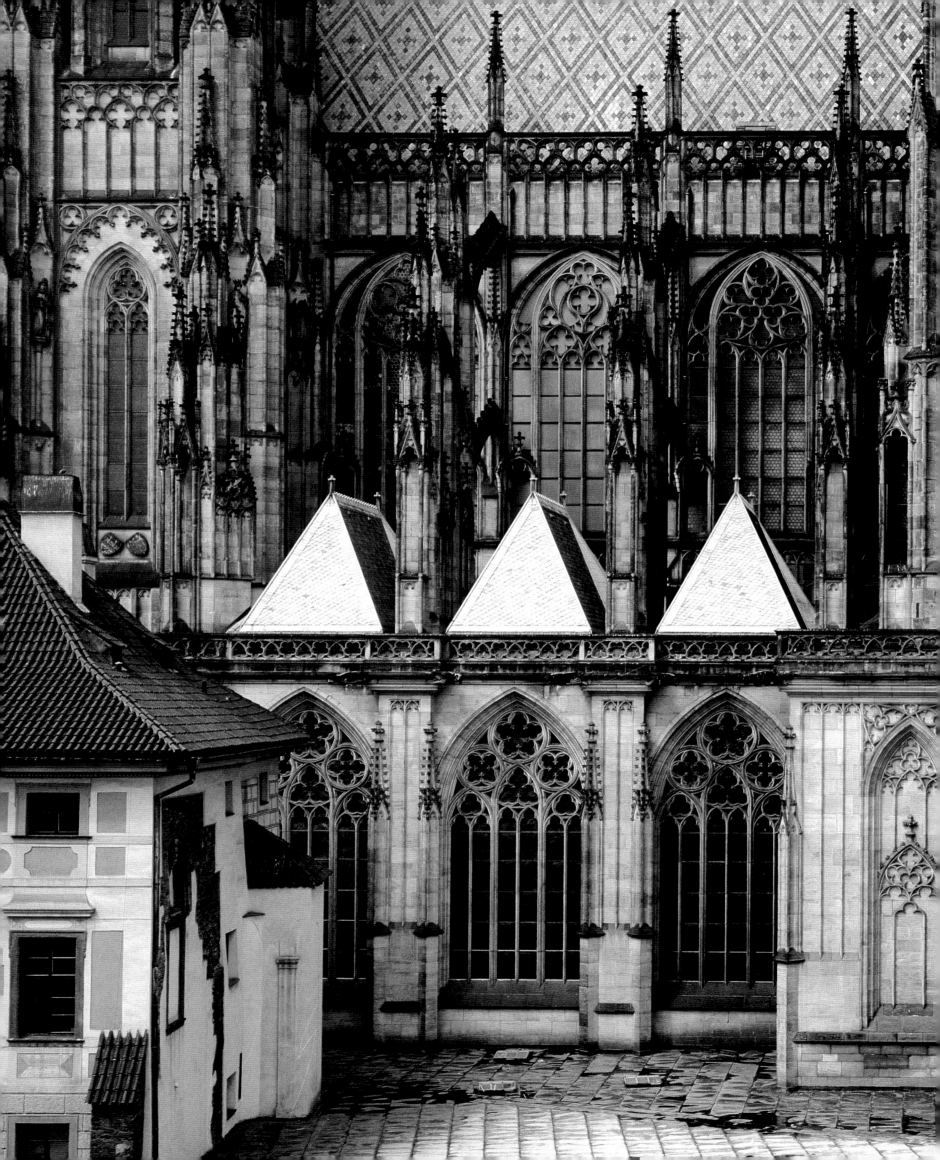

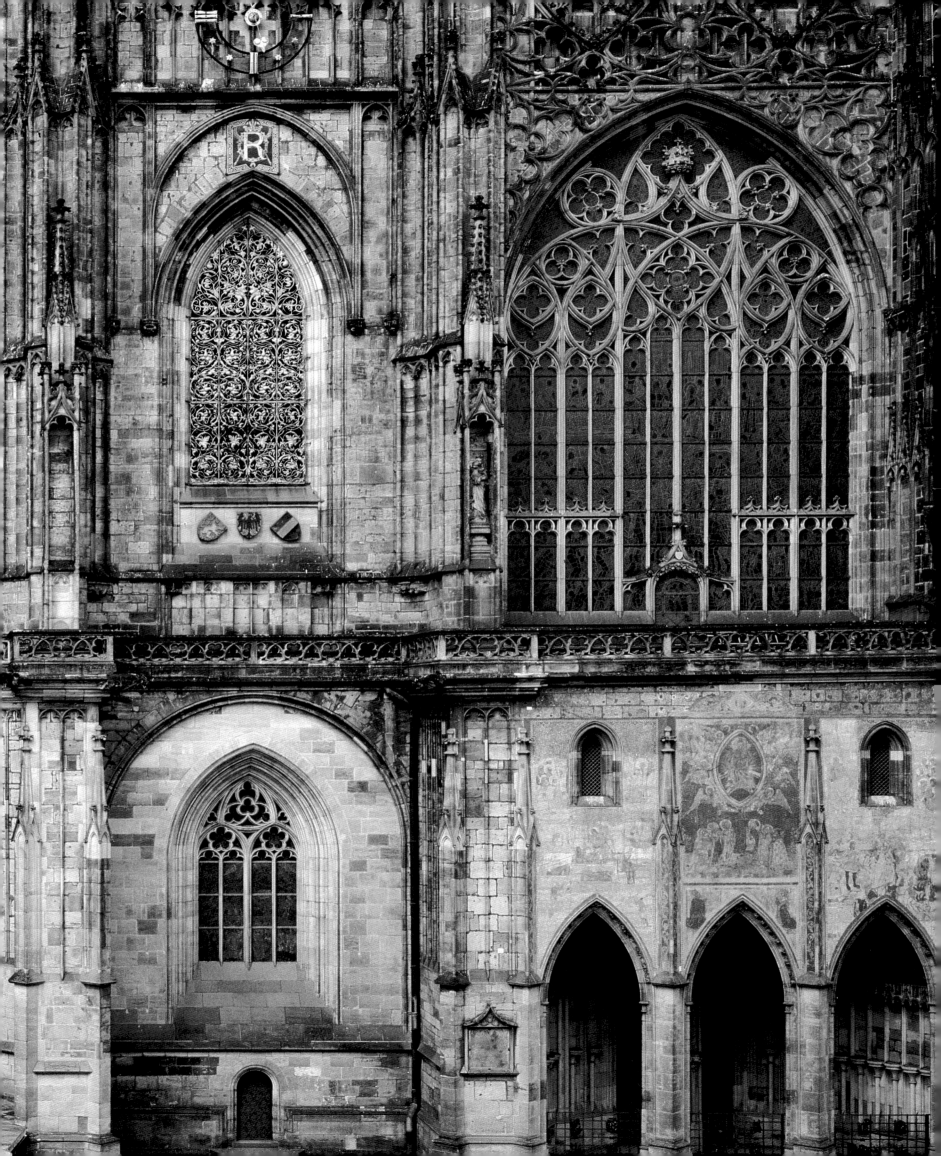

Below: *the flying buttresses* of the cathedral, like the pinnacles, show a high level of elaborate workmanship.

Opposite page: *spire on the roof of St Vitus's Cathedral*, above the point where the transept crosses the central nave. It is the dominant feature of the neo-Gothic roof, standing 26 metres (85 ft) high.

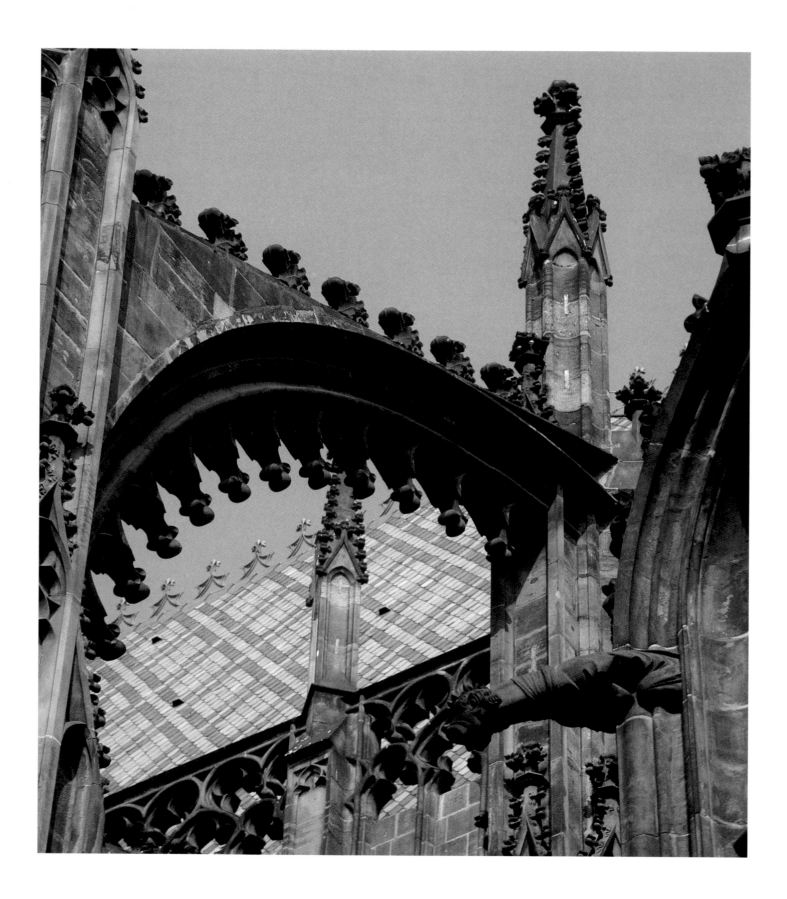

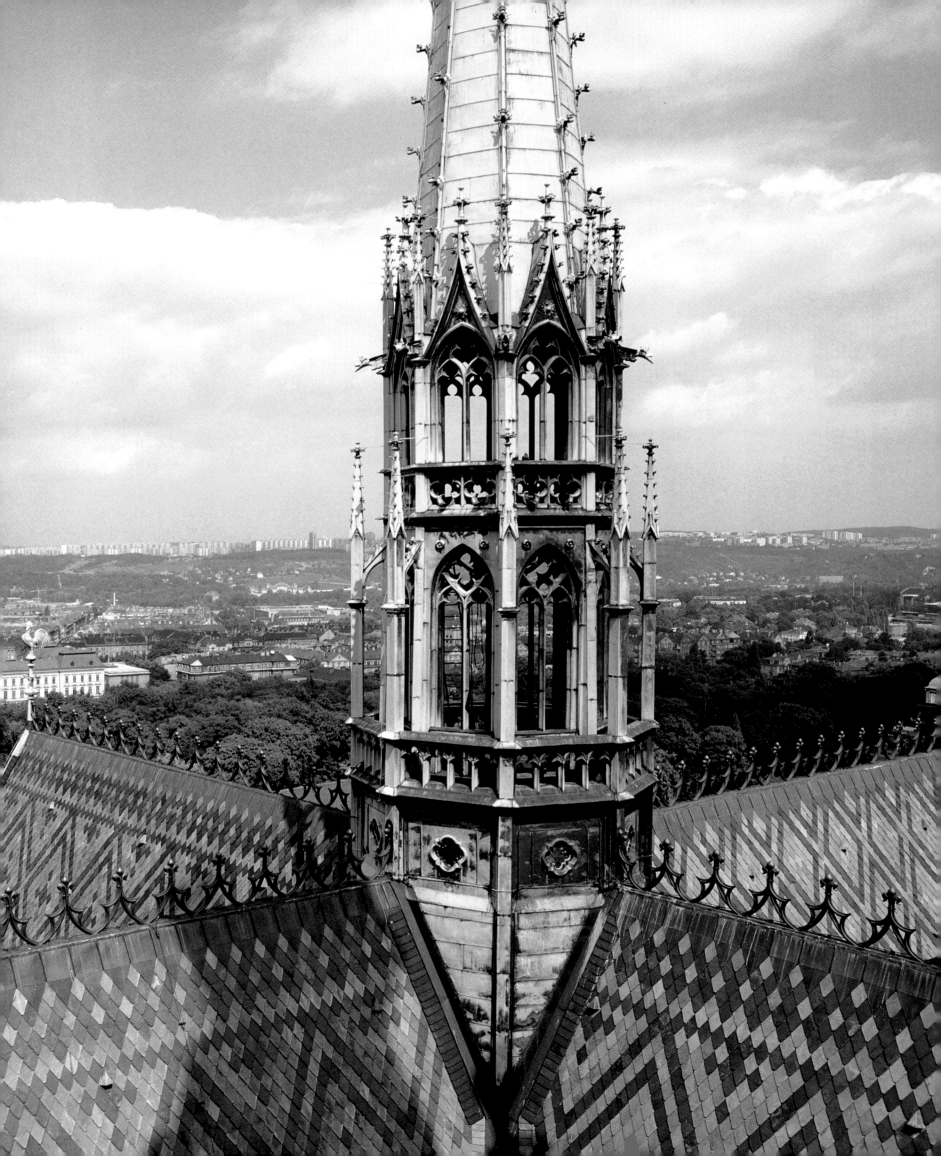

Console of the tabernacle of the south-eastern pillar at the end of the choir, with carvings on the theme of Original Sin, probably from 1385. A remarkable product of Peter Parler's workshop, it dates from the period when sculpture was evolving towards the Flamboyant Gothic style.

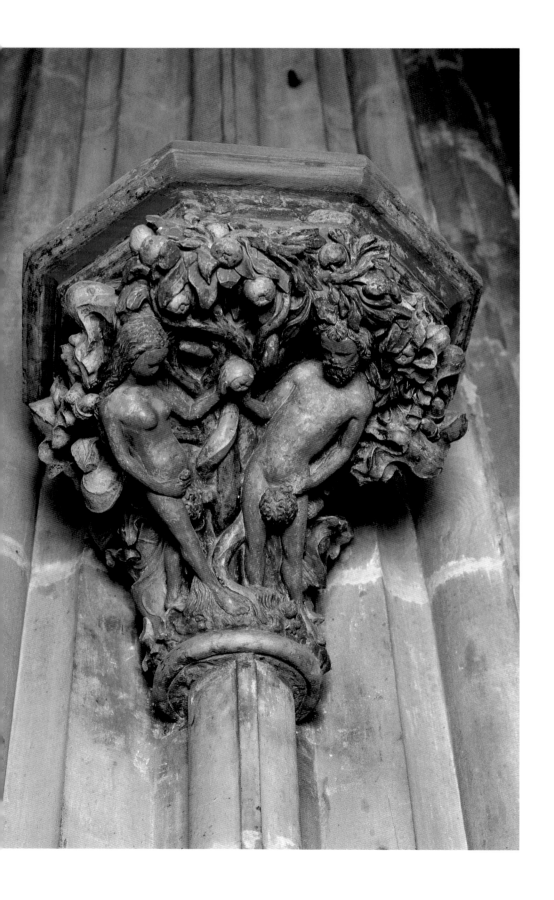

Opposite page, top to bottom: the emblem of the Czech kingdom (two-tailed lion), the crowned initial of King Vladislav II Jagiello, and his emblem (a crowned spread eagle) appear on a pendentive in the Royal Oratory.

Below: *the Oratory of Vladislav II Jagiello*, in the south nave of the choir, built by Hans Spiess from 1490 to 1493. With its wealth of ornamental and heraldic decoration in the naturalistic Late Gothic style, it is an important example of the development of the cathedral architecture under the Luxembourgs.

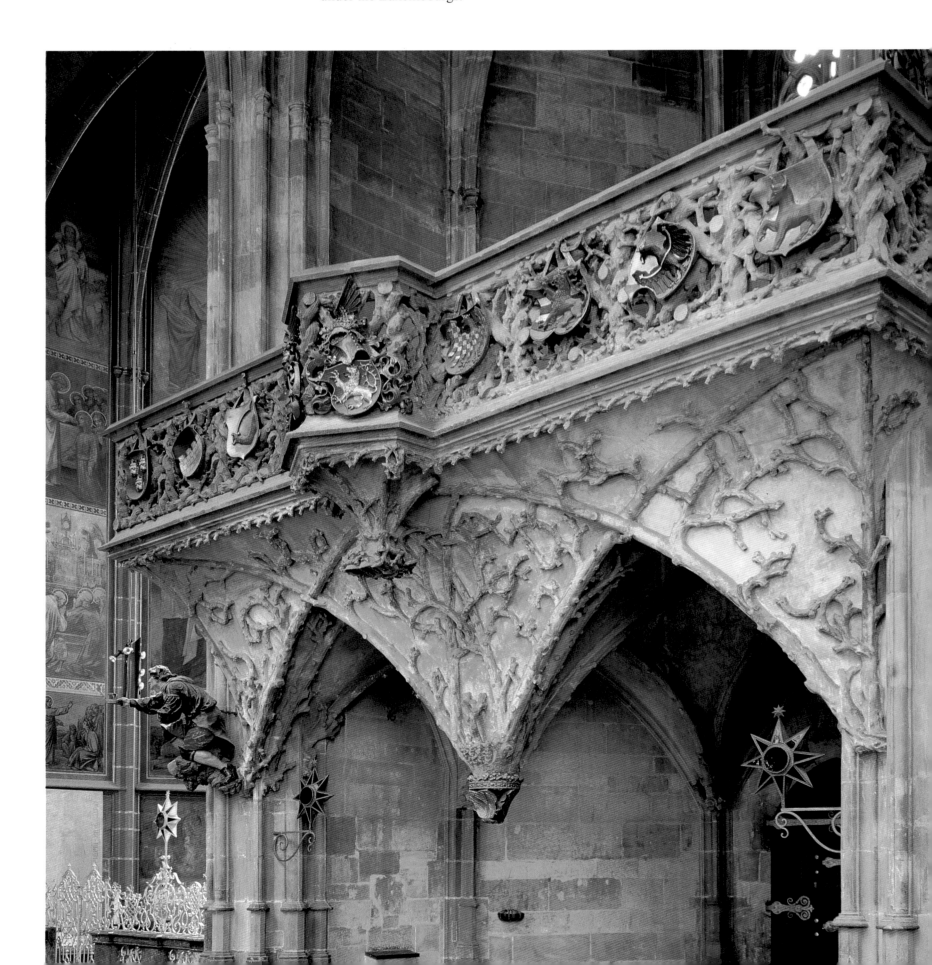

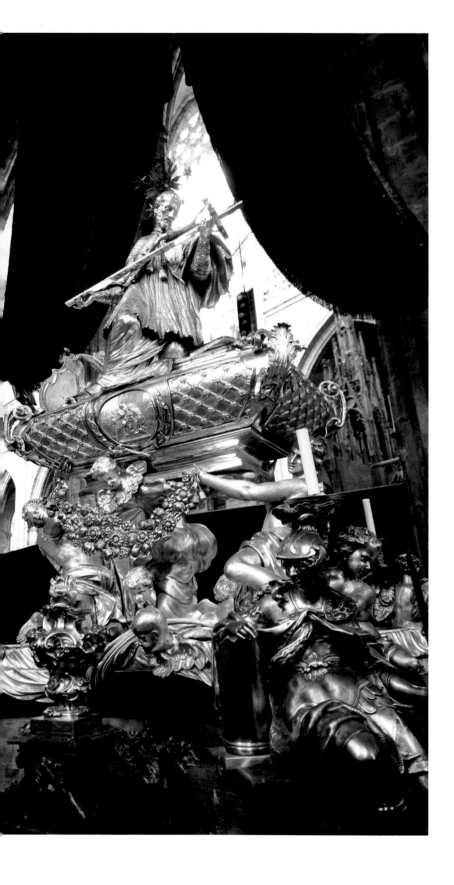

Opposite page, left: *sculpture of St John of Nepomuk* (canonised in 1729) on his Baroque silver sarcophagus at the south-eastern end of the ambulatory. This is a work by Antonio Corradini, dated 1733-6, after a model by Josef E. Fischer von Erlach.

Opposite page, right: *Apotheosis of St Sigismund* on the Baroque altar in this side chapel in the north nave, sculpted by František Ignác Weiss between 1735 and 1741. This example of the dynamic Baroque style found its way into the Gothic part of the cathedral following the victory of the Counter-Reformation in Bohemia and Moravia.

Below: *Baroque funerary monument of the Grand Chancellor Leopold Šlik* near the south pier of the ambulatory. It was made between 1723 and 1725 by Matyáš Braun, the most important Czech sculptor of the Late Baroque, and the assistants of his workshop.

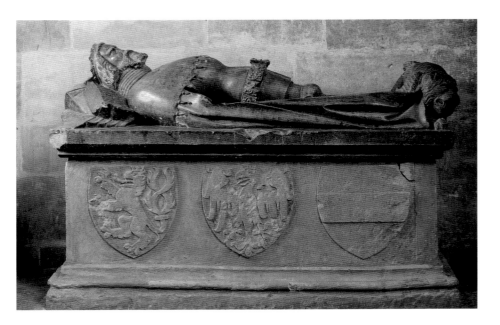

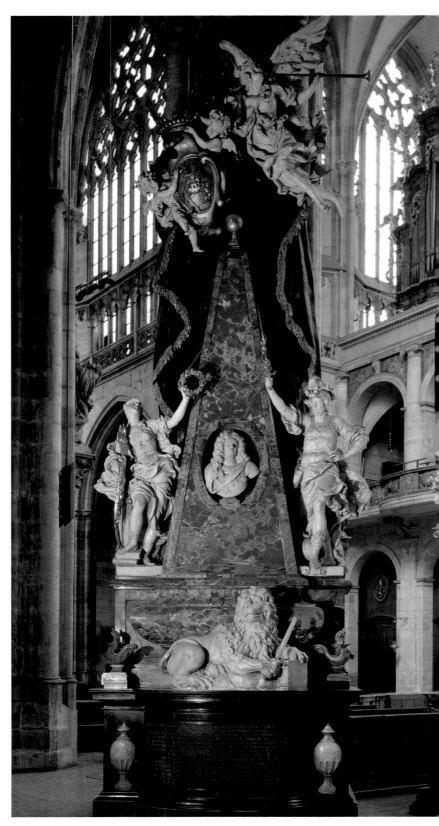

Above: *the sarcophagus of Přemysl Otakar II,* dating from 1366-7 in the Chapel of Holy Relics (Saxon Chapel). One of Peter Parler's most celebrated works, the sarco-phagus, with its recumbent figure, was commissioned by Emepror Charles IV in memory of the king who died tragically in the battle of Moravské Pole.

"The charm of Prague's Baroque night drew me like the stage of a theatre, invited me into its corridors, at once as actor and spectator. The towers of the cathedral, with their capitals and golden crosses, and the bold lines of the roofs of the palaces were, like an orchestra, in harmony with my inexpressible mood."

Alexandr Kliment: Trouble in Bohemia

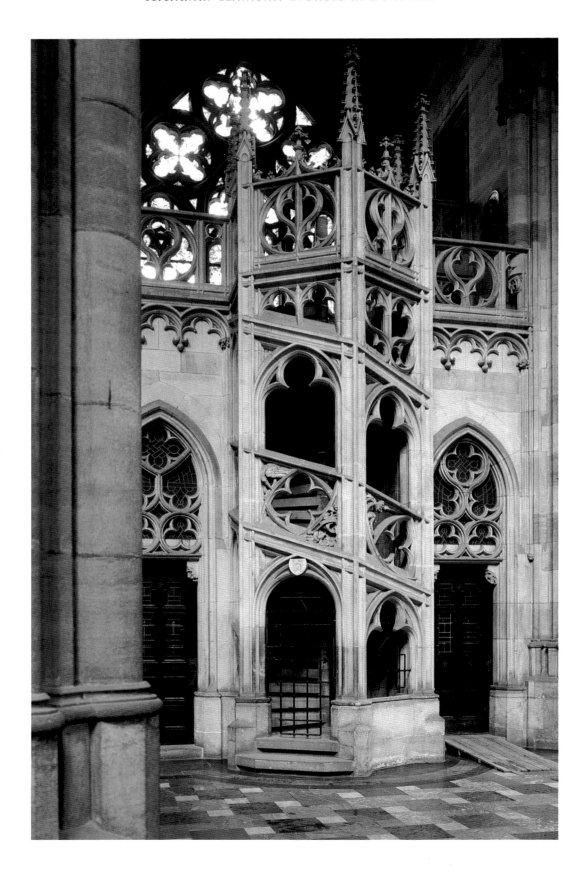

Spiral staircase leading to the Treasure Chamber of the cathedral. Neo-Gothic in style, designed by Kamil Hilbert, it was built between 1905 and 1909 by the stonemasons of St Vitus's new workshop.

Opposite page: *view from the west of the central nave*, after the removal of the wall separating the choir from the modern neo-Gothic transept and the three aisles of the nave. The vault of the choir was designed in 1385 by Peter Parler and that of the central nave in 1903 by Kamil Hilbert. At the eastern end of the cathedral, there is a strong contrast between the dark zone of the ambulatory arcades (attributed to the first builder of the cathedral, Matthew of Arras, who died in 1352) and the highly luminous effect created by the skeletal architecture of the triforium and Peter Parler's windows.

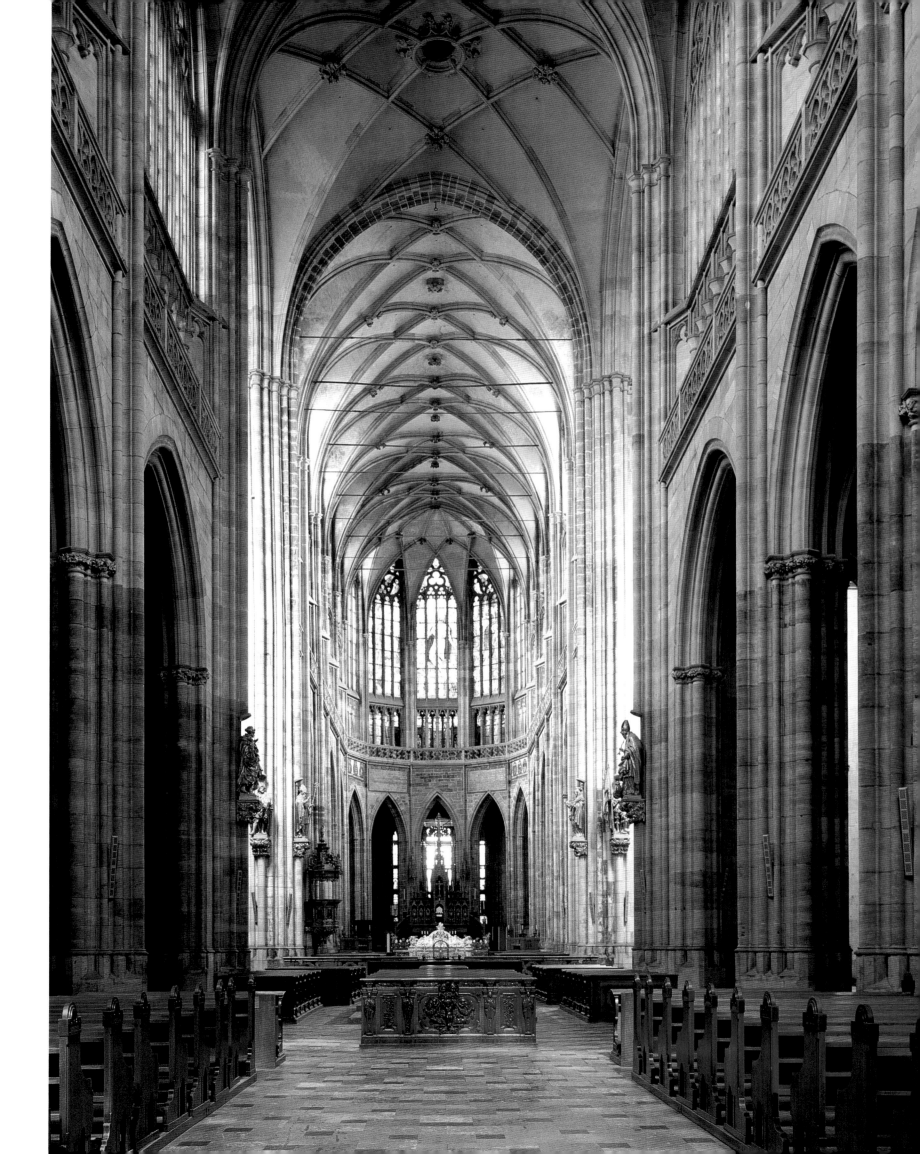

THE TRIFORIUM
GALLERY OF BUSTS

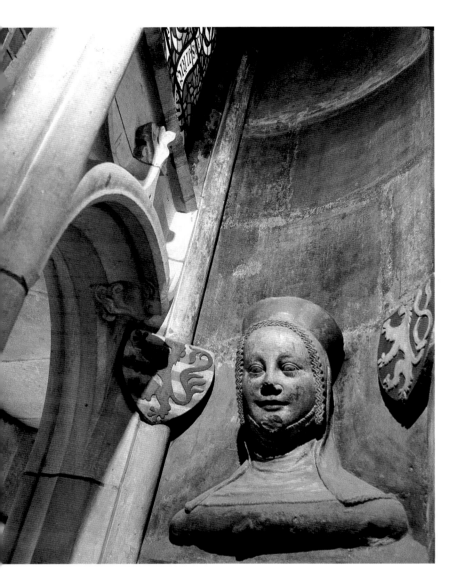

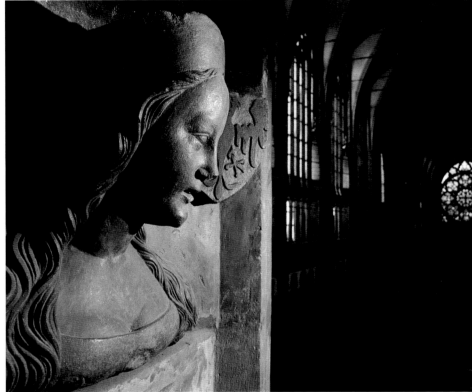

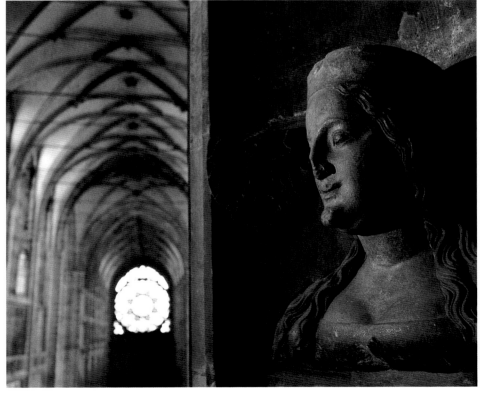

A unique group from the Middle Ages: Charles IV; his mother Eliška, last of the Přemyslids, wife of John of Luxembourg (above); and his four wives, Anne of Silesia, Elizabeth of Pomerania-Stolp, Blanche de Valois and Anne of Bavaria. These life-size busts were carved in sandstone in 1374-5 by Peter Parler and other sculptors of his workshop. The Latin inscriptions engraved beneath the busts in 1389-92 were undoubtedly suggested by the director of the works, Václav of Radeč.

"In the end we returned to Bohemia after an absence of eleven years. We no longer found our mother alive; she had died several years previ-ously... So it was that on our arrival in Bohemia, we found neither father, nor mother, nor brother, nor sister, nor even a friend."

Charles IV, in his autobiography

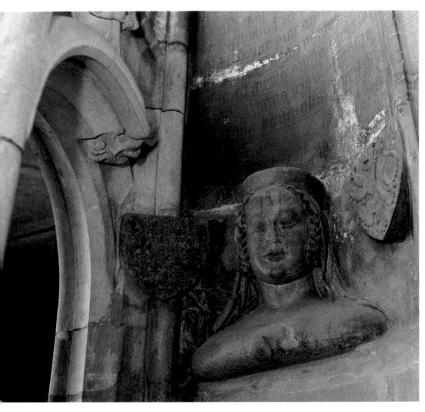

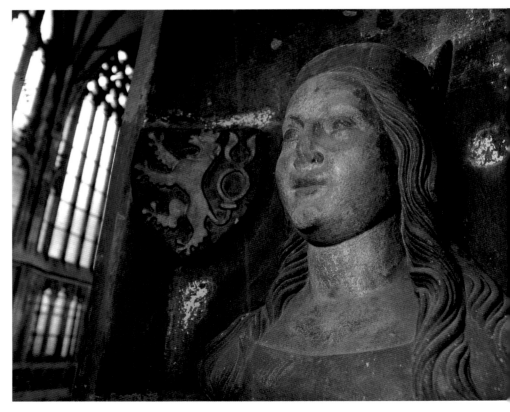

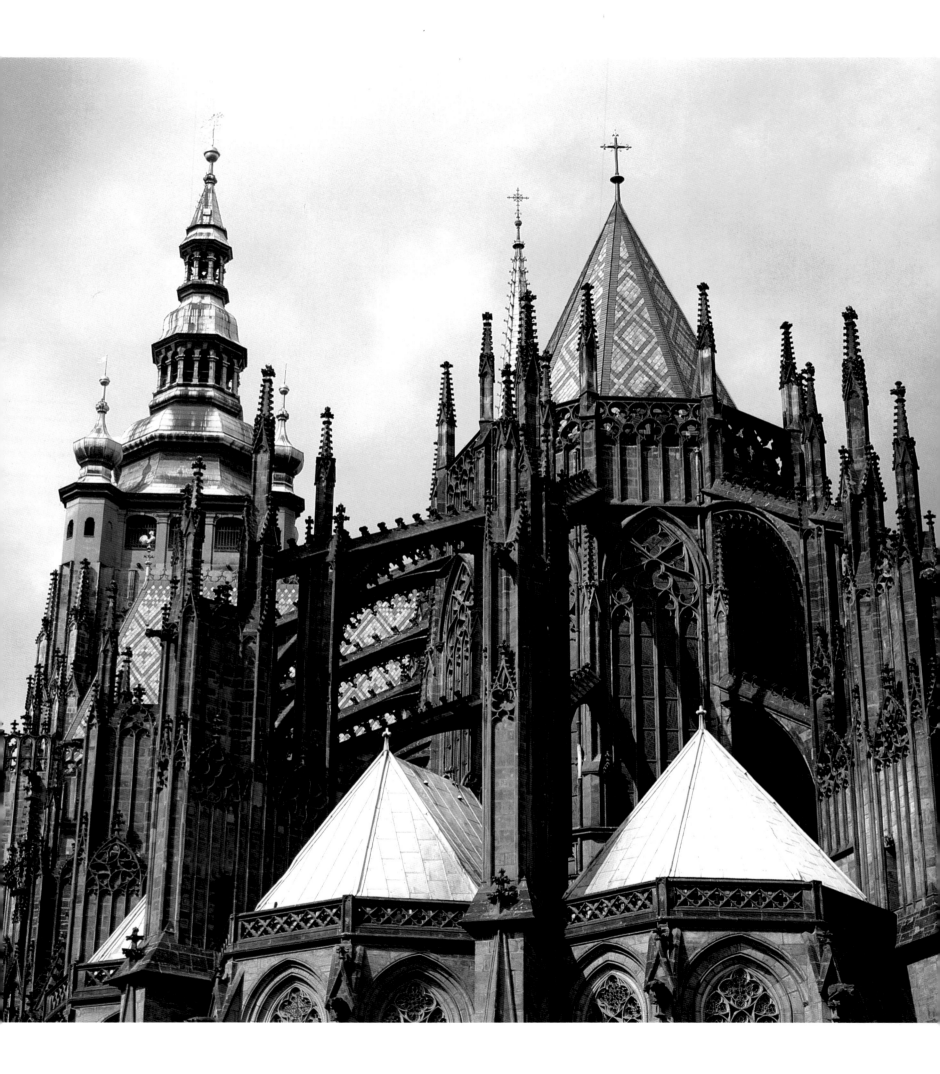

St Vitus's Cathedral: *view from the east of the choir* and its flying buttresses, the work of Peter Parler from 1371 to 1385. Behind is the Renaissance-style South Tower.

In 1421, because he had accepted the Four Articles of Prague that constituted the principal demands of the Hussites, the seventh archbishop of Prague, Konrád of Vechta, was anathematised. The archbishopric remained vacant for 140 years. Given the additional fact that after Wenceslas IV the Czech kings no longer resided in Prague Castle, little progress was made, in rebuilding the cathedral at the end of the revolutionary Hussite period, in 1434. A change of policy did not come about until the accession of the Catholic Vladislav II Jagiello, king of Bohemia from 1471 to 1516. For fear of disturbances among the Calixtin population of Prague, he took up residence at Prague Castle in 1483, and initiated a series of improvements, including the building of a new corridor linking the Royal Palace, by way of the Vladislav Hall, with the new Royal Oratory in the south nave of the cathedral (1490-3). The designer of this corridor was the Master Hans Spiess of Frankfurt-am-Main. The parapet of the oratory, in Late Gothic style and covered with a naturalist dead-branch pattern of ornament, bore many emblems of the Vladislav II Jagiello coat-of-arms. The creation of the Royal Oratory was the first building enterprise in the cathedral since the Hussite period. In 1509, Vladislav embarked on the even more ambitious scheme of completing the construction of the cathedral: work started on the foundations of the pillars of the church nave and of the North Tower, but it was abandoned after the third season.

Wishing to re-establish the tradition of Charles IV, by generous donations Vladislav II did much to replace the objects that had been destroyed. The cathedral treasury preserves the silver reliquaries in the form of busts of St Vitus (1484-6?), St Wenceslas and St Adalbert (1497-1500) which replaced the destroyed busts of the Luxembourg period. In the fine bust of St Wenceslas, J. Homolka has pointed to an early affinity, in the form and expression of the face, with Italian Renaissance sculpture. Like Charles IV, Vladislav II paid particular attention to St Wenceslas's

Chapel. He commissioned a mural painting of the Czech patron saints (probably in 1484-5) above the main altar. Among the group of saints are two angels on either side of Peter Parler's statue of St Wenceslas, placed on a bracket in the centre of the picture, after it had been transferred from its position outside (above the chapel, under a baldaquin). In 1502 the king donated a purple cloak specifically intended for this statue (*palium de purpura rubea supra imaginem s. Venceslai*).

The series of wall paintings relating the legend of the saint was doubtless part of the preparations for the ceremonial coronation of Louis II Jagiello as king of Bohemia in 1509 (while his father was still alive), in St Vitus's Cathedral. They were done by the Master of the Litoměřice Altar (the most expressive Late Gothic painter in Czech lands at a time of transition to the Renaissance style) and his assistants. The great scene of the miraculous reception of St Wenceslas at the imperial Diet by Emperor Henry I the Fowler (876-936), placed above the west entry to the chapel, is on two levels; the upper section beneath the vault recalls the ancient right of the kings of Bohemia to the first vote for the elector and, also without doubt, is an allusion to the agreement signed in 1507 for the marriage of Louis to the granddaughter of Maximilian I, Mary of Habsburg. Altogether, this scene, with its hierarchical organisation, is an elegant depiction of a court ceremony. It may be possible one day to identify more precisely each of the persons represented.

In this chapel and beneath this painting, so full of promise from the viewpoint of contemporary Czech aspirations, Ferdinand I was elected king of Bohemia on 24 October 1526. Founder of the reigning dynasty of the Habsburgs in Bohemia and Moravia (a dynasty that lasted until 1918), he succeeded his brother-in-law Louis II Jagiello, who died tragically after the defeat at Mohács without issue. So it was during the Habsburg era that the maltsters of Staré Město (the Old Town) made a donation to the cathedral, apparently to replace an

object from the time of Charles IV, of a bronze candelabrum in Early Renaissance style, made in 1532 at Nuremburg by Hans Vischer. This gift was intended to commemorate the saving of the cathedral in 1421.

A disastrous fire gutted the cathedral and the rest of the castle on 2 June 1541. Its restoration, in Renaissance style, took twenty long years. Among the work undertaken was the erection of a new loft for the organ and choristers in the western part of the church: it was built by the Prague court architect Boniface Wohlmut, originally from Uberlingen, in Baden, who died in 1579 (in 1924 this loft was transferred to the north arm of the transept). From the architectural point of view, it employed, for the first time in Bohemia, superimposed Renaissance columns, on the model of Sebastiano Serlio. As a man of the north, Wohlmut accentuated the link with the tradition of Gothic architecture by covering the ground floor with a massive, ingeniously designed, rib vault. His is also the original form — a Renaissance onion-shaped dome — of the present-day spire of the high South Tower of the cathedral, which was far removed from the Gothic spirit. On the first floor is the great Sigismund (Zikmund) bell which is 2.03 metres (78 in) high, cast in 1549 by Tomáš Jaroš of Brno.

The fire of 1541 destroyed the marble sarcophagus of St Adalbert, on the west side of the triple nave of the church built in the 14th century. In 1556, on the orders of Emperor Ferdinand I, the pillared arcades were removed and the space thus gained was used as a tomb: above the tomb of the saint, the Italian Ulrico Aostalli built, in 1575-6, perhaps according to an old plan of Wohlmut, an oval decagonal chapel (destroyed in 1879). This chapel was undoubtedly erected in response to the wishes of Antonín Brus of Mohelnice (1561-80), the first post-Hussite archbishop of Prague. Around 1566, to honour the memory of his dead parents (Ferdinand I and Anna Jagiello), Maximilian II commissioned from the Dutch sculp-

tor Alexander Colin (of the court of Ferdinand I at Innsbruck) a huge marble mausoleum which was placed, as a last resort, in front of the choir, on the central axis of St Vitus's Cathedral. The work was not completed until 1589, after modifications to the original design at the behest of Rudolf II (king of Bohemia from 1576 to 1611). At his express wish,

142

example of Renaissance craftsmanship. The reliefs on the circular medallions represent the Annunciation and the Holy Trinity; the other figures on the outside of the bell are the patrons of the country and Ferdinand I and his wife.

a statue of Maximilian II was added to those of Ferdinand I and Anna Jagiello on the lid of the mausoleum, while medallions of Charles IV and his four wives, of Wenceslas IV and two other Czech kings, Ladislav Posthumous (king of Bohemia, 1453-7) and his successor, George of Poděbrady (reigned 1458-71), were attached to the sides. The protective grille of the tomb, considered to be the most important piece of ironwork of the time in Bohemia, was made (except for the few later additions) by Jiří Schmidthammer, an ironsmith from the Malá Strana quarter. Below the mausoleum was the royal crypt, built in 1589-90 by Ulrico Aostalli, again at the wish of Rudolf II, who was eventually buried there in a richly decorated tin coffin. Among the numerous non-royal, but historically important burials in the cathedral at this time, mention must at least be made of the marble sarcophagus of Vratislav of Pernštejn (d. 1582) and the tomb that the Spanish aristocrat Maria Manrique de Lara had made for her husband, the grand chancellor of the kingdom of Bohemia.

In 1619, the Czech Estates deposed Ferdinand II and elected to the throne of Bohemia the Elector Palatine Frederick V, who was the head of the Evangelical Union. Following this decision, fatal from the political point of view in that it marked, in fact, the beginning of the Thirty Years' War, calamity struck St Vitus's Cathedral for the third time: on 21 and 22 December 1619, Calvinists led by Abraham Scultety, preacher of the royal court, devastated the cathedral, intent on making it a Calvinist oratory. The cathedral was not surrendered to the Catholics until after the victory of the armies fighting for Frederick II at the battle of the White Mountain, on 8 November 1620. Doubtless it was to compensate for the damage done to the cathedral that Ferdinand II donated a new reredos for the high altar: a large painted triptych with, in the centre, *St Luke Painting the Virgin Mary and the Infant Jesus*. It was a work by the celebrated Dutch painter Jan Gossaert, known as Mabuse, certainly done around 1513, which hangs today in the Prague National Gallery.

The progressive changes dating from the beginning of the Baroque period took place in the time of the cardinal-archbishop Arnošt of Harrach (1623-77). Caspar Bechteler, the court cabinet-maker, was responsible for the following works: in 1631, the throne; in 1630, the door in relief in the ground floor arcade of the organ loft, originally in the west wall of the choir; and also, after 1631, two large reliefs, on the south and north sides of the choir, representing, in strikingly epic terms, the destruction of the cathedral in 1619 and the flight from Prague of the King for a Winter, Frederick the Palatine, in 1620. An unfortunate soldier, but a great lover of art, Archduke Leopold William, who had been, among other things, bishop of Olomouc from 1632 to 1662, commissioned, in 1641, the design and casting in bronze of a new stand for the Romanesque candelabra, known as the Jerusalem Candelabra. This object, much prized in Czech history — it was reputed to have been the booty of a Czech duke at the capture of Milan — had been badly damaged by the Calvinists. Today, only four branches remain, with small busts of four patron saints of the kingdom, St Wenceslas, St Vitus, St Adalbert and St Methodius.

Inspired by local patriotism, Czech historians of the Baroque era drew heavily on the example of the old national patron saints and focused much attention on the religious history and monuments of the pre-Hussite period. The most important of these, the Jesuit Bohuslav Balbín (1621-88), as well as his colleagues, showed particular interest in St Vitus's Cathedral. Jan Tomáš Pešina of Čechorod (1629-80), then dean of the cathedral chapter and later titular bishop of Prague, published in 1673 a work entitled *Phosphorus septicornis, stella alias matutina (Seven-branched ray, otherwise morning star)*, one chapter of which was largely devoted to the relics of St Vitus's Cathedral. In the same year, G.D. Orsi, at the expense of Emperor Leopold I, king of Bohemia from 1657 to 1705, began digging again the foundations of the church nave — a nave

Etching: Coronation of Leopold I in St Vitus's Cathedral, by Kašpar Pluth, dated 1791, one of a series of twelve engravings printed for this occasion.

wholly Baroque in conception, radically different from the Gothic choir, as can be seen from contemporary paintings. But the great uprising of the serfs (1679-80), the disaster of the plague (1680) and the breakthrough of the Turkish army towards Vienna (1683) rapidly brought this project to an end.

There are, nevertheless, a number of valuable Baroque works in the cathedral. František Preiss (*c.* 1660-1712) carved wood sculptures, in 1696, of eight Czech patron saints, slightly larger than life-size: these sculptures are today in the crossing of the transept, whereas originally they were placed on the piers of the choir. The same Prague sculptor was also certainly responsible for the moulds of the silver busts of St Wenceslas, St Adalbert, St Vitus and St Cyril, initially made for the high altar and subsequently transferred to the Chapel of St John of Nepomuk (previously the Chapel of St Erhard and St Odile). These had been donated to the cathedral by Jan J. Breuner, archbishop from 1694 to 1710. Between 1735 and 1741 the reredos of the St Sigismund altar, undoubtedly designed by Jan B. Fischer von Erlach, took on a Baroque appearance thanks to a figurative representation of the saint's apotheosis by František Ignác Weiss (*c.* 1690-1756). The highly elaborate sculptures on the tombstone of Leopold Šlik, grand chancellor of the Czech kingdom, with its pompous epitaph dated 1723-5, were the work of Matyaš B. Braun (1684-1738), the most important of Bohemia's Late Baroque sculptors, and of his studio. It is not of very high quality and certainly does not rank among his best works. The same is true of the painting *Baptism of Christ* (1722), hanging near the sacristy, done by Petr Brandl (1668-1735), a Czech Baroque artist of the time.

After the end of the Thirty Years' War and the victory of the Counter-Reformation, the cult of the most popular saint of the Czech Baroque, the cleric John Nepomuk, martyred on 20 March 1393 and buried in the south part of the ambulatory of St Vitus's Cathedral, steadily intensified. He was canonised by Pope Benedict XIII on 19 March 1729. In that same year, Jan F. Schor (1686-1757) proposed completing the cathedral, this time in the Gothic style, but not even this project was carried out. The great silver altar-tomb of the saint, surmounted by a ciborium, was a magnificent monument, the culmination of the cult of St John of Nepomuk in St Vitus's Cathedral during the Baroque period. Baldaquin included, it stood five metres (over 16 ft) high and was fashioned in stages, on the site of the original burial of the saint, between 1733 and 1771, at the expense of Emperor Charles VI (king of Bohemia from 1711 to 1740). It represents the apotheosis of St John Nepomuk, carried in his shroud to heaven by angels. The central scene was created in Vienna between 1733 and 1736, based on the design of Josef E. Fischer von Erlach; Antonio Corradini modelled it in wood and Jan Josef Würthle sculpted it in silver.

The numerous attempts to complete St Vitus's Cathedral were not realised until the 19th century, when the Romantic movement looked to the past for evidence of the nation's political, religious and cultural stature. In 1842, Cologne Cathedral was completed; two years later, at the third congress of German architects, in Prague, Canon Václav Pešina (1782-1859) demanded the same for St Vitus's Cathedral. But the opportune moment only arrived during the time of Bedřich J. Schwarzenberg (cardinal-archbishop from 1849 to 1885). In 1859 a Union for the Completion of St Vitus's Cathedral was formed, with Count Thun Hohenstein as its first elected president. To bring the project to a successful conclusion, a new builder of the cathedral was appointed, the architect Josef O. Kranner (1801-71), born in the Malá Strana quarter of Prague. His first assignment was to save and restore the remains of the medieval building, which were in a dangerous condition (as a result of dilapidation and the 1575 Prussian bombardment during the siege of Prague). The contemporary fashion for purity of style persuaded him to adopt the Gothic and to reject the later ornamentation. To replace the Renaissance triptych, with its central painting by

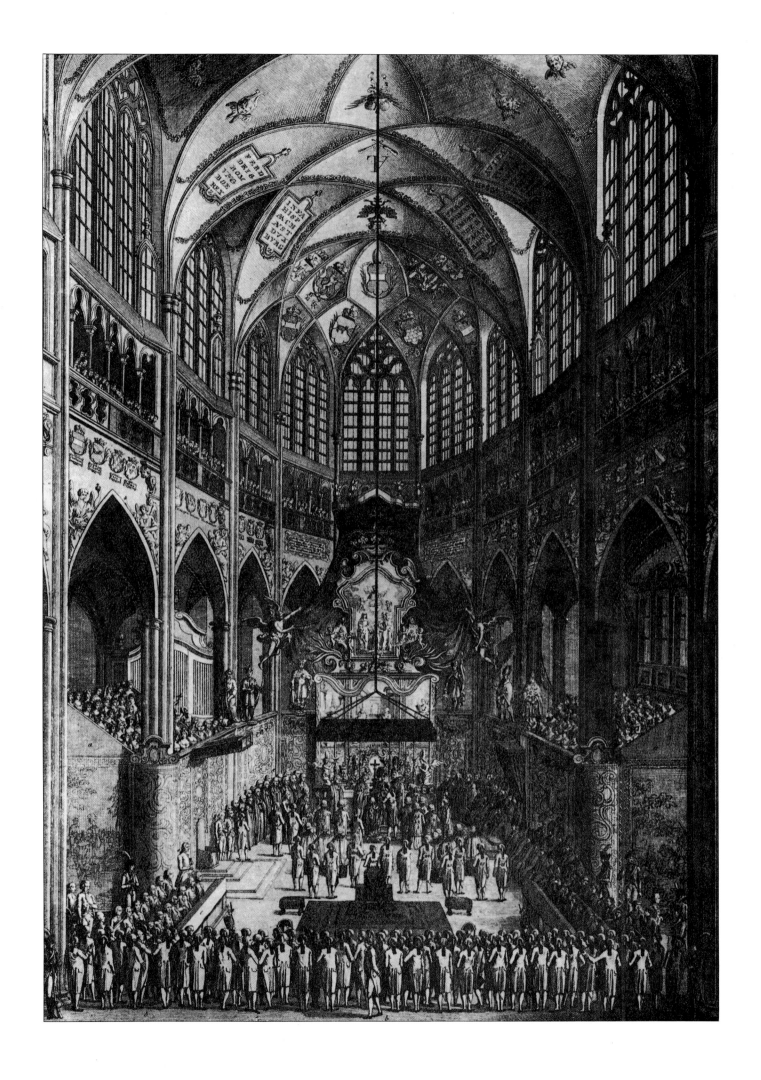

145

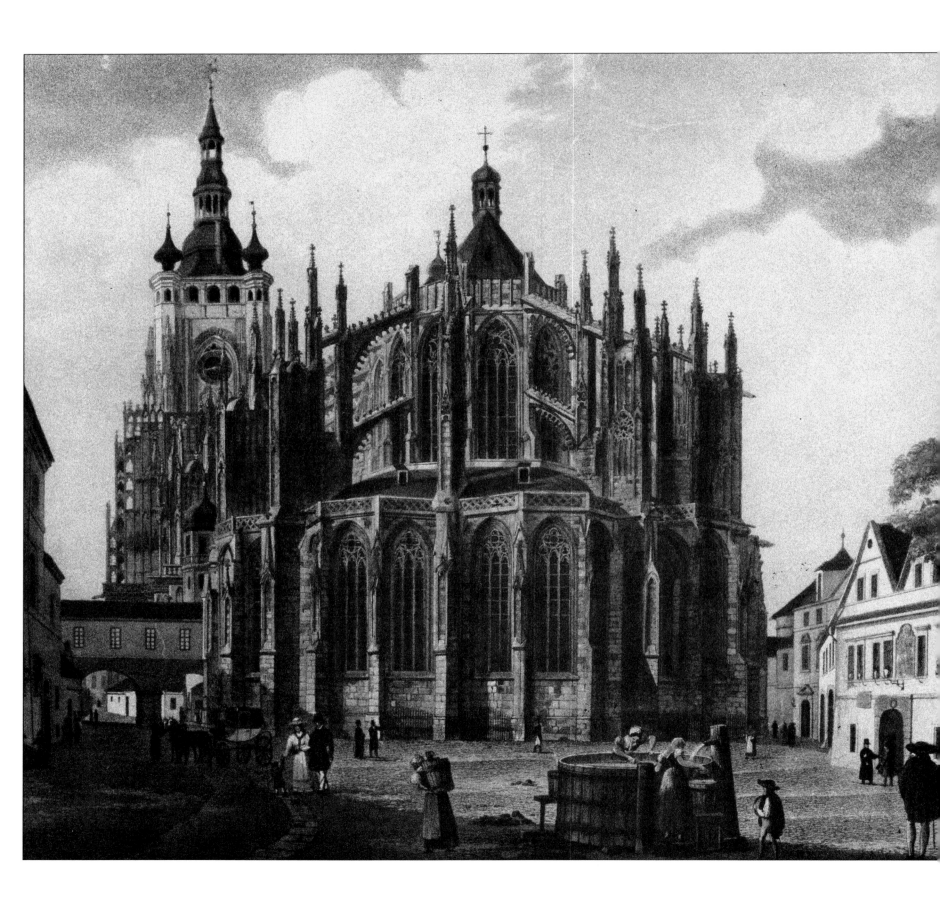

146

Jan Gossaert (Mabuse), which had been transferred in 1870 to the gallery of the Society of Patriotic Friends of Art, he designed a neo-Gothic high altar.

In 1866, because of the threat posed by the Austro-Prussian Seven Weeks' War, the Czech Crown Jewels were removed to Vienna. On their return, they were deposited in a new treasure chamber, built by Josef Kranner in the ancient sacristy above St Wenceslas's Chapel.

In 1873, on the 900th anniversary of the creation of the diocese of Prague, Cardinal Bedřich J. Schwarzenberg laid the foundation stone of the three-aisled nave; and in 1879 the St Adalbert (Vojtěch) Chapel, which had stood in the way of this project, was demolished. The work was directed by Josef Mocker (1835-99), the leading exponent of pseudo-Gothic building in Bohemia. He had studied at the Technology Institute and Academy of Fine Arts in Vienna, and had participated in some of the restoration work, from 1863 onward, at the St Stephen Cathedral in Vienna, directed by Friedrich Schmidt. On Mocker's recommendation, the three aisles were completed by a series of side chapels, and the distant view of the cathedral was highlighted by a new twin-towered west front. This academic approach, insensitive to local feeling, aroused criticism. Mocker was reproached for having obliterated the traditional panoramic effect of the old cathedral and for having 'destroyed the exclusively lateral orientation towards the town, which had been the hallmark of Peter Parler's building' (Josef Cibulka).

In the course of the 19th century the interior of the cathedral was considerably modified by the commissioning of new works in various styles imitating those of the past. Only a few of these can be mentioned. The altar-tomb of St Vitus, dating from 1840, situated in the centre of the ambulatory of the choir, was designed by Josef Kranner, and the statue of the saint executed by Josef Max (1804-55), chief representative of the Prague school of sculpture during the first half of the 19th century. Josef Kranner also designed the sandstone altar,

dated 1849, in St Ludmila's Chapel, which stood in the Chapel of the Virgin Mary until 1901. The carvings of this altar, including the statue of St Ludmila, in Carrera marble, were by Emmanuel Max (1810-1901), who had lived for some time in Vienna and Rome. The marl altar of St John the Baptist's Chapel was built in 1876 to the designs of Josef Kranner and Josef Mocker. Václav Levý (1820-70), who played an influential role in the development of Czech sculpture in the second half of the 19th century, did the terracotta statues for this altar, with one exception: the statue of St Methodius, made by Josef M. Myslbek (1848-1922) at the beginning of his career. Myslbek was the man who spearheaded the national revival of Czech sculpture, and he is represented in the cathedral by one of his most admired works: a monument cast in bronze, dating from 1891-5, in commemoration of Cardinal Schwarzenberg, 2.04 metres (80 in) high and standing in the north part of the choir. In the early 1980s it was still considered in Prague to be the most valuable Czech contribution to modern world sculpture (Antonín Matějček).

The rebuilding of the cathedral was nonetheless completed, as already planned, in neo-Gothic style, which thereby survived, in terms of general artistic development, far longer in Prague than in other parts of Europe. In 1903 the main nave was covered with a rib vault, on the lines conceived by Peter Parler. In 1909 a new sacristy was built in the northern side aisle; and over it a treasure chamber, which today once more houses the cathedral treasure. The great rose window of the west front dates from 1915. In 1924-5 a violent argument broke out between the supporters and opponents of a scheme to preserve the medieval wall separating the ancient and modern parts of the cathedral: the verdict went against those in favour of a strict conservationist approach, in keeping with the principles of Alois Riegl. Finally, to commemorate the millenary of the martyrdom of St Wenceslas, on 28 September 1929, the prayers of past generations

were answered and the completed cathedral was opened to the public.

The decoration and furnishings of the new part of the cathedral were not based on any homogeneous principle. The contemporary view of art was encouraged, but stress was laid on observing the decorous expression of religious art. Even today, only a few works of this recent period can be mentioned. The bronze west door was executed in 1927-9 after the designs of the painter Vratislav H. Brunner and the models of Otakar Španiel. On the sides of the rose window of the west façade are stone busts of the cathedral builders by Vojtěch Ducharda (1929). A large number of people who made contributions to the building of the cathedral are represented by sandstone busts in the new triforium. They are the works of a number of eminent pre-war Czechoslovak sculptors: Josef Štursa, Bohumil Kafka, Ladislav Kofránek, Jan Lauda and Břetislav Benda.

Of exceptional interest is the remarkable collection of stained glass, done well after 1929. The window of the Thun Chapel, a work by František Kysela, founder of modern stained-glass window art, has for its subject the threats against human life and its defence (1927, the donation of the first Czech insurance company). At the time of the Secession, Alfons Mucha (1860-1939), that great patriot and internationally famous artist, designed the window of the Archbishops' Chapel representing the legend of Cyril and Methodius, which was completed in 1931. Max Švabinský (1873-1962) also carried out many stained-glass projects; professor of graphic arts at the Academy of Fine Arts, Prague, until 1927, he found ample scope for his talents in the cathedral. Most notably he created the great window of the south arm of the transept, which depicts the Last Judgement (1935-9), and the windows at the end of the choir representing the Holy Trinity (1939-49).

There are many visitors to the Royal Crypt, refurbished from 1928 to 1935 to the designs of the architect Kamil Roškot. Together with the sculptor Ladislav Kofránek, he designed new tombs for the Czech monarchs buried there: Charles IV, Wenceslas IV, George of Poděbrady, and others. The work of embellishing St Vitus's Cathedral was resumed after the World War II and still continues.

Stained-glass window of the Archbishop's Chapel, in the north aisle of the nave. This Apotheosis of the evangelising saints Cyril and Methodius, with an allegory of the Slav people, is based on a design, inspired by Slav and Czeh patriotism, by Alfons Mucha, one of the best-known exponents of Art Nouveau.
The windows illustrated on the following pages are representative of the religious art of the Czechoslovak First Republic. All of them were created by Czech glass-makers based on the designs of painters from the Academy.

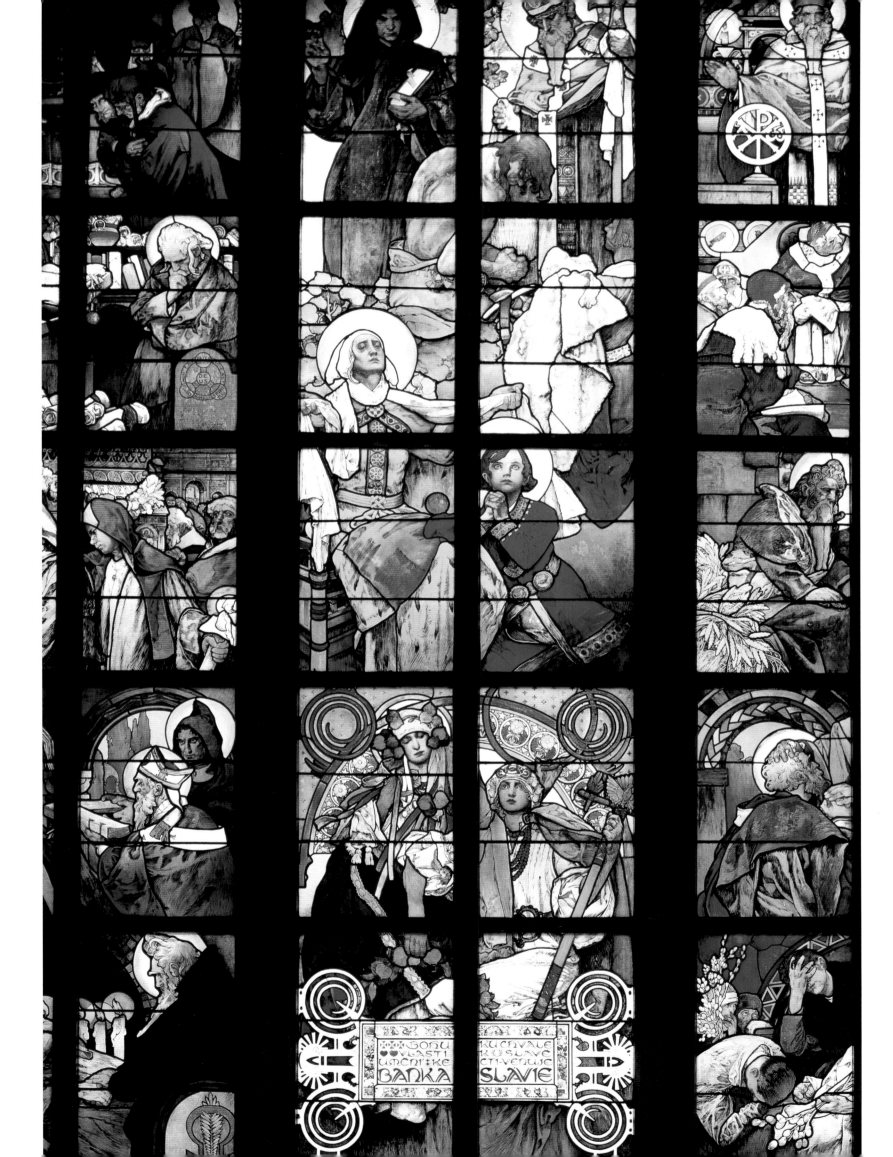

BANKA SLAVIE

Stained-glass windows of the north and south aisles of the nave; left to right:

Schwarzenberg Chapel: history of the Schwarzenberg family and of St John of Nepomuk; at the sides, scenes from the life of Abraham. Design by Karel Svolinský, 1931.
St Ludmila's Chapel (baptistry): Descent of the Holy Spirit, made in 1935 by Jan Jareš, to a design by Max Švabinský.

Bartoň of Dobenín Chapel: allegories of the Beatitudes, made in 1934 by Jan Jareš, to a design by František Kysela.
Thun Chapel: an allegory of Threat and Protection by Jan Jareš (1927) to a design by František Kysela.

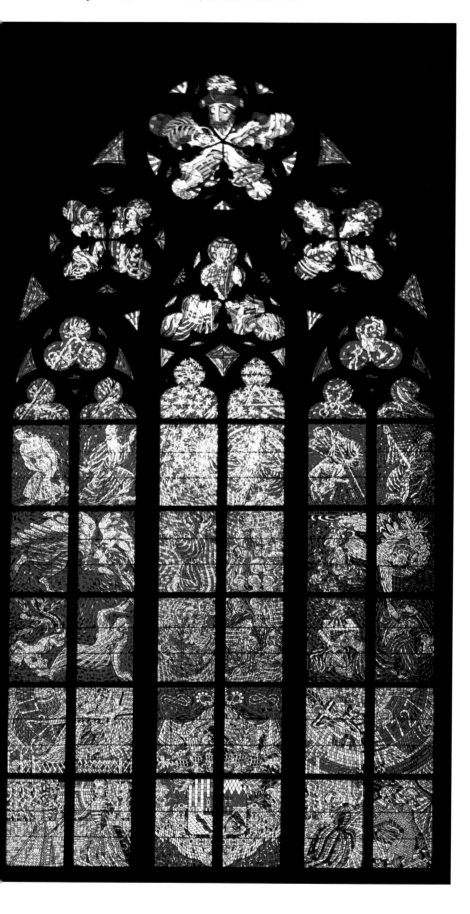

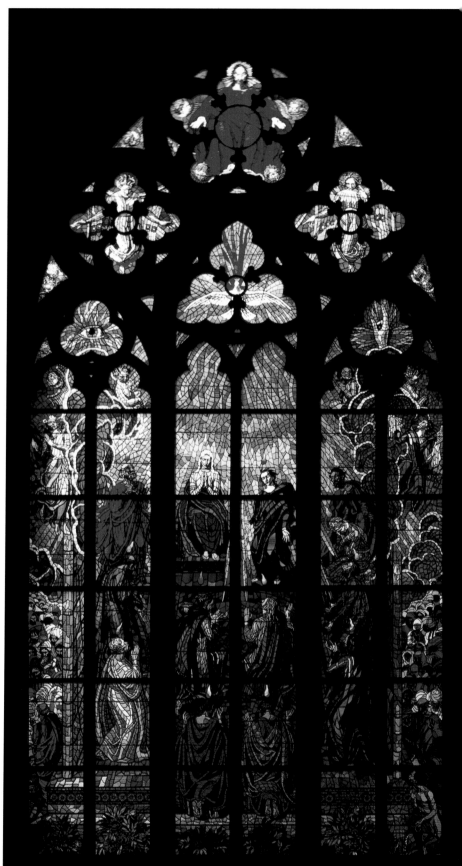

Pages 152-153: *the transept and central aisle of the nave*, with the great rose window of the west front, completed in 1929. In the foreground, left, is the royal mausoleum of Ferdinand I and Maximilian II, built in Innsbruck to the designs of the Dutch sculptor Alexander Colin. The pulpit, in Early Baroque style, was made in 1618 by Caspar Bechteler.

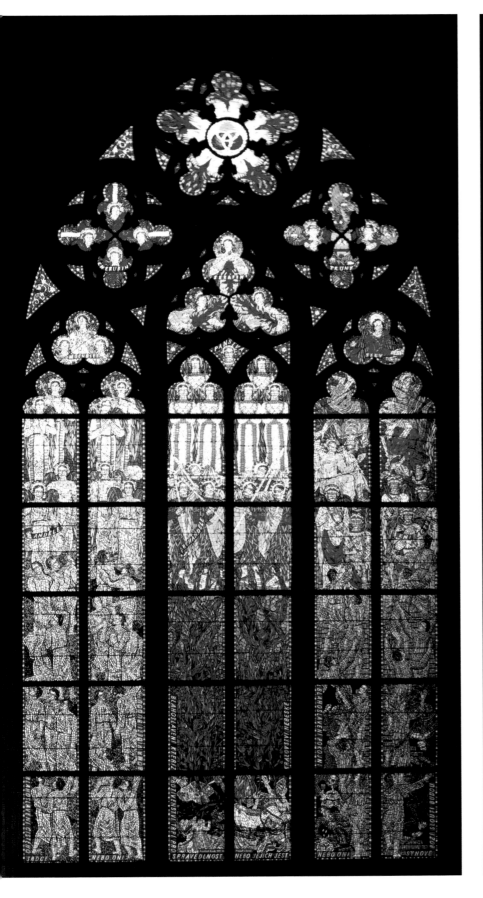

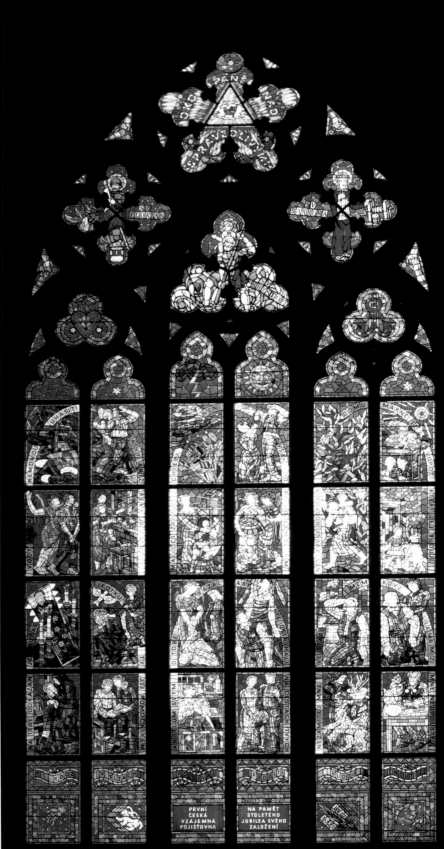

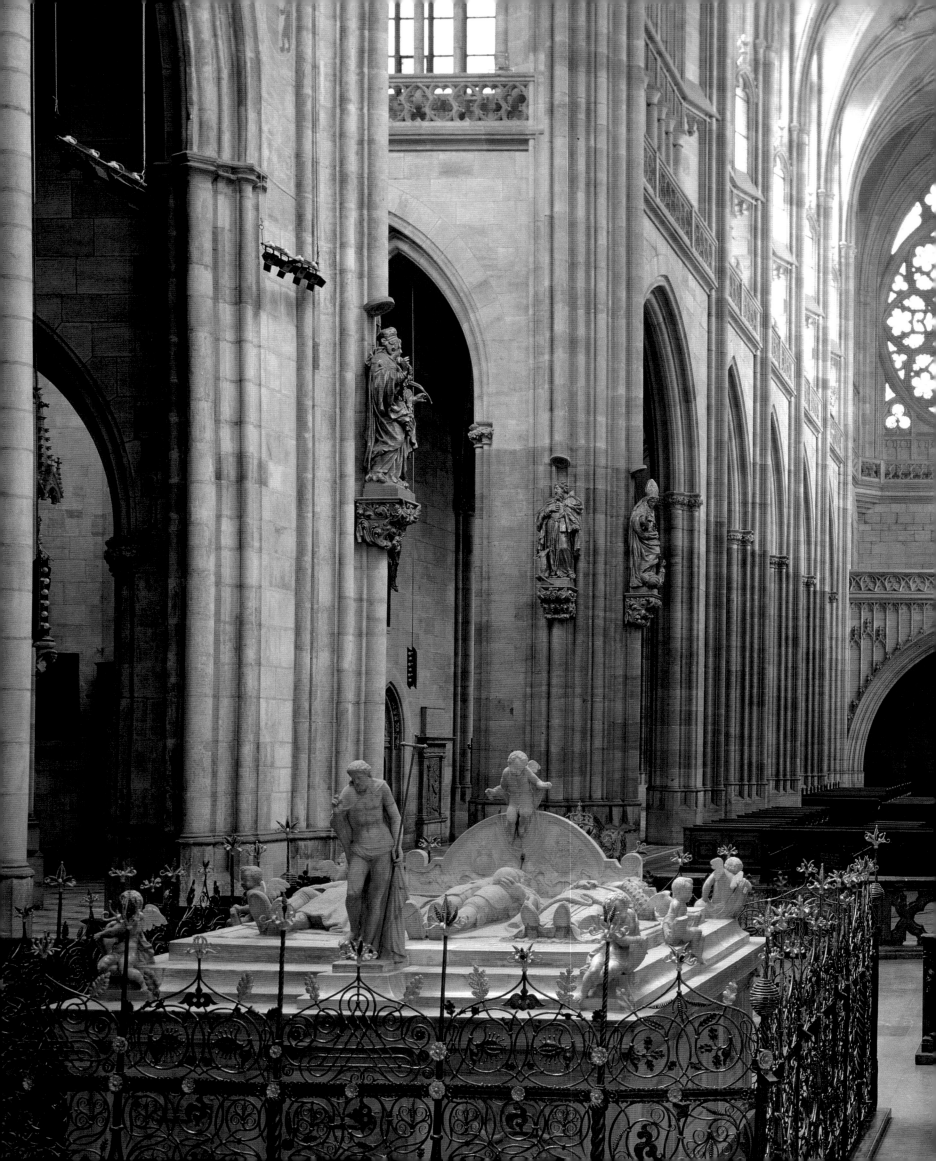

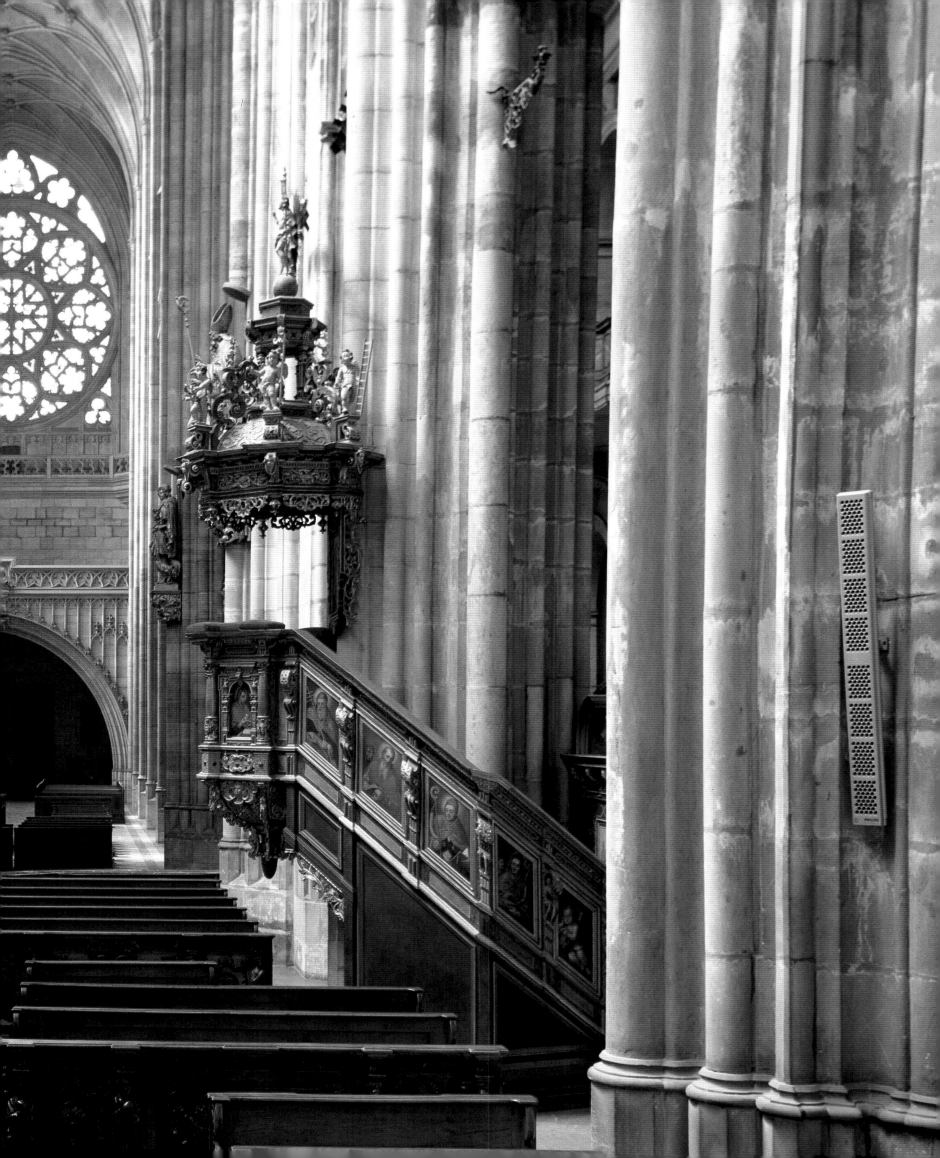

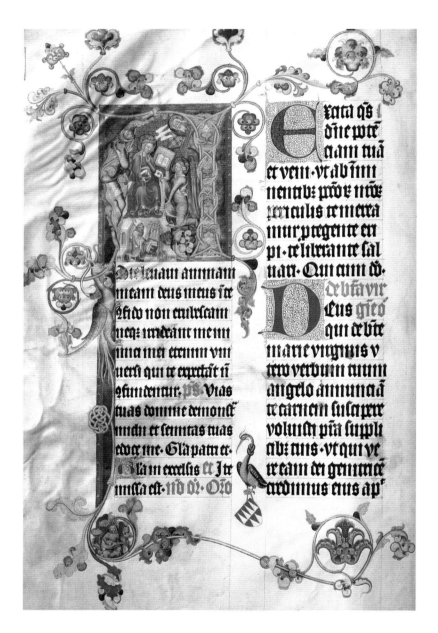

Missal of Jan IX of Středa, bishop of Olomouc: decorated initial representing the Annunciation and the donor (after 1364).This is one of the best-known illuminated manuscripts from the time of Charles IV, made on the orders of this royal councillor, known for his humanist leanings.

Right, below: *18th-century silk cover,* designed to protect a fragment of the *Gospel of St Mark*, dating from the 6th century, that Charles IV acquired in Italy. It is the oldest extant manuscript in Bohemia and bears an autograph of the emperor.

Opposite page, above: early Renaissance cover for an *Exegesis of the Apocalypse of St John*.

Below: *Latin Gradual*: manuscript on parchment with illuminations by Fabián Puleř, 1552; the decorated initial represents the Assumption of the Virgin Mary.

THE TREASURE CHAMBER

Crown of the Czech kings, known as St Wenceslas's Crown. Measuring 19 cm (7.5 in) high, it is made of gold and adorned with sapphires, spinels, pearls, emeralds and rubies. On top is a reliquary in the form of a cross containing a thorn of Christ's crown. Made for the coronation of Charles IV as king of Bohemia, in 1347, it underwent alterations between 1534 and 1587. It is the most important historical symbol of the medieval Czech state and a masterpiece of goldsmiths' work from the era of Charles IV.

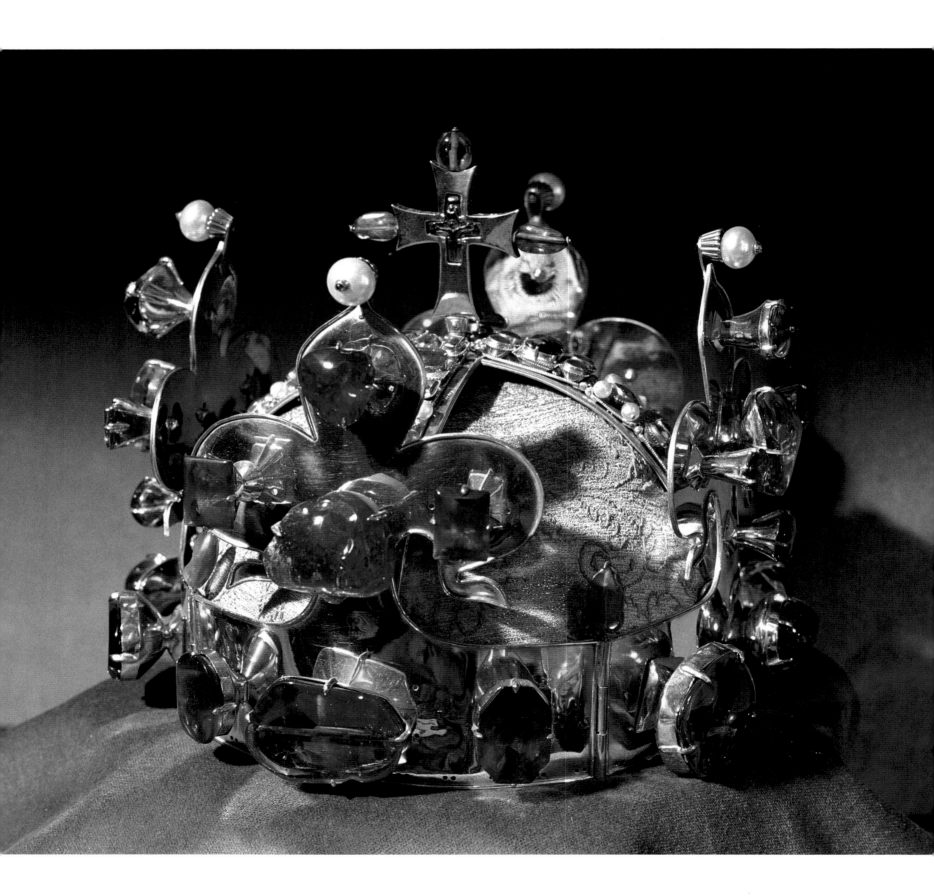

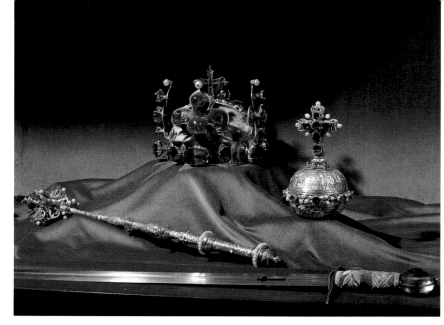

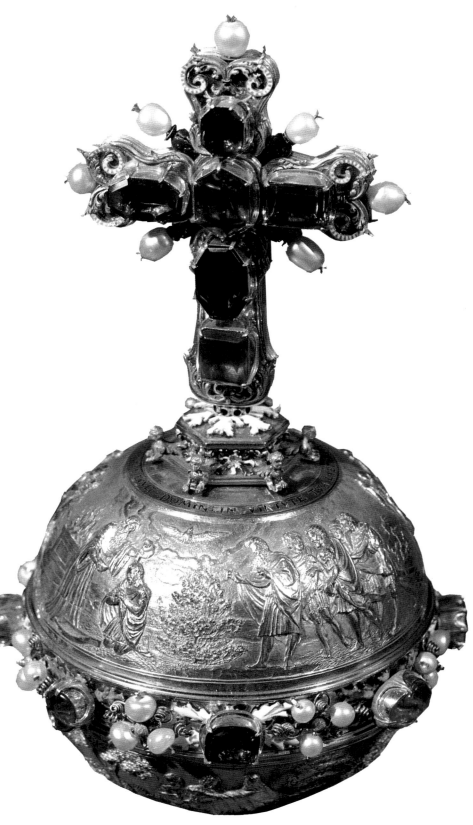

Sceptre and Orb. These remarkable Renaissance works of art, were undoubtedly made around the 1550s in southern Germany. (A sword dating from 1346, and a cape and a stole from the 18th century, are also among the Crown Jewels.) The orb, adorned with enamel, spinels, sapphires and pearls, is embellished with carved scenes: Adam before his Creator; the Entry to Paradise; the Creator warning Adam and Eve against eating the fruit of the Tree of Knowledge; the Anointing of David; and David fighting Goliath.

THE CATHEDRAL TREASURE

The origins of this treasure go back to the period of St Vitus's Rotunda, built on the same spot by order of Prince Wenceslas (d. 925 or 935). Charles IV (d. 1378) was one of the leading collectors of relics in the Middle Ages, as is attested by the cathedral inventories, the oldest of which dates from 1354. At the end of the 15th century, Vladislav II Jagiello tried to replace the precious reliquaries destroyed during the Hussite Wars (1419-34). The cathedral treasure was also greatly enriched over the following centuries. Not counting the valuable possessions of the chapter library, there are, in the Treasure Chamber, in the region of 350 objects, some of which are very famous.

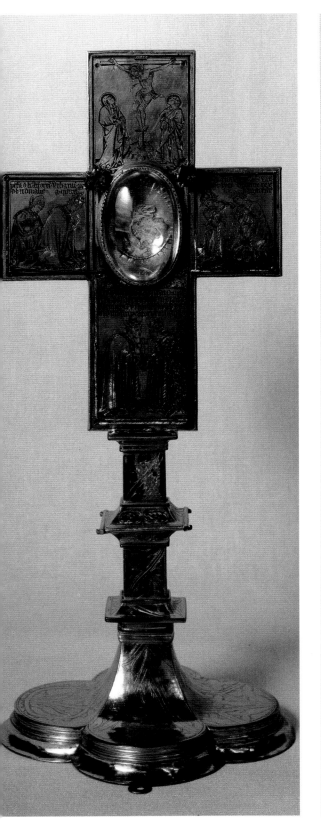 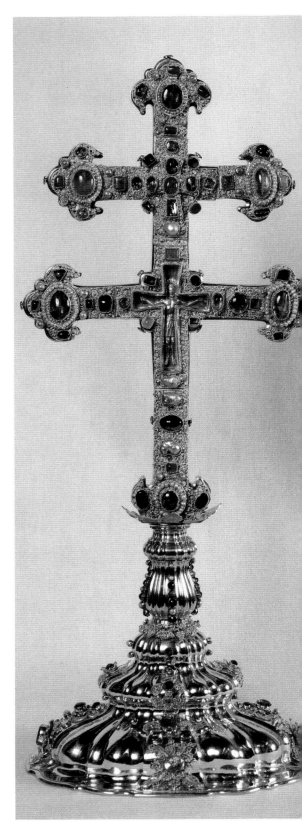

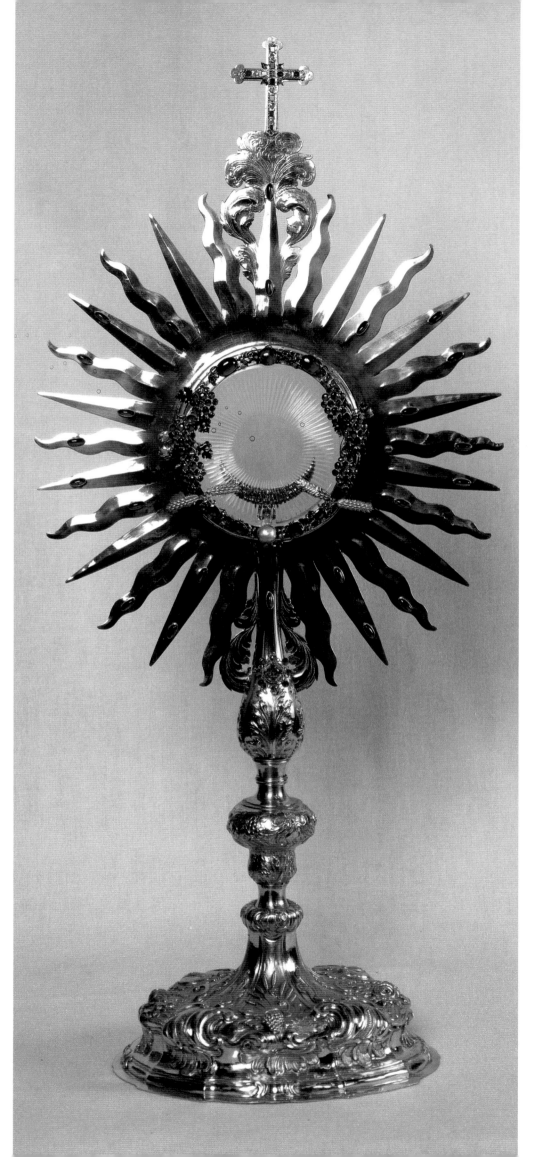

Left to right: *Cross of Pope Urban V*: height 31 cm (12 in); gold with crystal, sapphires and spinels; 1368 (and *c*. 1370).

Reliquary of St Catherine in the form of a monstrance: height 45 cm (18 in); silver gilt and crystal; *c*. 1380.

Cross of Zaviš: height 80 cm (31.5 in); gold inlaid with precious stones and decorated with filigree and enamel; *c*. 1220-30; the base was made later; the cross comes from the Cistercian convent of Vyšší Brod.

Monstrance of the prior Jan Dlouhoveský: 17th century (without the Mannerist pendentives, from the early 17th century); the base dates from the 1750s.

Reliquary-bust of St Vitus: height 51 cm (20 in); silver; after 1480.

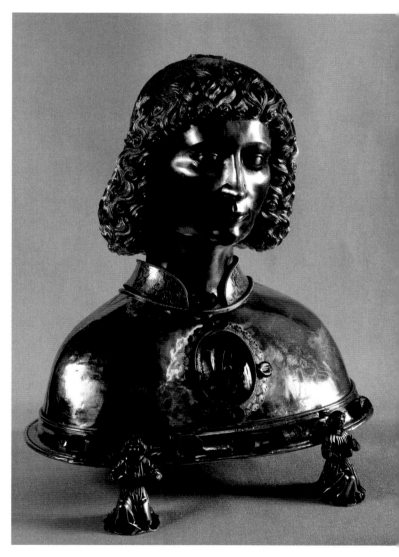

159

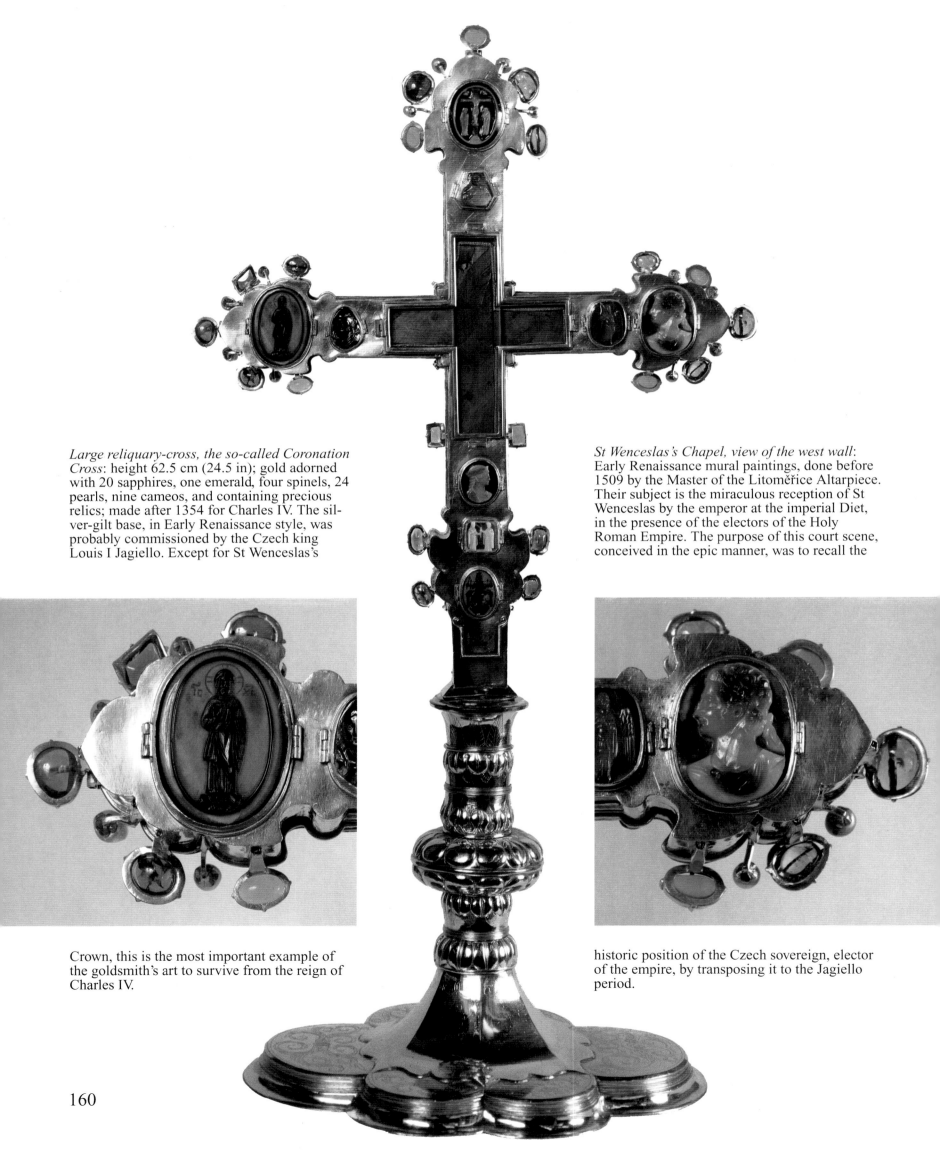

Large reliquary-cross, the so-called Coronation Cross: height 62.5 cm (24.5 in); gold adorned with 20 sapphires, one emerald, four spinels, 24 pearls, nine cameos, and containing precious relics; made after 1354 for Charles IV. The silver-gilt base, in Early Renaissance style, was probably commissioned by the Czech king Louis I Jagiello. Except for St Wenceslas's

Crown, this is the most important example of the goldsmith's art to survive from the reign of Charles IV.

St Wenceslas's Chapel, view of the west wall: Early Renaissance mural paintings, done before 1509 by the Master of the Litoměřice Altarpiece. Their subject is the miraculous reception of St Wenceslas by the emperor at the imperial Diet, in the presence of the electors of the Holy Roman Empire. The purpose of this court scene, conceived in the epic manner, was to recall the

historic position of the Czech sovereign, elector of the empire, by transposing it to the Jagiello period.

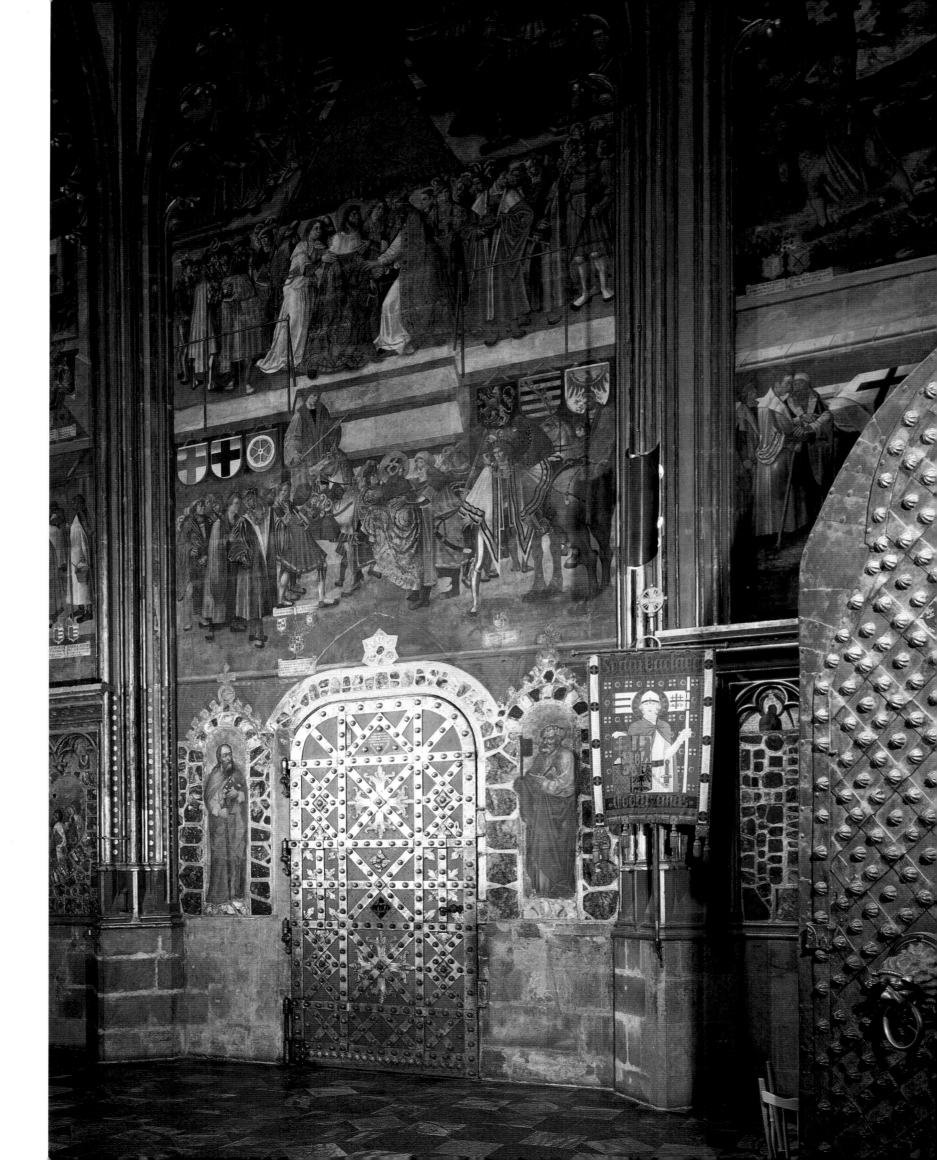

St Wenceslas's Chapel is the main shrine of the Přemysl prince and patron saint of his country. The chapel is a very individual, private place, covered with a stellar rib vault. Its massive walls and dim natural lighting combine with the overall decoration, especially that of the walls, to convey a wholly supernatural impression.

Below: on the north wall is a painting of *Christ before Pontius Pilate* part of a Passion cycle, by Master Oswald, painter to Charles IV, dating from 1372-3. The wall paintings are framed with amethysts, jasper and gilded stucco, part of the original decoration of the chapel.

Page 164: *Romanesque lion-headed door-knocker* of the north entrance door, made in the second half of the 12th century by a workshop of a Prague foundry. Originally it was in Stará Boleslav, where Prince Wenceslas was assassinated.

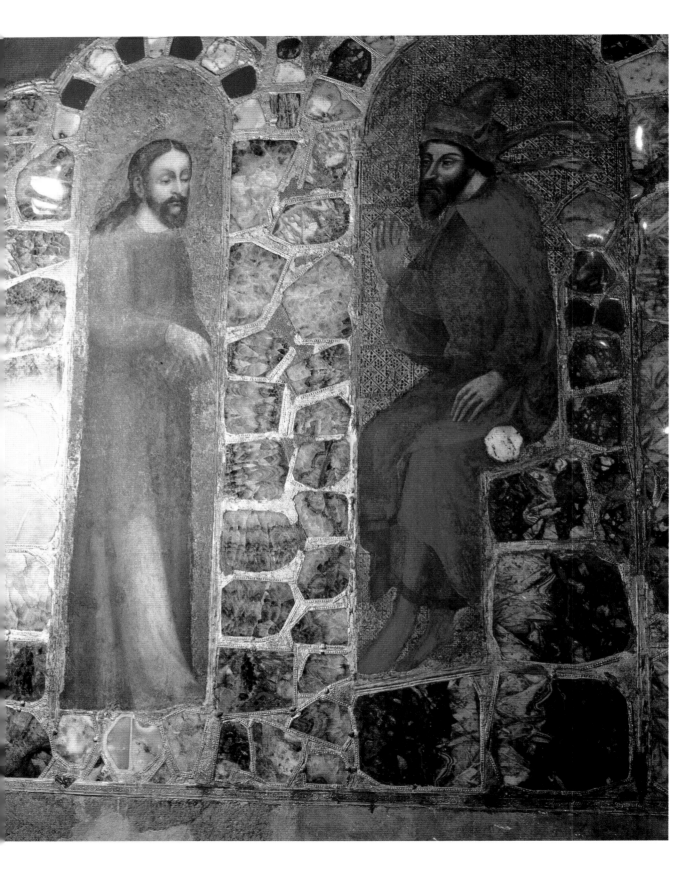

Opposite page: *the eastern part of St Wenceslas's Chapel.* In the foreground is the reliquary of St Wenceslas, made by Kamil Hilbert. The frontal of the altar table carved into the stone (and formerly in St Anne's Chapel) must have been made before 1358 by the cathedral workshop *(detail of the altar below).* Above the altar, on the cornice, is a statue of St Wenceslas, 2 m (6.5 ft) high *(see p. 16).* It is assumed to be one of the first

examples of the Flamboyant Gothic style. The mural paintings representing two angels and the patron saints of Bohemia were added later, around 1484-5. The large bronze chandelier was made in Nuremberg in 1532.

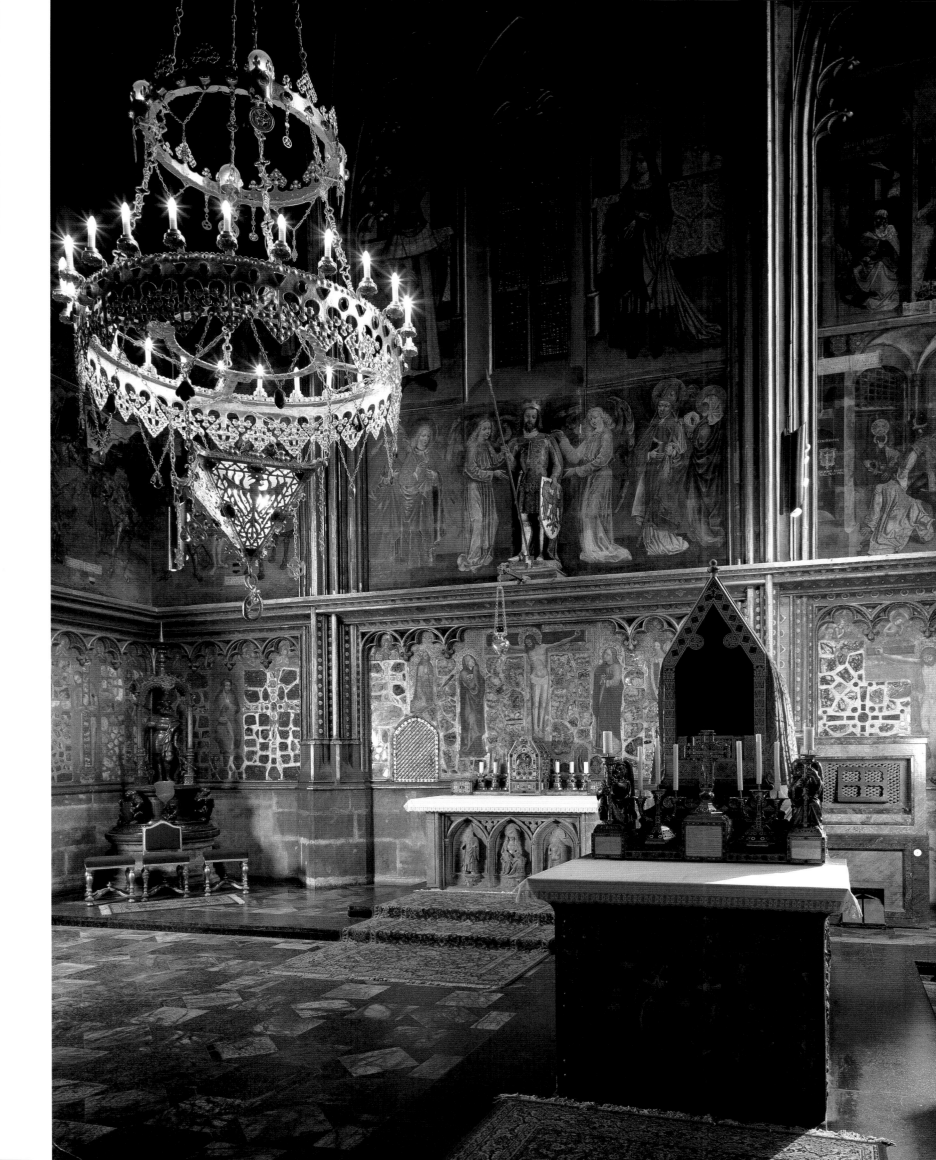

ST GEORGE'S BASILICA

The oldest church of Prague Castle, dedicated to the Virgin Mary, was founded by Prince Bořivoj I (baptised in 883 in Moravia). His son, Prince Vratislav I (c. 888-921) had a second church built: completed after his death, and was dedicated to St George. Its construction coincided with the upsurge of Christianity in Bohemia and the progressive establishment of the Přemyslid state. The original plan of St George's Basilica comprised three aisles which were incorporated into the east side of the present church. The later building of the south chapel is attributed to the translation, in 925, of the body of St Ludmila of Tetín.

The learned Mlada, sister of Prince Boleslav II the Pious (duke of Bohemia from 973 to 999), managed to win from Rome, in 973, certainly after tough negotiations, permission to create the diocese of Prague and, at the same time, her own consecration as abbess of the order of St Benedict under the name of Mary. The diocese was established at St Vitus's Rotunda, already built (by St Wenceslas, who died in 935), and Boleslav II had the Benedictine convent joined to St George's Basilica. A group of priests, the future canons of St George's, together with a provost father, recited mass. The Benedictine convent was the first monastic establishment in Bohemia, and the fact that it was founded by the Přemyslid family was to assure it of a privileged position in Bohemia and Moravia. In due course, the abbesses of St George's were granted the title of princess and the right to crown the Czech queens.

In response to the needs of the Mary-Mlada convent, the west side of St George's Basilica was enlarged: a separate choir for the nuns was built, as well as galleries over the side aisles. This 10th-century construction in Ottonian style was devastated in the castle fire of 1142. Under Bertha (abbess from 1145 to 1151), extensive rebuilding was undertaken in the prevalent Romanesque style of architecture, as used for St George's Basilica. From this period date the raised choir, still to be found on the east side of the basilica, the underlying three-aisled vaulted crypt, and a pair of twin, prism-shaped tow-

ers. The Chapel of the Virgin Mary was also rebuilt. The side aisles have since been covered with a vault and the galleries furnished with triplet windows. The three-aisled nave was again extended westward. Fragments of Romanesque paintings from this period are still preserved in the choir and northern side aisle. Under the abbess Agnes (1200-28), sister of Přemysl Otakar I, the raised St Ludmila's Chapel was built near the south side of the choir. The abbess and her royal brother are depicted on the walls by a three-part bas-relief, the central section of which represents the Virgin Mary in majesty, adored by the abbesses Mary and Bertha. This bas-relief, done during the time of Bertha, adorned the tympanum of one of the doorways, either of St George's Basilica or of the convent (the original is now in the Prague National Gallery). Dating from the same period are the wall paintings at the south end of the Chapel of the Virgin Mary and representing Christ in majesty and celestial Jerusalem.

A number of medieval manuscripts from St George's Convent have been preserved. The most precious is the Passional of the abbess Cunegonde (Kunhuta: 1265-1321), daughter of Přemysl Otakar II, who became abbess in 1302: it is now kept in the National Library of Prague. It was edited, calligraphed and painted between 1313 and 1321 by Beneš, canon and librarian of St George's. This manuscript, equally prized for its contents, is the most representative work of Czech culture from the first half of the 14th century.

In the centuries that followed, St George's Basilica underwent several changes. The effect of the alterations made during the reign of Charles IV is very evident, particularly in St Ludmila's Chapel. It was at this time, too, in 1371, that the high altar was again consecrated. The great south doorway of the basilica, in primitive Renaissance style and made by members of the royal castle workshop supervised by Benedikt Ried, undoubtedly dates only from 1510. The sculptures produced by this workshop were full of figurative detail, and this makes an extraordinary impact in the bas-relief of

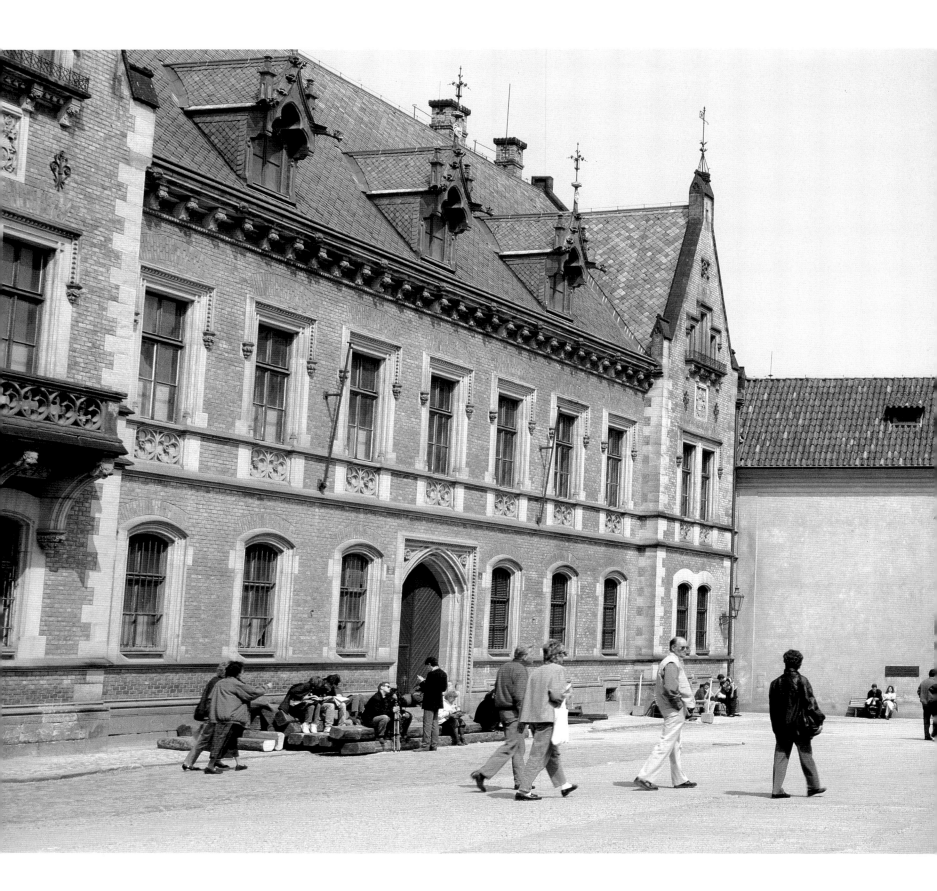

This square *(Jiřské Náměsti)* is dominated by the west front of St George's Basilica (*c.* 1770). At the back are the Romanesque towers of the basilica; on the right is St John of Nepomuk's Chapel, added to the basilica in 1718-22; on the left is the ancient Benedictine convent (abolished in 1782), which now houses the National Gallery's collection of ancient Czech art. St George's Basilica was founded by Prince Vratislav (d. 921), and the Benedictine convent, established by the reigning Přemyslid dynasty, was created in 973. The interior of the basilica contains the best-preserved remains of Romanesque and pre-Romanesque religious architecture in Prague.

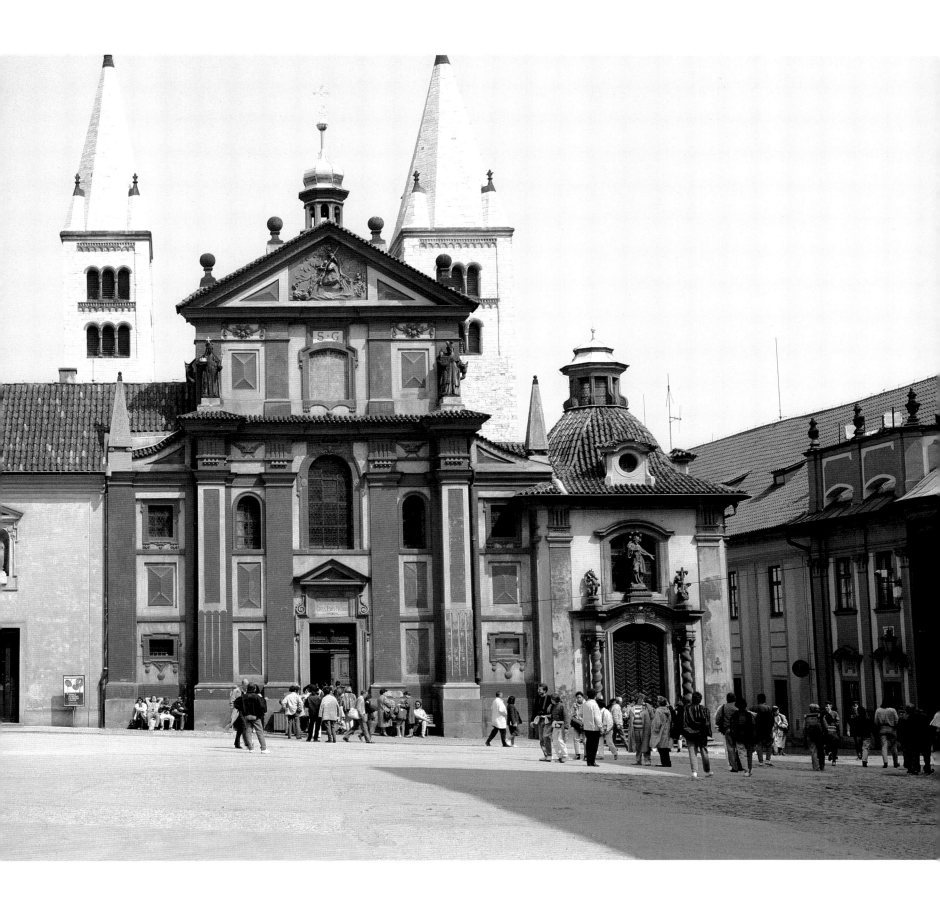

Opposite page: *George Street (Jiřská Ulice)*, with a view of the South Tower of St George's Basilica, constructed after 1142 and subsequently modified.

St George on the tympanum of the doorway (the original is now in the Prague National Gallery). The present vault of St Ludmila's Chapel and its Late Renaissance paintings date from the reconstruction that followed the fire of 1541.

In 1732 the Baroque staircase with two incurved flights leading to the raised choir was built. The outside appearance of the basilica was decisively altered as a result of the Early Baroque style of the west façade, undoubtedly dating from the 1670s, apparently designed by Francesco Caratti, originally from Bissone in southern Switzerland. Between 1718 and 1722 a small central chapel (Chapel of St John of Nepomuk) was added to the south side of the basilica by the architect František M. Kaňka (1674-1766). The fresco of the east dome was done by Václav V. Reiner (1689-1743), a notable Late Baroque Bohemian painter. During the reforms of Joseph II the convent was suppressed and St George's Basilica temporarily closed. The present appearance of this impressive building results from the restoration that lasted from 1888 to 1918. In 1962-3 the interior of the basilica was transformed into a museum, necessitating the removal of most of the furnishings.

St George's Basilica also has some historical importance as a burial place for the members of the ancient ruling dynasty of the Přemyslids. Two of them were provided with raised sarcophagi, of great artistic merit, which still exist today. To the southeast of the central aisle is the tomb of the basilica's founder, Prince Vratislav I (d. 13 February 921); inside is a lead reliquary in the form of a cist. Catherine of Lipoltice (abbess from 1378 to 1386) authenticated its contents after sealing it. The wooden piece of furniture, in the shape of a small house, above the sarcophagus is reminiscent in form of medieval reliquaries. Analysis of the painted ornaments, figurative and heraldic, indicates that this portion of the tomb was undoubtedly made between 1437 and 1442, evidently as part of a restoration.

The stone sarcophagus of St Ludmila, in the centre of the chapel added to the choir of the basilica, is much more important from the religious and historical points of view. Princess Ludmila, wife of Bořivoj I, was murdered at the castle of Tetín during the night of 15 or 16 September 921, on the orders of her daughter-in-law, Princess Drahomira. Ludmila, renowned for her virtuous nature and baptised, was the teacher of St Wenceslas. Her cult was deservedly propagated by St George's Convent. The sarcophagus contains St Ludmila's remains (clearly inscribed as such on a lead plaque) in a metal cist: it was undoubtedly made between 1350 and 1375 by at least three different craftsmen. The recumbent figure of St Ludmila (on the lid of the tomb), although badly damaged when the chapel vault was destroyed in 1541, is still a work of striking iconographic originality and great artistic quality. It was apparently done by one of the stonemasons of Peter Parler's workshop. The bas-reliefs on the sides, which depict the silhouettes of saints beneath baldaquins, testify to a fair amount of formal eclecticism but also, to some degree, a continuation of older styles, notably those of the stonecutters of the workshop of Matthew of Arras at St Vitus's Cathedral, dating from the 1350s. The head of St Ludmila was preserved in a silver-gilt reliquary-bust 34 cm (13 in) in height, also from the 1350s or later, which has been in the cathedral treasure since 1782.

Page 170: *St George's Basilica*: view from the east end of the raised choir (after 1142). The Baroque double-curved staircase dates from 1732. On the right is the Gothic funerary monument of Prince Vratislav, founder of the basilica.

Page 171: *St Ludmila's Chapel,* situated in the choir of St George's Basilica. The chapel was built under Agnes, abbess from 1200 to 1228, in Late Romanesque style. In the centre is a stone altar with the sarcophagus of St Ludmila (d. 921), decorated with a recumbent figure of the saint, a fine example of Czech tomb sculpture from the late 14th century.

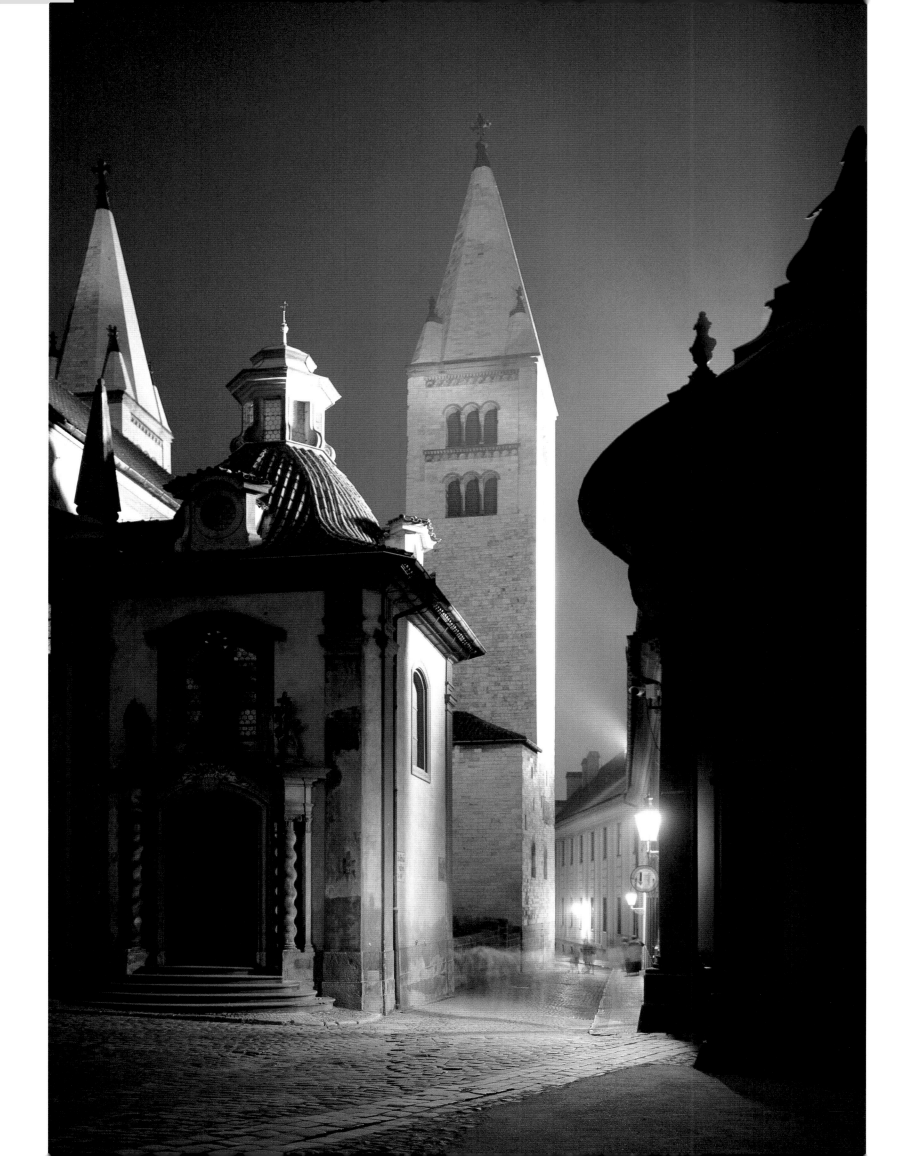

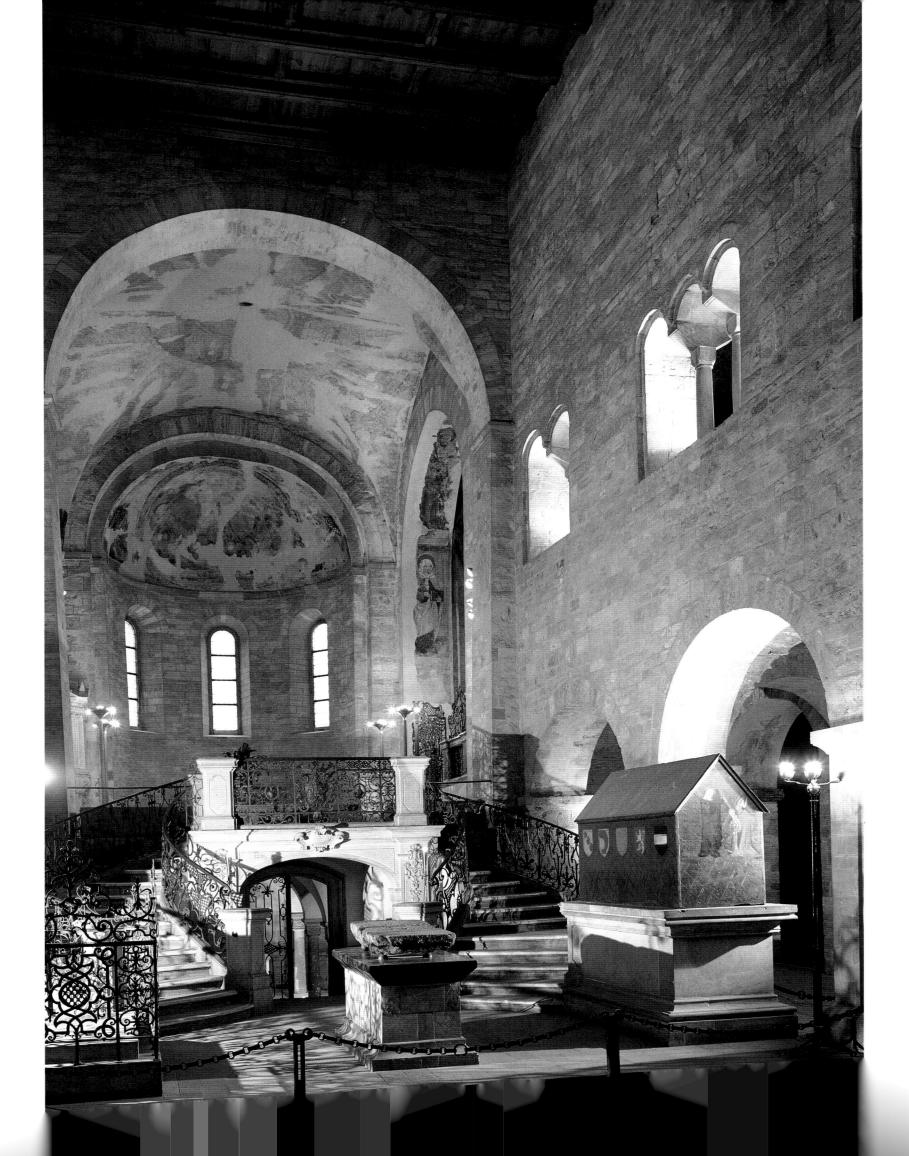

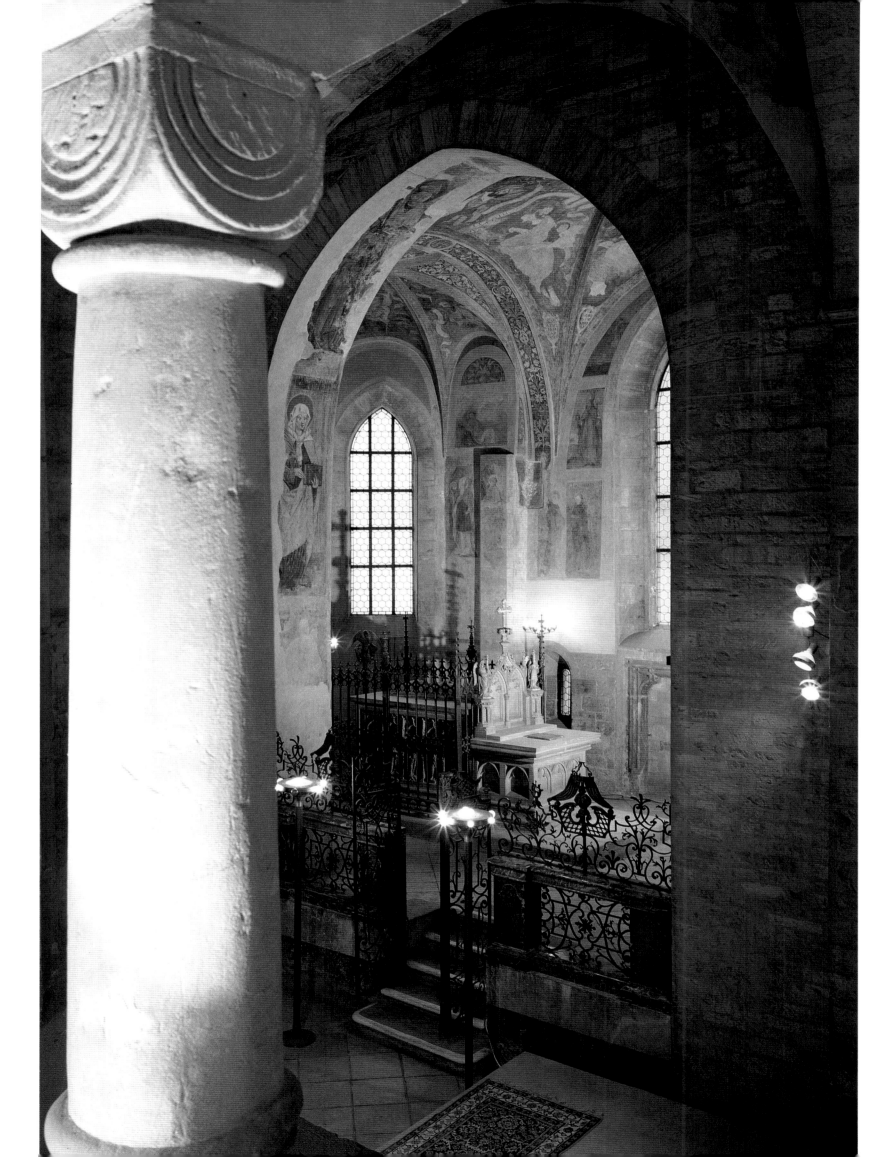

THE HOLY CROSS
ROYAL CHAPEL

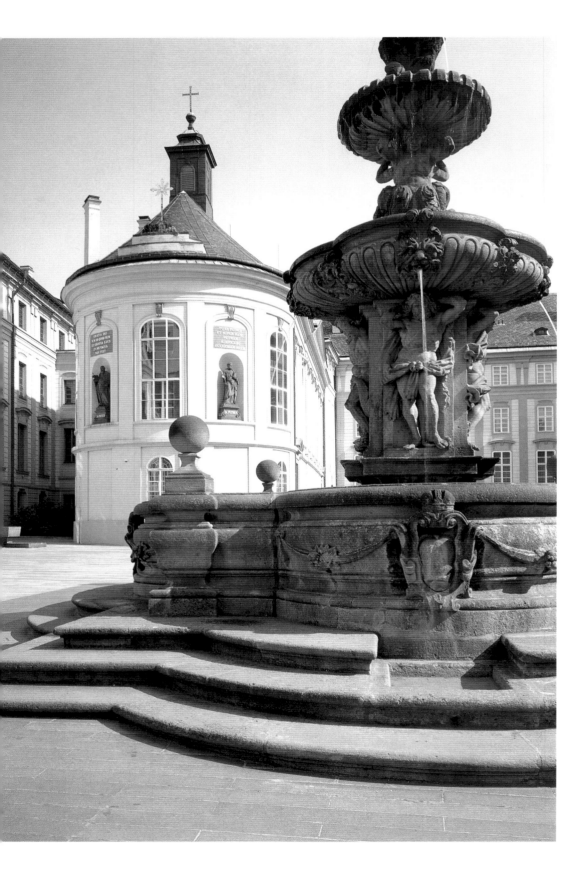

The Holy Cross Chapel, situated in the Second Courtyard of the castle, was built between 1756 and 1764 and reconstructed in classical vein from 1852 to 1856 for the ex-emperor of Austria, Ferdinand I (who lived in Prague, after his abdication, until his death in 1875). The statues of St Peter and St Paul, on the façade, are by Emanuel Max (1854). In the foreground is a sandstone Baroque fountain with sculptures by Jeroným Kohl (1686).

Above: cartouche with the monogram of Emperor Leopold I, on the Early Baroque fountain of the castle's Second Courtyard.

Opposite page: the neo-Baroque interior of the Holy Cross Chapel, dated c. 1855. The painting of the crucified Christ above the altar, dating from 1762, is by František Xaver Palko.

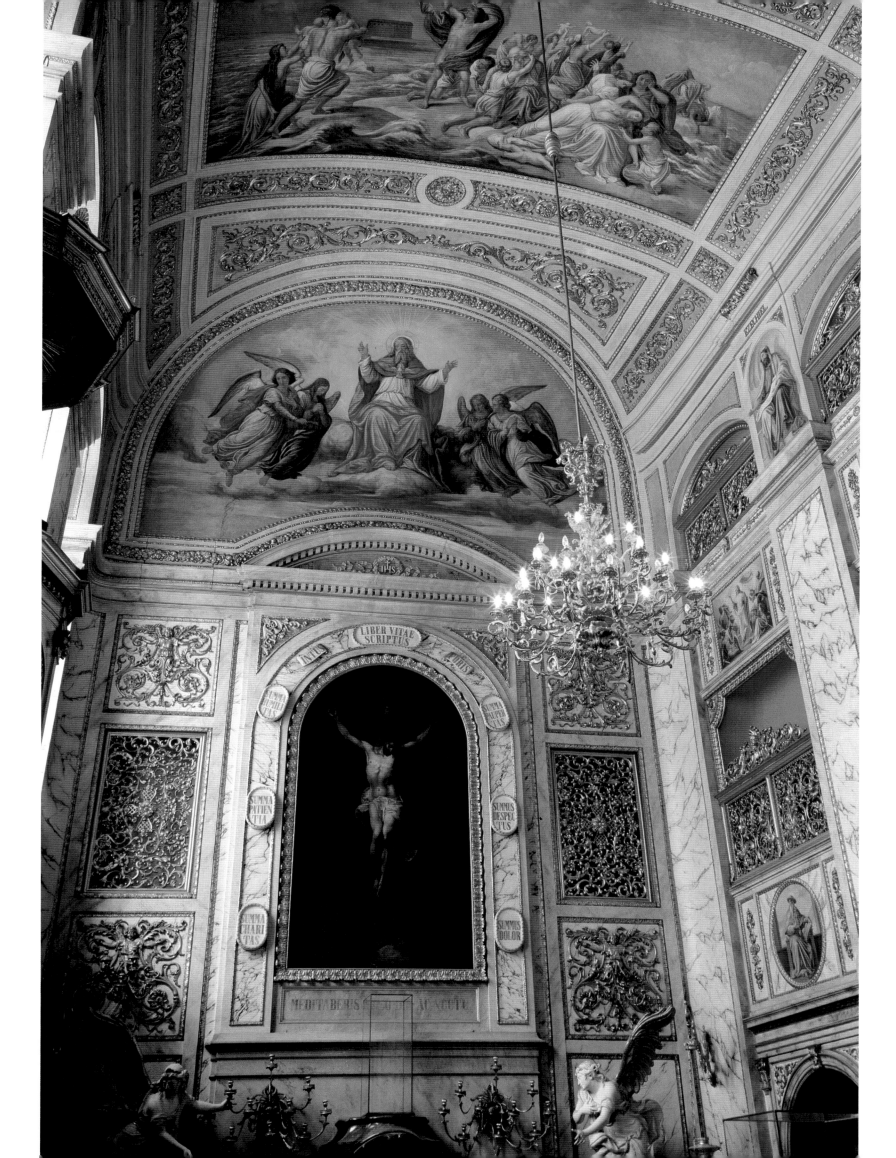

ALL SAINTS
COLLEGIATE CHAPEL

THE HOLY CROSS
ROYAL CHAPEL

In 1339 Charles IV (who was then merely margrave of Moravia) raised the chapel of the Royal Palace of Prague Castle to the status of collegiate church, generously providing it with a dean, a provost and eleven canons of the chapter. In addition he donated to the church 'a number of holy relics richly decorated in gold, silver and precious stones, as well as various priestly garments of high price, numerous chalices and monstrances, other objects of worship and everything necessary for the servicing and ornamentation... of a collegiate church' (Chronicle of Francis of Prague).

During the 1370s Peter Parler built, in place of the original chapel, a new church with a single nave, a very demanding project from the architectural viewpoint, which he decorated with no care for expense. Taking the Sainte-Chapelle in Paris as his model, Peter Parler produced a version in Prague which was wholly individual in style. As in the neighbouring cathedral, he made use of rib and net vaulting. The walls were encrusted with semi-precious stones, similar to those of Karlštejn Castle and St Wenceslas's Chapel. The lower floor was divided by stone stalls. The frames of the rose windows and the buttresses were treated in a special manner. This jewel of a church was completely destroyed in the castle fire of 1541. Its Renaissance-style reconstruction was not finished until around 1580; and in 1598 Giovanni Gargioli built the west door leading from the Vladislav Hall to the west organ loft.

On 28 May 1588 the remains of St Procopius (d. 1053) were placed in All Saints Chapel. This hermit of the Sázava region, who became abbot of the local Benedictine monastery using the Slav liturgy, had been canonised in 1204. The Baroque sarcophagus of the Czech saint, on the epistle side of the altar, was embellished in 1738 with sculptures by František Ig. Weiss. The legend of St Procopius was illustrated in the choir by a series of paintings, dating from 1669, by Kristian Dittman. The All Saints painting on the high altar was done in 1732 by Václav Vavřinec Reiner; the sculptures were the work of Richard J. Prachner (1750).

In the overall architectural reconstruction of Prague Castle as planned by Niccolo Pacassi, his successor, the Italian architect Anselmo Lurago (1701-56), built, in the Second Courtyard, a new chapel with a single nave, the Holy Cross Chapel, to adjoin the south wing of the palace. All that remains of the original building is the high altar of Ignác Fr. Platzer the Elder (1717-78), a Prague sculptor of the Baroque era, with a painting of *Christ on the Cross* by František A. Palko (1724-67).

Between 1852 and 1856 a neo-classical reconstruction of the chapel was put in hand, for the use of the old emperor of Austria, Ferdinand I (king of Bohemia under the name of Ferdinand V the Debonair), who had abdicated in 1848 in favour of his nephew Franz Joseph and who lived afterwards at Prague Castle with his wife Maria Anna, far from the Viennese court. The biblical frescoes on the ceiling are by Vilém Kandler, student of the Academy of Fine Arts in Prague, the stained-glass windows by Jan Z. Quast and the statues by Emanuel Max.

Opposite page: *the choir of All Saints Collegiate Chapel* originally the chapel of Charles IV's palace. It was built during the 1370s by Peter Parler and radically altered after the fire of 1541. The furnishings and decoration are Baroque.

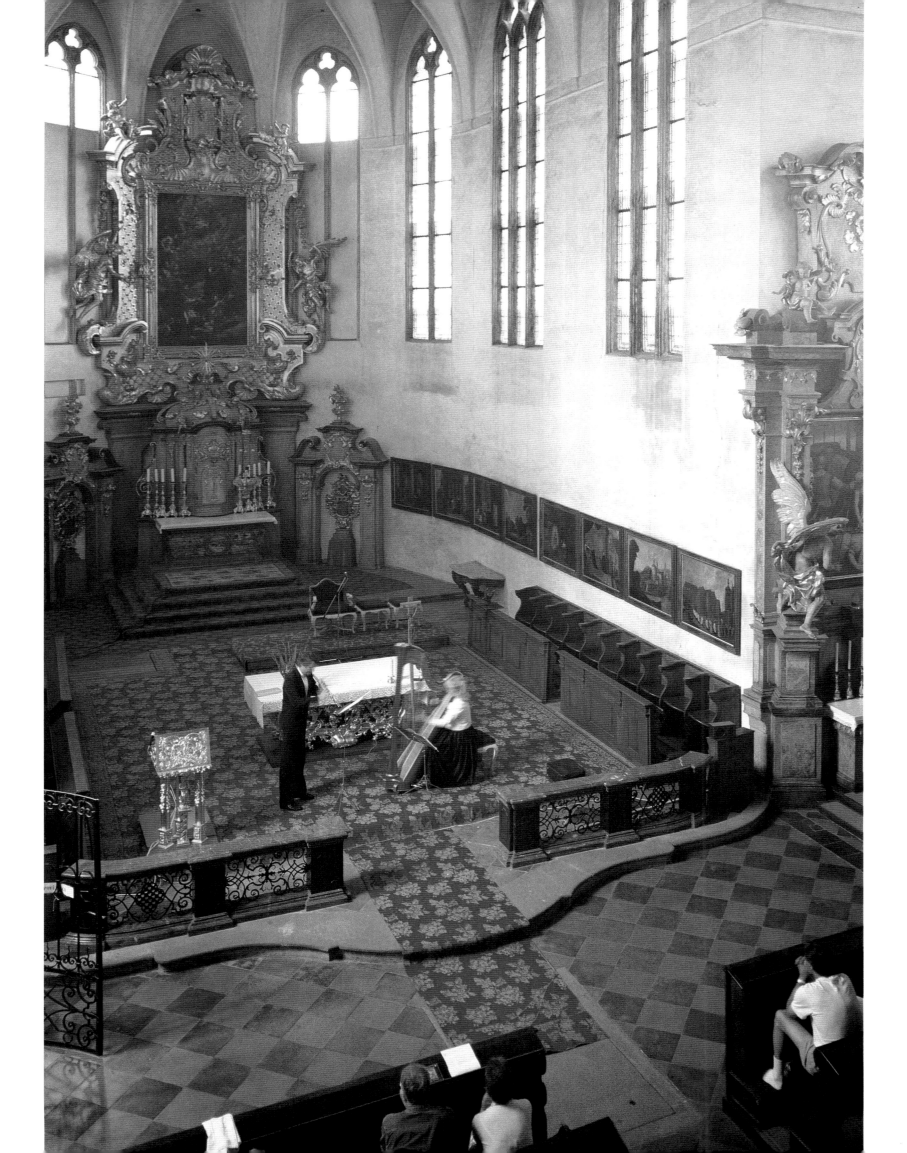

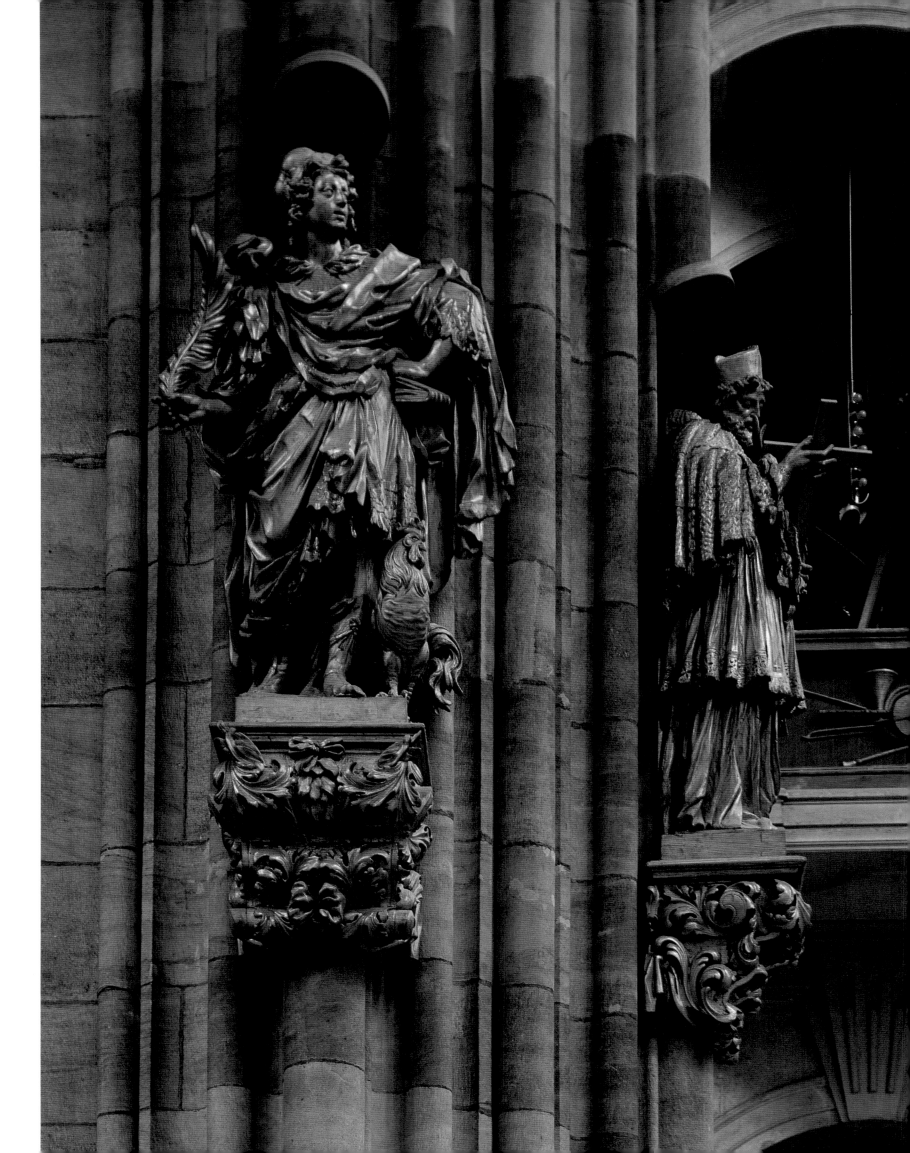

THE NATIONAL GALLERY
ANCIENT CZECH ART AT ST GEORGE'S CONVENT

St George's Convent is situated in the small, intimate, gently sloping George Square (Jiřské náměsti), and is approached from the east either by climbing the original ancient street winding up to the castle (Na Opyši) or by taking the old Castle Steps and then up George Street (Jiřské ulice), which leads into the square. From the west, you have to pass St Vitus's Cathedral on your right, cross the Third Courtyard of the castle and take the narrow Vicar's Lane (Vikářská). Once in the square, if you face the choir of the cathedral, you see that the left side of the square is enclosed by a row of splendid buildings, notably the Vladislav Hall, the Old Diet, All Saints Chapel and the Institute of Noblewomen; on the right is the pseudo-Gothic New Provost's Lodging. Turn halfway round and you will see in front of you the entrance to the St George's Basilica, with its low façade adjoining St George's Convent, which accommodates the National Gallery's collection of ancient Czech art.

Opposite page: *statues of St Vitus and St John Nepomuk in the transept of St Vitus's Cathedral.* Carved in limewood and gilded, they stand 2.20 m (7.25 ft) high, and were executed in 1696 by František Preiss. The metropolitan canon Tobiáš Jan Becker donated them to the cathedral, along with statues of six other Czech patron saints.

HISTORY OF THE CONVENT

The original St George's Church, the first Christian sanctuary in the centre of the castle itself, was a short, three-aisled basilica, founded around 920 by Prince Vratislav I. Its present appearance, with its two characteristic white towers, dates from the time of the abbess Bertha (1145-51), following the castle fire of 1142. In 973, beside the original church, a Benedictine convent was founded (the oldest monastery in Bohemia and Moravia) by Prince Boleslav II and his sister Mlada, and endowed with a canonry. The convent church occupied a broad area between George Street and the north wall of the castle.

This convent (which as yet had no cloister) was demolished under Vladislav II in 1142, when the castle was besieged by Konrád of Znojmo. It was entirely destroyed by the fire, as were the basilica and other nearby buildings. It was the abbess Bertha who had the convent rebuilt, earning herself the title of 'second founder'. These changes gave St George's Basilica its present-day appearance, whereas the convent later underwent various modifications. In the course of the 14th century the convent saw a succession of improvements and alterations. But it was continually subjected to the changing fortunes of peace and war, of prosperity and vandalism, with little prospect of continuity or permanence.

The convent was restored and revived by its Renaissance-style reconstruction in the mid-16th century. Its present aspect and layout date essentially from 1671 to 1680, during the time of the abbess A.M. Schwenweisová. It was the architect Carlo Lurago who drew up the Early Baroque plans for this rebuilding project. For a century or so, the convent was again used for its original purpose. Then, after more than eight centuries, the reform programme of Joseph II brought its tragic and proud history to an end. The convent was closed on 8 March 1782. The building was used to accommo-

date clergy and then was turned over to the military and converted into a barracks. Finally, in 1969, plans were made to transform it into an adjunct of the National Gallery. After a complete archaeological survey, this project was realised between 1970 and 1975, based on the designs of the architects František Cubr and Josef Pilař. The collection of old Bohemian art, comprising paintings and sculptures from the 14th to 18th century, was installed on the three floors of the new museum. A permanent exhibition was opened to the public in 1976.

LAYOUT OF THE CONVENT

The site of the convent, including the basilica, is broadly in the form of a large rectangle extending east-west. Immediately beyond the entrance is the Paradise Courtyard; on the other side, at the end, is a smaller courtyard with the back entrance to the building (used only for the interior, it faces a small square leading into Golden Lane). Around the Paradise Courtyard are the four galleries of the cloister: the south and west galleries are mainly for access, the north and east ones forming part of the exhibition. The medieval collections are housed on the lower and ground floors, the Baroque on the first floor. Below the Paradise Courtyard are the extensive foundations of the convent, discovered in the course of archaeological digs and well preserved: although accessible, they are not open to the public.

It will be opportune at this stage to provide a brief guide to the layout of the convent and the arrangement of the various parts of the collection. Facing the entrance door is the long corridor of the south wing of the cloister, passing the foot of the tower; to the left of the entrance is the west corridor leading to the collection on the lower floor. Here are works dating from about 1350 to 1370, comprising paintings and sculptures, mainly of mid-14th-century Madonnas, by the Master of the Vyššy Brod (Hohenfurth) Cycle, the Master of the Michle Madonna, Master Theodoric, etc.

On the ground floor is a large room, originally the old convent refectory, with a collection of work by the Master of the Třeboň Altarpiece. The north corridor contains works in the Flamboyant Gothic style and its followers, including the Master of the Rajhrad (Raigern) Altarpiece. In a small adjoining room is the Týn Tympanum. The north corridor leads directly to the north wing of the cloister with Late Gothic works of art. The exhibition then continues in the east wing, with the Master of the Litoměřice (Leitmeritz) Altarpiece and the Master of the Žebrák *Lamentation of Christ*, into the St Anne Chapel. Next to the chapel is a small room containing the sculptures of Master IP, the last room devoted to medieval art.

Visitors now take the stairs to the first floor, beginning with a small, select group of Mannerist works from the period of Rudolf II by Vries, Spranger, Aachen and others. The works of these foreign artists from Rudolf's court in Prague form a logical link between local Gothic and Baroque. On this floor, too, are Czech Baroque paintings and sculptures. The reconstruction of the building joined the north and south wings so as to form a number of impressively large rooms in which more than two hundred works are exhibited in chronological order. Some parts of this collection are devoted exclusively to religious subjects, but basically the three main rooms are designed to create an impression of size and space as a setting for the most important works of Czech Baroque art.

The first room is given over to Karel Skréta (1610-74); the second, and largest, to three Late Baroque painters, Braun, Brokoff and Brandl; and the third to Václav V. Reiner. This basic arrangement is completed by a series of smaller rooms and communicating corridors, displaying paintings by a number of other important artists, represented by works that are mainly of documentary interest: Willmann, Liška, Kupecký and minor figures of the Baroque such as Kern and Grund.

The second feature of the exhibition is the manner in which the space is divided rhythmically by a series of panels in a special stucco, either straight or curved in Baroque fashion, and in different colours: grey-black, red and russet. And as an additional touch, providing some relief and variation, there are showcases containing small works of sculpture and a modest selection of craft products of the 17th and 18th centuries.

A room on the west side of the first floor is devoted to temporary exhibitions, several of which are organised each year as an interesting supplement to the permanent collections. Behind this room are the offices and studios of the gallery's staff and specialists. The final treat for visitors, as they descend the staircase, is a fresco by Josef Kramolín, dating from 1782. Transferred here from the church of St Elisabeth's Convent, at Doupov in western Bohemia: it depicts angels with the attributes of the saint, with a cartouche inscribed *Cultui Divae Elisabeth oblatum*.

This gallery of paintings and sculptures was arranged chronologically to chart the course of the country's artistic development. However, this scheme is modified here and there by exhibits which are deliberately highlighted by reason of their symbolic or decorative effect within the context of the collection.

In the middle of the great Paradise Courtyard is a fountain: this is a contemporary classical work dominated by one of two angels by Matyáš Bernard Braun. This angel comes from a small town in central Bohemia and was carved in 1717-18; the other angel is in the Late Baroque room.

In the south wing of the cloister, just before the foot of the tower, is a sandstone sculpture of Vulcan, also by Braun, dating from 1714-16, which was originally on the attic storey of the Clam-Gallas Palace in Prague. In the smaller courtyard, another sandstone sculpture, by Ferdinand Maximilián Brokoff, dating from around 1710, shows Hercules fighting with Cerberus.

At the very start of the visit, at the basement entrance, there is a bas-relief fragment depicting an eagle which is the work of an unknown artist from St Vitus's Cathedral workshop in the second half of the 14th century.

Particularly beautiful, and open to visitors to the exhibition, is the chapel originally dedicated to the Virgin Mary, which underwent many transformations and was reconsecrated in the 17th century to St Anne. Although not very big, the reconstructed chapel displays characteristic examples, side by side, of three major art styles: one part, with its dressed stonework, is Romanesque; there is a Gothic high window; and the perfectly proportioned rose window and ornamental stucco vaulting are Renaissance. In addition, there are various Baroque features dating from the final period of alterations, around 1675.

The chapel is packed with rare objects relating to the history of the convent, either by reason of their provenance or because of their association with its religious purpose and mission. First of all there is a remarkable votive relief model of the court. Beside the remains of the abbesses (the engraved tomb of Cunegonde with a Baroque grille and, beyond that, the reputed remains of Mlada in a glass coffin placed in a niche on the epistle side — an arrangement adopted around 1733), there are objects and symbols of their office and rank: the abbatial cross and their princely crown. Among the paintings, the focus of interest is the so-called St George Triptych and — more of a curiosity — a Baroque painting which simultaneously represents Mlada's mission to Rome and the handing over of the foundation act of the diocese to Boleslav II.

To the right of the chapel entrance is the original of the semicircular high relief showing St George slaying the dragon: it can also be seen at a distance from the entry of the south wing. It was removed from the tympanum of the southern side door of the basilica (where a copy now stands). Originally, the clay relief was richly coloured and in some measure it resembles the technique of woodcarving. Its date is 1510-20. The interesting theory has been

advanced that it may have been a kind of homage paid to Prince Louis Jagiello, who had been crowned in Prague in the spring of 1509; and that it predicted his destiny of resisting the Turkish threat.

In the south wing of the cloister the tombstones of thirteen abbesses of St George's, dating from various centuries, are built into the walls. At the foot of the tower, a glass partition affords a beautiful and imposing view of the adjoining St George's Basilica.

THE HISTORY AND NATURE OF THE ART COLLECTIONS

It is worth saying a few words about the institution of the Prague National Gallery to give those who are interested a rather more detailed account of the somewhat complex origins, development and nature of the collections that form such an important part of the nation's heritage.

The Private Society of the Patriotic Friends of the Arts, which was founded on 5 February 1796 'once more to encourage art and good taste...', was the origin of the present-day National Gallery. This Society, with its noble intentions so clearly declared in its act of foundation, aimed to halt the decline of the fine arts (which had reached their peak in the second half of the 18th century) and to check the systematic export of art works belonging to old collections. The foundation of an Academy of Fine Arts would achieve the first of these objectives, while the second would be assured by the creation of a permanent gallery in Prague. The idea for the Society came from the cultured and scholarly Count František Šternberk-Manderscheid. During the Society's initial period, the paintings were not the property of the gallery but of the different members of the Society, who provided them on loan. An annual auction was held where members could purchase the paintings acquired during the year by the Society out of its funds. This system was abolished in 1835.

Certain key dates mark the subsequent development of what was eventually to become the National Gallery. Thus the Modern Gallery of the Czech Kingdom, as envisaged by the Society of Patriotic Friends, was completed in 1901 and created by an edict of Emperor Franz Joseph. Credit for the organisation and efficient running of the gallery goes to Vincenc Kramař (director from 1919-39), an internationally recognised expert and collector of Cubist paintings. In 1933, the state took charge of the collections, establishing what became known as the State Collection of Ancient Art. During the Second World War, it functioned under the title of the Czecho-Moravian Territorial Gallery of Prague. In 1945 the collections of ancient and modern art were handed over to the National Gallery, heir to a two centuries-old tradition, during which time chance had frequently played a role in determining where the collections were housed. Early in its history, in 1811, the Society had acquired the Sternberg (Šternberk) Palace, at Hradčany, and had held its first exhibition there. In 1885 the Society's works of art found another suitable home in the Rudolfinum, which had just been built to hold concerts; this was a donation from the Czech Savings Bank for local cultural activities.

After the First World War, this building was handed over to the Parliament of the new independent nation, which had no seat of its own. Thus art lovers were once more faced with the problem, as they had been a century or so before, of looking for a new gallery. In 1945, at the end of the Second World War, the National Gallery collections were housed in the Sternberg Palace, and selected examples of ancient Czech and European art were exhibited together. After the transfer to St George's Convent of the Czech painting and sculpture collections of the Gothic and Baroque periods, the rooms of the Sternberg Palace were reserved exclusively for foreign art. So the two central collections of the National Gallery, each with a clearly defined, specialised character, finally found suitable homes.

Since then, both collections have grown so rapid-

ly that new exhibition galleries have had to be acquired. In spite of this, only a tiny proportion of the art works in store is exhibited and accessible to the public. And even those works that form the core of the permanent exhibitions are likely to be subjected to essential changes in the near future. Although these are mainly owned by the National Gallery (through purchases, donations, legacies, etc.), many are works of art confiscated or stolen after the Communists seized power in 1948. They include the property of religious orders or church institutions, inheritances of aristocratic families, objects originally belonging to private collections, and so forth. Because the priority has been to establish the legal position and, where necessary, to make restitution in such cases, this has led to new relationships between the gallery and the various owners, taking the form of short- and long-term loans. Fortunately, all concerned are well aware of the historical and artistic importance of the nation's cultural heritage, and this provides a solid foundation for finding satisfactory solutions to the problem in the future.

As already mentioned, the Gothic works of art are exhibited in the basement, and those ranging from Late Gothic to the Renaissance on the ground floor of the convent. There are close to two hundred paintings and sculptures on display and, as far as circumstances permit, these follow a logical time-scale and sequence of development. They represent a golden age of artistic achievement during the reigns of two monarchs of the Luxembourg dynasty, the emperors Charles IV (king of Bohemia from 1346 to 1378) and his son Wenceslas IV (king of Bohemia from 1378 to 1419), at a time when Czech art played an important and, to some extent, leading role in the countries north of the Alps.

Charles IV, one of the great statesmen of the Middle Ages and by far the most influential monarch of his time, was directly or indirectly associated with all contemporary developments in learning and culture, particularly in the field of fine arts. According to its reputed date, the oldest fragment of panel painting (known as the 'fragment of the Roudnice polyptich') coincides, almost symbolically, with the accession of Charles IV; and the date of the emperor's death with the appearance of the Master of the Třeboň Altarpiece, who raised the level of Czech painting to new heights. A number of factors — the quality of the mural paintings and illuminations that have survived, the maturity of the local milieu, the abundance of mid-14th-century painting on glass and, finally, comparison with what was going on in neighbouring regions — point to the hypothesis that the earliest development of painting on wood could have occurred much earlier, perhaps dating from about 1310 to 1320, namely during the time of John (the Blind) of Luxembourg, king of Bohemia from 1310 to 1346. Yet, in spite of the astonishing wealth of preserved fragments, these represent only an infinitesimally small proportion of the original production. Thus, before 1420, there were 104 public sanctuaries in Prague, and 89 altars in St Vitus's Cathedral alone; in 1348 a brotherhood of painters had been founded, which subsequently became the Guild of St Luke, the first professional body of its kind in Europe. Consequently, any attempt to trace the development of medieval Czech art can only be theoretical since it is based merely on objects that have been preserved by chance: miraculously they managed to survive the unimaginable destruction wrought by the Hussite uprisings and other disasters brought on by war, natural causes or fatal actions stemming from ignorance and illiteracy.

The imperial policy of Charles IV was based essentially on principles of Bohemian centralism as well as personal and dynastic sovereignty. The emperor was fortunate in surrounding himself with the ablest representatives of the church hierarchy, and his activities as a builder and patron attracted, from near and far, the greatest masters in their fields: Matthew of Arras, Peter Parler, Nicolas Wurmser and others. The interchange of ideas from Italy and western Europe with those of local tradition rapidly produced a syncretism of different

influences and stylistic tendencies. Out of this emerged a local plastic style that was given the opportunity to develop and mature as a result of innumerable commissions obtained from the court of Charles IV and from other representatives of the upper echelons of society, both secular and religious. The development of the schools of Czech painting and sculpture (which in many respects strongly influenced each other) was determined and assured by a succession of creative geniuses: the Master of the Vyšši Brod Cycle, the Master of the Michle Madonna, Master Theodoric, the Master of the Třeboň Altarpiece, the Master of the Týn Tympanum, the Master of the Krumlov Madonna, the Master of the Rajhrad Altarpiece, and others.

All in all, the work of these masters showed an astonishing inner cohesion, for the creative impulse of each individual was conditioned by a common cultural and spiritual heritage. The formally late, but refined, expression of the Flamboyant Gothic style, dating from around 1400, was replaced by an art that already reflected the anxiety and the spiritual and social unease of pre-Hussite Bohemia; and this boded ill for the future of local plastic arts as a significant force in the overall context of European culture. During the ensuing fifty years or so, artistic output was sparse and uninspired. Not until the 1460s and the political changes associated with the accession of George of Poděbrady (king of Bohemia from 1458 to 1471) and the first of the two Jagiello monarchs, Vladislav II (king of Bohemia from 1471 to 1516) was there any evidence of a revival in architecture, painting and sculpture. Only then did local culture once more react and adapt to outside influences, stimulated by the example of its European neighbours.

Bohemia initially became aware of the realism of Flemish art, as evinced in varying measure by successive generations, through indirect contacts with German centres of painting in the Rhineland, Nuremberg and other places. Later still, this time learning from native example, Czech art derived inspiration from the Danubian school of land-

THE MASTER OF THE KRUMLOV MADONNA (active from the 1380s until the early 15th century)

St Peter, *c.* 1395, marl with traces of polychrömy, height.91.5 cm (36 in). The right hand and part of the keys are missing, the

182

nose is broken and there is slight damage to the drapery.

On the basis of stylistic studies, this sculpture has been attributed to an anonymous artist who owes his name to a statue of the Virgin and Child (made around 1400) from the town of Český Krumlov (southern Bohemia) and now to be found in the Kunsthistorisches Museum, Vienna. Whereas the curve of the body and the form of the drapery conform to the more or less obligatory criteria of modelling for this genre of sculpture, the head of the old man is rendered in a wholly unusual manner, representing a masterly synthesis of aesthetic idealism and intensely realistic observation. The sculpture was loaned to the National Gallery by the parish church of St Peter of Slivice.

scapists. From 1470 onward, until well into the early 16th century, a number of important new artists appeared, whose works were the equal of anything currently being done in Europe: the Master of the St George Altarpiece, the Master of the Puchner Altarpiece, the Master of the Žebrák *Lamentation of Christ*, the Master of the Litoměřice Altarpiece, Master IP, etc.

In the last part of the exhibition, certain general tendencies are evident: for example, the persistence of ancient tradition in painting and sculpture and the gradual conception and expression of Late Gothic. The breakthrough achieved by an objective approach to naturalism and realism, the changes in the artistic perception of space, of the human face and of the pictorial setting, and the differences in iconographic representation, etc. — all this is interesting and revealing in the light of the ensuing transformation from Late Gothic to the new viewpoint of Renaissance aesthetics.

If, for convenience, the collections of St George's Convent are defined broadly as Gothic and Baroque, the last works of the first section date from around 1530 (Master IW and Master IP). The oldest Baroque paintings and sculptures on display were done around 1630 (Karel Škréta and Arnošt Jan Heidelberger). This gap of a hundred years is bridged by a small but select group representing so-called 'Rudolfian' Mannerism: an art style created at Emperor Rudolf II's court in Prague. Actually, it is a specific and unique form of artistic expression, and the fact that it is included in the exhibition should not convey the impression that it represents any kind of continuity, spanning the two styles. In the last few decades keen interest and detailed study have thrown much light on the phenomenon of Mannerism. This body of painting and sculpture, created by foreign artists working in Prague, is now deservedly recognised as occupying a very prominent position in the history of art.

Rudolf II officially transferred the capital of his empire to Prague in 1583, eight years after being crowned king of Bohemia in St Vitus's Cathedral.

He then lived in the castle permanently until his death in 1612 and directed all the complex royal activities associated with the Habsburg dynasty from Prague. But although his imperial policies often aroused controversy, there can be no denying that, as a monarch, his interest in and passion for art, and his appreciation and understanding of all forms of artistic creativity were unrivalled. In his capacities as collector, promoter and patron, he surrounded himself with brilliant artists from virtually every corner of Europe, a dazzling list of names ranging, alphabetically, from Arcimbolo to Vries. His collections at Prague Castle were, and still are, of incalculable historical and cultural importance: his network of agent-buyers covered the whole of Europe, and his local colony of artists made priceless contributions in every field of the fine arts — examples of which can be found today in all the great world collections. Some twenty or so key figures of 'Rudolfian' art are represented in the aforementioned small selection in the convent: there are paintings by Bartholomeus Spranger, Hans von Aachen, Josef Heintz, Roelant Savery and others; and sculptures by Adriaen de Vries and Hans Mont. These works were chosen so as to provide a fair sample of this refined court culture, its motivation and content, its method and style, and, not least, to show off the astonishing virtuosity of its creators.

The first floor of the cloister is devoted to the Baroque. The period covered by the exhibits ranges from the earliest works of Škréta (in the 1630s) to the Rococo works of Norbert Grund (late 1760s) and even to the late classical style of the Platzer studio (around 1800). Paradoxically, these dates, insofar as they reflect social and political life in Europe generally, and in the Czech-speaking lands specifically, coincide with shattering events affecting ordinary people everywhere, from the horrors of the Thirty Years' War to the dramas of the French Revolution. The dates also span the reigns of some ten monarchs of the Habsburg dynasty, from Ferdinand II to Leopold II. In the religious sphere, this period saw the cruellest forms of repression and

the resurgence of Catholicism after the battle of the White Mountain (1620), which was lost by the Protestants (it is estimated that more than a quarter of the professional and educated classes went into forced exile). This was roughly the period that began with the return of the Jesuit order to Prague (from which it had been driven out in 1618), to become the principal agent of the systematic Catholicising policy of Ferdinand II, and with the founding of its college, the Clementium, around 1656, and ended in 1781 with Joseph II's Edict of Tolerance and the secularisation of monasteries.

Broadly speaking, during this period of some one hundred and fifty years, the irreplaceable loss that Bohemia suffered as a result of the departure of its intellectuals proved to be Europe's gain, with the arrival of many important figures, such as the writer and philosopher Comenius (Jan Ámos Komenský) and the designer and engraver Václav Hollar. But, in compensation, this same period saw a regular flow of artists and craftsmen in the reverse direction, from many European countries towards Bohemia, where they helped to establish the Baroque style throughout the Czech-speaking lands and, particularly, in the capital city of Prague.

This continuous exchange of personalities and ideas, of such lasting significance on a spiritual and cultural level, was one of the principal features of the Baroque era. Among those forced to leave was Škréta, who returned from exile in Italy in 1638, the same year that the architect Carlo Lurago arrived in Prague. Jan Kupecký, born in 1667, was to spend his entire life in exile, travelling all over Europe; Petr Brandl, on the other hand, born in 1668, never left his native land. One year separates the erection of the first statue on Charles Bridge (that of St John of Nepomuk, in 1683) and the birth of Matthias B. Braun (1684), the genius from the Tyrol and master of the Baroque whose sculpture was to adorn the bridge, one of the most important and famous cultural monuments in Europe, and many of the city churches. In that same year (1689) two great artists were born: Kilián Ignác Dienzenhofer, the most gift-

ed of all local architects, who created the so-called Dienzenhofer Baroque and whose masterpieces include that most beautiful of all the Late Baroque churches, St Nicholas's Church in the Old Town; and Václav Vavřinec Reiner, frescoist and painter, a dazzling exponent of Baroque art at its zenith. And as if to re-emphasise the close links and reciprocal influences of the three principal areas of the plastic arts, the previous year (1688) had seen the birth of Ferdinand M. Brokoff, another major figure of Czech sculpture and the very antithesis of Braun.

Czech Baroque art, after the Gothic of Charles IV and Wenceslas IV, made a significant contribution to European plastic arts. It was a highly complex phenomenon, inherently founded upon the synthesis and interplay of the three principal creative areas: architecture, painting and sculpture. The St George's Convent collection cannot possibly give a complete picture of the scope, diversity and individuality, nor of the harmony and homogeneity of this artistic heritage. Yet, in spite of such inevitable shortcomings, it remains an indispensable experience, intellectually and emotionally stimulating, with a significance beyond time and place.

Opposite page: plan of St George's Basilica and cloister, signed by Niccolo Pacassi (1789). The coloured area corresponds to the present-day site of the National Gallery.

Right: the south isle of the cloister seen from the main entrance; in the background is a semicircular high-relief from the early 16th century representing St George slaying the dragon.

Below: the north corridor, with 15th-century works in the foreground.

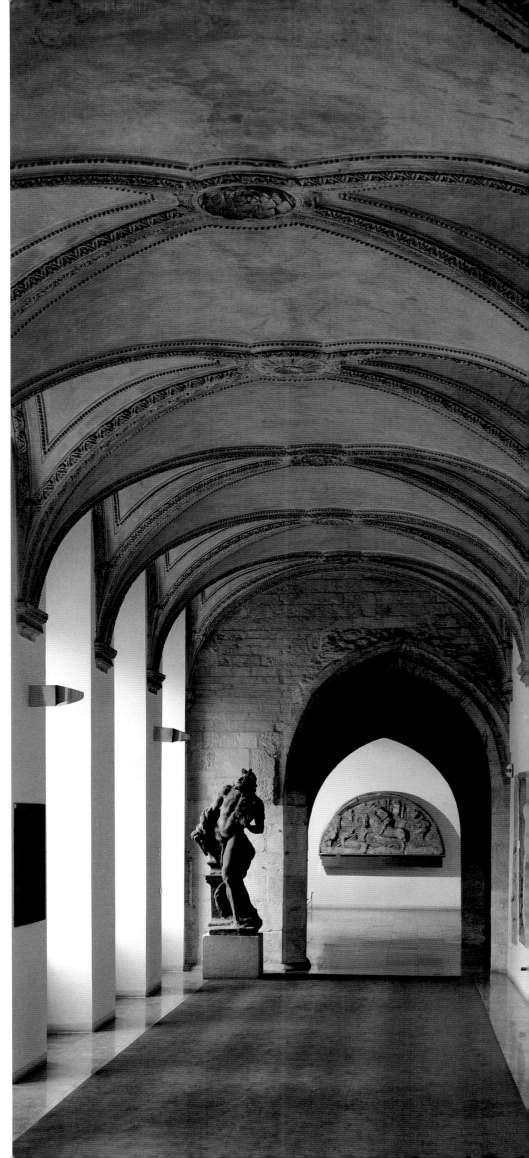

CZECH MASTER FROM BEFORE 1350

Fragment of a polyptich with the figures of St Andrew, St John the Evangelist and St Peter; before 1350, distemper on maple wood, mounted on cloth, height 40 cm (15.75 in), width 91 cm (36 in).

This fragment, dating from 1345-9, is

this town or, more probably, for the castle, which served as a summer residence for the bishops of Prague. The style of the painting is notable for its expressive drawing and numerous Italian features. It shows every sign of being a transitional work in which ancient, traditional forms were subjected to strong Italian influence, possibly transmitted by the importation of manu-

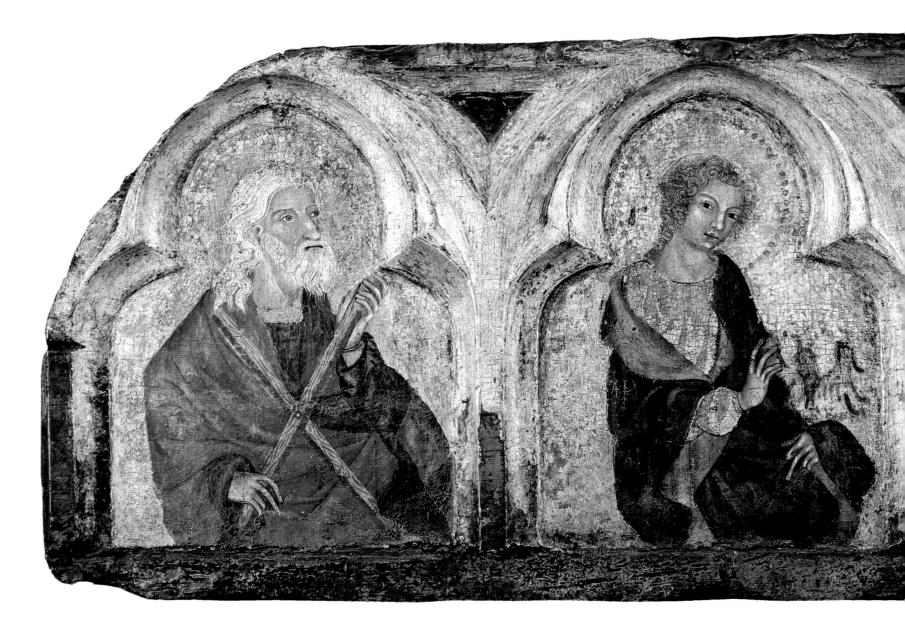

regarded as the oldest Czech painting on wood. It was long thought to be the lower part of the predella of an altarpiece, but today it is considered to be a fragment of a larger polyptich which represented the twelve apostles in several superimposed ranks. It comes from St Joseph's Chapel of Roudnice, but was doubtless originally intended either for the Augustine abbey of

scripts and by the artistic atmosphere diffused by the entourage of Bishop Jan of Dražice (d. 1343).

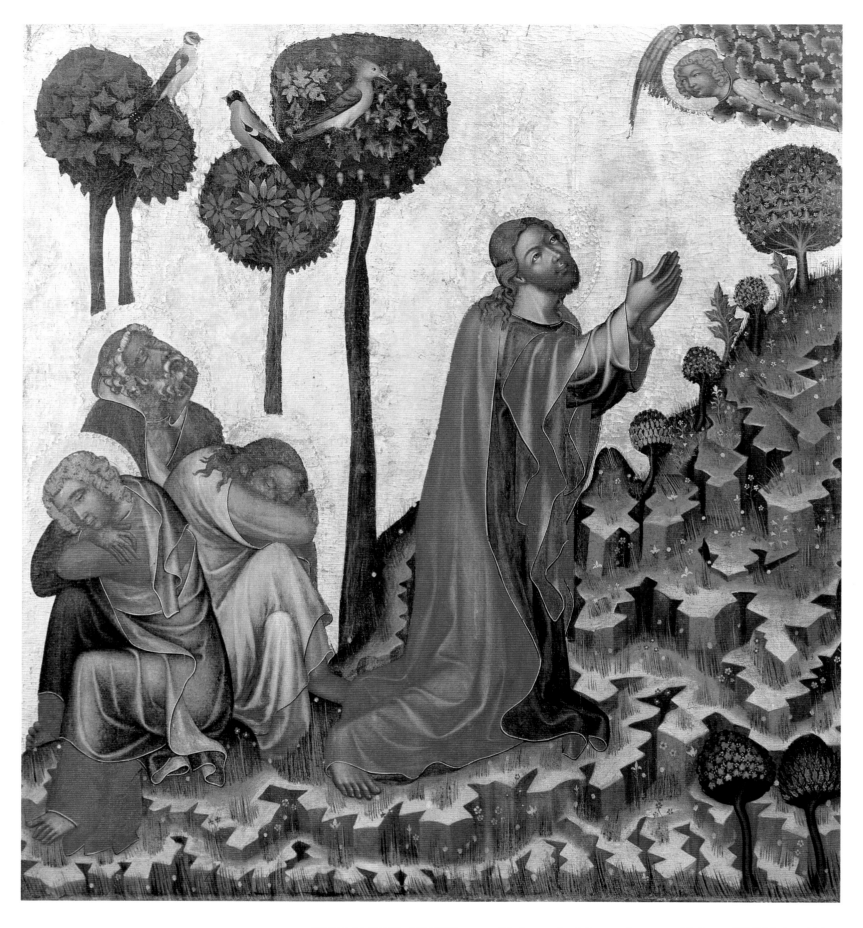

THE MASTER OF THE
VYŠŠI BROD CYCLE
(active 1340-60)

*Christ on the Mount of
Olives*; before 1350, dis-
temper on maple wood,
mounted on cloth, height

99.5 cm (39.25 in), width
91.5 cm (36 in). Scholars
now tend to agree that this
was part of a large square

altarpiece consisting of nine panels in three rows. The lower row of paintings would have represented the childhood of Christ; the centre row, his sufferings, and the upper row his apotheosis. On the basis of this reconstruction, the *Mount of Olives* would have appeared on the left-hand panel of the centre row. The nine panels which have been preserved thus make up a complete whole. They come from the Church of the Assumption of the Blessed Virgin in the Cistercian convent of Vyšši Brod (Hohenfurth). On the *Nativity* panel, the kneeling figure of the donor, Peter of Rožmberk (d. 1347), has been identified. His death probably indicates the latest date for the creation of the cycle. It has not yet been determined whether they originally came from Vyšši Brod or from Prague, but judging by the high quality it was undoubtedly created in one of the best court workshops. The Master of the Vyšši Brod Cycle was a dominant figure in the first generation of panel painters: as the founder of the Czech tradition of the genre, he had a profound influence not only on Czech painting but also, to a certain extent, on sculpture, elevating local production to European level.

MASTER THEODORIC
(active 1350-70)

St Elizabeth; *c.* 1365, distemper on beech wood, height 114.5 cm (45 in), width 86.5 cm (34 in).

Master Theodoric is the first Czech painter to be known by name, about whom we have personal information, and whose work has survived. Magister Theodoricus or Theodoricus pictor was court painter to Emperor Charles IV, first master of the confraternity of Prague painters and owner of a house in the Hradčany quarter. *St Elizabeth* was part of a series of paintings that Theodoric and his workshop did to decorate the Holy Cross Chapel in the dungeon of Karlštejn Castle: it comprised *The Crucifixion*, *The Man of Sorrows* and 127 panels with the figures of Christ's army. A letter from the emperor, dated 28 April 1367, announcing that the artist was to be paid for the finished work, makes it possible to affirm with certainty that the decoration of this chapel was completed by this date at the latest. The panels formed part of the overall ornamentation which included inlaid semi-precious stones in the walls, mural paintings, inlaid crystal in the vault, etc. The chapel was the repository of relics of the Passion of Christ and the Crown Jewels; and relics of various saints were also placed in the picture frames. Theodoric was the principal representative of the second generation of Bohemian painters on wood. Above: the room devoted to Master Theodoric.

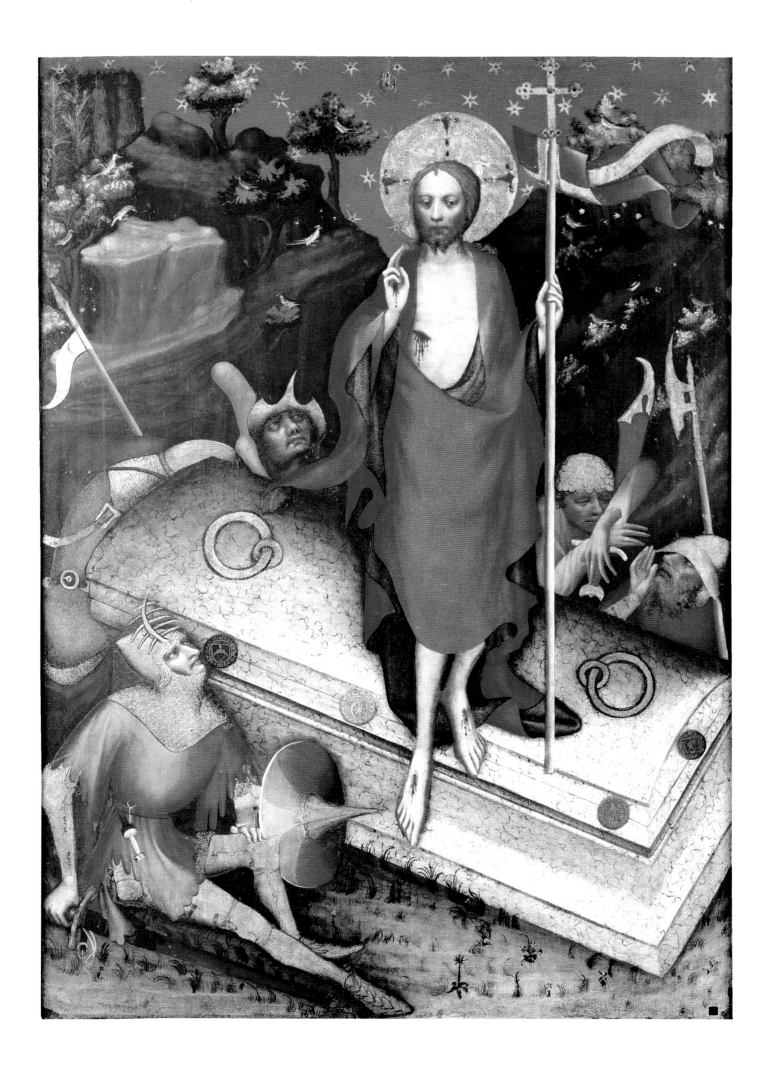

190

THE MASTER OF THE TŘEBOŇ ALTARPIECE
(active 1370-90)

The Resurrection of Christ; c. 1380, distemper on spruce wood, mounted on cloth on both sides, height 132 cm (52 in), width 92 cm (36.25 in).

The panel is painted on both sides. On the reverse are figures of three apostles, St James the Just (the Less), St Bartholomew and St Philip; on the front is the *Resurrection of Christ*. This is one of the three surviving panels from a large altarpiece, since dismantled. The two others represent *Christ on the Mount of Olives* and *The Entombment*, with, on the back of each panel, the figures of three saints. There is no doubt that other panels are missing, so that views differ as to the likely initial appearance of the altarpiece. Originally it was in St Giles's Church at the Augustine abbey of Třeboň (southern Bohemia); after the altarpiece was dismantled, the panels were given, in the first half of the 18th century, to local churches of the region. The Master of the Třeboň Altarpiece was a brilliant artist and, thanks to his work, the third generation of Czech painting reached unequalled heights.

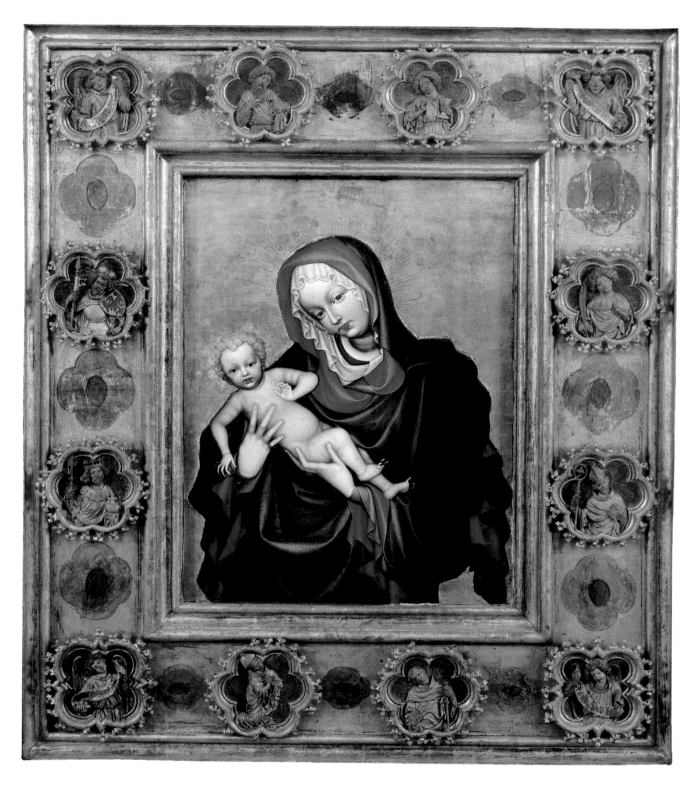

CZECH MASTER FROM BEFORE 1396

Madonna and Child known as *St Vitus's Cathedral Madonna*; before 1396, distemper on lime wood, mounted on cloth on both sides, height 51 cm (20 in), width 39.5 cm (15.5 in).

This is undoubtedly the best-known local Marian painting which, according to the second iconographical variant, shows the Mother and Child, the latter resting on Mary's right arm, directly facing the observer. In the corner quadrifoliate medallions of the carved frame, there are half-figures of four angels, with white ribbons bearing the abbreviations of the beginning of a Marian song. On the upper part of the frame, the half-figures of St John the Baptist and St John are placed in the six-lobed medallions. On the left of the frame are St Wenceslas and St Sigismund; on the right, St Vitus and St Adalbert. At the bottom of the frame, on the right, is the local St Procopius, particularly venerated by the donor, Archbishop Jan of Jenštejn, because of the extreme austerity of his monastic life. The archbishop is himself represented kneeling in the left-hand medallion. The blessing of the foundations of the three-aisled nave took place in 1392 and the archbishop gave up his functions in 1396; the work was painted between these dates and was undoubtedly a personal donation by Jenštejn to the cathedral.

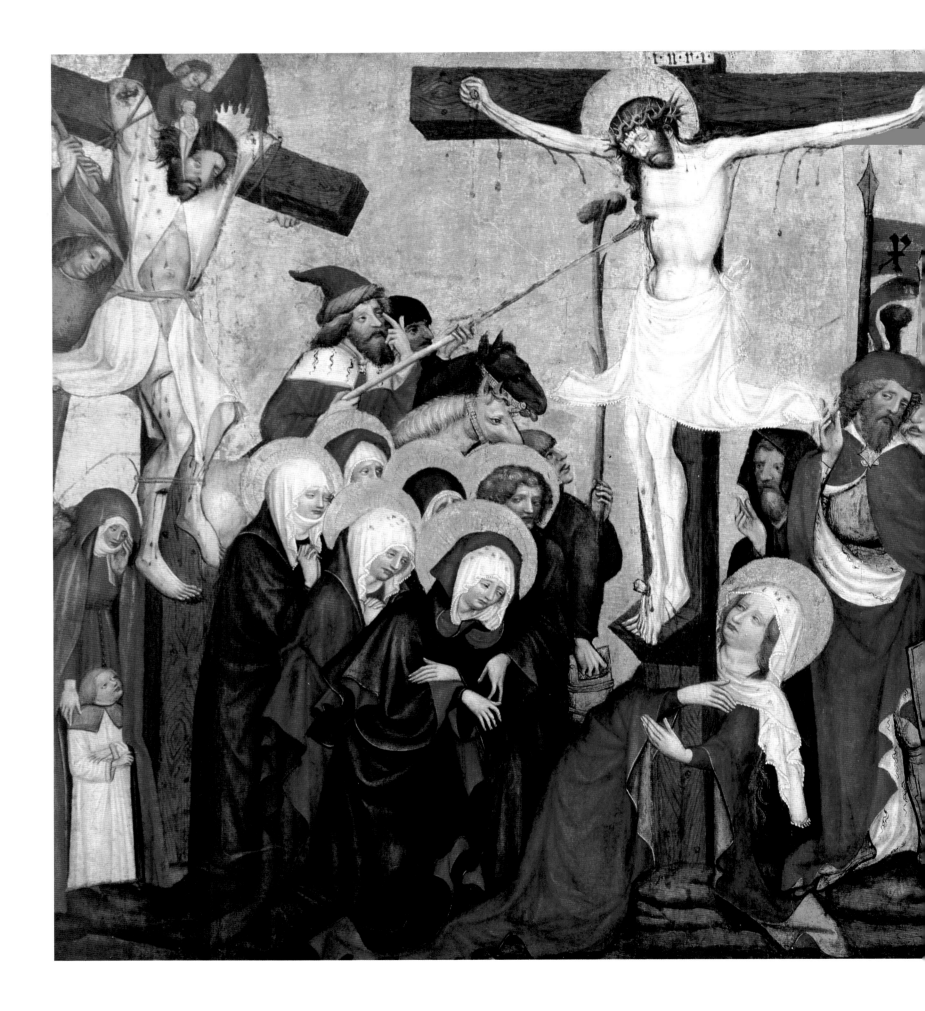

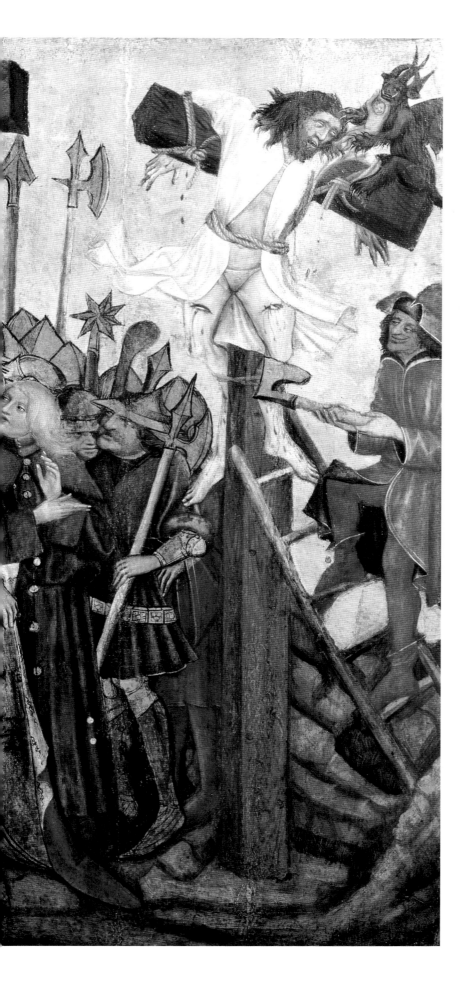

THE MASTER OF THE RAJHRAD ALTARPIECE
(active 1415-60)

The *Rajhrad* or *Nové Sady Crucifixion*; before 1420, distemper on spruce wood mounted on cloth, height 101 cm (39.75 in), width 142 cm (56 in).

This panel, painted on one side, is from a large, dismantled altarpiece, only six panels of which survive. The second

of the Holy Cross. The Master of the Rajhrad Altarpiece headed a large workshop, doubtless situated in Brno, since the surviving works are mainly of Moravian origin. His style is in the tradition of the Master of the Třeboň Altarpiece and Flamboyant Gothic, but also shows close familiarity with contemporary pictorial production (from France, the Netherlands, northern Germany, etc.). In fact, he represents the culmination of

panel, its width exceeding its height, shows the *Way of the Cross*, and the four others are smaller, but painted vertically. The two wide panels would have formed the centre of the altarpiece. The *Crucifixion* comes from the Church of St Philip and St James in Olomouc: it was brought there in 1784 from its original site, St Maurice's Church, in the same town. The iconographical subject of the altarpiece was Christ's Passion and the legend

Czech panel painting and was the last important painter before the start of the Hussite troubles.

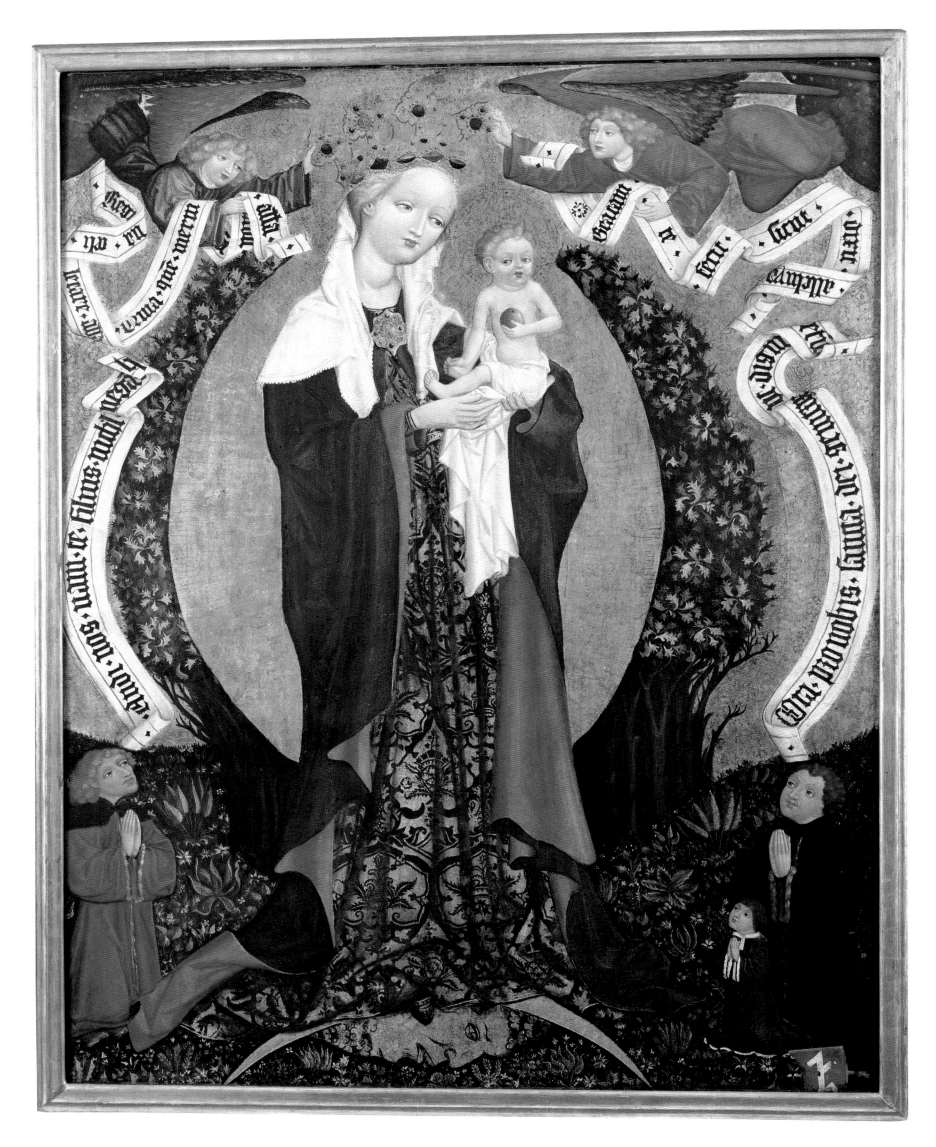

CZECH MASTER OF AROUND 1450

The Assumption in a Flower Garden, the so-called *Děstná Assumption*; *c.* 1450, distemper on spruce wood, mounted on cloth, height 144 cm (56.75 in), width 111 cm (43.75 in).

The Virgin Mary, hair in a halo, stands in a flower garden and holds the infant Jesus on her left arm; beneath her feet sin and evil are symbolically represented in a halfmoon, while at the top of the picture the Madonna is crowned Queen of Heaven by two angels. The highly complex iconography of this painting is to be interpreted principally as a devout manifestation of the Marian cult: the inscriptions with fragments of Marian litanies testify to this. The painting comes from St John the Baptist's

Chapel in Děstná (southern Bohemia). There are references in the picture to the Flamboyant Gothic style but also significant Late Gothic elements, as in the descriptive realism of the natural features and the folds of the draperies.

MASTER OF THE ST GEORGE ALTARPIECE (active 1470-85)

Triptych with the Death of the Virgin Mary, the so-called *St George Triptych*; *c.* 1470, distemper on lime wood, mounted on cloth on the central panel and on the inside of the two wings; panel, height 192.5 cm (75.75 in), width 114 cm (45 in); each wing, height 192 cm (75.75 in), width 56.5 cm (22.25 in).

The central panel of the open triptych rep-

resents the death of the Virgin Mary: above, in a square, is Christ with the soul of the Virgin Mary and a choir of seven angels. At the top of the left wing is the Visitation and, below, the Adoration of the Magi. When the triptych is closed, the reverse side of the left wing shows, above, St Wenceslas and, below, St Philip and St Simon with the donatrix, the kneeling abbess. On the reverse side of the right wing, above, is St George, one foot placed on the dead dragon and, below, St Andrew with the donor, the kneeling canon. The placing of a key scene of the St George legend as well as the image of the saint himself on the outer side of a triptych wing is rather unusual, but is explicable here by the fact that the triptych was originally intended for St George's Basilica.

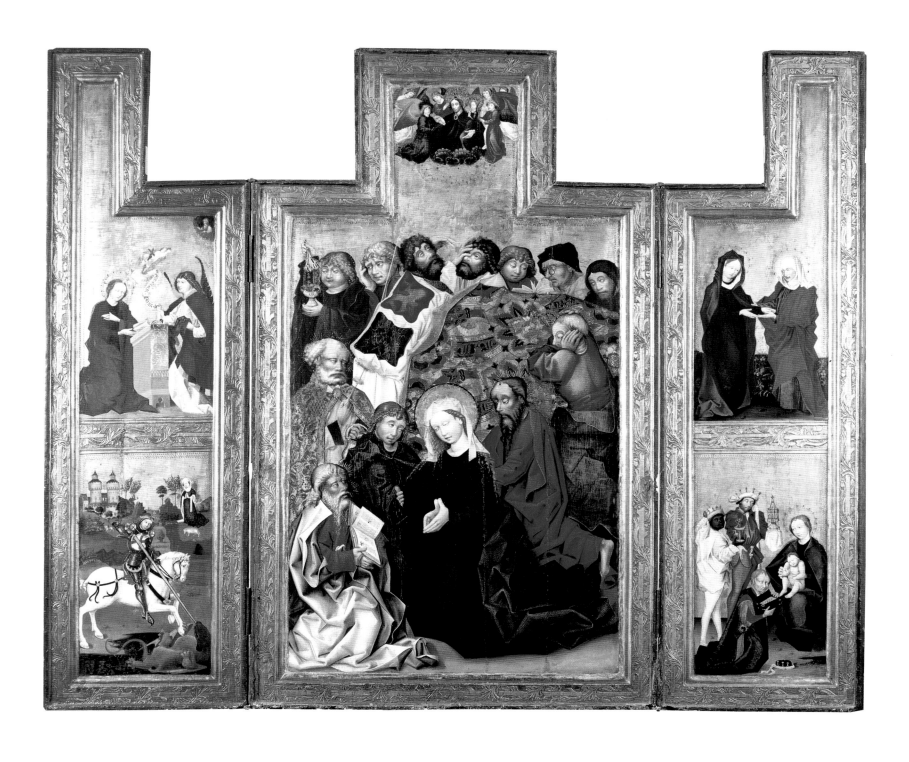

that such an altarpiece might have been destined for a chapel. *The Martyrdom of St Catherine* was bought in 1969 by a private Austrian collector; this work, as well as others by the same hand, show that the Master of the Litoměřice Altarpiece was one of the most important Czech painters during the first quarter of the 16th century.

CZECH MASTER FROM THE FIRST THIRD OF THE 13TH CENTURY

High-relief in three parts from St George's Basilica; 1210-28, gilded marl; centrepiece, height 88 cm (34.75 in), width 57 cm (22.5 in); wings height 66 cm (26 in), width 27 cm (10.5 in); traces of polychromy on central section; the left and right bases of the wings are broken and there is other slight damage. The central high-relief shows

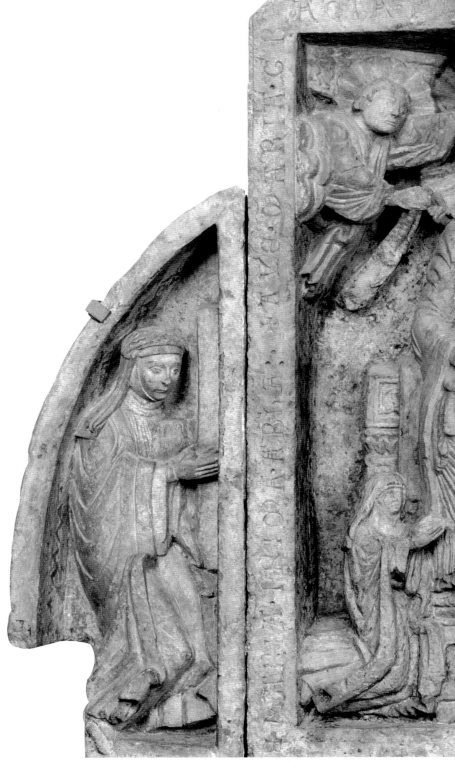

THE MASTER OF THE LITO-MEŘICE ALTARPIECE (active 1490-1520)

The Martyrdom of St Catherine; after 1510 distemper on lime wood, height 77.5 cm (30.5 in), width 44.5 cm (17.5 in).

The wood panel is painted on both sides. On the reverse is *St Catherine in Alexandria Debating with the Pagan Philosophers*. This is a movable wing, difficult to identify with precision, from a dismantled altarpiece which has not been entirely preserved. Four other

paintings belonging to it are known, on panels painted on both sides that were sawn off: *St Catherine before the Emperor Maximilian; The Burial of St Catherine; The Vanity of St Catherine;* and *St Catherine Visiting a Hermit.* They are all in foreign collections.

The fragmentary character of the remains of this altarpiece makes it impossible to theorise as to its original appearance. What is certain is that a complete wing painted on both sides has been lost. The smaller format of the paintings suggests

the Madonna in majesty, crowned by angels bearing monstrances. Kneeling at her feet are: left, the founder and first abbess of St George's Convent, Mary Mlada, and, right, the abbess Bertha known as the "second founder". On the right wing is the Přemysl king, Otakar I, on his knees, and on the left wing a nun, probably Agnes, half-sister of the king. The importance given to her suggests that she may have been the donatrix of the high-relief.

Experts do not agree as to where this sculpture was originally placed (either on the door of the Chapel of the Virgin Mary or on the main or south door of the basilica). The work is one of the most important examples of Czech Romanesque art.

CZECH MASTER FROM THE FIRST QUARTER OF THE 14TH CENTURY

Madonna and Child, the so-called *Strakonice Madonna*, *c.* 1300, fir wood, height 183 cm (72 in); sculpture carved on the back with traces of polychromy; the right hand of the Madonna is missing; the head and left hand of the infant Jesus (in lime wood) have been added.

The statue comes from the Way of the Cross of the Hospitallers' Convent of St John of Jerusalem, Strakonice. According to an inventory of

1742, it was then placed in the chapter room, namely St George's Chapel. It was acquired for the National Gallery in 1927. This Madonna ranks as one of the most important Central European works of art, exemplifying a phase of development towards an abstract post-classical style. The statue occupies an exceptional place in Czech Gothic sculpture by reason of its close link with monumental French sculpture and with the same trend of cathedral sculpture in the Rhineland.

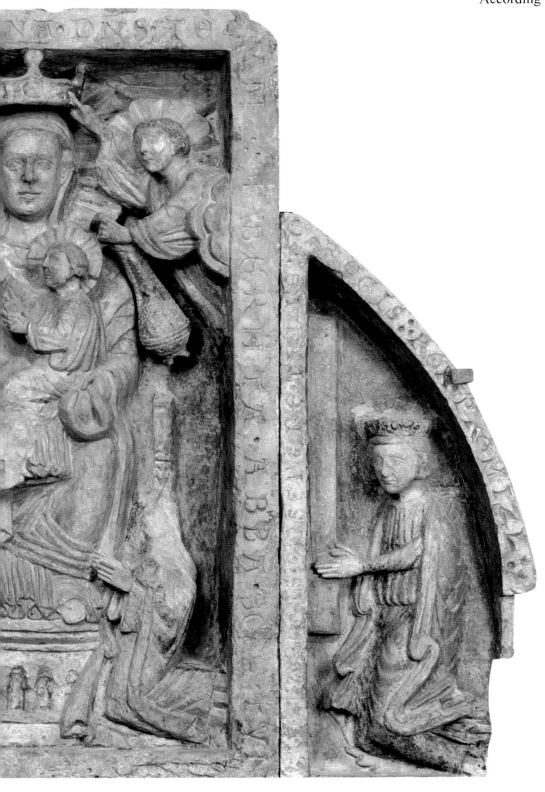

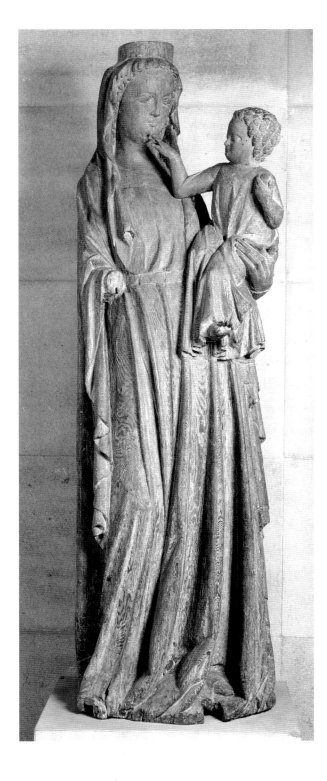

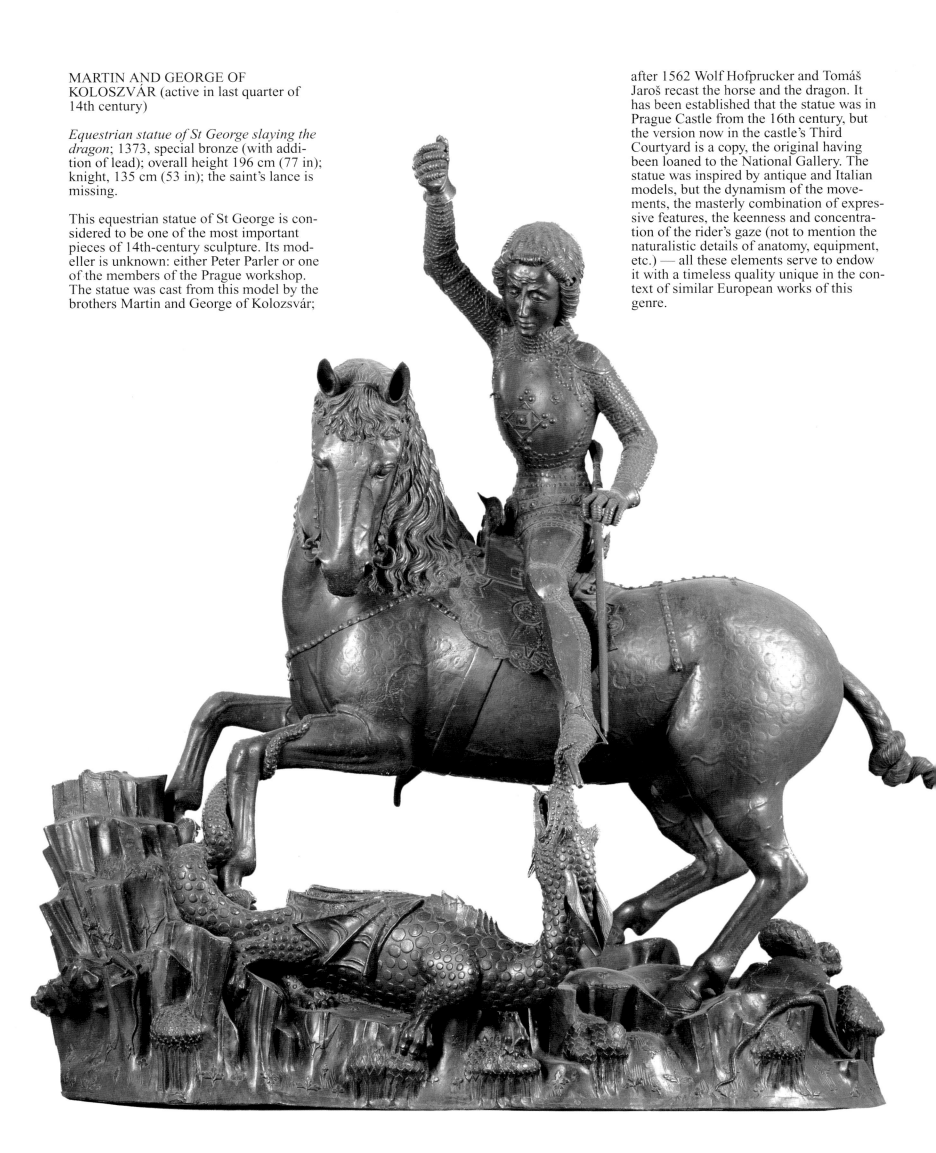

MARTIN AND GEORGE OF KOLOSZVÁR (active in last quarter of 14th century)

Equestrian statue of St George slaying the dragon; 1373, special bronze (with addition of lead); overall height 196 cm (77 in); knight, 135 cm (53 in); the saint's lance is missing.

This equestrian statue of St George is considered to be one of the most important pieces of 14th-century sculpture. Its modeller is unknown: either Peter Parler or one of the members of the Prague workshop. The statue was cast from this model by the brothers Martin and George of Kolozsvár;

after 1562 Wolf Hofprucker and Tomáš Jaroš recast the horse and the dragon. It has been established that the statue was in Prague Castle from the 16th century, but the version now in the castle's Third Courtyard is a copy, the original having been loaned to the National Gallery. The statue was inspired by antique and Italian models, but the dynamism of the movements, the masterly combination of expressive features, the keenness and concentration of the rider's gaze (not to mention the naturalistic details of anatomy, equipment, etc.) — all these elements serve to endow it with a timeless quality unique in the context of similar European works of this genre.

THE MASTER OF THE LAMENTATION OF THE CHRIST OF ŽEBRÁK (active in first third of 16th century)

The Lamentation of Žebrák; *c.* 1510, lime wood, height 126 cm (49.5 in), width 121 cm (47.75 in); traces of original polychromy and later white painting, series of cracks and slight damage.

This remarkable work owes its name to its anonymous creator, an important sculptor in wood who ran a workshop at České Budějovice, in the south of the country. This sculpture is his only work that does not come from that region. The Prague Museum acquired it from a private owner in Žebrák early in the present century and loaned it to the National Gallery. Research has uncovered more works by this artist and deduced that in his early days he was taught by the Masters of the Kefermarkt Altarpiece (Austria), and that he developed this style in a very personal manner, notable particularly for a depth and tension of subjective feeling, a spiritual dimension and an authenticity of form and expressive means.

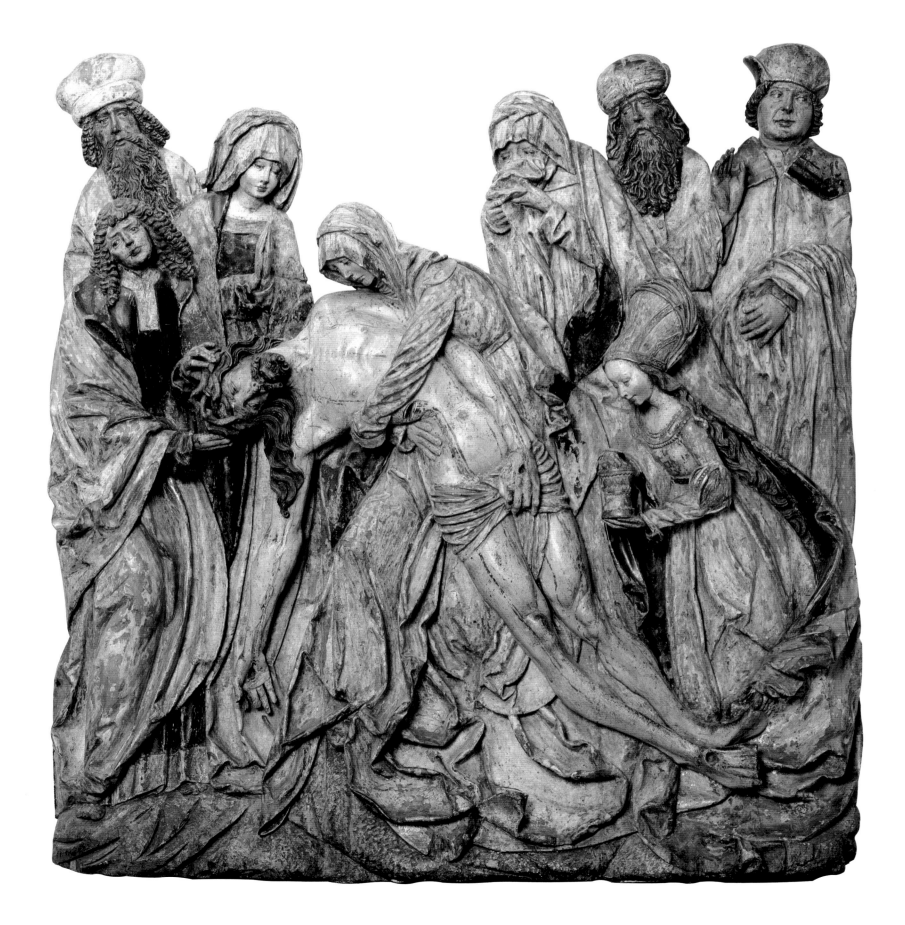

ADRIAEN DE VRIES (The Hague, 1545 - Prague, 1626)

Hercules in the Garden of the Hesperides; *c.* 1625, bronze with original patina, height 162.5 cm (64 in).

The mythological hero holds the golden apples of the Hesperides (daughters of Atlas) in his right hand, which rests against his side, while the left hand grips a club resting on his shoulder. There is no way of telling whether the subject is standing or walking. The somewhat subdued dynamism of the figure, the fluidity and roughness of the modelling, and the vague facial expression are characteristic elements of the artist's late style. The rich play of light on the curves and crevices of the statue, which still retains traces of original patina (due to always having been kept indoors) produces a remarkable effect. Like some other mythological statues, it was intended originally for the garden of the Wallenstein Palace, but in 1648 it was carried off to Sweden by General Königsmark as a trophy of war.

BARTHOLOMEUS SPRANGER (Antwerp, 1546 - Prague, 1611)

Painting to the Memory of the Prague Goldsmith Mikuláš Müller; *c.* 1592, oil on canvas, 243 cm x 160 cm (96 x 63 in), unsigned.

The goldsmith Mikuláš Müller, who died in 1586, had been summoned from Brussels to Prague by Archduke Ferdinand of Tyrol before 1566. His daughter Christina was the wife of Spranger, who did the painting in memory of his father-in-law for St Matthew's Chapel of St John's Church in Malá Strana. The painting, which originally hung beneath the portrait of *God the Father and Two Putti* by Adriaen de Vries, later adorned the tomb of Spranger himself, before becoming private property when the church was closed. At the feet of Christ triumphant over Evil is the family of the deceased, this being a

transalpine convention. On the left is the deceased and his son Jacob; on the right is his wife in a hat and, behind her, their daughter Christina, with a little girl in the foreground. According to Karel Van Mander, the celebrated biographer of artists, Spranger regarded this as one of his best works from the viewpoint of coloration.

JOSEF HEINTZ THE ELDER (Basel, 1564 - Prague, 1609)

The Adoration of the Shepherds; c. 1598, oil on copperplate, 29.7 cm x 21.8 cm (11.75 x 8.5 in), unsigned, illegible inscription on back.

A remarkable example of Heintz's mastery of colour, this painting, although small, nevertheless makes a considerable impression. Heintz was inspired by the central part of Hans Holbein the Younger's *Altarpiece of Chancellor Hans Oberried* (the wings of which are today in Freiburg Cathedral). The shepherd standing at the far right, with his

broad-brimmed hat (*detail above*), is almost identical in the two works, and experts surmise that this is not simply a return to the cultivated past on the part of Rudolfian Mannerism but a direct tribute by Heintz to Holbein the Younger, whom he considered an important source of artistic inspiration. The painting, which was originally in the collections of Rudolf II, came into the possession, at some undetermined time, of the gallery of the Premonstrant Convent in Strahov.

KAREL ŠKRÉTA (Prague, 1610 - Prague, 1674)

St Charles Borromeo Visiting Victims of the Plague in Milan; 1647, oil on canvas, 210 cm x 147.5 cm (82.5 in x 58 in), unsigned; the dedication on the altar, in the centre of the painting, reads: "E/EGO MAX ANTONIUS CASSINIS F.C. 1647".

The painting shows the future St Charles Borromeo, then cardinal, carrying out his pastoral duties during the plague epidemic of 1576. It emerges from the dedication that this painting was commissioned by M.A. Cassinis of Bugella, a member of the presidency of the Italian Congregation. The picture was designed for the high altar of

the painting: he is the bearded man pointing to the inscription, behind St Charles Borromeo, seen blessing the sick. The person standing behind the saint and looking outward is Škréta himself: this is the only self-portrait of the artist to have survived. Škréta painted this work nine years after returning from exile to Prague and three

the Church of St Charles Borromeo in the Italian hospital situated in the quarter of Malá Strana. The donor is represented in

years after his enrolment in the famous confraternity of painters of the Old Town, when he was already a recognised artist.

JAN KUPECKÝ (Prague, 1667 - Nuremberg, 1740)

Self-Portrait: the Artist Working on a Painting of His Wife; 1711, oil on canvas 93.5 cm x 74.5 cm (36.75 in x 29.25 in), signed on the back: "Joh. Kupezky pinx. 1711".

This is one of many self-portraits by Kupecký and resembles the more famous *Self-Portrait of the Artist Working on a Painting of a Man* (perhaps of A.B, de Löwenstadt, a citizen of Wroclaw) in the Österreichische Galerie of Vienna. The Vienna portrait is dated 1709, and that of Prague two years later. This was the year Kupecký, the son of emigrés, who in 1707 had settled in Vienna, and where he was to live until 1723, returned for the second time to his native land for a short stay in Karlovy Vary (Karlsbad), where he painted a commissioned portrait of Tsar Peter the Great. This self-portrait was in the collection of Prince Wenceslas Paar.

204

VÁCLAV VAVŘINEC REINER (Prague, 1689 - Prague, 1743)

Orpheus and the Animals; before 1720, oil on canvas, 199 cm x 167 cm (79 in x 65.75 in), unsigned.

The subject, known best from Ovid's *Metamorphoses*, relates to the mythological fable of Orpheus, founder of poetry, who, having lost his wife Eurydice, expresses his deep grief by playing his lyre and so enchants the different animals that they gather round to listen in a spirit of harmony and conciliation. It is an allegory that aims to underline the magical power of music and poetry, superior to the very forces of nature. This theme is found nowhere else in Reiner's body of work (though there is a similar painting, *Landscape with Birds and a Pointing Dog*, also in the National Gallery). It harks back to an older painting of Orpheus by Michael Leopold Willmann, dated 1670-5. Reiner's two pictures come from the collection of the Counts Nostitz (Nostic) and faithfully reflect the thinking and attitudes of the cultured aristocracy.

PETER BRANDL (Prague, 1668 - Kutná Hora, 1735)

Simeon with Jesus; shortly after 1725, oil on canvas, 78 cm x 60 cm (30.75 in x 23.5 in), unsigned.

This is among Brandl's most beautiful paintings and one of the greatest examples of Czech Baroque art. The painter has chosen the moment when the elderly Simeon recognises the child Jesus as the Messiah and thanks God in these words: "Now thou dost dismiss thy servant, O Master, according to thy word, in peace; Because mine eyes have seen thy salvation, which thou hast prepared before the face of all the peoples: A light of revelation unto the gentiles, and glory for thy people Israel." (*St Luke's Gospel*, ii, 29-32).
The picture is unique in its technique: it is possible to distinguish clearly in this deeply felt painting the areas in which the artist has used the other end of his brush and those where he has modelled the thick layers of paint with his fingers. The date given (just after 1725) is based on the fact that this was the period when Brandl's art reached its culmination. The first known owner of the painting was Count Fr. Šternberk (Sternberg), who had it in his collection.

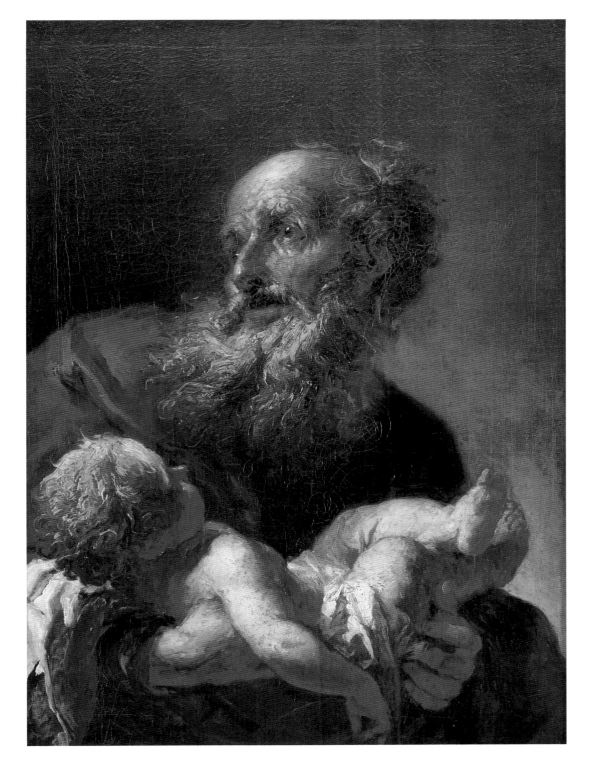

205

NORBERT GRUND (Prague, 1717 - Prague, 1767)

The Sculpture Studio; before 1767, oil on beech wood, 25 cm x 34.7 cm (9.75 in x 13.75 in), unsigned.

This painting is the pendant to *The Painting Studio*, which dates from the same year.

The two paintings form part of a very large group of works which the doctor J. Hoser donated, in 1843, to the gallery of painting installed at the Sternberg Palace by the Patriotic Friends of the Arts. This painting in the intimist genre shows the studio of the sculptor František Platzer (1717-87), who worked in Prague and was one of Grund's generation. The sculpture is one of the two groups of *Fighting Giants* (the left-hand one) commissioned for the railings of the Court of Honour of Prague Castle. The original sandstone sculptures were delivered to the castle before 1769, but as they could not be preserved, in 1919 they were replaced by new copies. Small terracotta models are to be found in the National Gallery collections.

MATTHIAS RAUCHMILLER (Radolfzell, 1645 - Vienna, 1686)

St John of Nepomuk; 1681, terracotta with additions of plaster, height 41 cm (16 in); the sculpture is fully worked on the back; subsequent inscription on plinth: "Matthias Rauchmiller fec. Viennae Ao 1681".

Although this work is by a foreign artist, it appears here because it represents an eminent and highly popular local saint, and because of its unusual historical link with Prague. Rauchmiller submitted his small terracotta model in 1681 and it was from this that Jan Brokoff carved a larger model, from which, in turn, Wolff H. Heroldt, in 1683, cast the definitive bronze statue, in Nuremberg. That same year the statue was erected on the Charles Bridge; the first and oldest of its famous double line of statues (the eighth on the right as one comes from the Old Town). The model of the statue's plinth was by the distinguished architect Jean-Baptiste Mathey, and again it was Brokoff who cut it in stone. Of all the statues on the Charles Bridge, it is unrivalled for sheer majesty. It was commissioned by G.M. Wünschwitz as an ex-voto.

207

FERDINAND MAXIMILIÁN BROKOFF (Červený Hrádek, 1688 - Prague, 1731)

St John of God; *c.* 1724, lime wood, height 185 cm (73 in); sculpture hollow on reverse, with original polychromy; the rayed halo is missing.

St John of God, founder of the order of Hospitallers of St John of God (canonised in 1690) is shown dressed in a black robe and wearing a crown of thorns, symbol of deep repentance. In 1620 the order obtained an abbey and a hospital from Ferdinand II, with the adjoining Church of St Simon and St Jude. It is known that in 1724 Brokoff helped to decorate the church organ. The effigy of this stern saint can still be seen on a side altar, painted by J.R. Byss, an artist originally from Soleure (Switzerland), who lived in Prague intermittently between 1689 and 1737.

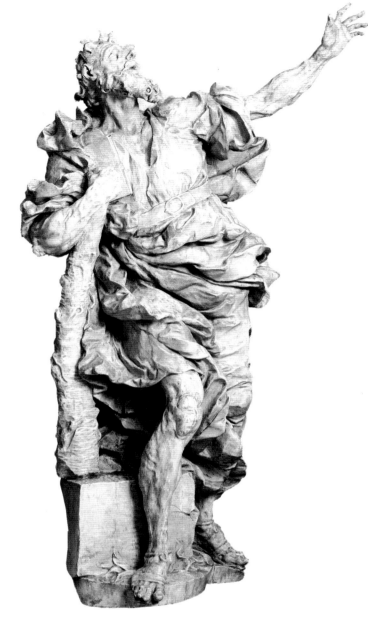

MATYÁŠ BERNARD BRAUN (Oetz [Tyroll], 1684 - Prague, 1738)

St Judas Thaddeus; 1712, lime wood, height 192 cm (75.75 in); sculpture hollow on reverse; later layer of white paint applied to original surface, whitened with chalk and polished.

This work is one of the jewels of Czech Baroque sculpture, Braun being the finest representative of the "school of Bernini". It is interesting to note that it is a fairly early work. Braun settled in Prague in 1710 and became instantly famous for his two statues on the Charles Bridge, of St Ludmila (1711) and of St Ivo (1712). The wooden carving of St Jude Thaddeus was part of the decoration prepared by Braun for the altar of the Church of the Virgin Mary (built in the Middle Ages), which was demolished in 1791 when outbuildings were erected for the Clam-Gallas Palace. This altar had been made in 1712 by the architect František Maximilián Kaňka with the assistance of Braun and Brandl. The sculpture of the apostle, furnished with a club and book (current attributes of local Baroque iconography), was later found at the Clementium, the oldest seat of the Jesuits in Prague, and was added to the National Gallery collections in 1939.

208

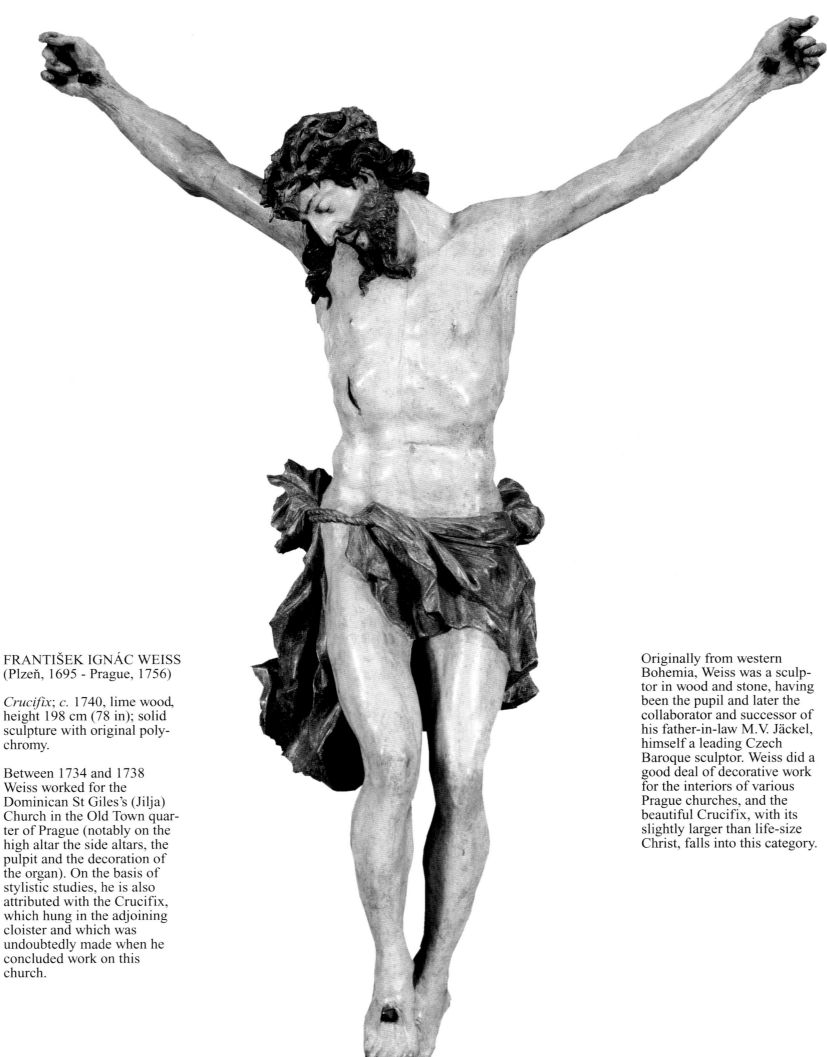

FRANTIŠEK IGNÁC WEISS
(Plzeň, 1695 - Prague, 1756)

Crucifix; *c.* 1740, lime wood,
height 198 cm (78 in); solid
sculpture with original poly-
chromy.

Between 1734 and 1738
Weiss worked for the
Dominican St Giles's (Jilja)
Church in the Old Town quar-
ter of Prague (notably on the
high altar the side altars, the
pulpit and the decoration of
the organ). On the basis of
stylistic studies, he is also
attributed with the Crucifix,
which hung in the adjoining
cloister and which was
undoubtedly made when he
concluded work on this
church.

Originally from western
Bohemia, Weiss was a sculp-
tor in wood and stone, having
been the pupil and later the
collaborator and successor of
his father-in-law M.V. Jäckel,
himself a leading Czech
Baroque sculptor. Weiss did a
good deal of decorative work
for the interiors of various
Prague churches, and the
beautiful Crucifix, with its
slightly larger than life-size
Christ, falls into this category.

THE COLLECTION OF ANCIENT EUROPEAN ART AT THE STERNBERG PALACE

Leaving the castle's Court of Honour through the gate of the Rococo railings dating from the reign of Empress Maria Theresa, the visitor comes across the life-size version of the two *Fighting Giants* which appeared in miniature in Grund's painting (the sculptures are copies dating from 1912; the originals, accompanied by decorated vases of putti, were done in 1768 by Ignác Platzner the Elder). In front is the vast expanse of Hradčany Square where, back in the depths of time, a path ran through a dark forest, leading to what is today the Pohořelec and the Strahov quarter. Here is the last of Prague Castle's galleries of art. The most immediately striking of the buildings around the square, on the north side, is the façade of the Archbishop's Palace: this house, of Renaissance origin, was transformed between 1669 and 1694 into an Early Baroque palace by Jean-Baptiste Mathey (the main doorway and the central construction on the roof date from this period). The Rococo appearance of the façade is due to its reconstruction by Jan Josef Wirch at the time of Archbishop Antonín Příchovský (1764-5).

A passage in the west extension of the Archbishop's Palace leads to the hall of the Sternberg Palace where the National Gallery collections are exhibited: these comprise ancient European art and selections of modern European art and French 19th- and 20th-century art. This town mansion with gardens, situated below the level of Hradčany Square, has four wings enclosing an inner courtyard and a large cylindrical projection on the west wing, marking the original entrance to the small adjacent garden. It was Václav Vojtěch of Šternberk (Sternberg) who decided to build the palace, a masterpiece of Late Baroque architecture. The original plans by the Viennese architect Domenico Martinelli were realised around 1698-1708 by Giovanni Battista Alliprandi and Giovanni Santini Aichel. There is still no agreement as to which parts should be attributed to which architects, the relationship between the different projects, nor even on the exact history and date of the building.

The subsequent fortunes of the gallery are worth recording. On 1 July 1811 the Society of Patriotic Friends of the Arts bought the palace, adapted it as necessary and exhibited paintings in twelve rooms. The gallery remained intact until 1871; after 1872 the building was briefly used for charitable and military purposes, and later, as a result of the problems experienced by other Prague museums, the Sternberg Palace housed collections from the National Museum. After the Second World War — and by now it was part of the National Gallery — a selection of the huge store of European art was displayed on two floors of the palace and in the two ground-floor wings facing the garden and the Stag Moat.

As in all institutions of this type, growth of the various collections was conditioned by changes in the National Gallery's organisation and ownership of art works, and by alterations of distribution and layout. Here, too, the basis of the collections consists of both works owned by the National Gallery and loans from the Church or private persons, so it is to be expected that this collection of European art will be subject to the same changing circumstances as those of the St George's Convent.

Today the first-floor rooms house the works of the Italian Primitives, as Vasari described them in the 16th century without any pejorative connotation.

Coat-of-arms of the Šternberk family, dating from the 17th century, in the Burgrave's House.

They are works ranging from the *trecento* (14th century) to the first third of the *cinquecento* (1533). Naturally the Prague collection is far from complete and can merely reflect the evolution or representative styles of the many different Italian schools. The paintings come mainly from the collection of Archduke Francis Ferdinand d'Este. Among the truly representative works is a small triptych with a *Madonna in Majesty* by Bernardo Daddi, *The Lamentation of Christ* by Lorenzo Monaco, a large polyptich with saints by Nardo di Cione and another reredos by Antonio Vivarini and Giovanni d'Alemagna, works by Cosimo Rosselli, a rare Pasqualino Veneto, a Bartolomeo Montagna, etc.

Another group is made up of Dutch and Flemish paintings, of which the most important are *The Adoration of the Magi* by Geertgen tot Sint Jans, the large and beautiful composition of *St Luke Painting the Virgin Mary* by Jan Goessart, known as Mabuse, a *Landscape with Forge* by Herri met de Bles, paintings by Jan Mostaert, Cornelys Massys and Karel van Mander and a small group of paintings by the large Brueghel family. On of the jewels of this National Gallery collection is Pieter Brueghel the Elder's *Haymaking*. A third group comprises a large, but excellently chosen, collection of 15th- and 16th-century Russian icons.

The works on the second floor are displayed in rooms of various size which communicate freely within the four wings of the palace. Especially notable are the stucco ceilings of G.D. Frisoni and the murals of *The Death of Dido* and *The Sorrow of Artemis*, attributed to Halwachs or Bys, in rooms decorated with the motif of the Šternberk star.

The next collection (German painting from the Middle Ages and the Renaissance) is of paramount quality, with altarpieces by Hans Holbein the Elder and Bernhard Strigel, a series of paintings by Lucas Cranach, Albrecht Altdorfer and Hans Baldung Grien and, in the centre, the large and celebrated *Festival of the Rosary* by Albrecht Dürer. This is followed by the collection of 16th- to 18th-century Italian paintings, including works by Palma the

Elder, Sebastiano del Piombo, Agnolo di Cosimo, known as Bronzino, Boccaccino, Tintoretto, Domenico Fetti, Alessandro Magnasco, known as Lissandrino, Sebastiano Ricci, Giovanni Battista Tiepolo, Francesco Guardi and, in particular, Giovanni Caneletto, represented by the magnificent *View of London with the Thames*, from the Lobkowicz collection.

The collection of Spanish art is not large, but paucity of numbers is redeemed by high artistic quality, as in two canvasses by Jusepe de Ribera, a marvellous *Bust of Christ* by El Greco and the *Portrait of Don Miguel de Lardizabal* by Francisco Goya. The numbers, the comparative cohesion and the quality of the collection of Dutch paintings testifies to the Czech preference for 17th-century Dutch art, chiefly attributable to commercial motives. Beginning with Rembrandt's *Old Scholar* and Frans Hals's *Portrait of Jasper Schade van Westrum*, the collection includes remarkable works in every genre: portraits (Ter Bosch), landscapes (Jan van Goyen, Salomon van Uyl, van de Velde, Willem Kalff, Abraham van Beyeren), figurative paintings (Jacob Ochtervelt, Arent Gelder, Gerbrandt van den Eeckhout, Gerard Dou, Gabriël Metsu, Jan Steen, Adriaen van Ostade), etc. Flemish painting is also worthily represented, with several magnificent works by Peter Paul Rubens, including the two compositions of the *Martyrdom of St Thomas and St Augustine*, commissioned in 1637 for St Thomas's Church in Prague. There are also works by Jacob Jordaens, Antony van Dyck, Frans Snyders, David Teniers and others.

At the very end of the section devoted to the collections of ancient European art, there are a number of paintings and sculptures (arranged in no particular order) showing the development of fine art in Europe to the present day: these include works by Gustav Klimt, Egon Schiele, Oskar Kokoschka, Max Lievermann, Lovis Corinth, Max Slevogt, Max Pechstein, Karl Hofer, Giorgio de Chirico, Carlo Carrà, Joan Miró, Manzu and Henry Moore.

The final group is French art. Although the oldest schools of painting are represented only in a frag-

mentary manner (Vouet, Mignard and Boucher), the 19th- and 20th-century collections are a delightful surprise, even for the connoisseur. Entrance to this part of the exhibition, on the ground floor, is by way of the courtyard, in the centre of which is a monumental sculpture by Antoine-Louis Barye. Arranged in chronological order, and with only a few gaps and, inevitably, some fluctuations of quality, the collection traces the evolution of French painting from Eugène Delacroix onward. Artists representing the schools and movements of the mid-19th century include Camille Corot, Honoré Daumier, Théodore Rousseau, Charles-François Daubigny and Gustave Courbet. There is then a natural progression to the artists of the Impressionist school — Claude Monet, Auguste Renoir, Alfred Sisley and Camille Pissarro — and on to the next generation: George Seurat, Paul Gauguin, Paul Cézanne and Vincent van Gogh. There are also portraits by Edgar Degas and Edouard Manet, and a marvellous painting by Henri de Toulouse-Lautrec. In addition to works by Pierre Bonnard, Henri Matisse, Maurice Utrillo, Le Douanier Rousseau and Marc Chagall, there is a large group of pictures by Pablo Picasso (particularly from the 1906-13 period), Georges Braque and André Derain. This section of the exhibition is also particularly rich in sculpture: works by François Rude, Antoine-Louis Barye, Jean-Baptiste Carpeaux, Antoine Bourdelle, Aristide Maillol, Charles Despiau, Henri Laurens and, above all, an important selection of sculptures by Auguste Rodin, whose first exhibition abroad, in 1902, was held in Prague.

Few galleries in the world, if any, can offer the visitor who is on the point of leaving such an enticing farewell present: a ravishing glimpse of more than five centuries of European art is followed by a view of the realm of monumental art: the city of which the National Gallery forms an organic part. Having enjoyed the riches of the Sternberg Palace collection, the visitor has only to cross Hradčany Square diagonally to reach the ramp of the castle, with its magnificent view of the river and the historic, beautiful and tragic city of Prague.

ALBRECHT DÜRER (Nuremberg, 1471 - Nuremberg, 1528)

The Festival of the Rose-Garlands; 1506, distemper on poplar wood, 161.5 cm x 192 cm (63.5 in x 75.75 in), signed and dated on the right of the painting, on the parchment held by Dürer, leaning against a tree; it reads: "Exegit quinquemestri spatio Albertus Dürer Germanus MDVI. AD."

The painting was bought in 1606 by Emperor Rudolf II for his collections in Prague. After various vicissitudes, it reached the Premonstrant Abbey in the Strahov quarter of Prague and was eventually bought from the canons in 1934 by the Czechoslovak state. The genesis of the painting is of interest, being related in detail in Dürer's correspondence with one of his Nuremberg friends, the humanist Willibald Pirckheimer. Dürer painted the work during his second trip to Venice for the local St Bartholomew's Church; it was commissioned by the Fondaco dei Tedeschi, a society of German merchants who administered this German church.
The painting shows a scene in which the Virgin Mary, with the infant Jesus and St Dominic, bless the onlookers and distribute small symbolic coronets of roses. This *Sancta Conversatione* comprises a series of portraits: on the right is Emperor Maximilian I, on the left, Pope Julius II and, behind him, Cardinal Domenico Grimani (all kneeling). Each of the persons in the picture can be identified. This celebrated painting by Dürer is one of the three most important works by foreign artists to be found in Czechoslovakia (the others being Brueghel and Titian).

213

PIETER BRUEGHEL THE ELDER
(Breda, 1525 to 1530 - Brussels, 1569)

Haymaking; 1565, oil on oak wood, 117 cm x 161 cm (46 in x 63.5 in), unsigned.

The painting belongs to the collection of the Lobkowicz family of Roudnice on the Elbe and its changing fortunes can be traced back to the exact date when they begin, on 21 November 1565. It is part of the cycle of *The Months* or *The Seasons*, five of which still survive: in addition to *Haymaking* in Prague, there are three in the Vienna Kunsthistorisches Museum (*Hunters in the Snow*, *The Dark Day* and *The Return of the Flocks*) and one in the Metropolitan Museum, New York (*Harvest*). Brueghel actually painted six, for his friend, a wealthy Antwerp banker, Niclaes Jongelinck. This cycle, which was sadly dispersed later, was a kind of variation on the subject of work in the fields in different months of the year. Such cycles were very fashionable at this time, particularly in France and Flanders, appearing in the form of calendars and Books of Hours. Judging by similar cycles (cf the miniaturist Simon Bening and his circle), the Prague painting would appear to show the month of July. Of the five surviving pictures, only the one in Prague bears neither date nor signature; it is considered by some to have been the first work of the cycle. The picture, which brilliantly suggests the harmony of nature, work and human destiny, epitomises Brueghel's thoughts and feelings about life and is one of the world's great artistic masterpieces.

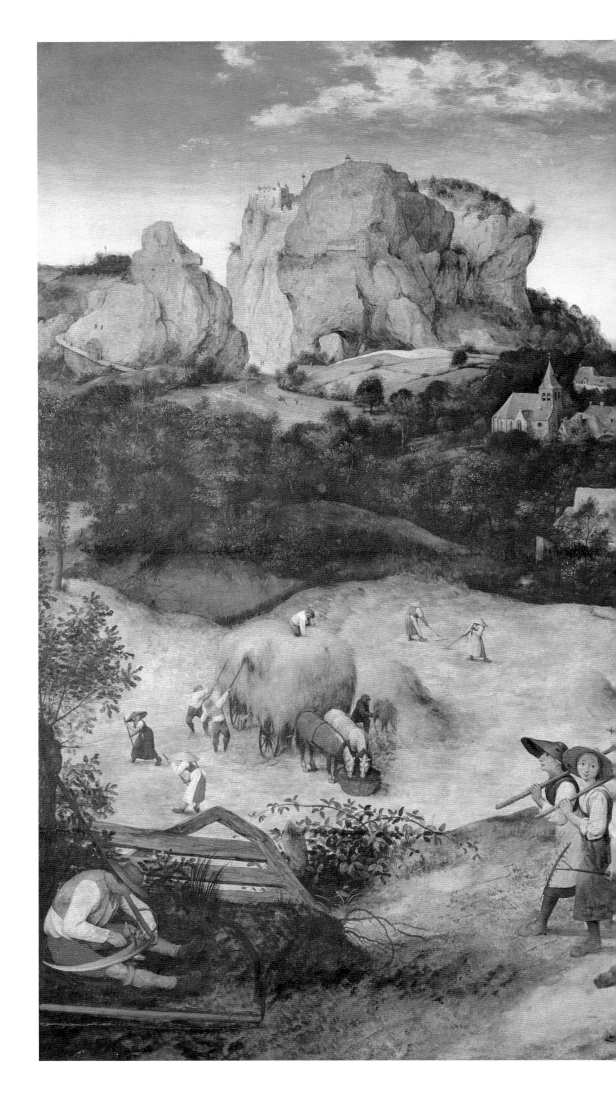

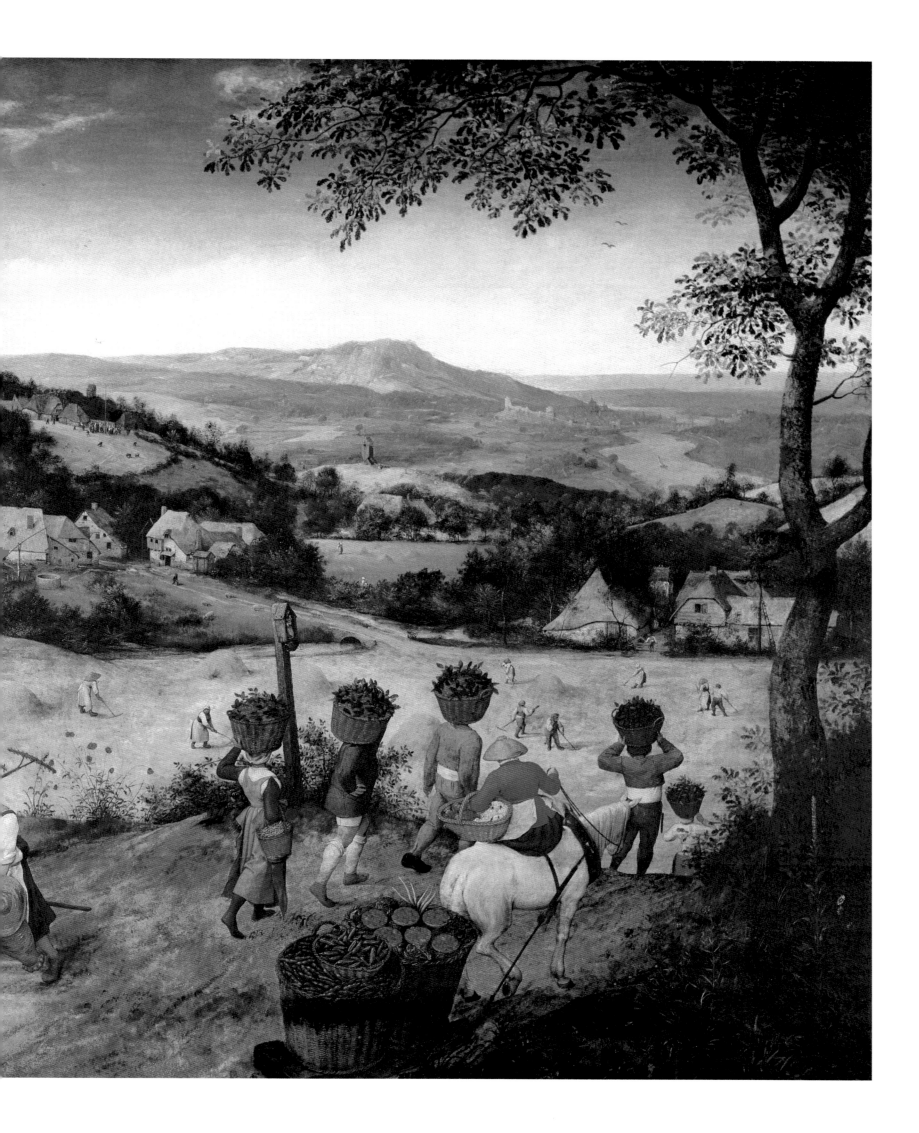

REMBRANDT, HARMENSZ
VAN RIJN (Leiden, 1606 -
Amsterdam, 1669)

*A Scholar in His Study (The
Rabbi)*; 1634, oil on canvas,
141 cm x 135 cm (55.5. in x
53.5 in), signed lower left:
"Rembrandt f. 1634".

This painting from the collec-
tion of the Counts Nostitz is
regarded by experts as the only
authentic work by Rembrandt
in Czechoslovakia. It was done
soon after he arrived and set-
tled in Amsterdam (1631-2),
the same year, in fact, that he
married Saskia van
Uylenburgh. The identity of the
old man represented in the pic-
ture has not been satisfactorily
resolved, although the same
model is to be found in several
of Rembrandt's works. The
extraordinary maturity of the
young artist at this period is
evident from the searching
gaze and expressive features of
the scholar, abruptly interupted
in his studies, and in
Rembrandt's masterly handling
of his different materials.

Rembrandt, triste hôpital tout rempli de murmures,
Et d'un grand crucifix décoré seulement,
Où la prière en pleurs s'exhale des ordures,
Et d'un rayon d'hiver traversé brusquement.

Charles Baudelaire: Les Phares (Excerpt)

HENRI ROUSSEAU, known as LE DOUANIER ROUSSEAU (Laval, 1844 - Paris, 1910)

Self-Portrait; 1890, oil on canvas, 146 cm x 113 cm (57.5 in x 44.5 in), signed lower left: "Henri Rousseau, 1890".

The artist entitled this painting *Moi-même, Portrait Paysage*. Painted in 1890, as the date attests, it was exhibited in the spring of the same year at the Salon des Indépendants, in the Pavilion de la Ville de Paris, on the Champs Elysées. Rousseau represents himself dressed in a sober black suit, wearing a beret and carrying a palette and brush. In the years that followed, he made some interesting modifications to the picture. He reduced the size of the human subject and made two minor changes that were not discovered until the painting was restored, in 1961: thus in 1901 he added to the lapel of his jacket the Ministry of Education badge he received on becoming professor of drawing at the rue d'Alésia. On the heart-shaped palette there are two names: Clémence and Joséphine. The former is that of his first wife, *née* Clémence Boitard, who died in 1888. Originally, the other name was Marie; but after marrying, in 1899, Joséphine Noury (who died in 1903), he substituted her name for that of Marie. The painting was exhibited in Prague in 1923 and bought locally for the Sergei Yastrebtzov collection.

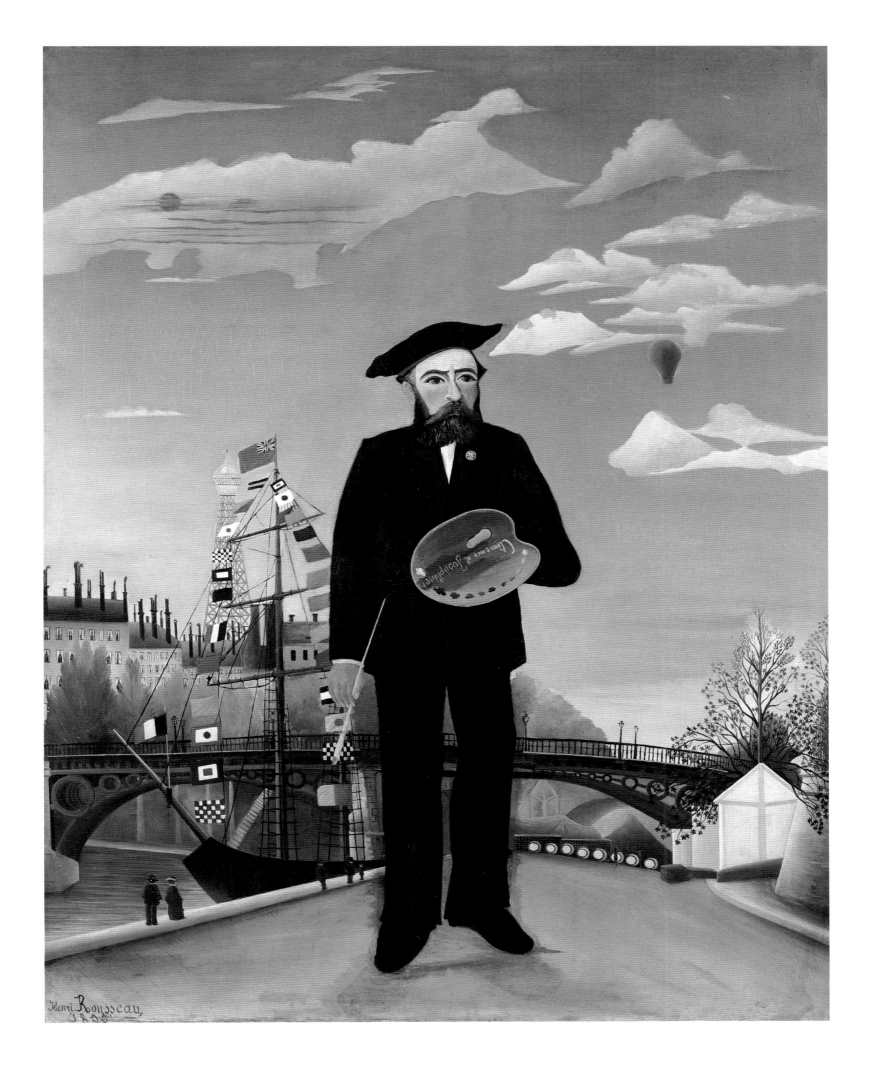

219

THE CASTLE PICTURE GALLERY

Back in St George's Square, after leaving the National Gallery, the visitor takes Vicar's Lane around the cathedral, where a passage opposite the west front leads into the Second Courtyard. The history and construction of this courtyard are described elsewhere. Suffice it to say that it was built between 1525 and 1550 by filling in a double ditch that ran from north to south across the court. On the north side, that is, to the left of the passage leading from the castle to the Powder Tower (Prašný Most), is the entrance to the picture gallery of Prague Castle. Here, underneath the Spanish Room, were the stables of the old palace of Rudolf II. In 1964-5, this area was converted into a public art gallery, planned by the architects František Cubr and Josef Hrubý. In due course paintings and sculptures were exhibited there as part of the castle's own collections, having been identified, listed and, in many cases, rediscovered as a result of thorough study and restoration in 1962-3 thanks to a team led by Jaromír Neumann and, to an even greater extent, to his personal research.

Informed visitors to this gallery will inevitably react in different ways, as is always the case when confronted by beautiful and valuable works of art. Such impressions are likely, however, to go far beyond a simple appreciation of artistic values, remarkable though they certainly are, and to touch upon an entirely different and complex dimension. This can perhaps be described as a sense of historic portent and inevitability, which colours the thoughts and perceptions of everyone who visits Prague, who comes to know the city and its monuments, and who is affected by its unique atmosphere and spirit. The old Latin adage *habent sua fata libelli* (writings have their own destiny) is equally, and possibly even more strongly, applicable to collections of art. The contrast, on the one hand, between the corporate efforts, the knowledge, the taste, the love and the passion, the material means and the actions that went into their creation and their development, and, on the other, the manner in which they were dispersed, damaged and broken up by subsequent gen-erations and later owners — all this virtually amounts to a symbolic metaphor of human destiny.

The more important and famous the collections, the more potent this feeling of mortal transience. From a certain viewpoint, given the conditions of its genesis, its size and scope, its unimaginable value and its changing fortunes, the Prague collection of Rudolf II is the most famous of its kind in European history. In its way, the Prague Castle picture gallery is the last reflection of this collection's original splendour (in terms both of place and tradition), and also a highly interesting document of its experiences. It was Neumann who most recently charted the path of its historical fortunes, based on documents and other evidence of attribution, identification and reconstruction, so as to evaluate it for the purpose of public display.

Yet, despite the many intensive investigations and studies conducted in recent years, it has still proved impossible to compile an exact list of Rudolf II's original collection. This is because there is no inventory from the period, except for the finest craft objects for the years 1607-11. The private collection of the emperor, who was '... the greatest contempor-ary admirer of painting in the world...' (K. von Mander) was only partially registered in 1619; and then, especially, in the great inventory of 1621, drawn up after the battle of the White Mountain. But we know that immediately after the death of Rudolf II in 1612, Matthias II (imitated subsequently by Ferdinand II) had dozens of paintings taken to Vienna. However, the real tragedy for the collection occurred when the Swedes occupied Prague in 1648, just before the Treaty of Westphalia, motivated, it would seem, by the desire to get their hands on the castle treasures. An inventory of 1652 listing the collections of Queen Christina of Sweden indicates clearly that out of the 750 paintings, 570 came from Prague. And the castle paintings did not all end up in the Swedish royal collection. The treasure chamber and rooms containing art objects were ransacked and pillaged with unequalled ruthlessness, with results that were on the scale of a natural catastrophe.

The brother of Ferdinand III, Archduke Leopold William, tried to establish a large collection again in Prague Castle (which had remained the royal residence until the reign of Charles VI) by making spectacular purchases, acquiring, for example, the old collection of the Duke of Buckingham at an auction in Antwerp. According to a new inventory drawn up in 1685, there were then 551 paintings at the castle, so forming once more an important collection and recognised as such in a wider European context. There is no space here for anything but the most summary account of the subsequent fortunes of the gallery which, after its brief period of pre-eminence, again saw hard times, firstly in the 18th century and then, as incredible as it may seem, at the beginning of the 20th century. The reason for the gallery's decline was the changing situation of Prague *vis-à-vis* a centralist Vienna, and the regular transfer of paintings from the castle to Viennese collections.

It is worth mentioning two significant events in the long history of Bohemian art. The first is so involved that it sounds like an episode from a novel: a choice of paintings from Prague destined for the Dresden gallery of Augustus III, elector of Saxony, was made under a false name by Guarienti, inspector of the Dresden museums, and this eventually resulted in the sale, in 1742, at Dresden, of 69 Prague paintings by Empress Maria Theresa for the sum of 50,000 florins. Then, as a kind of funereal epilogue to a once-remarkable collection, there was the famous auction of 13-14 May 1782, under Joseph II, which amassed the total amount of 577 florins 35 kreutzers for some 60 paintings and 70 sculptures: Dürer's *Festival of the Rose-Garlands* was knocked down for one florin and the famous bust of a Trojan for 10 kreutzers. Finally, in the 19th century, even though matters were by now professionally handled (with valuations by Professor Woltmann), dozens more paintings were exported, with the result that the castle's art collections were almost denuded by the end of the First World War.

The present contents of the gallery constitute no more than an intimist miniature, made up of scattered and isolated fragments, of a grandiose, monumental fresco. The fact that, in spite of this, the visitor can find so much of historical and artistic interest, testifies to the rich traditions of the Czech lands and of Prague itself. The arrangement of the works on display certainly reflects the fragmentary nature of the castle collections; it does not begin to suggest the harmony and balance that generally applies to collections of ancient art. The works exhibited in the gallery have been chosen not only for their quality but also, to some extent, for their original provenance. Alongside ancient Czech art (Brandl, Kupecký, Grund) and works by artists of the court of Rudolf II (Aachen, Spranger, de Vries) are small collections of the Dutch and Flemish schools, of the vast region of Central Europe and, above all, Italian painting. There are works of a reasonably high standard by the Bassanos, Frans Floris de Vriendt, Francesco Furini, Hoefnagel, Samuel van Hoogstraten, Palma the Younger, Pordenone, Carlo Saraceni and Paolo Veronese; and there are a few of extraordinary quality by Guido Reni, Domenico Fetti, Peter Paul Rubens, Tintoretto, Titian and others.

JACOPO ROBUSTI, a.k.a.TINTORETTO
(Venice, 1518 - Vencie, 1594)

The Flagellation of Christ; between 1555
and 1560, oil on canvas, 165 cm x 128.5
cm (65 in x 50.5 in), unsigned.

This painting, listed in the inventory of the
castle collection, dated 3 April 1685, had
been bought in 1648 at the famous sale by
auction of the Duke of Buckingham's col-
lection in Antwerp. In 1635 it figured in
the inventories of the Buckingham collec-
tion as an original work by Tintoretto, but
in a bigger, squarer format. Subsequently,
the work was somewhat roughly handled:
it was literally cut in order to reduce it to
the present format and some of the glazing
was obliterated. Moreover, it was variously
attributed in lists and invenories of the
18th and 19th centuries, and often moved
around. Its final home was Opočno Castle
where, in 1962, Jaromir Neumann recog-
nised and identified it. *The Flagellation of
Christ* was a theme frequently treated by
Tintoretto. The Prague painting is distin-
guished by its dramatic contrast of light
and shade — the contrast being equally
marked in the case of the human figures
viewed from the front and back, and in the
details of their anatomy — and by the
broad, confident brush-strokes.

BENEDIKT WURZELBAUER
(Nuremberg, 1548 - Nuremberg, 1620)

Venus with a Cupid; 1599, bronze, height
123 cm (48.5 in)

The group of sculptures representing
Venus holding the hands of a Cupid who
stands on a dolphin constitutes the upper
part of the famous fountain, the lower part
of which (together with a copy of this
upper part) is in the garden of the
Wallenstein Palace in Malá Strana.
Originally the fountain was commissioned
in 1599 by Christoph Popel of Lobkowitz,
chief steward of the Czech kingdom, for
the garden of his Hradčany house.

Wurzelbauer, the Nuremberg Mannerist
influenced by Giambologna, cast the foun-
tain and delivered it to Prague a year later.
Albrecht of Wallenstein bought it for his
palace before 1630. Eventually, in 1648,
Venus with a Cupid was removed as booty
by the Swedes and was subsequently found
in the collection of Queen Christina. After
varying fortunes, it fittingly found its way
back to Prague (thanks to a purchase in
Berlin in 1889) and still remains the only
original work of art, out of all the war
booty taken by the Swedes, to have
returned to Prague.

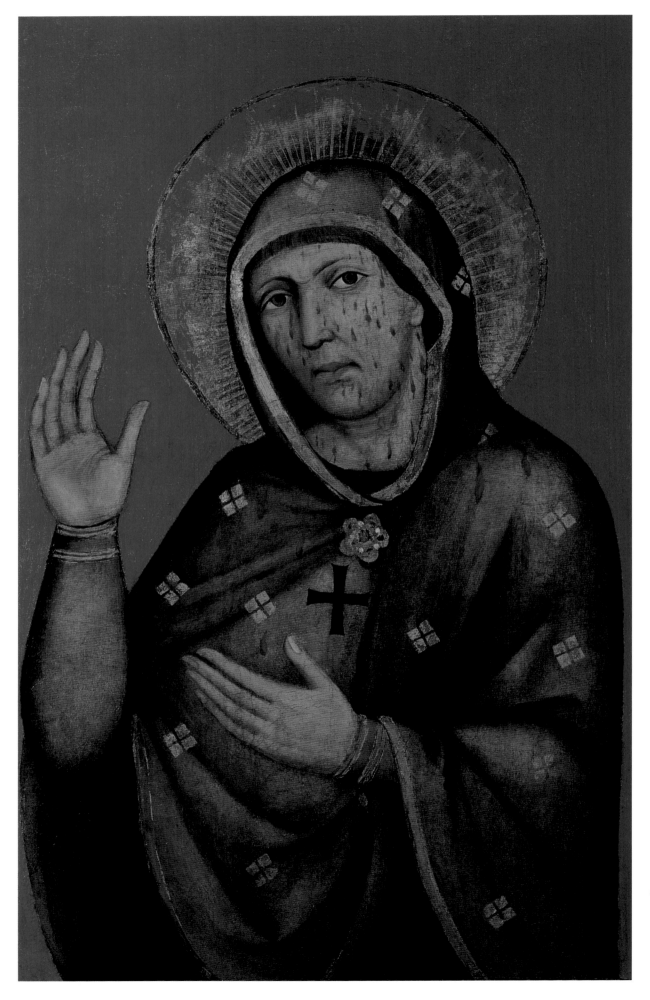

CZECH MASTER OF THE THIRD QUARTER OF THE 14TH CENTURY

The Madonna of Aracoeli; *c.* 1370, distemper on new panel of laminated wood fibre, height 101 cm (39.75 in), width 64.5 cm (25.5 in).

This is a very important panel painting, frequently written about, but sometimes considered to be a 19th-century copy. Complete restoration in the 1980s, together with a detailed technological analysis, proved it to be a significant transitional work from around 1370 by one of the many followers of Master Theodoric. It bears a close technical resemblance to the latter's work, but in certain features anticipates that of the Master of Třeboň. The inspiration of the painting is the 5th-century Byzantine Virgin Agiosoritissa and its Romanesque version in the basilica of Sta Maria in Aracoeli, Rome. In 1368, on his visit to Rome for his second coronation, Emperor Charles IV had a copy made of it, since vanished, but which served as the model for this *Madonna* and, some twenty years later, for another painting of the subject from the workshop of the Master of the Třeboň Altarpiece. This *Madonna* was a royal gift to St Vitus's Cathedral. The drops of blood are a characteristic feature of Czech religious art.

THE GARDENS

Like other great cities, Prague owes much of its beauty to its gardens. But, in contrast to many other towns, the lie of the land, with its slopes, ridges and hollows, and the consequent absence of large, level expanses of ground, makes it necessary to construct terraces and lay out ornamental areas on a fairly small scale. Architects, therefore, have been forced to plan accordingly and to restrict themselves to sites that are easily shaped and modified.[1] This holds true, in general, for all the gardens of Prague, which harmonise perfectly with their surroundings.

The terrain on the north side is separated from the castle hill by the valley of the Rusnice stream, traditionally, though wrongly, called the Stag Moat (wrongly because it does not comprise part of the man-made fortifications and because its depth qualifies it more for the name 'ravine'; yet correctly in the sense that, from the late 16th century until 1741, red and fallow deer were raised here). Moreover, until the 16th century, the ground situated beyond the northern limit of the castle had nothing in common with it, and the vineyards there did not belong to the king. But in 1534 Ferdinand II bought the land and had it laid out as a garden of unprecedented size: the Royal Garden. For natural reasons, work began with the construction of the Powder Bridge, on five rectangular pillars supporting the wooden structure of the covered bridge. This *entresol* permitted the king to enter and leave the garden without being seen, which, according to texts that have underlined the point, suited the rather introverted Rudolf II very well. On the north side, outside the castle, the bridge terminated in a tower-shaped gate with a high roof, the appearance of which we know from an engraving[2] and a drawing by Stevens[3]. Furnished with a semicircular arch, the gate was framed by rustic work and the whole structure topped with a rounded cornice. These two architectonic features, typical of Mannerist architecture, were doubtless created only in the second half of the 16th century. On the castle side there must also have been a drawbridge at that time.

The site of the garden was almost rectangular or, more precisely, trapezoid, fairly long and very narrow; Giovanni Spatio, the builder of the bridge, was also instructed to enclose the garden with a wall. Existing sources provide us with more information about the names of the gardeners and the plants grown than about the garden's appearance. They name the Italian Francesco, Ludovico Brandis of Trieste, Hugo Venius of Flanders and the brothers Reinhardt of Germany. Tropical fruits, roses and select grape varieties were all grown.

In 1538 work commenced on a building described by the documents as a 'summer pleasure house', designed to be the dominant feature of the garden. This summer pavilion was built by King Ferdinand I for his wife, Queen Anna Jagiello. Known as the Royal Belvedere (Královský letohrádek), it is situated at the eastern end of the site, on ground that slopes down to the east: there are thus two levels on this side, but only one on the garden side.

The idea of a pavilion exclusively intended for summer relaxation was popular in Italy at the time of its construction, although not by any means in the countries of northern Europe. It is worth noting that the building which most resembles the Belvedere in general design is a 'pleasure pavilion' constructed in 1583-93 in the gardens of Stuttgart Castle, of which only a fragment remains today. Consequently, the Prague pavilion, intact apart from a few modifications, is of unique interest.

The story behind this fairly modest building is long and complicated. In the first instance, from about 1536 to 1538, while the basement and ground floor were under construction, the architect was Giovanni Spatio. He was then replaced by Paolo della Stella, who arrived in Prague with thirteen stonemasons: he was to supervise the project until his death, in 1552. It was apparently at this time that work was completed on the gallery of arcades surrounding the pavilion, the doors and windows (a magnificent achievement by the stonecutters to designs by Sebastiano Serlio), and, finally, the

reliefs on the pedestals of the columns and above the spandrels of the arcades, constituting a group of sculptures unique in both subject and form. Boniface Wohlmut, the last architect in charge of the work (from 1556 to 1563), built the first storey and an interesting keeled roof.

The conclusion to be drawn from the various relevant surviving documents suggests that the first builder of the pavilion, Giovanni Spatio, did not actually draw up the plans, and that the most likely designer, though this cannot be established for certain, was Paolo della Stella. There is uncertainty, too, as to the origin of the artistic prototype for this remarkable structure: a fairly long rectangle of 51.5 m by 21 m (170 ft by 70 ft) which originally comprised three ground-floor rooms (two of which were almost square and the third twice as long as it was wide) and two above (a square room and the main room three times as long as it was wide). This layout is to be found nowhere else in the entire field of European Renaissance architecture. The horizontal plan of the pavilion is strongly reminiscent of a Greek *peripteros* (a building surrounded by isolated wall columns)[4]; but comparison of plans of Greek temples with that of the pavilion shows essential differences. The impression of lightness, the airy, immaterial character of the Prague arcades are further enhanced by the form of the balustrade, made of graceful banisters. The first-floor terrace balustrade appears at first sight to be solid, but it is actually a masterpiece of the stonecutter's art, resembling work in a much softer material.

If doubt remains as to where the overall design of the pavilion originated, the same is unfortunately true of the decorative sculptures. The inspirational source of the group by Paolo della Stella can almost certainly be found in contemporary Italy, as attested both by the mythological, historical and allegorical motifs and subjects, and by the narrative realism of the figures (including the representation of the builder himself and his wife), convincingly solid and contoured, usually portrayed in lifelike poses. Nevertheless, no close parallel has yet been estab-

lished. It is clear that the sculptors must have drawn on many sources of reference. Of the 74 sculpted scenes, apart from a single religious subject depicting the meeting of Jacob and Esau, from the Old Testament, there is a series on the Labours of Hercules, Ovid's *Metamorphoses*, Livy's *History of Rome* and the Trojan War, scenes of Olympus and of the history of Alexander the Great; there are also bacchic and satirical episodes, hunting and battle scenes (legendary and historical) and, specifically, the victory of Emperor Charles V over the infidels at the port of La Goulette, in Tunisia.

There is also a singular absence of satisfactory information as to why the pavilion was built in the first place. It is probable that the kitchens and other offices were situated in a separate annex on one floor, implying that none of the rooms inside the pavilion needed to be used for any practical function. We know indirectly that the largest room served, among other things, as a ballroom: this information is contained in a letter from Archduke Ferdinand of Tyrol to the architect Wohlmut, reminding him not to tile the floor in marble because it would be too slippery for dancing[5]. Nor do we know anything about the interior decoration, either because it was unfinished (Ferdinand of Tyrol wanted an astronomical subject for the ceiling of the main hall) or because nothing is left of it.

After the reign of Rudolf II, who used the pavilion for his collections and astronomical observations (Tycho Brahe himself worked there), fate did not smile upon the building, and in the late 18th century it was turned over to the army service corps. Not until 1839 was it decided once more to use the summer pavilion for cultural purposes, as a picture gallery run by the Society of Patriotic Friends of the Arts. Soon afterwards, the staircase was rebuilt and the great hall was repainted with historical scenes, designed by Kristián Ruben.

Renaissance and Mannerist architectural and artistic activities in the Royal Garden were not restricted, however, to the Belvedere. During the 16th century two other important additions to the

garden were the Singing Fountain and the Royal Ball Court.

In 1538 Ferdinand I had commissioned, in Innsbruck, designs for six fountains destined for the Royal Garden. There is no evidence that this plan was ever realised, but it does suggest that the place of honour given to the fountain, in the centre of the parterre in front of the Belvedere, had apparently been projected by its builder. In the event, it was the model submitted by the court painter Francesco Terzio, dating from 1562, that was accepted: in the same year, the woodcarver Hanuš Peisser prepared a wooden mould and the fountain (in bronze) was cast between 1564 and 1568 by Tomáš Jaroš, a bell-founder and gunsmith from Brno, and by his assistants Vavřinec Křička and Wolf Hofprucker. The most delicate parts of the fountain — the column, the upper basin and the little piper on top — were chiselled by the sculptor Antonio Brocco. The name Singing Fountain is doubtless explained by the melodious sound of the water splashing into the metal basin. In 1603 the traveller Pierre Bergeron compared the sound to the lilt of the pipe[6]. The rich ornamentation of the fountain is not confined to musical subjects: alongside classical motifs such as palmettes, masks, bucranes, festoons, etc., there is, on the shaft, Pan with a deer and shepherds.

Another 'marvel' of the Royal Garden which visitors never failed to mention in reports of their visit, was the Large House of the Ball Court, so named to distinguish it from a smaller games-court situated in the courtyard just beside the gate of the Powder Bridge. The two courts were of the same width, but the larger one was three times as long. Bergeron noted that it was a ball-court 'à la française, of extraordinary length'[7]. Evidently Boniface Wohlmut built both courts[8]. The smaller one was a simple, unpretentious building with seven round windows, apparently placed (given its function) as high as possible, near the roof. We do not know what it looked like originally, before it was transformed according to designs by Dietzler[9]. An inner gallery, against the south and west walls, was intended for spectators, among them, according to observers, Emperor Rudolf I in person, who watched the matches hidden behind a screen.

The construction of the Large Ball Court (1567-69) was much more difficult: it was raised on the slope just in front of the Stag Moat (its basement was intended as a stable for eighty horses) and the north façade, on the garden side, was an enormous colonnade broken by great arcades. This building is evidence of Wohlmut's partiality to massive and powerful forms, which has sometimes been described, not altogether correctly, as Palladianism. Ionic half-columns bear an entablature with a cylindrical frieze (of the type found in many villas and palaces built by Palladio). The composition of the north façade is very interesting: niches divide the two outermost axes of the two sides into two 'levels', thus seeming, by an optical illusion, to accentuate the size of the central arcades. But the most characteristic element of the façade is undoubtedly the deliberate, and typically local, sgraffito ornamentation — something not found in Palladio's work. The sgraffiti are, in fact, both decorative and pictorial. In the spandrels of the arcades is a cycle of the liberal arts (astrology, geometry, music, arithmetic, rhetoric, dialectic and grammar), personified by allegorical female figures based on graphic models by Frans Floris, published around 1560 by Hieronymus Cock. Then come the four elements (earth, air, water and fire), the seven virtues (the four cardinal virtues of courage, justice, prudence and temperance, and the three theological virtues of charity, hope and faith)[10]. The author of the sgraffiti certainly did not copy his models slavishly, but was inspired by them to create fairly condensed scenes that nevertheless give an impression of depth thanks to the smaller accompanying figures. The pictorial sgraffiti were modelled by Cornelis Bose, who was one of the leading exponents of *beschlagwerk*, i.e. hammered ornaments, together with compositions of grotesque fantasy. Such combinations were familiar themes of the northern variant of Mannerism.

After the fire of 1950, the interior, covered with barrel vaulting, was divided into three exhibition rooms. Across the large central room are balconies for spectators[11].

From the Middle Ages, menageries, usually situated in the castle moats, were important features of royal households. Although originally intended to be of practical use in guarding the castle, they soon assumed purely symbolic roles. For many European courts, the lion was a heraldic animal, not to mention its traditional connotations of strength and courage (as in the biblical story of Daniel in the lion's den). In the 16th and 17th centuries there were menageries at the Tower of London, in Versailles, Potsdam, Dresden, Kassel, the Hague, Turin and elsewhere. In the Austrian territories, there is a mention in 1552 of menageries at Ebersdorf, near Vienna, and others at Neugebäude, at the Belvedere and at Schönbrunn.

For the Prague menagerie, in contrast to others created later (like the menagerie at Versailles with its radial layout), a less elaborate design was chosen: simply a rectangular building comprising in all seven enclosures of the same size — 3.2 metres by 4.5 metres (10.5 ft by 15 ft) — all facing east, not by chance but taking into consideration the Bohemian climate. Even so, a number of the more delicate animals, by all accounts, were lost. The original construction was of wood; not until 1581-3 did the court architect, Ulrico Aostalli, replace this with a stone building.

Approaching the castle from the north, one can still see in the present-day Lion Court vestiges of the foundations of the old menagerie: these show that the courtyard stands on the site of the animal enclosure which was on the south side, while on the north side there was a small yard leading to a corridor which enabled the staff to clean the cages, bring in the food and make heating arrangements. In one corner of this little courtyard, on the garden side, a spiral staircase led from the lion enclosure up to the visitors' gallery. The west wing (the present entrance to the building) was added later as living quarters for the keepers of the wild animals.

This building, of little architectural interest, was originally adorned with a small sgraffito inscription and with decorative bosses to the small doorways. Yet although the story of how it was built is ordinary enough, that is by no means true of its animal occupants. There are colourful reports brought back by travellers of the time. In 1594, Fynes Moryson noted, after a trip to Prague, that the emperor kept 'twelve camels; an Indian ass, yellow, quite hairy, with hair like a lion. Then an Indian calf and two cheetahs which apparently were tame, as far as such a wild animal can be. They are yellow with black stripes, they have a head that is rather like that of a cat, the tail of an ass and the body of a greyhound. When the hunters go hunting, at their command, the cheetahs jump behind them and remain seated like dogs on the back of a horse. They run very fast, which doubtless makes them capable of bringing down a deer'[12].

The account of the journey of Jacques Esprinchard (in 1597) provides another source: 'Near the Ball Court, there is an enclosure where wild and domestic animals are kept; given that almost all of them had died the previous year, we only saw one big lion, a leopard and two large civets'[13]. In 1603 Pierre Bergeron wrote: 'Then there was a menagerie with lions, leopards and civets, as well as a crow as white as snow'[14]. In 1611, just prior to the death of Rudolf II, the inventory of live animals in the Lions' Court was 'one lion, two tigers, one bear and two wildcats'[15]. During the 17th century there were tigers, bears and lynxes, but by the end of the century all that remained were two bears and three elderly wolves; occasionally, some foxes were kept for hunting. Information on the animals ceased in 1720 and in 1740 the building was adapted for use as stables[16].

From these accounts, it is clear that the Lions' Court was not simply an enclosure for an animal of local emblematic significance, but a true menagerie, a kind of forerunner of the modern zoological gardens. Rudolf II, contrary to his portrayal in litera-

ture, until quite recently, as an adventitious collector of rarities and curiosities, emerges as a man of broad-ranging interests. As shown by his systematic acquisition of art treasures, in a similar manner to alchemists in their laboratories and observatories, he was intent on discovering the mysteries of the world, of seeking the links between the macrocosm and the microcosm[17].

The original overall plans of the Royal Garden have not survived, and nothing is known of them except for one project by Boniface Wohlmut. According to contemporary descriptions, however, the garden was divided into three sections: the western part, near the Powder Bridge, was a pleasure garden; the central part was more utilitarian, on the lines of an orchard; and the eastern part, the smallest, was a miniature pleasure garden in front of Queen Anna's summer pavilion (the Royal Belvedere).

The two ends of the garden were linked by a covered walk, planted in 1640 at the latest, and perhaps earlier, by L. Hartung. It appears on a series of 17th-century engravings, which show how access to the walk was provided, at given points, by three slightly larger circular areas in the form of pergolas. This broad corridor of interlaced hazel branches and osiers, covered with a variety of climbing plants[18] — still existed in the 18th century, as can be seen from surviving plans.

It would be reasonable to suppose that the garden also contained other sculptures similar to the Singing Fountain (the archives state that in 1598 Hans Vredeman de Vries, the eminent architect and artist, was paid retainers covering projects for seven fountains in all[19]); but there is no concrete evidence for this, and the same goes for other features: artificial grottoes, aviaries, mazes and the like, such as were found, in the early 17th century, for example, at Hellbrunn, near Salzburg, or the Wallenstein (Valdštejn) Palace in Prague. There was one other certified Renaissance building, namely the Fig House, a rectangular, unheated glasshouse with a detachable roof, located not far from the Belvedere.

On the same level, between the Royal Garden and the Stag Moat, there stood a shooting gallery which was converted into stables in 1723, on the occasion of Charles VI's coronation.

Whereas information about the Royal Garden is sparse, much more is known of the garden extending west of the path leading to the Powder Bridge. In 1572 (the date is preserved) a rectangular stable building was put up. Then, in the reign of Rudolf II, a pheasantry was built, still accessible through small doorways decorated with bosses, and a rectangular fishpond made for keeping rare tropical fish. This pond has survived until today.

The dominant feature of the western portion of this garden is certainly the Royal Riding School. At the beginning of the 17th century horses were groomed in the open air, as we know from *Equine Medicine* by Master Albrecht[20]. The Winter Riding School, designed by Jean-Baptiste Mathey was not built until 1694-5. Its dimensions are impressive, almost 90 m (300 ft) in length, and the main and lateral façades are characterised by splendid pilastered arcades. In the right-hand corner, a narrow, single-storey passage with twelve arcades, at right angles to the main building, formed a covered balcony for visitors to the Summer Riding School (a piece of terraced ground leading towards the Stag Moat).

The most important Baroque construction was undoubtedly Dientzenhofer's glasshouse. Kilián Ignác Dientzenhofer, appointed Master Mason of the Court in 1737, built the glasshouse when he began his activities on behalf of the Court Building Office. There were long discussions about improvements to the Royal Garden, in which three generations of gardeners had been involved: Mates Zinner, his son František Josef and, finally, his grandson František, who submitted a Baroque garden design[21].

The glasshouse project had been drawn up in 1731 by the court overseer, František Hoffe, but Dientzenhofer was responsible for the principal motif of the south front, with its central arched window placed higher that the side windows. This was,

in fact, a classic variation of European architecture, described as the 'Serliana' or, later, the 'Palladian window'. In the whole of Czech architecture, only Dientzenhofer[22] seems to have used it. The importance of such a motif was evident: in a building that was essentially utilitarian, the glasshouse was in this way given special architectural emphasis. Contemporaries of Dientzenhofer clearly approved of his architecture, as was evident some time later when, in 1757, during the siege of Prague by the Prussians, the glasshouse was shattered by an artillery shell. The two wings with their three large square windows were never rebuilt but the architect Haffenecker transformed the central part of the glasshouse into a garden pavilion[23]. Nor did the changes of 1776 conclude the story of this small but charming building: in the 20th century it was transformed yet again (still retaining its historic central portion) into a presidential villa.

The original appearance of the glasshouse is known to us from a drawing of 1724 by J. Dietzler[24]. Its striking outline was derived from a very complex arrangement of roofs: the central part, with a single storey, had its own roof, which stood higher than the mansard roofs with skylights that covered the two wings of the building. This dynamic effect was accentuated by two ovals along the axis of the entry. The first oval is formed by the entrance hall, with a mythological fresco on the slightly raised semicircular vault; the second is created by two flights of stairs, each semi-oval and separated by a small central corridor.

Much less is known about another Baroque building in the Royal Garden — the theatre, built in 1681 by order of Leopold I, situated in front of the Riding School. The simplicity of the exterior does not appear to have changed over the centuries. On the other hand, according to plans dating from the mid-18th century, the interior was sumptuously furnished, with a curved balcony that extended on either side towards the stage, at the eastern end. This stage was fairly deep, approximately seven times the length of the side corridors. An idea of the quality of the décor in Prague at that time is suggested by paintings that show the stage sets for *Constanza e Fortezza* (Constancy and Fortitude), an opera by Johann Josef Fux, performed for the coronation of Charles VI in 1723 at Prague Castle, on the ramparts of the Virgin Mary (Mariánské hradby), which enclose the Royal Garden to the north. This décor was the work of Giuseppe Galli Bibbiena, one of the most famous theatrical designers of the 18th century[25]. The theatre itself certainly suffered the same fate as the other buildings in the garden: it was burned down and never rebuilt.

It would appear that the Baroque changes to the garden were concentrated more on the northern access route to the castle than on the ends. Evidence of this comes from the changing appearance of the large geometrical parterre close to the Lion Court and the theatre, which extended almost to the line formed by the east side of the Royal Ball Court. At this point the parterre had box edgings of shrubs that formed long, elegant volutes, while a composition of clipped limes and obelisk-shaped conifers added a vertical touch. A circular pool with a water jet formed an appropriate central feature of the parterre.

The sculptural decoration of the garden seems to have been fairly modest. The only two sculptures that survive are a Baroque fountain by J.J. Bendl, dating from 1670 and representing Hercules, and a magnificent allegory of *Night* by M.B. Braun, from the 1730s. The Braun studio evidently supplied other ornamental features, such as huge vases and sculptures of lions.

The garden retained its formal decorative character until the end of the 18th century. After the reconstruction of the castle by the court architect, Niccolo Pacassi, there were changes that affected the land north of the castle. Until the pillars of the Powder Bridge were knocked down in 1769-70 in order to create a broad entry road, the north garden had constituted a kind of enclave which, whilst being wholly independent, complemented the inimitably dramatic form of the castle. For this age of sober classicism,

with its rational image, the unique qualities of the Stag Moat in the context of the landscape at large were considered somewhat odd and unremarkable. The utilitarianism of the era of Joseph II was soon made manifest: the Royal Belvedere, the Ball Court and the Riding School were all commandeered by the army service corps.

It was only with the arrival of European romanticism that the final change occurred which was to transform the north garden into a natural park, with winding paths and marvellous long vistas.

The unique significance of the Renaissance castle and all the buildings described in this chapter prompted the authorities, when an independent Czechoslovakia was created, to return at least a part of the Royal Garden to something like its original state. In 1938 and 1955, under the direction of the architects Pavel Janák and Otakár Fierlinger respectively, the little garden in front of Queen Anna's summer house was restored.

The gardens to the south of the castle have had as long a history as those of the northern side. The Paradise Garden, situated at the western end, was created in 1562, at the time of Archduke Ferdinand of Tyrol, and altered under Rudolf II, when a small pavilion with an aviary and pools were added: the archives mention a basin 1.8 metres (6 ft) deep. And in the reign of his brother Matthias, a charming bugler's pavilion was built alongside the wall enclosing the garden, opposite the new castle staircase. In the Baroque era the garden was divided into two parterres: the west parterre was square and box-edged with shrubs, surrounding a small central pool; the east parterre was rectangular, surrounded by six lawns and decorated with a flat edging in the shape of an ellipse.

The other part of the south gardens, extending eastward to form the Ramparts Garden, was created only in the 19th century on the site, as its name suggests, of the ancient Late Gothic fortifications. Originally this was simply an alley of trees that linked the Hradčany and Klárov quarters.

The two gardens acquired their present appearance when Prague Castle was adapted as the residence of the Czechoslovak president.

1. Z. Wirth: *Pražské zahrody* (The Gardens of Prague), Poláček, Prague, 1943, p. 4.
2. J. Krčálová: *Poznámky k rudolfinské architektuře* (Notes on Architecture in the Time of Rudolf II), Academia Umění, 1975, p.507, ill. 6.
3. E. Fučiková, B. Bukovinská, I. Muchka: *Die Kunst am Hofe Rudolfs II* (Art at the Court of Rudolf II), Dansien, Hanau, 1988, p. 34.
4. A. Mihulka: *Královský letohrádek zvaný Belvedere an Hradě Pražském* (The Royal Summer Pavilion called the Belvedere at Prague Castle), Kruh pro pěstování dějin umění, Prague, 1939, p.12.
5. J. Svoboda: *Královský letohrádek* (The Royal Summer Pavilion), Památky a příroda, Panorama, Prague, 1987, p. 7.
6. E. Fučiková: *Tři francouzšti kavaliři v rudolfinské Praze* (Three French Knights in the Prague of Rudolf II), Mladá Fronta, Prague, 1989, pp. 82-3.
7. ibid.
8. J. Morávek, Z. Wirth: *Pražsky hrad v renesanci a baroku 1490-1790* (Prague Castle from the Renaissance to the Baroque, 1490-1790), Prague, 1947, p.10.
9. V. Fabian: *Dietzlerova kresba: Pohled z věže chrámu s. Vita na hradě Pražském k severu* (A drawing by Dietzler: View towards the north, from a tower of St Vitus's Cathedral to Prague Castle), Památky archeologické, 1921, p. 151.
10. M. Lejsková-Matyášová: *Florisův cyklus sedmexa svobodných umění a jeho odezva v české renesanci* (The Floris cycle on the seven liberal arts and its repercussion on the Czech Renaissance), Academia Umění, Prague, 1960, p. 396.
11. P. Janák: *Obnova sgrafit na mičovně* (Restoration of the sgraffiti of the Royal Ball Court), Academia Umění, Prague, 1963, p. 220.
12. F. Moryson, J. Taylor: *Cesta do Čech* (Voyage in Bohemia), Mladá Fronta, Prague, 1977, p. 33.
13. cf note 6, p. 33.
14. cf note 6, p. 82.
15. F. Kašička, M. Vilímková: *Lvi dvůrPražského hradu* (The Lion Court at Prague Castle), Panorama, Prague, 1970, pp. 34-41.
16. ibid., p. 40.
17. cf note 3, p. 22.
18. V. Procházka: *Zahrady pražského hradu* (The Gardens of Prague Castle), Obelisk, Prague, 1976, no pagination.
19. Cf *Jahrbuch der kunsthistorischen Sammlungen des allerhöchsten Kaiserhauses in Wien* (Yearbook of the Art Collections of the Mighty Emperor in Vienna), 1891, register no. 8317.
20. cf note 2, ibid.
21. M. Vilímková: *Stavitelé chrámi a palaci* (The Builders of the Churches and Palaces), Prague, 1986, p. 165.
22. Cf 'One of the variants of the plan of the Ursuline convent at Kutná Hora', in the book by H.G. Franz: *Bauten und Baumeister der Barockzeit in Böhmen* (Buildings and Architects of the Baroque Era in Bohemia), Seeman Verlag, Leipzig, 1962, ill. 261.
23. cf note 21, p. 230, note 16.
24. cf note 9, ibid.
25. P. Preiss: *Italští umělci v Praze* (Italian Artists in Prague), Panorama, Prague 1986, p. 419.

THE FORTIFICATIONS

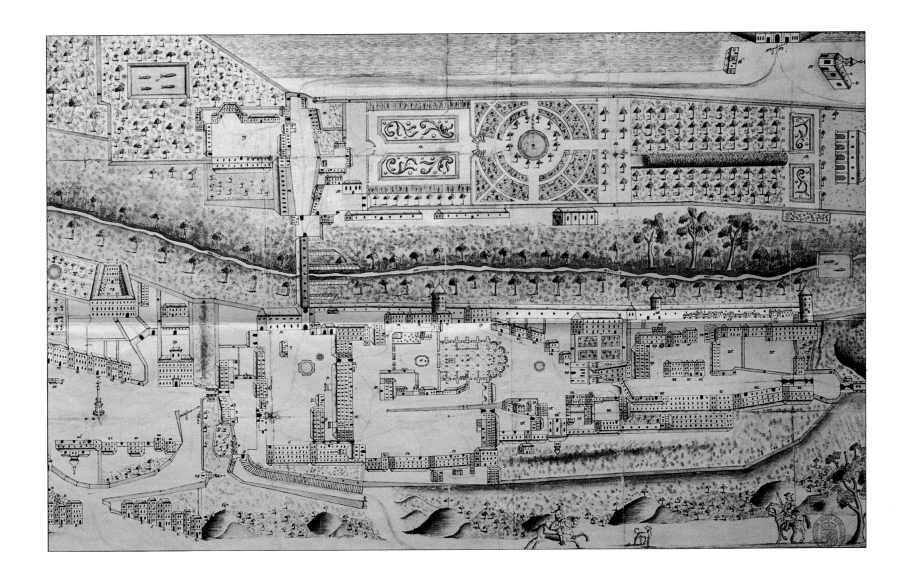

Plan of the site of Prague Castle and of a part of Hradčany, in the library of the Prague National Museum. Made during the second half of the 18th century, shortly before the reconstruction ordered by Maria Theresa, the plan includes, for the first time, all the buildings, with a semblance of perspective created by the inclination of the different façades of the buildings, except for St Vitus's Cathedral. Thus, the representation of the covered bridge, resting on its stone piers and linking the castle to the northern gardens, is very explicit.

Opposite page: *the Powder Tower*. In the northern section, the fortifications run very close to St Vitus's Cathedral, which is separated from them only by a few buildings in Vicar's Street (Vikárka) and a very narrow courtyard. Around 1500 the enclosing walls were reinforced with large round towers that accommodated cannon, the new form of firearms.

The castle's northern fortifications are located on the edge of the escarpment known as the Stag Moat, one of the site's important natural defences. After the invention of artillery, in the 15th century, the castle had to be protected against possible attack from the northern plain. Three round towers were therefore built, to designs by Benedikt Ried, with foundations deeply embedded in the Stag Moat: the Daliborka, the new White Tower and, mightiest of all, the Powder Tower.

"I climbed the silent, dark, echoless streets to the top of the high hill crowned by the immense castle of the kings of Bohemia. The sombre outline of the building was silhouetted against the sky; no light shone from its windows; its solitude was somewhat reminiscent of the site and grandeur of the Vatican or of the temple of Jerusalem as seen from the valley of Jehoshaphat..."

Chateaubriand: Mémoires d'outre-tombe, 24 May 1833

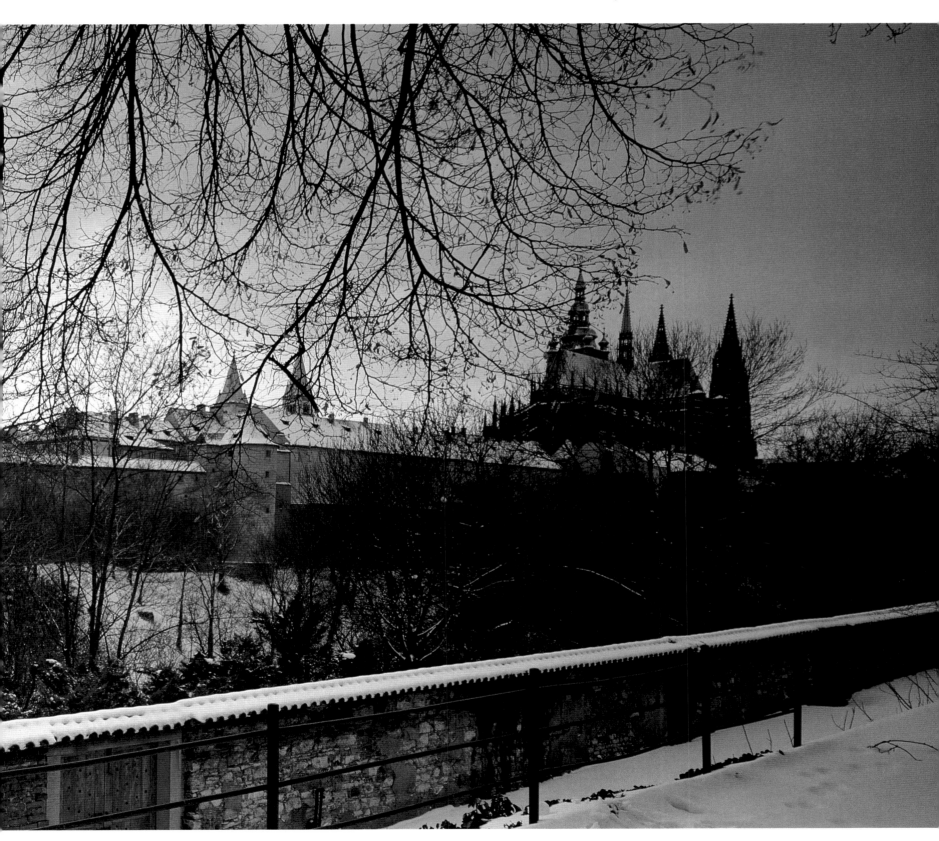

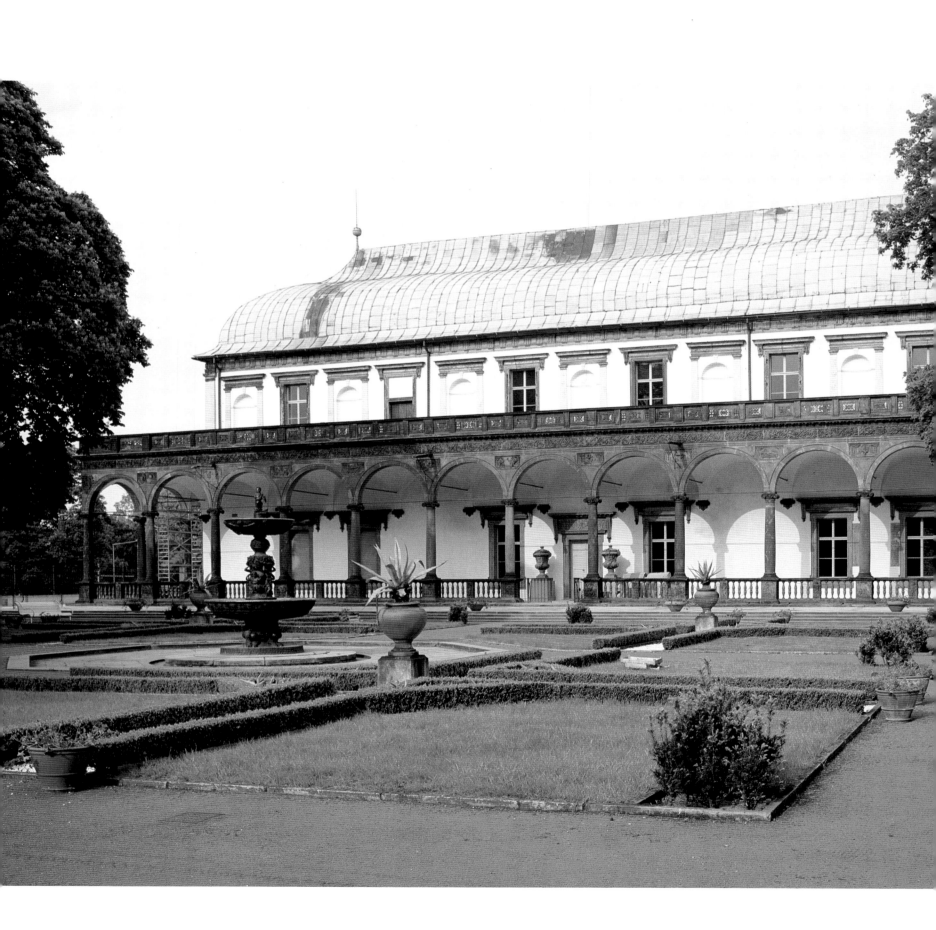

After 1354 Emperor Ferdinand I converted the extensive area to the north of the castle into a garden that became known as the Royal Garden. It was enclosed, to the east, by this pavilion (known as the Royal Belvedere) which the emperor commissioned for his wife, Queen Anna. A small garden, one of the loveliest to be found north of the Alps, was laid out in front of the building. The parterres were reconstructed, quite freely, in the 20th century.

The Singing Fountain, detail. This fountain consists of two superimposed basins on a shaft with sculptures of Pan bearing a deer and shepherds. Carved by Antonio Brocco, court sculptor, they testify to the excellence of Renaissance sculpture in Prague.

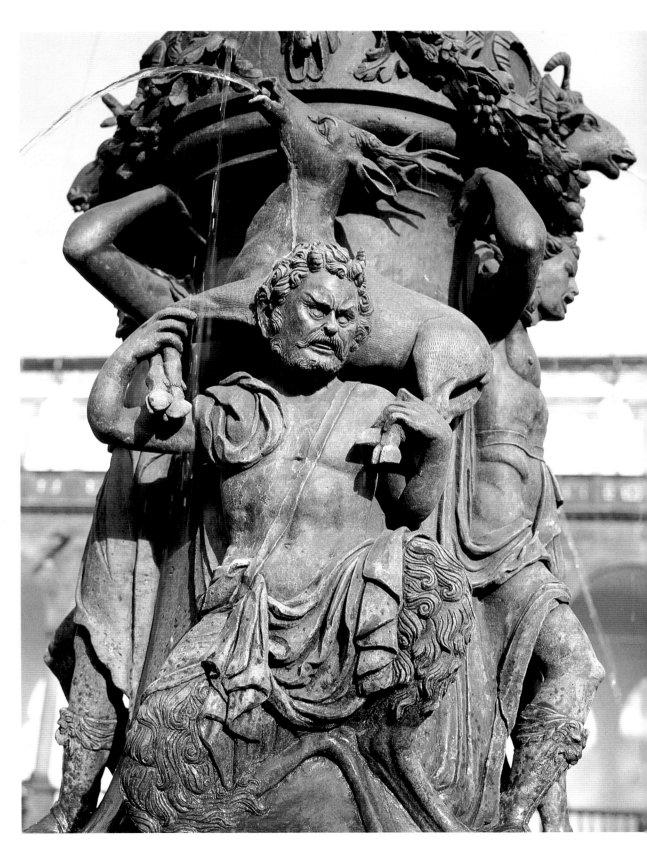

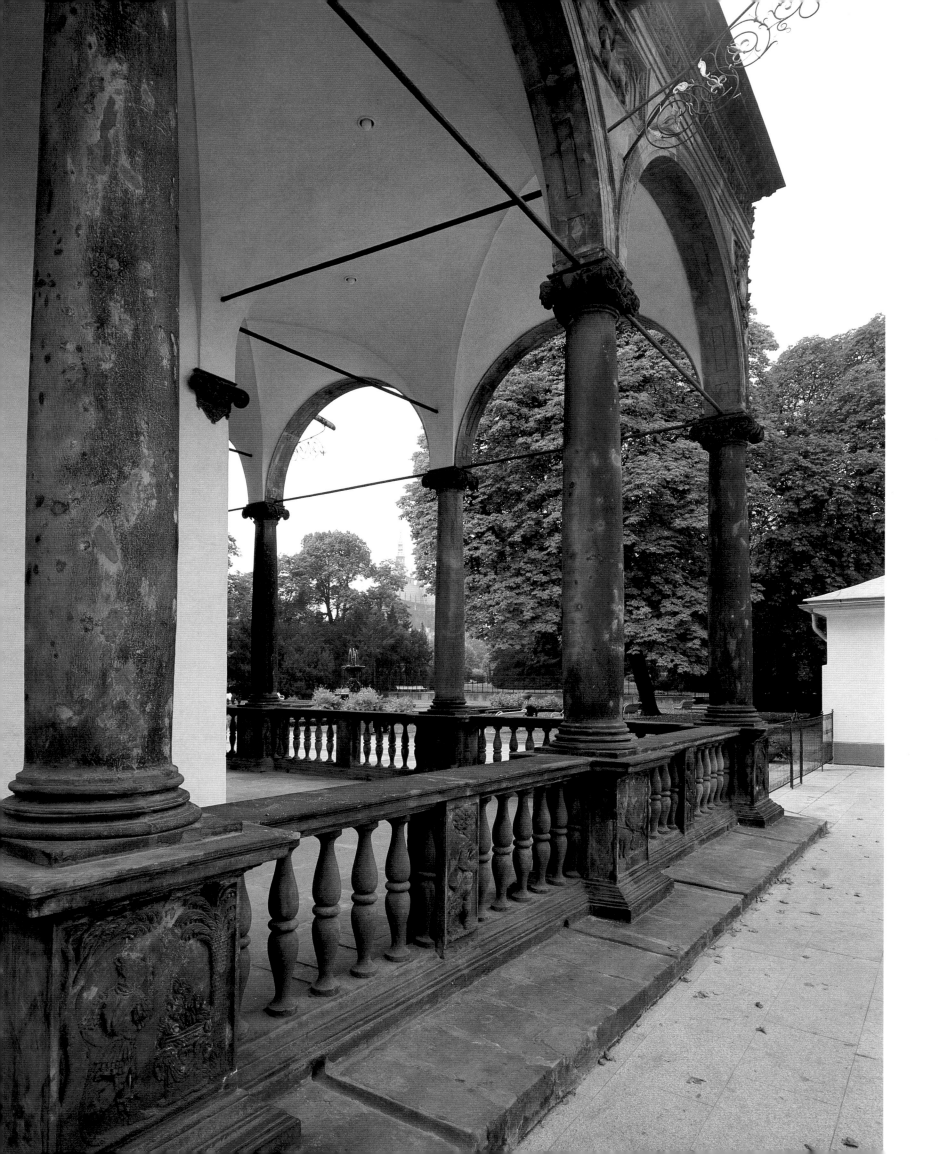

Opposite page: *the arcades of the Summer Pavilion*. The type of construction used for the pavilion is a variant of the antique *peripteros*, a Greek temple consisting of a rectangular hall surrounded by a line of columns detached from the wall. The semi-circular arcades are enclosed at the base by an elegant balustrade, and the capitals, stylobates of the columns and areas above the spandrels are adorned with remarkable sculptures, made in the middle of the 16th century by Paolo della Stella and his assistants.

Below: *the Singing Fountain* in the centre of the little garden in front of the Belvedere was, based on the designs of the court painter, Francesco Terzio, and cast in bronze in 1564-8 by Tomáš Jaroš, bell-founder and armourer of Brno. It owes its evocative name to the melodious sound of the water splashing into the bowls.

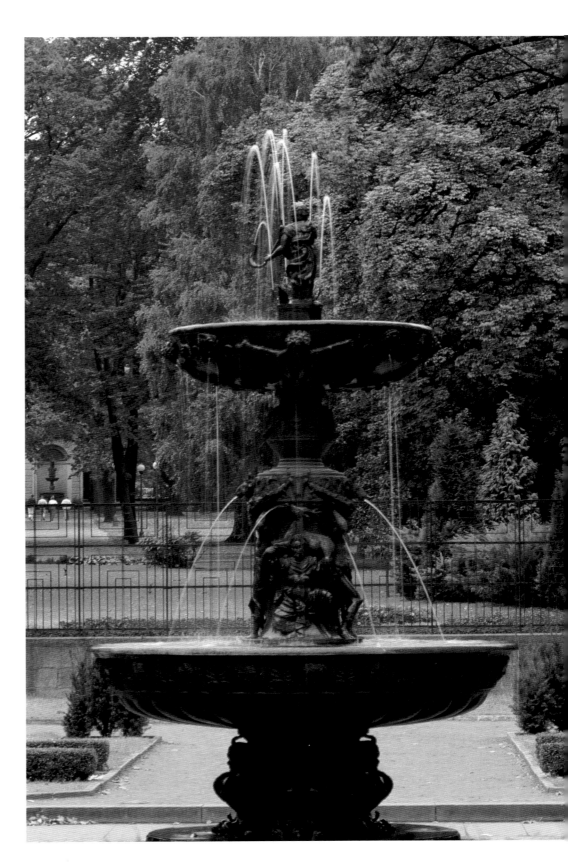

Above: *two reliefs on Queen Anna's Summer Pavilion*. The upper one represents the forge of Vulcan with Venus, and the lower, Zeus metamorphosed into an eagle carrying Ganymede up to Olympus. Thirty-two rectangular reliefs constitute the main decoration of the pavilion. They treat various subjects from Greek mythology, Roman history and contemporary themes, such as hunting. The overall interest of the group derives not only from the subjects but also from the exceptional artistic quality displayed by the stonemasons of the workshop of the Italian sculptor Paolo della Stella.

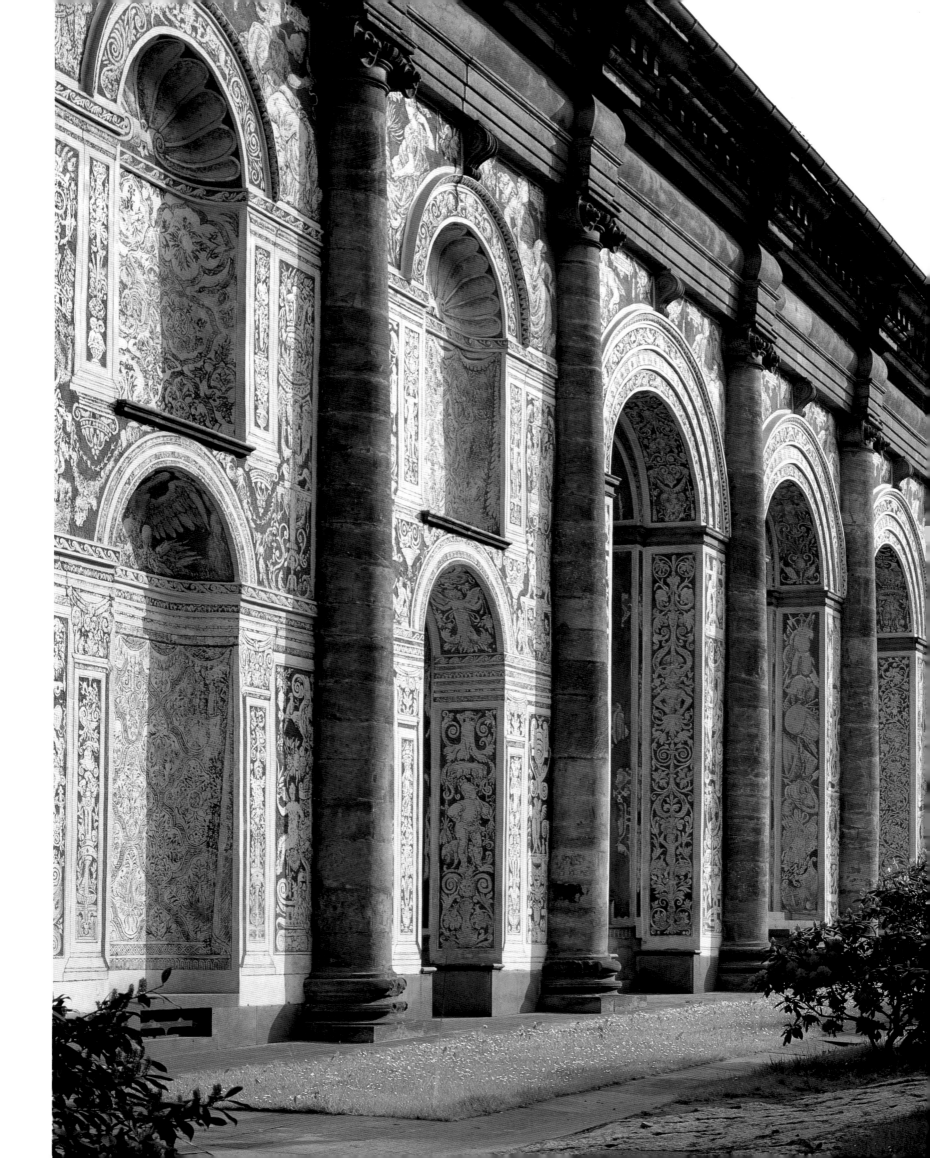

THE LARGE HOUSE OF THE BALL COURT

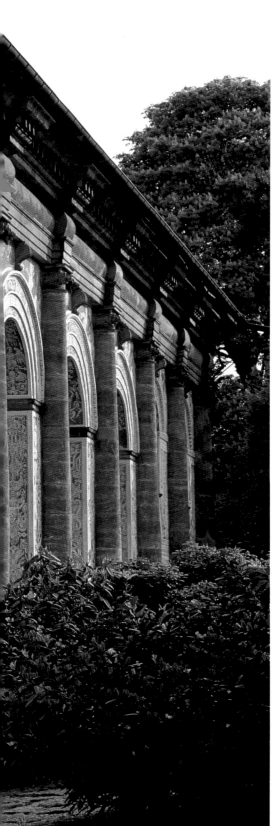

Two ball courts catering for a sport much enjoyed during the Renaissance formed part of the amenities of the Royal Garden. The smaller of the two, situated near the covered bridge, in the service courtyard, is of no great artistic merit. The larger court, on the other hand, built in 1567-9 by Boniface Wohlmut, has a remarkable sgraffito façade and makes a distinctive artistic contribution to the central part of the garden.

Right: *Night*. The statues of the Royal Garden dating from the Baroque era are fairly sober in decorative style. Most of the sculptures come from the workshop of Matyáš Bernard Braun, who was responsible not only for the statues of lions and the large vases of the parterres but also for the admirable allegorical *Night* which stands in front of the Royal Ball Court.

THE ROYAL
RIDING SCHOOL

Because of the specific configuration of the castle site, a number of the buildings traditionally associated with the concept of an imperial residence lie outside the site proper, to the north of the Stag Moat.
In the 16th century this area boasted large stables, with an open-air riding school. The present building, the Winter Riding School, dates from 1694-5 and was constructed to the plans of Jean-Baptiste Mathey.
A narrow wing was later added at right angles to the rectangular building. Having semicircular arcades on the ground floor and first storey, it formed covered balconies for visitors to the Summer Riding School. Today the area is laid out as a garden, with parterres, which provides unusual views of the cathedral, the Spanish Room wing and the Powder Tower.

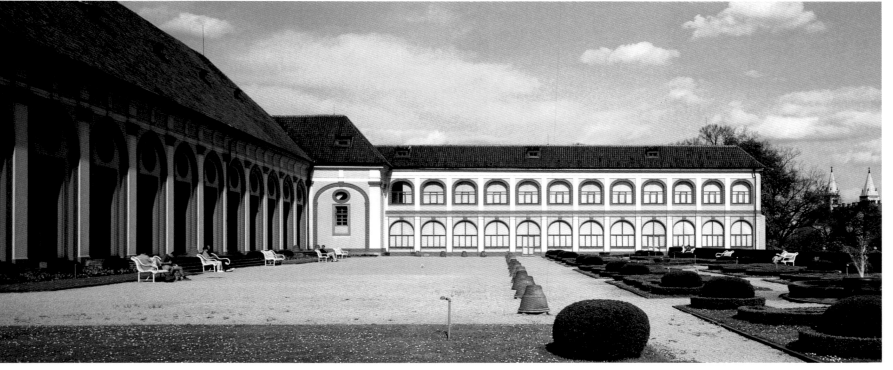

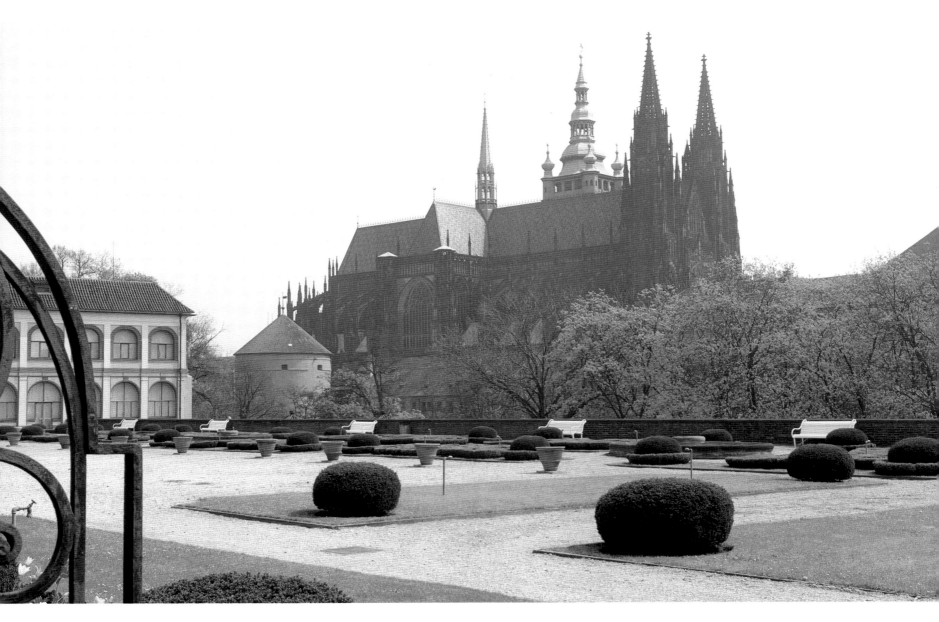

THE ROYAL GARDEN

"Prague is one of the noblest cities and my thoughts often turn to Rome, the city it most resembles. Nor can I refrain from mentioning the charm of the festivities in the gardens of the palace, the spring flowers and the aristocratic beauty of the Prague women, their sensuous bearing and their clothes, so charming and so elegant that they put me in mind of Dante's Paradiso."

Auguste Rodin in 1902

Originally the garden was laid out with parterres and box edging, bounded to the north by the enclosure wall and to the south by a glasshouse built to the plans of Kilián Ignác Dientzenhofer. This building, small but architecturally interesting, was renovated several times, most recently after the Second World War, when the castle was being refurbished as a residence for the presidents of the Republic.

PLEČNIK'S GARDEN WORKS

Left to right: *the Bugle Pavilion*, dating from the first half of the 17th century; renovations were carried out by Plečnik's assistants.

View from Plečnik's new staircase, which leads from the Third Courtyard of the castle to the Ramparts Garden. Plečnik used the pure classical form of Ionic columns.

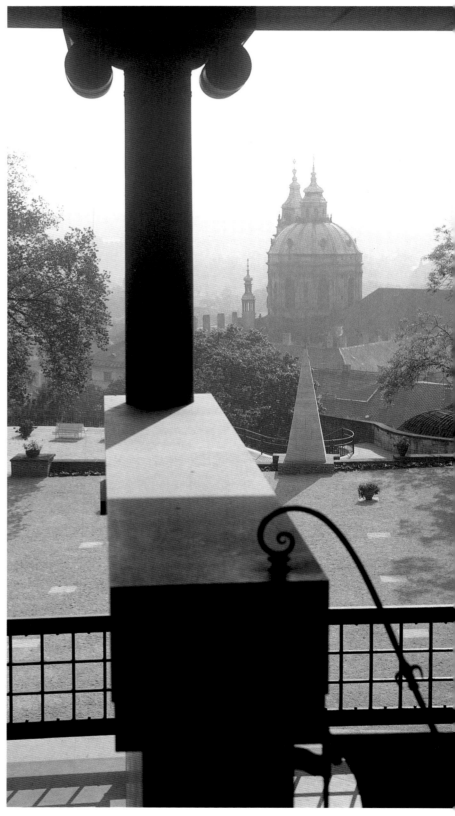

Under the staircase of the Paradise Garden, Plečnik placed *a small wall fountain*, a fine example of the ironworker's craft.

The central point of the Paradise Garden is *a large granite basin* weighing forty tons.

In the Bastion Garden, Plečnik utilised the classical motif of *the double flight of semicircular steps*, concave and convex, a form that is found in European architecture, in the Vatican.

247

At the entrance to the Paradise Garden (reached via the ramp from Hradčany), Plečnik used the suggestive motif of *a narrow Greek vase*, placed in a rectangular niche. In the Ramparts Garden the *obelisk-pyramid* (right) serves as a very expressive vertical landmark in this part of the castle.

OTHER SECULAR BUILDINGS OF THE CASTLE

THE ROSENBERG (ROŽMBERK) PALACE

The building of this palace was doubly influenced by the fire of 1541 which destroyed much of the Malá Strana quarter (including the residence of the Rožmberk family) and of Hradčany where, from then on, plans were made to replace the former small buildings with larger ones. All the evidence shows that the undamaged rubble of older houses was used in the building of the Rosenberg Palace[1].

Initially, from 1545 to 1560, a palace was built under the direction of Hans Vlach[2], the four wings of which formed a closed courtyard with galleries of arcades. But there were no arcades on the ground floor and first floor except along the shorter lateral wings of the courtyard; and on the access side to the palace (George Street) there was a massive arcaded entrance (still existing today), the smooth façade of which may have been covered with ornamental sgraffiti. On each of the two floors of this south wing there was a large room, the one on the ground floor having direct access to the court through a doorway. On either side of these large rooms there were two smaller rooms of identical size. The strict symmetry of this layout, linked to the axis of the main entry, was very evident and was undoubtedly a novelty in the mid-16th-century architecture of Prague.

In contrast, the remains of the façades of the street and garden sides show a picturesque asymmetry that was more or less in accordance with contemporary architectural style: they had been constructed almost directly on the foundations of the Roman surrounding wall and the bases of this wall had been used to break up the south front with polygonal turrets. Apart from their bossed doorways, the principal decorative element of these façades were the gables, partly functional (since they provided a saddleback cover to the roofs of the shorter east and west wings) and partly *trompe l'œil*, devoid of any practical purpose. The picturesque

outlines of these large and small voluted gables (the garden front had ten in all) are more in keeping with local architectural tradition, as was the structure of the façades they surmounted. In any event, the main cylindrical cornice (placed on top of the western part and built later) is rightly regarded as the most characteristic feature of the palace.

The next stage was to enlarge the site of the palace westward (towards All Saints Chapel). In 1573-4 Ulrico Aostalli built a long rectangular garden in this area, lying on the same level as the first floor of the palace, because of the sloping ground. This garden was also surrounded by a gallery of arcades, with thirteen arches on the north and south sides and six arches on the west side. Above the arcades was an enclosed corridor with oblong windows surmounted by a straight moulding. In 1600, following an exchange, the Rosenberg Palace became the property of Emperor Rudolf II, and its subsequent fortunes were a royal concern. Nevertheless, this Renaissance palace, the biggest in Prague, retained its original appearance until the 1720s and it was only at this period that fundamental changes were made. The architect Tomáš Haffenecker heightened the palace by adding a second storey, partitioned the wings of the single block and connected the two parts with corridors giving on to the courtyard.

The present appearance of the palace is the result of changes ordered by Empress Maria Theresa when she decided to convert the building into the Institute of Noblewomen. Niccolo Pacassi was commissioned to enlarge the palace, adding the part contiguous to All Saints Chapel. This is where the present main entrance to the palace is situated, beneath a rounded portico, and where a large hall and staircase were also built. So the turrets were destroyed and the façades joined, while the Renaissance arcades inside were bricked up. The new building was impressively large, with some thirty-five windows opening on to George Street and almost fifty along the south front, which was still broken up by seven terraced bastions. Within the panoramic con-

text of the castle as a whole, it created a counterbalance to the south wing of the Royal Palace, the façades of which, incidentally, were by the same architect.

Inside the old west wing of the Rosenberg Palace (between the courtyard and the garden) Pacassi built a chapel and its adjoining four-curved monumental staircase. The original garden was slightly shortened and a small garden-court was built on the west side. The two gardens had lawns with curved borders and an oval pool in the middle. The Institute accommodated thirty or so girls of noble families. Each had her own apartment comprising an antechamber, a bedroom (with no door leading to the corridor) and a small room for a maid. All the apartments were absolutely identical. The palace, as modified by Pacassi, has remained virtually unchanged to this day.

Until 1970 the Rosenberg Palace housed the Historical Institute of the Academy of Sciences. The palace was cleared during the programme of 'normalisation' that followed the invasion of Czechoslovakia by troops of the Warsaw Pact, more than seven hundred research students being dismissed and the building confiscated by the Ministry of the Interior, which still occupies it today.

Right and opposite page: *terracotta fragments*. Reconstruction during the Early Baroque era destroyed virtually all the original ornamentation of the Pernštejn Palace. Only a few fragments have been discovered to convey any idea of the wealth and quality of the terracotta decorations that framed the doors and windows, as in Italian palaces of the 15th century.

Tu es dans le jardin d'une auberge aux environs de Prague
Tu te sens tout heureux d'une rose sur la table
Et tu observes au lieu d'écrire ton conte en prose
La cétoine qui dort au coeur de la rose

Epouvanté tu te vois dessiné dans les agates de Saint-Vit
Tu étais triste à mourir le jour où tu t'y vis
Tu ressembles au Lazare affolé par le jour
Les aiguilles du quartier juif vont à rebours
En montant au Hradchin et le soir en écoutant
Dans les tavernes chanter les chansons tchèques.

Poem by Apollinaire

THE LOBKOWICZ (FORMERLY PERNŠTEJN) PALACE

In addition to the Rožmberks, there was a second noble family, the Pernštejns, whose representative could even lay claim to the royal crown. Only a narrow alley or passage separated the homes of the two families. The Pernštejn Palace dates from 1554-60, at which time it had four wings and a single storey with two prismatic towers of the original ancient south-side fortifications giving it an unmistakable outline. On the south wing there was a semicircular arcade decorated (like many other architectural features of the palace) with terracotta ornamentation unique of its kind. The Pernštejns had already used terracotta for other buildings, notably at Pardubice, in eastern Bohemia, but in that case it was apparently a matter of standardising construction methods because the Pernštejn brickworks turned out, among other things, shaped bricks for vaults and cornices, casings for doors and windows, etc. It would appear that terracotta was used in Prague for quite another reason, notably the artistic possibilities arising of this material, probably introduced to Prague by artists from Italy. There are numerous examples of the masterly employment of the terracotta technique in many parts of Europe, often far removed from one another (Wismar, Schallaburg, etc.). The bas-reliefs of the Pernštejn Palace in Prague are of exceptional artistic quality, even if they exhibit ornamental features that could be considered purely local and sometimes rather rustic: for example, the figurines of antique-type dolphins mingled with leaves and acorns.

The sumptuous façade that faces the street must have been created towards the end of the 16th century, judging by the large roof gables (known from a drawing dated 1622[3]). The entrance wing already had two floors with gemel windows, and even triplet in the centre of the façade, and straight mouldings. The main doorway or, more precisely, the triangular gable above it, its line broken by a segment of the cornice,

Putti. The gardens to the south of the castle contain more sculpture than the Royal Garden itself. The majority were executed in the 18th century, like these putti supporting a cartouche with the blazon of the Czech lion surmounted by a crown.

constituted a highly advanced stylistic feature.

The palace did not receive its present-day appearance until it passed into the hands of new Czech owners, the eminent Lobkowicz (Lobkovic) family. Carlo Lurago refurbished the palace in 1651-68 for Wenceslas Eusebius Lobkowicz; and it was after this owner's forename that the chapel on the first floor was dedicated to St Wenceslas, whose legend served as the subject of the paintings on the walls and ceiling. The paintings are by Fabián Hárovnik, while Domenico Galli[4] did the sculpted stucco work that frames them. These two artists also collaborated in other parts of the palace, notably in the hall, in the adjacent dining room and in the large reception room of the south wing. The interiors of the hall and dining room are almost wholly preserved, including the two hall chimney-pieces, whereas the reception room was later partitioned and only fragments of its original decoration scheme remain. As was often the case in the Baroque period, the theme of the paintings was associated with the purpose of the room: for example, the dining room contains a painting of the feast of the gods on Olympus, and so forth. When the palace was renovated between 1973 and 1987 in order to hold exhibitions of the National Museum, a number of Carlo Lurago's architectural features were rescued, such as the staircase with its stone door casing and the two principal doorways. Even so, the original layout was badly disrupted as, for example, by building a new staircase near the large reception room[5].

THE BURGRAVE'S HOUSE

The house of the grand burgrave was built in 1555, close to the beautiful Renaissance palaces belonging to the Rožmberk and Pernštejn families. The burgrave of the time was a member of the Lobkowicz family, John, who commissioned not only this mansion but also the splendid palace bearing his family name (today the Schwarzenberg Palace) on Hradčany Square. The Burgrave's House doubtless contained the offices associated with that functionary's official duties. (The burgrave was an important nobleman who managed royal business during the absence of the king.) For this building the Italian architect Giovanni Ventura utilised, for the first time in Bohemia, pierced gables, in which the vertical elements (the small pilasters) were omitted, so that they were segmented only by thin horizontal cornices. This solution reinforced the overall monumental effect[6]. Originally it had been a medieval building flanked by a Romanesque tower, which Ventura modernised, notably by adorning the façade with simple sgraffito work. It was then refurbished, during the 1590s, by the court architect Ulrico Aostalli. It was certainly in this period that the walls and ceilings of one of the first-floor rooms were decorated with paintings, which were discovered and restored in 1962-3 when the building was transformed into the Czechoslovak Children's Home by the architect Josef Hlavatý[7]. Until then, the original beamed ceiling had been covered by a false wooden ceiling, decorated with a fresco, *The Judgement of Solomon*, a theme highly suitable for a room devoted to matters of state. The allegorical figures of the five senses appear on another grotesquely ornamented wall frieze. Most interesting, however, are the genre landscapes on the side of the beams.

The building underwent further reconstruction in the Baroque period. Still visible on the door are the finely carved coats-of-arms of the four burgraves then in office.

GOLDEN LANE

Behind the Burgrave's House is one of the most fascinating parts of the castle complex, Golden Lane (Zlatá) which, according to the archives, was originally known as Goldsmiths' Lane (Zlatnická). The small houses that line the lane to this day are typical of the period when the castle area still resembled a little town, separate and enclosed. Tucked into the twenty or so Romanesque arches of Soběslav I's enclosure wall were tiny houses, usually of one storey, with a single door and window on either side, or sometimes with an upper storey, in a few cases projecting and supported by consoles. This was a typical feature of contemporary Bohemian bourgeois architecture: where conditions permitted, such an overhang was designed to increase the habitable space of the house. The houses, which also received some light through a window looking out on the Stag Moat, were extremely narrow, and the two storeys were linked by a little crooked staircase. It is interesting to see, in Golden Lane, built into the fortifications, surviving examples of the 'humble dwellings' that could also be found, until the reign of Rudolf II, in other areas of the castle: for example, in the outer moat, at the western entrance to the castle, or built very high up in the southern part of the castle, beneath Maximilian's kitchens (their existence is known from drawings by Rudolf II's court painters, for whom they were a picturesque subject). At the time of Rudolf II, the lane was mainly inhabited by the castle guards charged with entry gate and prison duties. Originally, the lane led to St George's Convent, but this section of it was destroyed at the request of one of the abbesses because of 'the stink and the smoke, as well as the din coming out of the taverns, disturbing the nuns'[8].

THE FORTIFICATIONS

Nothing is known for certain about the appearance, the layout or the exact extent of the most ancient fortifications of the castle. Archaeological discoveries here and there indicate that they consisted of a raised mound of earth strengthened by tree trunks on the inside and by rough stones on the outside. A shallow ditch encircled this mound. Nor is there much more information concerning the fortifications of the Romanesque period, which were begun in 1135, during the reign of Soběslav I. Traces of them can be seen in several places: for instance, in the passage between the Second and Third Courtyards, where an idea of their thickness can be obtained from an opening made in the enclosure wall: meticulously fashioned of marl rubble, the wall at this point measured an astonishing height of some 14 metres (45 ft). It is easy to reconstruct the outlines of this enclosure and of the three towers that gave access to the castle site. On the west side, the White Tower wall has been preserved in the wall up to the third storey; its interior is also intact and is accessible from the 'central' (perpendicular) wing. To the west of the Royal Palace was an entry gate on the town side; it has been partially preserved in the underground passages below the Vladislav Hall. To the east, entry was via the Black Gate, preserved in its entirety. The enclosure wall was additionally reinforced on the east and west sides by other prism-shaped towers and, on the south, by small turrets which were either polygonal (near the Royal Palace), semi-cylindrical (near what was to become the Institute of Noblewomen) or prismatic (near the future Lobkowicz Palace). The towers and turrets of the south side have also been partially conserved: for example, on the terraced bastions adjoining the castle façade, near the Ramparts Garden, and also farther west, near the Paradise Garden[9].

The next stage in the extension of the fortifications, dating from the Late Gothic, owed more to the development of firearms than to evolution of the

Wood engraving: the oldest view of
Prague, from the *Liber Chronicarum* by
Hartmann Schedel (1493). The principal
features of the castle can be clearly seen:
from left to right, the White Tower, St
Vitus's Cathedral and the Black Tower.

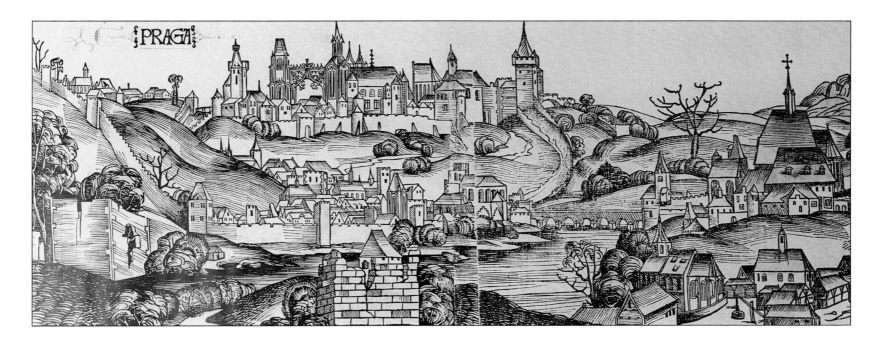

arts. The castle had to be protected against artillery fire, mainly by the construction of powerful bastions to accommodate such weapons. These improvements were carried out by one of the most important architects in the castle's history, Benedikt Ried. Not only did he certainly build the three solid bastions for cannons in the new, outer zone of the castle's southern fortifications, but he was also responsible for the barbican situated to the east and the three round towers near the Stag Moat: the Daliborka, the New White Tower and, most important of all, the Powder Tower (wrongly called 'Mihulka'). There were loopholes on all four floors of the tower, so that 18 cannons of various calibre could be fired, aimed at the base of the tower, the Stag Moat and, finally, the terrain directly opposite, to the north. There were separate entrances to each storey. Originally, the Powder Tower was not roofed as it is today but encircled by a terrace with a parapet, making it easier to defend. In the course of recent reconstruction of the tower, the system of closing the loopholes was restored. This quite exceptional technique is perpetuated in another form, in Ried's Švihov Castle, in western Bohemia.

The last step in the rebuilding of the castle fortifications, which left them looking more or less as they do today, came during the reign of Rudolf II, almost at the end of the 16th century. The south entry disappeared and a new main entrance was constructed to the north, from the two sides of the Powder Bridge which straddled the Stag Moat. In modern parlance it would be fair to say Rudolf II proceeded like a big property developer, merging into a single entity (with fixed outer boundaries) the patchwork medieval 'town' created by a large number of minor builders, independently of one another. He is sometimes described, not altogether incorrectly, as 'the greatest architect of the castle's secular buildings'.

The first feature to be completed was the east gate of the Black Tower: its outer portals have a semicircular archivolt with alternately long and short voussoirs. Another work with more or less the same appearance is the small portal of the Stromovka in Prague, bearing the monogram of Rudolf II and the date 1593. The interior portal of the Black Tower is bordered with typically Mannerist diamond-point bossage (rustication).

Around 1600 the North Gate was built, in front of which, in the time of Pacassi, a columned Mannerist

portal was added. The upper part of the portal had been bricked up in the passage vault in the Baroque period. This part of the portal was discovered during the restoration of the flooring of the Spanish Room: in sharp contrast to the rough bossage, its beam was adorned with very delicate ovolo moulding, giving it an antique appearance.

The best-known example of Mannerism in the castle, however, is the Matthias Gate, bearing an inscription relating to the activities at the castle (1614) of Rudolf II's brother, Matthias II. Considering that this gate formed the main entrance to Prague Castle and that it once gave access, on the right, to the staircase leading to the staterooms of Rudolf's palace, it is probable that it was constructed earlier, around 1600, and merely completed, under Matthias, by the addition of a stucco plaque that differed, in both materials and artistic style, from the other parts in sandstone[10]. It was with the creation of these three large gateways that the development of the Prague Castle fortifications, extending over several centuries, came to an end.

'Prague will not let us go. Neither of us.
This little mother has claws. We must submit,
or else ... We ought to set fire to the two ends,
at Vyšehrad and at Hradčany;
perhaps then we could free ourselves of her.
Think of this from now until Carnival.'

Franz Kafka: Letter of 20.12.1902 to Oskar Pollak

1. A. Kubiček: *Rožmberský palác na Pražském hradě* (The Rosenberg Palace in Prague Castle), Academia Umění, Prague, 1953, p. 308.
2. J. Krčálová: *Palác pánů z Rožemberka* (The Palace of the Lords of Rožmberk), Academia Umění, Prague, 1970, p. 469.
3. *ibid.*, p. 477, ill. 7.
4. A. Lewiová: *Doklady ke stavbě Lobkovického palác* (Documents on the building of the Lobkowicz Palace at Prague Castle), Památky archeologické, 1925, pp. 250-6.
5. V. Procházka, P. Chotěbor: *Lobkovický palác* (The Lobkowicz Palace), in: *Průvodce historickou expozicí Národního Muzea* (Guide to the Historical Exhibition of the National Museum), Narodní Museum, Prague, 1987, pp. 7-11.
6. E. Šamánková: *Architektura české renesanse* (The Architecture of the Czech Renaissance), Nakladatelsví Krásné literatury hudby a umení, Prague, 1961, p.39.
7. J. Krčálová: *Obnovené renesančni malby purkrabství Pražského hradu* (The Restored Renaissance Paintings of the Burgrave's House at Prague Castle), Orbis, Prague, Památkova páče, 1964, p. 275.
8. P. Chotěbor, J. Svoboda: *Pražský hrad* (Prague Castle), Olympia, Prague, 1990, p. 86.
9. *ibid.*, p. 12.
10. *Ausstellungskatalog Prag um 1600, Kunst und Kultur am Hofe Rudolfs II* (Catalogue of the Prague Exhibition *c.* 1600, Art and Culture at the Court of Rudolf II), Villa Hügel, Essen, 1988, pp. 86-7.

Opposite page: *the Royal Garden.* The avenue of trees in the central part of the garden did not form part of the original scheme. The pleasure garden to the west and the Summer Pavilion at the eastern end were originally linked by a long arbour covered with climbing plants, as shown on a plan dating from the second half of the 18th century (see p. 232). It was not until the middle of the 19th century that the arbour was replaced by an avenue of trees leading to a niche with a statue of Hercules by Jan Jiří Bendl (1670).

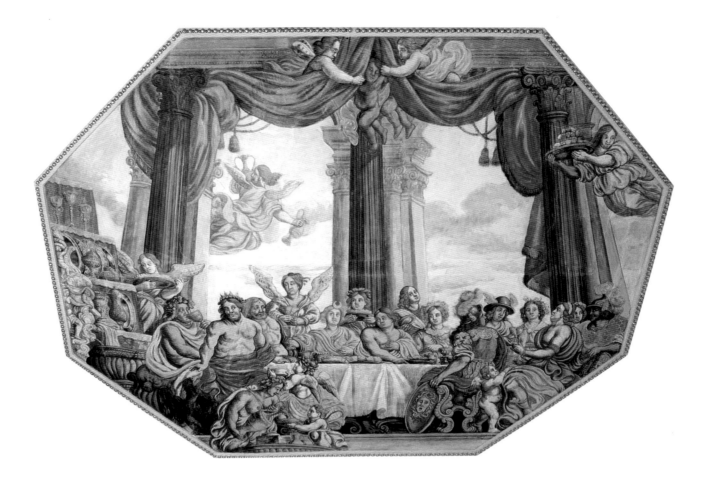

THE LOBKOWICZ PALACE

This palace was created by the reconstruction of the Renaissance-style Pernštejn Palace. In the second half of the 17th century, the architect Carlo Lurago collaborated with the most famous Prague ornamentalist of the period, Diminik Galli, and the painter, Fabián Harovník, to do the interior decoration. On the first floor were the reception rooms, decorated, as was the Baroque custom, according to the function of the particular room. The ceiling of the dining room, for example, was adorned with a fresco showing a feast of the gods of Olympus. The oriental room, in the Black Tower of the fortifications, is of interest as the only example of decoration in the romantic style.

Right: *the music room*, with an exhibition of instruments: a square piano, Bohemian, from the first half of the 19th century; a basset horn by František Doleisch, Prague, 1796; a double-action harp from the early 19th century; a guitar by Jean Baptiste Dvořak, Prague, second half of the 19th century; a guitar by Gennaro, Naples, 1819.

Left: *the beamed ceiling.* The residence of the burgrave was built in the 16th century, at which time the walls and ceiling of one of the first-floor rooms were decorated with wonderful paintings. The painter used the sides of the supporting beams very cleverly for interesting countryside scenes. The frieze below the ceiling, contains allegorical pictures of the five senses, a very popular subject at the time.

At the eastern end of the castle the Italian architect Giovanni Ventura built the palace of the grand burgrave of the Czech kingdom, the official who took the place of the sovereign during his absence (below). Above the main gate are the coats-of-arms of certain distinguished families whose representatives carried out this function.

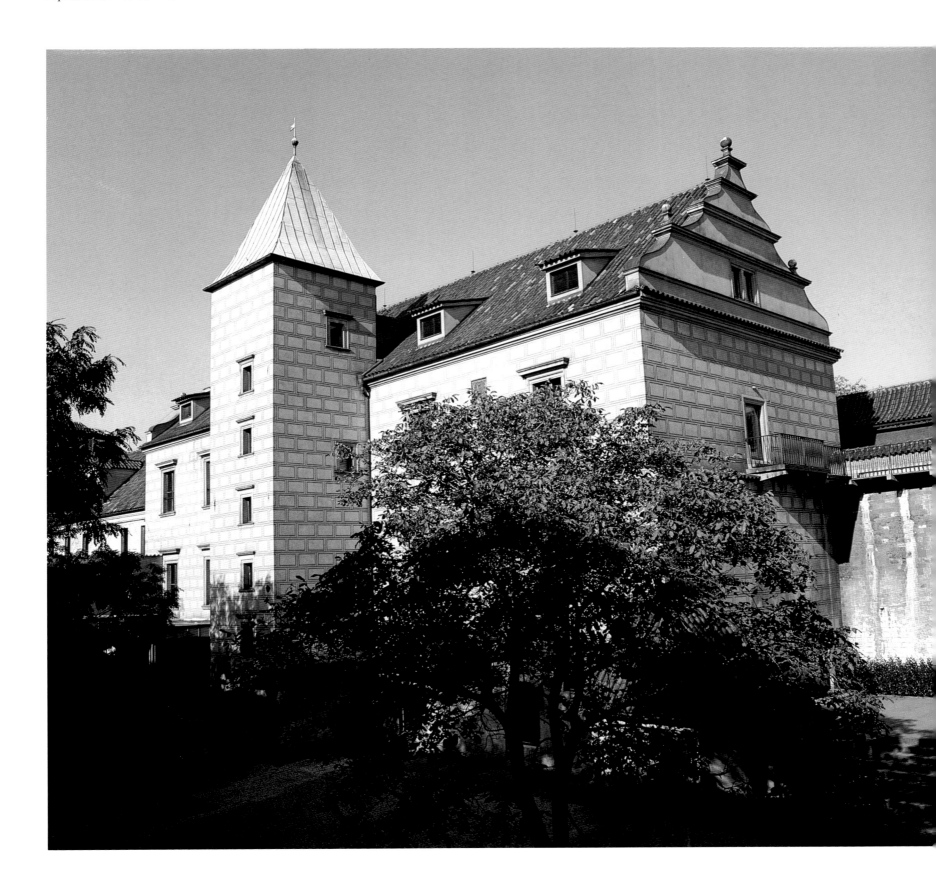

Below: *George Street (Jiřská ulice,)* the oldest in the castle area. From the 9th century it was used for crossing the fortified site from east to west. To the east, the castle site is reached by way of the Black Tower, after climbing the picturesque Old Castle Steps (Stare zámecké schody).

GOLDEN LANE

This lane is certainly the castle's biggest tourist attraction, rich in legends concerning the alchemists who lived there in the reign of Rudolf II. The street was created by building tiny houses intended for the castle guards, in the gaps formed by the arcades of the Romanesque enclosing wall of Soběslav I. The picturesque charm of this lane derives particularly from the crooked overhangs and roofs. At one time the writer Franz Kafka had his study on the ground floor of the house numbered 22.

262

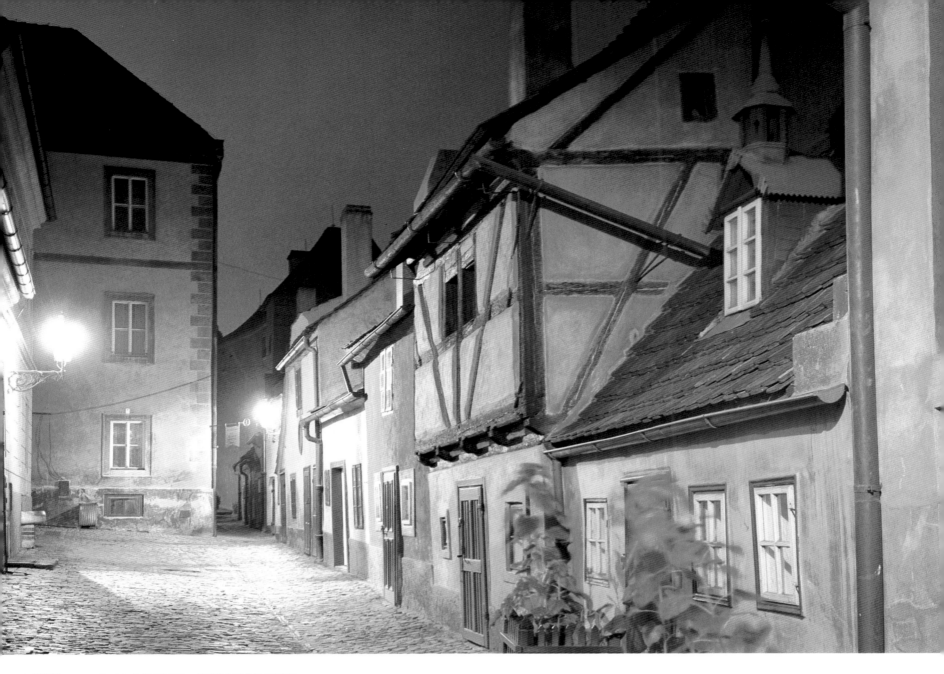

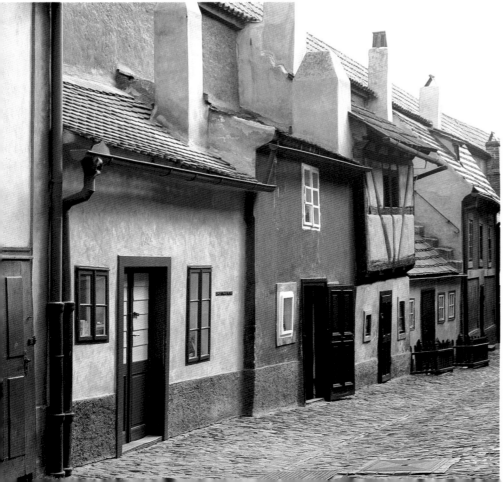

Page 264: *view of the north-eastern end of the castle fortifications, from Queen Anna's Summer Pavilion.* The large polygonal tower, known as the Black Tower, formed part of the Romanesque enclosing wall and served as the main entrance to the castle for visitors arriving from the east. In the Late Gothic period massive round towers were built to strengthen the fortifications. One of them, the Daliborka Tower, took its name from a legendary figure of Czech history, the nobleman Dalibor of Kozojedy, whose opposition to royal power caused him to be locked up in the tower and then executed. To pass the time, he learned to play the violin, attracting passers-by who, it is said, gathered outside his prison to listen.

APPENDICES

BIOGRAPHIES

EMIL M. BÜHRER (design). After an apprenticeship in graphic arts, he worked as an editor, photographer and art director for the journal *Camera*. In his capacity of book designer and art director, he created a number of internationally successful works, among them 'Leonardo', 'The Kingdom of the Horse', 'Journey Through Ancient China', 'The Sistine Chapel', 'The Silk Road', 'The Himalayas', 'Great Women of the Bible', 'Chess — 2000 Years of the Game's History'. Emil M. Buhrer died on January 2 1994 in Luzern.

IVO HLOBIL, born in 1942 at Přerov, has been teaching since 1990 at František Palacký University, Olomouc, where he had previously taught from 1974 to 1981. He is a specialist in the medieval art of Bohemia and Moravia, particularly in Moravian Late Gothic and Early Renaissance, and is also interested in the theoretical problems of conserving ancient monuments. After university studies at Prague, this art historian worked from 1970 to 1973 in the State Office in charge of the conservation of historic monuments in Ostrava. His research studies have appeared in translation in a number of publications. After 1981 he worked at the Art History Institute of the Czechoslovak Academy of Sciences, Prague.

MIROSLAV HUCEK (photography). Born in 1934 at Malacky, he has been a freelance press photographer since 1975. After studying at the Academy of the Cinema, in Prague, he worked as a television cameraman from 1958 to 1962; and then, until 1975 as a photographic reporter for the weekly *Mladý Svět* (World of Youth). He has contributed to various publications, brought out some ten albums of his own photographs and taken part in many exhibitions. He is included in the *International Encyclopedia of Photography from 1839 to the Present Day* (Michel Auer, Zurich, 1985), and some of his works can be found in the Bibliothèque Nationale of Paris. His wife Arita works closely with him and their daughter Barbara is following in their footsteps.

BARBARA HUCKOVÁ (photography). Since completing her studies at the Academy of Fine Arts, Prague, in 1988, Barbara has spent some time training in France with a FRAC grant. She has already exhibited in Prague, Paris, Milan and Stockholm and has contributed to several publications. She worked with her father in illustrating this book.

Other photographic sources:
JIŘÍ CESÁK pp 12-13; FOTO ČSTK pp 42-3, 44

LADISLAV KESNER, born in Prague, has been director, since 1991, of the Prague National Gallery's collection of ancient art at St George's Convent. After studying art history and aesthetics at Charles University, Prague, he worked from 1954 in the National Gallery as curator specialising in ancient art, serving as acting director from 1965 to 1969 when, for political reasons, he was removed from his post. In 1974 he was employed at St George's Convent, where the National Gallery had installed its ancient Bohemian art collection. He was appointed its director after a brief period as director of the National Gallery (from 1990 until early 1991).

IVAN P. MUCHKA, born in 1946 in Prague, has worked since 1986 at the Art History Institute of the Czechoslovak Academy of Sciences. This art historian specialises in the conservation of historical monuments and has been engaged in this work since graduating from Charles University, Prague, in 1969. Thanks to grants, he worked in Italy (1968), France (1973) and the United States (1990), which allowed him to attend many seminars and conferences. In 1985, in his Institute for the Preservation of Historical Monuments, he was put in charge of the department of state castles and historic houses. The following year he entered the Art History Institute. Author of numerous publications on the castles of Bohemia and Moravia, he has also helped to prepare exhibition catalogues, notably on art at the court of Rudolf II (Paris, 1990). He also contributed to the exhibition on Prague in the 1400s.

PRINCE CHARLES OF SCHWARZENBERG, former head of the chancellery of the presidency of the Czechoslovak Republic, was born in Prague in 1937. In 1948, the year of the Communist *coup d'état*, his family settled in Austria, in the village of Strobl on the Wolfgangsee. He studied forestry in Vienna, Munich and Graz, before taking over the administration of the family property. From 1984 to 1991 he was president of the Helsinki International Federation for Human Rights and in 1989, jointly with Lech Walesa, received the Council of Europe prize. Shortly after his election to the presidency of the Republic, on 1 January 1990, Václav Havel appointed Prince Charles director of his group of counsellors; then, after his re-election, to be head of his chancellery, a post he held until 1 July 1992. He is now director of the Bohemian Foundation, which aims to promote abroad the image of the Czech nation, its citizens and industries.

TOMÁŠ VLČEK, born in 1941, has been director of the Art History Institute of the Czechoslovak Academy of Sciences since 1990. This art historian, specialising particularly in the 19th and 20th centuries, is also director of the Central European University (installed at Prague), a college specialising in the history and philosophy of art and architecture. Since 1991 he has been chief editor of the journal *Estetika* (Aesthetics). He travelled widely abroad in the 1980s and belongs to various national and international organisations (including the AICA — Association Internationale des Critiques d'Art).

BIBLIOGRAPHY

Bondzio, Bodo, Feyfar, Petr and Ladwigová, Karla: *Prag*; Bucher Verlag, Munich and Berlin, 1990.

Burian, Jiří and Svoboda, Jiří: *Le château de Prague*; Olympia, Prague, 1974.

Coster, Léon de and Coster, Xavier de: *15 promenades dans Prague*; Casterman Coll. Déecouvrir l'architecture des villes, 1992.

Chotěbor, Petr and Svoboda, Jiří: *Pražský Hrad* (Prague Castle); Olympia, Prague, 1990.

Doležal, Jiří and Ivan: *Praha*; Olympia Prague, 1983.

Doležal, Jiří and Ivan: *Zlatá Praha* (Prague the Golden); Olympia, Prague, 1971.

Fernandez, Dominique: *Le Banquet des Andes, L'Europe de Rome à Prague*; Plon, Paris, 1984.

Galmiche, Xavier and Král, Petr: *Prague, Secrets et métamorphoses*; Autrement, Série Monde, H.S.N. 46, Paris, 1990.

Hlavsa, Václav: *Praha, očima staletí* (Prague, Seen through the Centuries); Panorama, Prague, 1984.

Hoensch, Jörg K.: *Geschichte Böhmens* (History of Bohemia); C.H. Beck Verlag, Munich, 1987.

Král, Petr: *Le surréalisme en Tchéchoslovaquie*; Gallimard, Paris, 1983.

Kutal, Albert: *L'art gothique en Tchéchoslovaquie*; Cercle d'Art, Paris, 1971.

Macek, Josef and Mandrou, Robert: *Histoire de la Bohême, des origines à 1918*; Fayard, Paris, 1984.

Mosler, Axel M., Kliment, Alexandr, Novák, Petr and Cmíral, Pavel: *Tschechoslowakei*; Bucher Verlag, Munich and Berlin, 1991.

Mráz, Bohumír: *Prague, coeur de l'Europe*; Librairie Gründ, Paris, 1986.

Mucha, Jiří: *Mucha* (Alfons), monograph; Flammarion, Paris, 1976.

Neubert, Karel: *Pražský Hrad* (Prague Castle); Panorama, Prague, 1990.

Porter, Tim: *Prague Art and History*; Flow East Ltd, Prague, 1991.

Staňková, Jaroslava, Stursa, Jiří and Voděra, Svatopluk: *Pražská architektura* (Prague Architecrture); Ing. arch. Jaroslav Stanek, Prague, 1990.

Stejskal, Karel: *L'art en Europe au XIVe siècle;* Librairie Gründ, Paris, 1980.

Vancura, Jiří: *Hradčany, Pražský hrad* (Prague Castle); SNLT, Prague, 1976.

COLLECTED WORKS

Exhibition catalogues:

1957 *L'art ancien à Prague et en Tchéchoslovaquie*, Paris, 1957, Musée des Arts décoratifs.

1966 *L'arte de Barocco in Boemia*, Milan, 1966, Palazzo Reale.

1968 *Petr Brandl*, Prague, 1968, Národní Galerie.

Josef Šima, Paris 1968, Musée d'Art moderne.

1969 *Baroque in Bohemia*, London, 1969, Victoria and Albert Museum.

1974 *Karel Škréta*, Prague, 1974, Národní Galerie.

1975 *Dix siècles d'art tchèque et slovaque*, Paris, 1975, Grand Palais.

1977 *Kunst des Barock in Böhmen*, Essen, 1977, Villa Hügel.

1978 *Rudolfínska kresba* (Rudolfian Drawing), Prague, 1978, Národní Galerie.

1981 *Le Baroque en Bohème*, Paris, 1981, Grand Palais.

1985 *Kunst der Gotik aus Böhmen*, Cologne, 1985, Schnutgen Museum.

1988 *Prag um 1600, Kunst und Kultur am Hofe Rudolfs II*, Essen, 1988, Villa Hügel, and Vienna, Kunsthistorisches Museum.

Staré české uměni (Ancient Czech Art), Prague, 1988, Národní Galerie.

1990 *Prag um 1400: Der Schöne Stil, Böhmische Malerei und Plastik in der Gotik*, Vienna, 1990, Historisches Museum der Stadt Wien.

INDEX

Numbers in *italic* indicate captions

A

Abondio, Alessandro: 21, *23, 34*
Abondio, Antonio: 21, *34*
Adalbert (St, a.k.a. Vojtěch): 17, 19, 20, 114, 117, 119, 120, 122, 141-144
Agnes (abbess): 165,*168, 197*
Aichel, Giovanni Santini: 49, 210
Albert II of Habsburg: *33*
Alexander the Great: 226
Alliprandi, Giovanni Battista: 210
Altdorfer, Alfrecht: 211
Anna Jagiello (queen): 50, 142, 225, 229, 231, *237, 263*
Anne of Bavaria: 121, *138*
Anne of Silesia: 138
Aostalli, Ulrico: *57*, 142, 143, 228, 249, 253
Apollinaire, Guillaume: 45, *250*
Arcimbolo, Giuseppe: 21, 183
Arnošt of Harrach (cardinal-archbishop): 143
Arnošt of Pardubice (archbishop): 113, 120
Arras, Matthew of: *see Matthew of Arras*
Auerbach, Johann Karl: *90*
Augustus III: 221

B

Babbiena, Giuseppe Galli: 230
Balbín, Bohuslav: 22, 143
Barye, Antoine-Louis: 212,
Bassano, Jacopo: 211, 221
Baudelaire, Charles: *217*
Bechteler, Caspar: 143, *150, 151*
Becker, Tobiáš Jan: *177*
Bedřich J. Schwarzenberg (cardinal-archbishop): 144, 147
Benda, Břetislav: 148
Bendl, Jiří: 230, *256*
Benedict XIII (pope): 144
Beneš, Edouard: 24, *30*, 165
Beneš Krabice of Weitmile (archbishop): 113, 118, 119, 120
Bening, Simon: *214*
Bergeron, Pierre: 227, 228
Bernini: *208*
Bertha (abbess): 165, 177, 197
Beyeren, Abraham von: 211
Blanche de Valois: 121, *138*
Bles, Herri Met de: 211
Boccaccino: 211

Boitard, Clemence: *218*
Boleslav I the Cruel: 18, *27*, 118
Boleslav II: 18, 165, 177, 179
Boleslav the Brave: 19, 46
Bonnard, Pierre: 212
Borch, Ter: 211
Borivoj I: 46, 165, 168
Borivoj II: *19*, 120
Bose, Cornélius: 227
Boucher, François: 212
Bourdelle, Antoine: 212
Brahe, Tycho: 21, *37*, 226
Brandl, Petr: 144, 178, 184, *205, 208*, 221
Braque, Georges: 212
Braudis of Trieste, Louis: 225
Braun, Georg: *51*
Braun, Matyáš Bernard: *94, 135*, 144, 178, 179, 184, 208, 230, *241*
Breuner, Jan J. (archbishop): 144
Brožík, Václav: 92
Broca, Giovanni Antonio: 81
Brocco, Antonio: 227, *237*
Brod, Max: 45
Brokoff, Ferdinand Maximillian: 179, 184, *208*
Brokoff, Jan: *206*, 278
Bronzino, il (Agnolo di Cosimo): 211
Bruegel, Pieter, the Elder: 211, *212*, 214
Brunner, Vratislav H.: 148
Bruno, Giordano: 21
Brus of Mohelnice, Antonín: *57*, 142
Břetislav I: 19, 46, 120
Buckingham, Duke of: *223*
Byss, J. R.: *208*, 211

C

Canaletto, Giovanni: 211
Čapek, Karel: *109*
Caratti, Francesco: *57*, 168
Carpeaux, Jean-Baptiste: 212
Carrà, Carlo: 212
Cassinis of Bugella, M. A.: *202*
Catherine of Lipoltice (abbess): 168
Cézanne, Paul: 212
Chagall, Marc: 212
Charlemagne: 115
Charles IV: *7, 10*, 19, 20, *22*, 30, 31, 47, 8, *62, 74, 78*, 113, 114, 115, 116, 117, 118, 119, 120, 121, 123, *124, 126, 135, 138*, 141, 142, 144, 148, *154, 156, 158, 160, 162*, 165, 174,

181, 184, *189, 224*
Charles V: 226
Charles VI: 221, 229, 230
Charles VII: *92*
Charles X: 23
Chateaubriand, René de: *235*
Chirico, Giorgio de: 211
Chody, Jindřich Hýrzl of: *37*
Christina (queen of Sweden): 22, 220, *223*
Cibulka, Josef: 147
Cione, Nardo di: 211
Claesz, Pieter: 211
Clement VI (pope): 113, 114, 116, 119
Cock, Hieronymus: 227
Colin, Alexandre: 142, *151*
Comenius, Jan Ámos: 184
Corinth, Lovis: 211
Corot, Camille: 212
Corradini, Antonio: *135*, 144
Courbet, Gustave: 212
Cranach, Lucas: 211
Cubr, František: 178, 220
Cunegonde (abbess): 165

D

Daddi, Bernardo: 211
Dalibor of Kozojedy: *263*
Dante Alighieri: *244*
Daubigny, Charles-François: 212
Daumier, Honoré: 212
Dětmar: 18, 19
De Vriendt, Frans Floris: 221
Dee, John: 21
Degas, Edgar: 212
Delacroix, Eugène: 212
Derain, André: 212
Despiau, Charles: 212
Dienzenhofer, Kilián Ignác: 184, 229, 230, *245*
Dietzler, Johan Joseph: 227, 230
Dittman, Kristian: 174
Dlouhoveský, Jan: *159*
Doleiš, František: *259*
Dou, Gérard: 211
Dražice, Jan de: *186*
Drahomíra (princess): 168
Dubček, Alexander: 44
Ducharda, Vojtěch: 148
Dürer, Albrecht: 211, *212*, 221
Dvořák, Jean Baptiste: *259*
Dvořák, Karel: *126*